DAN CRUICKSHANK'S

BRIDGES

Heroic Designs that Changed the World

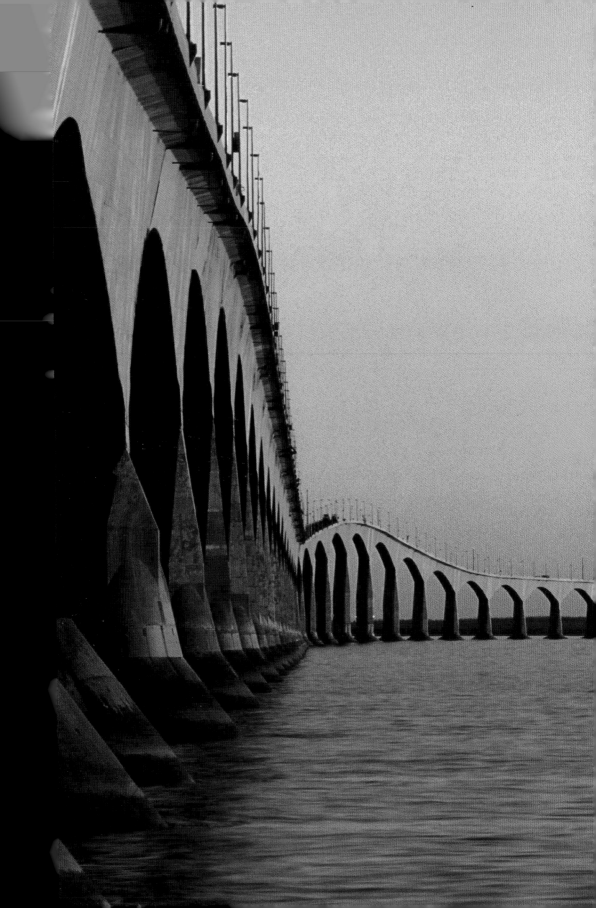

DAN CRUICKSHANK'S

BRIDGES

Heroic Designs that Changed the World

Collins

First published in 2010 by Collins
an imprint of HarperCollins*Publishers*
77–85 Fulham Palace Road
London W6 8JB

www.harpercollins.co.uk

13 12 11 10
9 8 7 6 5 4 3 2 1

A catalogue record for this book is available from the British Library.

ISBN: 978-0-00-731818-6

Typeset by The Urban Ant Ltd.

Colour reproduction by Dot Gradations Ltd, UK
Printed and bound in Italy by L.E.G.O SpA

Mixed Sources
Product group from well-managed
forests and other controlled sources
www.fsc.org Cert no. SW-COC-001806
FSC © 1996 Forest Stewardship Council

FSC is a non-profit international organisation established to promote
the responsible management of the world's forests. Products carrying the
FSC label are independently certified to assure consumers that they come
from forests that are managed to meet the social, economic and
ecological needs of present and future generations.

Find out more about HarperCollins and the environment at
www.harpercollins.co.uk/green

PICTURE FACING TITLE PAGE: The Confederation Bridge linking Prince
Edward Island with mainland New Brunswick, Canada. The bridge
was completed in 1997 and with a length of nearly 13 km is the world's
longest bridge over ice-covered water. The bridge is of post-tensioned
concrete box-girder construction and undulates dramatically to
incorporate 60 metre high 'navigation arches'.

CONTENTS

PREFACE

Great cities are built on great rivers and so, sooner or
later, great bridges arise – bridges that not only connect
and transport but also that play key roles in creating and
defining the character, nature and aspirations of the city.
Bridges, among all their many attributes, are incomparable
place-makers, man-made landmarks that vie with the
memorable works of nature. This is most obvious in cities
and towns, but is also the case in more remote places where
so often it is bridges that excite, that stir the imagination, as
they soar above chasms and canyon, knife across vast tracts
of water – as they dare and achieve the almost unimaginable.

Humanity's inventiveness and structural ingenuity in the
creation of bridges, in the evolution of structural systems,
in the utiliz ation of technology and materials, is on a par
with the engineered excellence of the Gothic cathedrals of
medieval Europe. Great bridges and great cathedrals both
express – in the most sublime manner possible – the
aspirations of their age, of the civilisation that built them.
In Europe and America the genius of bridge building was –
in the past – expressed most forcefully in mighty works,
especially by the great railway bridges of the 19th century –
utilitarian objects of supreme daring, forged of wrought-iron,

steel, masonry in sweat and blood – that in the perfection of their function and their fitness for purpose achieved poetic beauty.

Now – in the early 21st century – there are few structural restraints that can stymie bridge-builders, there is little that engineers dare not aspire to, little that they cannot achieve. This has become the age of the mega-bridge where boundaries of ambition and scale are being regularly extended through ever growing technological prowess. This is impressive with unprecedented structures being realised. But often these mega-scale solutions are formulaic. Now, in many ways, the outpouring of ingenuity and creativity that distinguish the best bridges of the past is found not in huge creations but in smaller bridges where the challenge is not so much to achieve a crossing on an heroic scale but to do so in a manner that is consciously intended to delight and to give a place identity. In parallel to the rise of the mega-bridge is the evolution of the gem-like, small-scale bridge – often only a pedestrian bridge such as the Gateshead Millennium Bridge in England – that functions not just as a route but also as a work of art – as a creation that provides a promenade, that grants character, distinction and sense of place.

This book is a very personal journey into the world of bridges. I focus almost exclusively on those I've seen and experienced and so, naturally, the text dwells on those that exist rather than on great bridges that are no more, like Robert Stephenson's seminal Britannia Bridge, Wales of 1846-50 that has been largely rebuilt and altered out of all recognition. This means, of course, that virtually all the works described can be seen – and enjoyed – by all who read this book and who – like me – are always thrilled and stirred by the sight of a good bridge.

Dan Cruickshank
August 2010.

> ‘Always it is by bridges that we live.’
>
> Philip Larkin, *‘Bridge for the Living’*

INTRODUCTION

From earliest times, mankind has built bridges, and still today bridge construction remains heroic, the most absolute expression of the beauty and excitement invoked by man-made constructions that are practical, functional, and fit for their purpose. Bridges that are leaps of faith and imagination, that pioneer new ideas and new materials, that appear both bold and minimal when set in the context of the raw natural power they seek to tame, are among the most moving objects ever made by man. They are an act of creation that challenge the gods, works that possess the very power of nature itself. They are objects in which beauty is the direct result of functional excellence, conceptual elegance and boldness of design and construction.

Like most people, I am addicted to bridges – to their raw, visceral punch, to their often astonishing scale and audacity, enthralled by their ability to transform a place and community and amazed by the way a bold bridge can make its mark on the landscape and in men's minds, capture the imagination, engender pride and sense of identity and define a time and place. A great bridge – one that defies and tames nature – becomes almost in itself a supreme work of nature.

Bridges embody the essence of mankind's structural ingenuity, they show how nature can be tamed by harnessing

nature, how mighty chasms and roaring waters – the very embodiment of natural power and grandeur – can be spanned by utilizing the structural forces and principles inherent in nature; bridge design demonstrates – with startling and dramatic clarity – the structural potential of different materials and how these materials can be given added strength through design, through the use of forms that work in accordance with the structural laws of nature. For example, stone can be given additional load-bearing capacity and be used to bridge wider spans by being wrought to form well-calculated arches, and wood and metal can achieve great spans if used not as simple beams but when fabricated to form lattice-like, triangulated, trussed structures, where load-bearing capacity comes not through mass but from thoughtful engineering.

The most thrilling bridges are, in many ways, those not enhanced by superficial or extraneous ornament or cultural references. What moves and impresses is their honest expression of the materials and means of construction – their only ornament is a direct result of the way in which they are built and perform. A great bridge has an emotional impact, it has a sublime quality and a heroic beauty that moves even those who are not accustomed to having their senses inflamed by the visual arts.

Bridges are a great paradox, they not only use nature against nature, but magically the best examples do not defeat or damage nature but enhance it, and, in ways that are sometimes hard to fathom, achieve a deep harmony with their surroundings. For these reasons bridges have captured the imagination of people through the ages and now they are the only large-scale and radical examples of modern design and construction that the public generally applaud. All can see that bridges stand for something most significant, for the indomitable human spirit, the love of daring and of challenge, the power of invention.

Bridges, of course, inhabit worlds way beyond the merely physical and visual. Having excited human imagination they have, for centuries, possessed a powerful symbolism. They

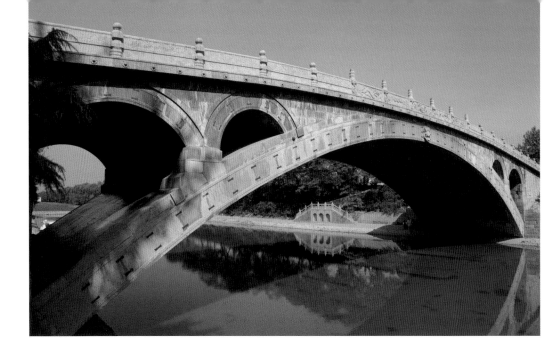

have been seen as links between this world and the next, as symbols of transition, and as metaphors for life and death on earth, and of the journey of the soul to the afterlife – the means of crossing the great divide. This symbolism and fancy have, occasionally, been reinforced by fact, for some bridges have, quite literally and rivetingly, been bridges between worlds and have possessed almost more meaning than physical substance. For example, the stone-arched Bridge of Sighs in Venice, built in 1602 by Antonio Contino (who had earlier worked for his uncle Antonio da Ponte on the Rialto Bridge, see page 158) that formed a covered way between the interrogation rooms in the Doge's Palace and the adjoining prison. It has long been assumed that the small windows in the bridge offered convicted prisoners their last view of Venice or of life. The idea of the bridge as a metaphor for transition or for a journey of the spirit seems universal. In fifteenth century Peru, the Inca saw the rainbow as a bridge between their homeland and heaven, while some of the indigenous people of Australia conceive of the link between worlds taking the form of the vast, arching and bridging body of the rainbow serpent, a creature as it

ABOVE: The Zhaozhou or Anji Bridge, Hebei province, China, completed in AD 605: an object in which form is dictated by function to achieve beauty and eternal elegance.

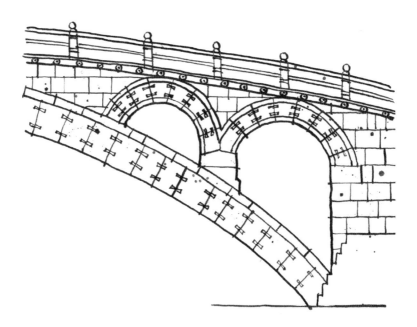

ABOVE: Detail of one
of the arched and open
spandrels of the Zhaozhou
or Anji Bridge. This is the
world's oldest surviving
open-spandrel, segmental
arched bridge built in
stone. The joints between
the masonry blocks
forming the arches are
reinforced by wrought-
iron bars or cramps.

happens that is most similar to the Lebe snake, the
bridge-like ancestor of the Dogon people of Mali, Africa.

For all these reasons bridges have been applauded as
heroic, sacred – almost mystic – works by all cultures.
Bridges of great scale or span were venerated in Medieval
Europe, either as pious works that glorified God or as almost
impossible acts of daring that could only have been achieved
with the aid of the Devil (see page 94). Great bridges were,
people assumed, creations that could only be completed
through prayer and divine guidance or by the sale of the soul
to dark forces. They were places where you could meet angels
and saints as if conducting you to Heaven, or the Devil
himself collecting his toll. Similarly in China: the truly
remarkable Zhaozhou or Anji Bridge in Hebei province,
built between 595 and 605 AD to the designs of Li Chun and
the world's oldest open-spandrel segmental arched masonry
bridge, is particularly rich in myth, legend and stories of the
supernatural. This is mainly because its construction methods
and ambitious scale – its main arch of segmental forms spans
a mighty 37.7 metres – astonished most contemporary observers.
Li Chun achieved the wide span of the bridge by using 28

parallel and abutting arches, each formed with massive, precisely cut and wedged limestone voussoirs whose joints were strengthened with wrought-iron cramps or bars. The arch-topped open spandrels not only reduce the weight of the bridge without weakening it but also – by creating additional openings through its body – protect the bridge from being washed away by the force of unusually high and powerful flood waters. These novel design features and construction techniques gave the bridge great strength but also the flexibility necessary to withstand earthquakes.[1]

Li Chun – clearly a man of advanced practical know-how – was himself not ignorant of the worlds of magic and of the spirits. The bridge is of pure, simple and practical design yet the keystones at the crown of the main arch are embellished with carvings that show the leering and horned heads of the Taotie motif. These beings from the spirit world were intended to protect the bridge from floods and from the potentially malevolent spirits of the river that might resent the bridge, for it robbed them of some of their power over those mortals who wanted to cross the water. In a Taoist culture, where all is animated and nature is seen as the great guide and inspiration, everything is alive – not just the river but the stones from which the bridge is made and, indeed, the bridge itself.

One legend about the bridge is like those attached to many European medieval bridges of prodigious span or slender form: it was constructed by an inspired human, in this case the fifth century BC engineer and philosopher Lu Ban, working with the aid of spirits. Another legend is that two Taoist Immortals – perfected beings who are masters of time and space and travel between the earth and the distant stars – decided to test the strength of this unprecedented bridge by thundering across it in tandem. The bridge survived this ordeal just as it survived resentful water spirits and – perhaps more impressively – earthquakes and centuries of neglect. It still stands, still does the job for which it was built 1,400 years ago, and continues to inspire and astonish – a thing of perpetual delight and timeless beauty that contrives, despite all it has seen and suffered, to look eternally youthful and modern.

ABOVE: The Humber
Bridge, linking Yorkshire
to Lincolnshire, was opened
in 1981, and was seen by
the poet Philip Larkin as
a great symbol of human
existence. 'Always', he
observed, 'it is by bridges
that we live'.

THE ART OF BRIDGES

Always bridges have been seen as things of breathtaking, elemental beauty, as audacious and epic engines of transformation. The profound role that bridges play, in all their symbolical and metaphoric richness, in our imaginations is revealed – and confirmed – by the works of poets, painters and writers. Shortly before the Humber Bridge in England opened in 1981 – a huge and daring suspension bridge whose span of 1,410 metres was until 1997 the widest in the world – Philip Larkin wrote a poem about the arrival of this new creation near his home town of Kingston-upon-Hull. For the first time ever, the mighty Humber Estuary, dividing those on its Lincolnshire south bank from the natives of Yorkshire on the opposite bank and defining the character of the area, had been bridged. Larkin pondered on the way the bridge transformed the landscape and communities and promised new life to all the area – even, as it were, to the dead: 'Lost centuries of local lives that rose...Seem now to reassemble and unclose, All resurrected in the single span'. Larkin also saw the bridge – the act of

bridging – as a great symbol of human existence, of the transition from the past to the present, from life to death and to rebirth: 'Always it is by bridges that we live'.[2]

Larkin, although suspicious of change, clearly had a guarded enthusiasm for such bridges. So it is perhaps slightly disappointing that this particular great engine of transformation has never quite lived up to its promise and proposed purpose. The bridge remains magnificent and sound but not used by the numbers that were anticipated. The communities on each side of the Humber have not embraced the opportunity to mix quite as fully as Larkin and the bridge builders imagined. So in this case the bridge has taken on another symbolism, one somewhat removed from that envisioned by Larkin – and has become the personification of the ancient Greek concept of hubris, the excessive pride and daring arrogance that leads man to defy the gods, and by so doing, create the implacable mechanism of his own downfall.

Many painters, for reasons never fully explained, have not only included bridges in their works as seemingly peripheral objects, but have at times become obsessed by them, or by their apparent meanings. Indeed, for some artists, bridges have become veritable muses, objects that unleash the creative force of the imagination. In the romantically rude but also idyllic landscape that enfolds behind the Mona Lisa there is a bridge. It has several arches that appear semi-circular in form. It could be Roman. Why did Leonardo da Vinci include a bridge in this particular portrait? There are any number of possible answers, the least acceptable of which is that he was merely reproducing a landscape and details with which he was familiar, painting what he saw. The pioneering technique he used to render the landscape – depth is implied by the use of paler, misty-looking colours and by a softening of detail – gives all a naturalism and realism. But this is clearly a fictitious and unreal landscape and one pregnant with deep meaning – but what meaning?

Whatever the meaning, it matured over the years. Leonardo started the work in 1503 and seems to have taken around fifteen years to complete it, mulling over it, carrying it with him into

France, putting it aside, then taking it up. It was his shadow, a thing haunting him. Is it really just a portrait of *ma donna* – my lady – or *m'onna Lisa*, the wife of the wealthy Florentine silk merchant Francesco del Giocondo? Perhaps, but also – in certain ways – it is surely more. The time and care indulged means that, among other things, the Mona Lisa is a self portrait of the painter's soul. His soul, with a bridge nearby. As well as being a painter, Leonardo was an inventor of technically advanced machines, an architect and a military engineer. Without doubt he knew much about bridges and almost certainly loved them for their structural logic and power. He probably also saw them as emblems of human achievement, as Humanist creations that reveal the dignity, value, ingenuity and intrinsic worth of man. Even without reference to God, man was confirmed in his high status by such acts of genius and endeavour as bridge construction.

Bridges appear in the paintings of Botticelli, Raphael and, in particular, in the work of Canaletto. He paints not just bridges in Venice but also, in the mid 1740s, in London. The wonder-bridge at the time was Westminster Bridge – the first major bridge over the Thames built since London Bridge was completed in the very early thirteenth century (see page 16). The new bridge had inspired London-based artists from the moment construction started in 1739 on the designs of the Swiss engineer, Charles Labelye. Richard Wilson had, in 1744, painted its arches rising from the water. When Canaletto painted the bridge in 1746, he placed it in an almost Venetian context – showing the river packed with boats and large ornamental barges – and also produced a remarkable view of London framed by one of the arches of the bridge, complete with timber centering still in place.

This playful and inventive work by Canaletto seems to have challenged – and inspired – the London-based artist Samuel Scott who around 1750, when the bridge was nearing completion, produced an almost obsessive series of paintings. He portrayed the bridge in its setting and, more remarkably, produced over half a dozen studies showing details of, and views through, a couple of arches. Scott was evidently

determined to out-do Canaletto at his own game, for not only
did he emulate Canaletto's unusual arch-framed view of the
city but also embellished his images of the bridge with the
trappings of daily life. Scott placed bustling or pondering
people on the bridge and showed construction details – it was
to be an emblem of urban vitality, of change, of London, and
a vehicle for grasping new and unexpected views of the city.

In fact this was another favoured symbolic role for
the bridge – an elevated and disinterested platform from
which to see the world in revealing perspective, as if an
Olympian god were looking down on the world of mortals.
In September 1802 this was precisely the lofty position that
inspired William Wordsworth – who was in fact given extra
elevation by being perched on top of a stagecoach – when
he wrote *Upon Westminster Bridge*. Apart from the reference
in the title, the poem doesn't mention Westminster Bridge
directly but it is obvious that without the bridge – without
the experience of passing over water atop a slowly moving
vehicle on a still, late summer morning – nothing would

BELOW: One of a series
of paintings by Samuel
Scott showing Westminster
Bridge under construction
in around 1750.

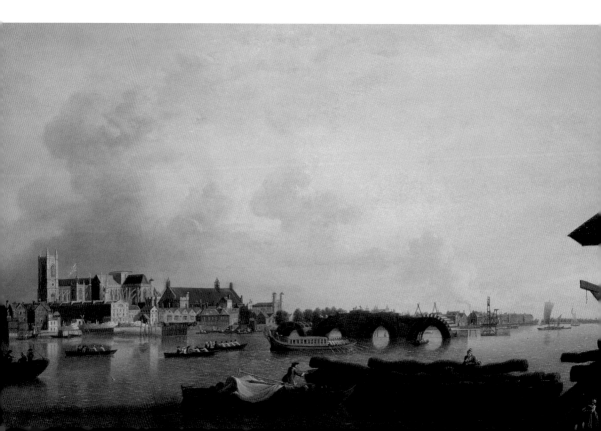

have been possible, no insights or pleasures gained. Moved by the view of the metropolis offered by this relatively new vantage point, Wordsworth had a sudden vision of urban beauty and, in homage, created a hymn to London: 'Earth has not any thing to show more fair...The City now doth, like a garment, wear/ The beauty of the morning: silent bare...Ne'er saw I, never felt, a calm so deep!/ The river glideth at his own sweet will:/ Dear God! The very houses seem asleep;/ And all that mighty heart is lying still!'[3]

As artistically ecstatic are the paintings by Pierre-Auguste Renoir and Claude Monet. Paris's oldest surviving bridge – the Pont Neuf completed in 1609 – and the life it engendered over the reflective river inspired Renoir in the early 1870s to help forge the fleeting light effects and immediacy of Impressionism. A few years later Monet became entranced by the little Chinese-style timber bridge he had created in the early 1880s within his garden at Giverny, France, and painted it in different lights to create a series of studies that in a sense define his art.

For both these artists bridges were clearly admirable things, just as they were a few years later for Surrealist and Dadaist artist Marcel Duchamp. In 1917, when defending his decision to display a urinal as a work of art in a New York gallery, Duchamp explained that by placing the urinal at an unusual angle, in the novel context of an art gallery, and naming it 'Fountain', its familiar 'significance disappeared under a new title and point of view'. Duchamp claimed to have transformed the essence of the object in an almost alchemical manner by creating 'a new thought' for it in the eyes of the viewer. He'd opened, in the prophetic words of William Blake, new 'doors of perception'.[4] And to those who argued that to display such a piece of off-the-peg plumbing as a urinal was just plain vulgar and could not possibly be art, Duchamp simply replied: 'that is absurd. The only works of art America has given are her plumbing and her bridges'.[5]

It is not just poets and painters who have viewed bridges as potent symbols and metaphors. So have novelists. For example Thornton Wilder, in *The Bridge of San Luis Rey*,

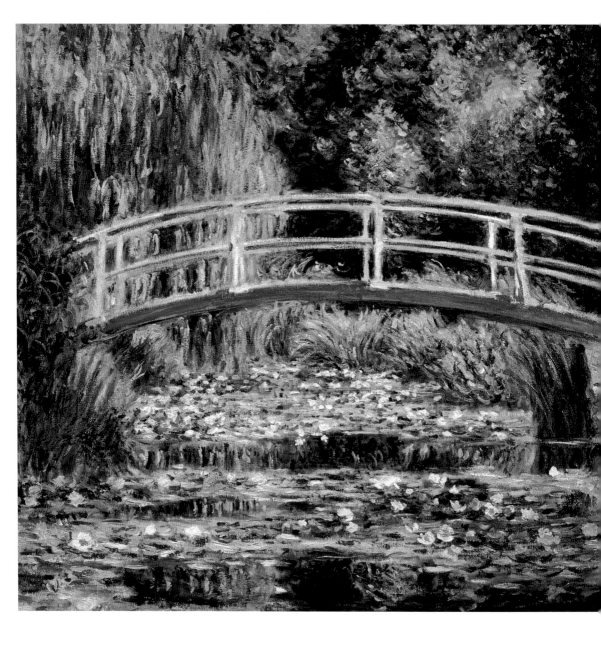

published in 1927, uses the sudden collapse of an ancient, creeper-built suspension bridge in Peru in which five people are killed, to explore the nature of God and religion. The fate of the bridge becomes a metaphor for the fate of man, a symbol of divine will. Were the deaths merely random, revealing that God has no plan and ultimately that life is arbitrary or was the bridge's collapse the long-ordained and deserved termination of the lives it took?

ABOVE: Claude Monet was inspired in the 1880s to produce numerous versions of the play of light on the Chinese-style bridge in his garden at Giverny.

BRIDGES OF DEATH AND REDEMPTION

Perhaps the most relentless literary pursuit of the bridge as symbol is Ivo Andric's *The Bridge on the Drina*, a novel published in 1945 and inspired by Bosnia's history and quest for independence and identity. The novel focuses on the town of Višegrad and the Mehmed Paša Sokolović Bridge over the Drina river and spans 400 years from the time the region, town and river were dominated first by the Muslim Ottoman Turks and then by the Christian Austro-Hungarian Empire. It chronicles the religious battles between the communities that co-existed in a border town on a river forming a frontier between different peoples – and the thread that holds the narrative together and that weaves through time is the bridge.

In the novel – and in reality – the bridge is a mighty work. The Ottomans were skilled and prodigious bridge builders who, like the Romans before them, understood that bridges and roads were the means of expanding, holding and controlling a sprawling empire and of linking and unifying the diverse peoples that it contained. The Mehmed Paša Sokolović Bridge was completed in 1577 to the designs of the Ottoman court architect Mimar Sinan on the orders of the Grand Vizier of Bosnia. Sinan was the greatest architect of the Golden Age of Ottoman power, the designer of the spectacular mid-sixteenth century Süleymaniye Mosque complex in Istanbul that remains an exemplary essay in the creation of an Islamic paradise on earth.

Sinan's bridge over the Drina was nobly conceived – it was to measure 180 metres and cross the water by means of eleven stone-built pointed arches, each with spans of between 11 and 15 metres. In the novel, the Vizier had, as a boy, been kidnapped into slavery in Bosnia and resolved to build a bridge at Višegrad to purge his memories of initiation into slavery aboard a boat while crossing the Drina. The tale woven around fact tells of the harsh conditions and chaos of the initial phases of construction – marked by episodes of gruesome cruelty – gradually giving way to order, to harmony, and to final completion when the bridge becomes a source of pride and prosperity for Muslims and Christians alike.

The bridge, with its mid-span meeting place, assumed the symbolic – in many ways actual – role of town centre and focus of activities that gave the community identity and cohesion. Then decline sets in, the bridge loses its importance as a trade route and finally – in the novel and in reality – soon after the start of the First World War ceased to exist as any sort of route at all because retreating Austrian forces blew up a number of its arches as the enemy approached. As Andrew Saint has observed of the way the bridge is presented in this novel: 'Here is an engineer's story, [it is] about courage, effort and technique; about the benefits a magnificent and useful monument can confer across generations; about amazement at its construction and pride in its endurance'.[6] He could have added that the story also talks of the way bridges can bring prosperity and unite communities.

The real-life story of the bridge across the Drina after the publication of the novel (that in 1961 won the Nobel prize for literature) has bizarre and brutal twists worthy of the darker moments of Andric's imagination. The three arches destroyed in the First World War were repaired, as were the five subsequently destroyed in the Second World War and by the 1990s the bridge was regarded as a major historic and architectural monument of Yugoslavia. Then descended the dark and ancient shadow of hatred and cruelty. There was division, fragmentation, a return to religious war, the imposition of the ghastly mechanisms of 'ethnic cleansing' and land appropriation by the most violent means imaginable. In 1992 a large group of local Muslims were herded to the centre of the bridge – to the place of creative and convivial gatherings in Andric's vision of the history of the bridge – and then flung off 'and shot at for sport by Serbs as they fell'.[7] The bridge, now again a place of calm and beauty but more than ever haunted, currently belongs to the Republic of Serbia. Few visit it: the suffering it has seen is too great for most to bear.

One bridge nearby, with a comparable history and story, I have explored in detail. The bridge at Mostar was completed in 1566 and with a single and elegant stone arch spanning 29

metres and rising 19 metres above the water, is one of
the great engineering marvels of the Ottoman empire –
a testimony to the taste, culture and scientific skills of the
Muslim world that created it. The construction technique
was ingenious – the limestone blocks were finely cut and
their joints strengthened by the use of wrought iron pins,
set in lead to prevent them rusting, expanding and cracking
the stone. As in Andric's story of the bridge at Drina, the
bridge at Mostar – with what many at the time believed was
the longest stone-built arched span in the world – became
a great source of local pride and brought prosperity and
distinction to the town. It also became the focus of customs
and rituals – notably offering young Mostar males of all
persuasions the opportunity to publicly demonstrate their
virility to all who might be interested by leaping from the
crown of the bridge into the generally shallow water below.

The history, beauty and technical excellence of this bridge
proved its undoing. The same vicious conflict following the
break-up of Yugoslavia that led to the deaths on the bridge
across the Drina also engulfed Mostar. The town had a
complex and mixed community – Orthodox Christian
Bosnian Serbs, Slavic Muslims and Roman Catholic Croats
– and in mid 1992 this long stable but potentially volatile
community fragmented. Fighting flared on opposite sides of
the bridge, each the territory of neighbours now in conflict.
Outside forces arrived and the bridge became a target – this
was culture very much in the firing line. The bridge was
obviously of military and strategic significance in the
fighting – but it was also a symbol, an emblem of Muslim
presence, of Islamic culture. As such some of the fighting
factions found it intolerable. Despite attacks, the bridge
managed to survive until November 1993 when Croat forces
finally shelled it to destruction.

When the fighting gradually died down, and Mostar found
itself stabilized as part of Bosnia and Herzegovina, it was
resolved that this cultural wonder must be rebuilt. This was
not only to reclaim lost beauty and history, but was to be an
act of reconciliation that would give Mostar back its heart,

its identity and its role as a trading centre. The European Union got involved, money was made available by various states and an exemplary reconstruction took place utilizing as many of the old stones as possible and using traditional building materials and techniques. By July 2004 the great wrong had been put right and the noble bridge rebuilt. I saw it a few months later. It looked superb, as if the last ten years had never been. Mostar has its wonderful bridge back, the ancient trade routes are reconnected, and customs revived. Even while I was there muscular young men were gaily tossing themselves off the top of the arch to splash into the water far below. But near the bridge I spied a stone standing against a wall, and on the stone was written, 'Don't forget'. The stark and powerful words provoked memories of ancient,

BELOW: Mostar, Bosnia and Herzegovina, in November 2004. The beautiful mid-sixteenth century bridge had recently been reconstructed after its destruction in 1993, but the words written on a stone nearby – 'Don't Forget' – were a reminder that the intense emotions that had been aroused by the destruction of the bridge (a symbol of Muslim culture as well as a military target) – had not been fully pacified by its rebuilding.

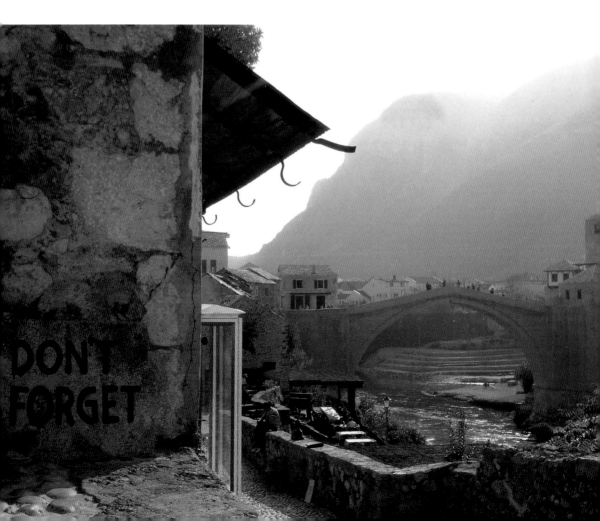

prophetic texts, especially those touching on mortality and transience. I looked up the famous lines from the eleventh century *Rubaiyat of Omar Khayyam*: 'The moving finger writes: and, having writ, moves on: nor all your piety nor wit shall lure it back to cancel half a line. Nor all your tears wash out a word of it'.[8] Yes indeed, we are 'weighed in the balance, and…found wanting' (Daniel, 5:27). A bridge, for all its engineering wonder and potential symbolism, is in many ways just a bridge, a physical fact. The sign near the bridge at Mostar, I suppose, is saying that some things when lost cannot be found, that it is easier to mend a broken bridge than it is a broken heart.

The bridges at Višegrad and Mostar have, by turn, been symbols of identity, despair, death and redemption. Other bridges have not had such emotional, roller coaster rides but, nevertheless, have still enjoyed extraordinary existences that have made them central to the life of their city or nation and so much more than just routes of communication or means of crossing a great divide. The Széchenyi chain bridge in Budapest, stretching 375 meters across the Danube and completed in 1849, launched the fortunes of the city and has become a symbol of Hungarian pride and liberty (see page 245). Similarly, although for differing reasons, the Brooklyn Bridge in New York (see page 284), the Sydney Harbour Bridge (see page 218), and the Golden Gate Bridge in San Francisco (see page 228) have all become the much-loved emblems of the cities in which they stand. These were all, in their time and in their different ways, bold technical pioneers and creations of epic scale and ambition. But earlier ages have also produced bridges with comparable emotional punch. There were the paradise bridges of Persia (see page 118), the great pious works of medieval France, such as the bridges at Avignon and Orléans (see pages 92 and 82), and of central Europe.

THE ALCHEMICAL BRIDGE
The Charles Bridge in Prague, the Czech Republic, is perhaps the best-known man-made object in a city packed with

architectural wonders. The bridge has an extraordinary life and history, and a great importance. When completed in the very early fifteenth century the 516-metre-long, stone-built, sixteen-arch bridge not only connected the two halves of the city in spectacular style (an earlier ramshackle affair had been swept away in the 1340s) but also, as the only route across the mighty river Moldau (Vltava) formed a vital trade route that – almost literally – connected Europe to the east. It was – in fact as well as fancy – a bridge between worlds, with both its ends secured by robust guard towers.

The importance of the bridge was recognized from the moment construction started. The foundation stone was laid in 1357 with, it is alleged, the Emperor Charles IV insisting that the event take place at 5.31 am on 9 July. Royal astronomers, mathematicians and those learned men consulted had, apparently, ordained that this moment was auspicious because it enshrined a palindrome comprising all the odd numbers 1-3-5-7-9-7-5-3-1. A palindrome is a sequence of numerals or letters – sometimes arranged in a 'magic square' – that either reads the same from different directions or possesses different meanings or pronunciations when read from different direction. For example, 'a man, a plan, a canal, Panama' has the same letters from either direction but is not pronounced the same from either direction – to grasp the point try saying 'amanap lanac a nalp a nam a'.

Medieval Prague was indeed a meeting place of east and west, a melting pot of different cultures and religions. It had a large Jewish community from as early as the tenth century but this suffered waves of persecution culminating in the late twelfth century with an obligation imposed on all Jews to settle in an enclave on the east bank of the Moldau, near the main city square – and thus was created the first Jewish Ghetto. In the mid fourteenth century Charles IV relinquished some of the state power of the Jewish community, and perhaps even consulted rabbis about the construction of the bridge. These men would undoubtedly have enshrined the ancient esoteric wisdom of the Kabbalah, the branch of mystic Judaism devoted to the quest for the

origin of life, of creation, and of the nature of the relation between God and man.

A key part of this quest – the code that could explain all – was language itself, in particular the twenty-two 'foundation letters' of the Hebrew alphabet which Kabbalists believed was the creation and direct gift of God and pregnant with many layers of meaning. One of the most important Kabbalistic texts – the 2,000 year old *Sepher Yetzirah* or *Book of Creation* – states most directly that God 'ordained' the letters of the alphabet: 'He hewed them, He combined them, He weighed them, He interchanged them. And He created with them the whole creation and everything to be created in the future'. So if Kabbalistic rabbis were involved with the ritual of the foundation of the bridge, then the ceremony was evidently of a deeply mysterious nature, akin to casting a spell. This was the age of alchemy and of miraculous transformation, of the quest for the Philosopher's Stone, the 'elixir of life' and of attempts to transmute base matter into fine, the material into the spiritual. The construction site of the bridge could have been seen as a vast alchemical laboratory, for bridges are, in their way, a form of alchemy – they transform, they bring life. As Philip Larkin wrote in 1981: 'All will be 'resurrected in the single span'.⁹

A significant clue to the meaning of the foundation ceremony, and to the power of the Kabbalah in fourteenth-century Prague, lies in the story of one of the most remarkable alleged inhabitants of the medieval city – the golem. This is a creature of Jewish legend that – like Adam – is made of mud, but animated by man not God. In consequence the golem was a parody of divine creation, a mere perverse shadow of humanity, lacking a soul but desiring one and given to hubristic displays leading to chaos and, eventually, self destruction. The golem is mentioned in the *Talmud* and implied in several Old Testament texts, notably Psalm 139:14-16. Here, in most mystic fashion, a being seemingly full of pride addresses God and says: 'I will praise thee; for I am fearfully and wonderfully made...My substance was not hid from thee, when I was made in secret, and curiously wrought

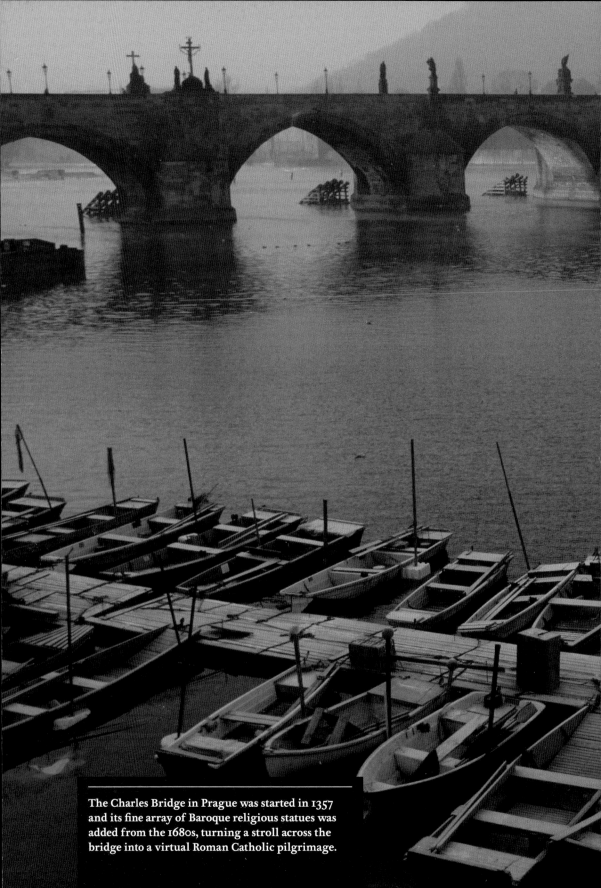

The Charles Bridge in Prague was started in 1357 and its fine array of Baroque religious statues was added from the 1680s, turning a stroll across the bridge into a virtual Roman Catholic pilgrimage.

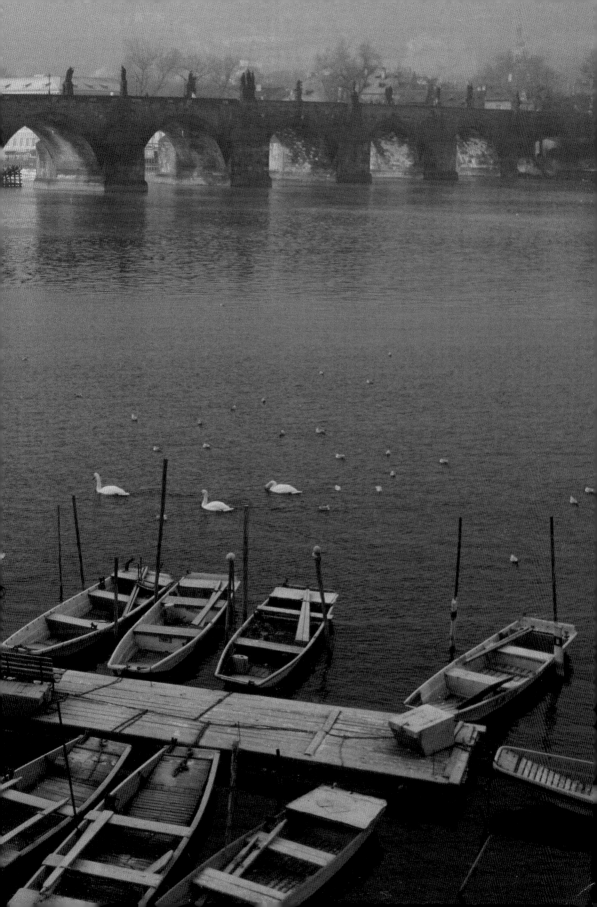

in the lowest parts of the earth. Thine eyes did see my substance, yet being unperfect; and in thy book all my members were written, which in continuance were fashioned'. An 'unperfect' or unshaped substance in Yiddish is 'goylem'.

The means of animation was by tradition a deep and closely guarded secret but involved the Kabbalah and the use of certain letters from the Hebrew alphabet and magic words from, no doubt, the 'book' in which all about the golem was 'written'. To deactivate his creation the magician, for such he was, had to remove letters from words to transform their meaning. For example, one legend says, that to bring the golem to life the word 'truth' has to be written in Hebrew on its forehead, and to kill it a letter has to be removed from that word that changes its meaning from 'truth' to 'death'. Or to kill the golem the magician had to pronounce the animating word – the magic palindrome – backwards.

For reasons now lost in myth, the golem became closely associated with Prague and, in legend, was created and animated by rabbis as a means of protecting the inhabitants of the ghetto from anti-Semitic attacks. In the early nineteenth century the writer Berthold Auerbach went so far as to identify the learned late-sixteenth-century Prague rabbi Judah Loew ben Bezalel as the creator of a golem. Interesting, at this very time, the emperor Rudolf II gave active encouragement to alchemists at his court in Prague as they pursued their various vital and curious quests.

Given all this, and assuming some mystic intent, it must be assumed that the palindromic foundation time and date was intended to give the bridge some special quality – to protect it presumably, but perhaps even animate it in some way. And there is another peculiarity about the bridge. Legend says eggs were mixed into the mortar used to bind the stone and recent analysis suggests the old mortar does indeed contain some unusual organic matter.

Why eggs? Well, it is possible that their addition hardened or improved the mortar in some practical manner. But also, of course, eggs are pretty universally regarded as emblems of life, virility, of creation – especially, as it happens, in Islam

'Assuming some mystic intent...the palindromic foundation time and date was intended to give the bridge some special quality – to protect it presumably, but perhaps even animate it in some way.'

where mosques often contain an ostrich egg. I remember seeing – to my surprise – a couple perched on the roof of the massive mud-built mosque in Djenne, Mali. The 79th sura, or chapter, of the Koran explains all. This sura – entitled rather intriguingly 'The Soul Snatchers' – starts by warning that the hearts of all humanity – including 'those who snatch away men's souls' – will 'on the day the Trumpet sounds its first and second blast...be filled with terror'. The sura then goes on to discuss creation and states that God 'spread the earth, and, drawing water from its depth, brought forth its pastures'. This is one English translation of the seventh century Arabic of the original text.[10] Other English translations use slightly different words, but in the original Arabic text is the word 'daha', which can be taken to mean an elliptical, geoid or, indeed, an ostrich-egg shape. Did the Arabs of the seventh century really know, as suggested through the revelation of the Koran, that the world was of spherical form? This would be an extraordinary insight for the time and is one that current Islamic scholars use to support their argument that the Koran is truly the word of God, for in the seventh century only He knew the shape of the world.

So eggs had huge and ancient symbolic meaning in the fourteenth century, particularly in those countries of central Europe relatively close to the borders with Islam and familiar with its religious beliefs and customs. Were they added to the material body of the Charles Bridge – originally called simply the Stone Bridge – as part of some magic or religious

ritual to quicken it? This is perhaps not as odd as it sounds. Stone has been venerated by different peoples and religions throughout time. The Ka'ba in Mecca – the holiest place in Islam – enshrines a stone, now called 'the Black Stone', that is perhaps a meteorite. In Islamic belief the stone fell from heaven – a gift of God – for Adam and Eve to use as an altar and was later used by Abraham. Whatever the truth, this stone was an ancient sacred object well before the rise of Islam. The Dome of the Rock on the Temple Mount in Jerusalem covers a pinnacle of stone held sacred by both Muslims and Jews because they believe it to be both the rock on which Abraham proposed to sacrifice Isaac, and the veritable Foundation Stone of God's creation mentioned in the *Book of Isaiah* where God says: '...Behold, I lay in Zion for a foundation a stone...a precious corner stone, a sure foundation'. (Isaiah 28:16).

When Jews pray towards the west or 'Wailing' wall of the Temple they are in fact facing the buried body of the stone that peeps above the surface within the Dome of the Rock. They are praying towards what many believe to be Mount Moriah, now embraced by the Temple Mount and which, as the place where all things started, bears, as it were, the direct traces of God's presence. And for Christians, rocks are an ever-present imagery (see page 91). Christ told Peter that he was his 'rock' upon which he would build his church (Matthew 16:18) and referred to himself as the 'stone which the builders rejected' – prophesized in the 118th Psalm – that would 'become the head of the corner' – which is to say the foundation stone of the church of redemption, (Matthew 12:10).

Whatever the intention behind the bridge's foundation rituals, as it turned out, they brought no good to the Jews of Prague. During Easter 1389, as the bridge was nearing completion, the clergy in the city inflamed the latent anti-Semitic feelings of the population by announcing that Jews – long held responsible by Christians for the death of Christ – had desecrated the host, the Eucharistic wafer that becomes the body of Christ during the mystery of the Roman Catholic Mass. Murderous chaos followed which resulted in the Jewish

ghetto being pillaged and burnt, and much of the Jewish
population of Prague – estimated at around 3,000 people –
being murdered.

Four years later the bridge – still incomplete – became
itself the focus of a grim event that, in later centuries, did
much to define the character and spiritual aspirations of the
city. On the night of 20 March 1393, John Nepomuk was
killed by being thrown from the bridge on the orders of
Wenceslaus, King of Bohemia, who in 1378 succeeded his
father, Charles IV, as ruler of Prague. Nepomuk was a principled
cleric who displeased Wenceslaus by refusing to divulge to
him the secrets of his Queen's confession. In consequence
Nepomuk was tortured (apparently his tongue was removed
in no uncertain manner) before being tossed from the
Charles Bridge. His sufferings and manner of martyrdom led
Nepomuk to be canonized, made the patron saint of Prague,
the official holy protector against floods, and inspired within
Bohemian architects for years to come a morbid interest in
tongues. As motifs, as plan forms or vault patterns, stylized
tongues, small or vast in scale, enliven the sacred architecture
of the region.

The Charles Bridge stood firm and largely unaltered
for nearly 300 years, maintained by a toll collected by the
crusading military order of the Knights of the Red Cross
and Star whose mother-house was located next to the bridge.
Then, in the 1680s, the bridge's lurid past caught up with it.
This was a time of Roman Catholic resurgence in Bohemia,
following the dramatic defeat in 1620 of Protestant forces
at the Battle of the White Mountain, and if the bridge's
foundation had anything to do with the ancient arts of
magic, alchemy or the Kabbalah, then the Catholics felt
something had to be done about it. And it was. From 1683
until about 1714, the bridge's parapets were loaded with
statues carved of stone, mostly of saints and clerics –
including, of course, an image of St John Nepomuk. The
bridge was turned into a Roman Catholic shrine – walking
along it became a mini-pilgrimage – with the flamboyantly
posturing parade of saints, carved in ostentatious baroque

manner, being a tremendous late flowering – in theology and in art – of the Counter Reformation. Virtually every one of these statues has now gone, their weathered and battered hulks carted off to the Lapidarium museum and replaced by replicas. But the fourteenth century bridge endures, a tribute to its robust construction, to the skill of the master mason Peter Parler who supervised building works and – perhaps – to the strange ritual of its foundation.

STRUCTURAL PRINCIPLES

During the late fourteenth century in Europe, when the Charles Bridge was being built, the technical approach to bridge building was starting to change. Masons like Peter Parler tended to have an almost intuitive understanding – honed by years of experience and exposure to the trade 'mysteries' of their craft – of the structural forces engaged in bridge construction. Their responses to these forces of nature, and to the manner in which loads are contained or transmitted by structures of different forms or materials, were usually pragmatic and the result of empirical observation, practical experiment and trial and error. This resulted in safe and conservative designs with few great and dramatic leaps forward – which is what makes the unusually wide-span elliptical arches of the mid fourteenth century Ponte Vecchio in Florence so novel and interesting (see page 150). Throughout the fifteenth century things started to change, gradually at first, as bridge building became more theoretical and finely calculated. But it was not until the late sixteenth century that scientific understanding of the theory of bridge construction started to dominate the business of bridge building.

Crucial to this new understanding was the ground-breaking research and analysis undertaken in the late sixteenth and early seventeenth centuries by mathematician, astronomer and philosopher Galileo Galilei. This allowed late Renaissance engineers to calculate the ways in which the shape and size of structural members – for example beams and trusses – and the materials from which they were made

would affect their ability to carry and transmit loads. Significantly Galileo identified the 'scaling problem'. He established the principle that as a beam increases in length it decreases in strength, unless its thickness and breadth increase disproportionately. He also demonstrated that this escalation of scale has very definite limits dictated by nature. Quite simply, if a beam is increased in scale beyond a natural limit it will be capable of supporting no loads at all and break under its own weight.

In the late sixteenth century the scientific and mathematical approach to construction was in fact being explored by many and evolved at a rapid rate. For example, the architect Andrea Palladio's *Quattro Libri dell'Architettura* of 1570 included the first published illustration of a triangulated truss – a robust structure for transferring loads through a rigid system of triangular forms. Other important publications pioneering, promoting or explaining theories of bridge construction included *Machinae Novae* of 1595 by Fausto Veranzio, which includes information on tied-arch bridge construction, the oval lenticular or lentil-shaped truss, and the iron chain-link suspension bridge. A key later work containing much technical information is *Traitre des Ponts* of 1716 by Hubert (Henri) Gautier.

BRIDGE DESIGN AND CONSTRUCTION

The permutations of materials and structural principles employed in bridge construction are seemingly many, varied and complex – timber, brick, stone, cast and wrought iron, steel, hydraulic cement, mass concrete and steel-reinforced concrete, arches of diverse form, beams, cantilevers, pylons, cables and masts. But in its aim bridge construction is straightforward and construction simple. The object is to link two points of land as safely and efficiently as possible. If the obstacle being bridged is running water, then the ideal is to achieve wide spans with minimal support rising from the water to make the bridge easier to build and maintain, to avoid disturbing navigation, and to reduce the risk of the bridge being swept away.

In essence bridge construction is of two basic types. The carriageway – be it for vehicles or pedestrians – is either supported from below or suspended from above. If the 'dead' load of the carriageway (its weight) and the 'live' load of the carriageway (the weight of the use it carries plus the 'environmental load' comprising the weight and pressure of rain, snow and wind) are supported from below it must be carried on arches or vaults of varied types; on beams either cantilevered from, or supported by, abutments and piers; or set within a lattice-like engineered truss wrought of timber or metal. There are two models of nature for support from below: rock formations that arch over; and timber logs or beams laid across, chasms or rivers.

If the 'dead' and 'live' loads are supported from above, the carriageway must be suspended from well-anchored cables or chains stretching over masts to form inverted arches of strong catenary shape, or from natural features – a system known in China from the second century BC. Cables can also be stayed or anchored firmly to a single support to create a cable-stayed bridge. The prototype in nature for these types of suspension bridges is a walkway formed by, or supported by, hanging vines and vegetation.

These different approaches are determined by a variety of circumstances but all are responses – in various and appropriate ways – to the four basic types of forces that

BELOW: A bow-string truss or tied-arch bridge: the horizontal thrust of the arch, from which the carriageway or deck is supported from above, is restrained by the horizontal tie on which the carriageway sits.

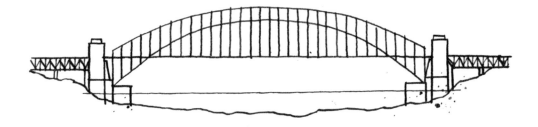

act on bridges, either singly or in combination: tension, or a tendency to stretch or pull apart; compression which pushes together and compacts; shear, which is a sliding force; and torsion which is a twisting force.[11] The form of the bridge, and the materials used in its construction, also create different – and utilize different – structural forces.

For example, the beam in a beam bridge is under both compressive and tensile forces, itself exerting a downward, compressive force on its piers. The weight of arched bridges is carried downwards from the crown to the ends of the arch and then not only vertically but also laterally because an arch, by its nature, thrusts outwards. The force of an arch's lateral thrust depends largely on its form, but also to a degree on its materials of construction and sheer mass and weight. Clearly, a shallow, elliptical arch of masonry will have more lateral thrust than a semi-circular arch formed with timber members. For the arch to function structurally this outward thrust must be contained – possibly by a horizontal tie linking both ends of the arch but usually, in bridges, by abutments that exert a compressive force to prevent the arch from spreading apart.

In addition, the material from which a masonry arched bridge is constructed is under compression, being forced together by the loads carried and by gravity. This is why an arch made of brick or stone voussoirs is such a perfect form

BELOW: A suspension bridge, in which the carriageway is supported almost fully from above: the suspension cable, passing over the tops of the suspension towers and anchored firmly in the ground, is connected to the carriageway by vertical suspender cables.

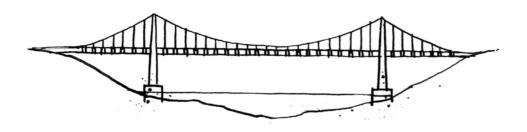

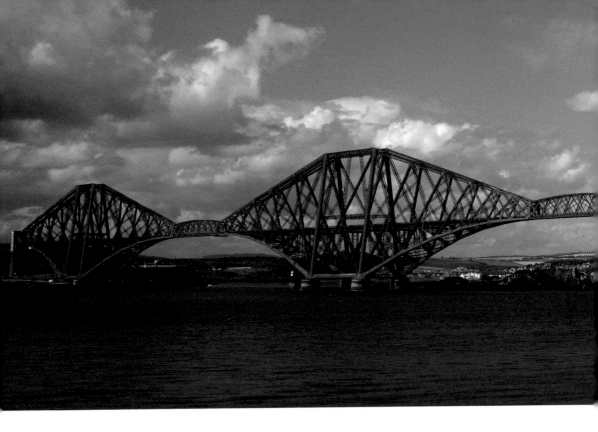

for a load-carrying structure – the more weight that is placed upon it (within reason) the more rigid it becomes because the load ensures that the components are locked more firmly together.

In contrast, bridges with their carriageways suspended from cables are structures operating under tension because the loads on the carriageway pull – or stretch – the cables.

These basic strategies can be combined to create composite structures in which different members are acting under both compression and tension. For example, the cantilever bridge is a more complex version of the beam bridge, utilizing additional structural principles. The Forth Railway Bridge of the 1880s in Scotland is a useful illustration (see page 294). It incorporates massive steel lattice-work pylon towers, forming projecting 'arms' that are, in effect, huge balanced cantilevers linked by suspended spans.

The loads at work within the lattice towers of the Forth Bridge are complex, with vertical members in compression and diagonal members in tension, but broadly speaking, the

ABOVE: The Forth Railway Bridge, Scotland, completed in 1890: balanced cantilever arms linked by suspended spans.

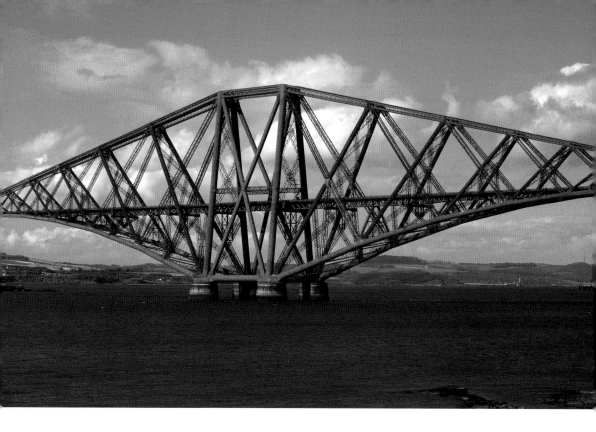

upper raking steel principle members of the cantilevers
are under tension, being pulled down by the weight of
the carriageway below them, while the lower steels of the
cantilevers are under compression, being pushed down by
the weight of the carriageway above them. The structure
of the Forth Bridge confirms an ancient and elegant
engineering ideal expressed in such great Gothic cathedrals
as Notre Dame in Paris or Reims. In this ideal engineering
model, conflicting forces are made to balance, to compensate
for each other, with thrust met by an opposite and equal
counter thrust, and weight balanced by weight, all calculated
to create structural equilibrium and to achieve strength and
solidity not through mass but through pure engineering
know-how.

Another fascinating example of a bridge design embracing
and utilizing different structural forces is the bow-string truss
bridge, or tied-arch bridge, in which the outward, horizontal
force of the arch is restrained by a horizontal tie rather than by

abutments and the bridge's foundations. Ideally the horizontal tie – when linked to the arch by vertical and diagonal members – also functions as the carriageways – as in the great examples of the type bridging Sydney Harbour and the River Tyne in Newcastle (see pages 219 and 179).

The design of this type of truss – which by necessity must be made of metal or timber – was perfected in the second half of the nineteenth century by engineers who were fully able to calculate forces at work in bridge construction and in the natures of different materials. These engineers were obliged to do so because of the unprecedented methods of modern transport in which increasingly heavy and rattling railway engines and their carriages put particularly strong stresses on bridges. One of the pioneers of the precisely calculated and very strong metal railway bridge, was the American engineer Squire Whipple, who in 1841 patented his all-iron bow-string truss bridge design. In Whipple's conception, a pair of these arched trusses, set side by side, carry a carriageway set on a platform built off the beams forming the strings. But the key point about Whipple's bridges was not so much their form but the fact that all was calculated by scientific analysis and the size of all members dictated by the forces they carried. His book, *A Work on Bridge Building* of 1847, is one of the key nineteenth century publications on structural mechanics.

The choice of form chosen for the bridge usually depends on a number of factors: on the width, height and type of obstacle to be bridged; on the function of the bridge and estimated forces of 'dead' and 'live' loads; on time and materials available for use (masonry and cast-iron were really only appropriate for compression structures while more flexible or 'elastic' timber, wrought-iron or steel worked for tensile structures); and – of course – on the skill, knowledge, intentions and nerve of the bridge builder.

BRIDGE OVERVIEW

The principles of bridge construction, and the problems and potential of different forms and materials, are best explained in further detail by reference to a few specific examples of bridges. For reasons of clarity and instructive comparison, the examples are arranged and grouped according to primary construction materials.

Timber

Timber is, presumably, the earliest bridge-building material in large scale and continuous use. Only when grandeur or longevity was required, or in regions with no easily available timber – such as Mesopotamia – would stone or brick have been used in preference. And when timber is used the beam-type design, incorporating piers, is the obvious choice if reasonably short unsupported spans are acceptable. Two early timber bridges survive and are available for scrutiny – not in physical reality but in informative contemporary descriptions. During the Gallic War, in 55 to 53 BC, Julius Caesar built two military bridges over the River Rhine. The purpose of the bridges was both strategic and political. They were to demonstrate to aggressive tribes east of the Rhine that Roman power was ubiquitous, that the legions could roam at will – even the mighty Rhine was no obstacle – and that they didn't need to scrabble around in boats, but could move with majesty and dignity over the water.[12]

The first bridge was located between Andernach and Neuwied, and took 40,000 legionaries ten days to build. It was 140–400 metres long and 7–9 metres wide, across 9 metres of water. Caesar's description of the bridge's construction is obscure and has led to disputes about its exact design. But it is clear that the carriageway rested on piles, each formed by a pair of pointed logs 0.46 metres (1.5 feet) thick and fastened together 0.61 metres (2 feet) apart. The two-pronged piles were driven into the riverbed using pile-drivers, 'not vertically… but obliquely', set alternately so as to be 'inclined in the direction of the current' and 'in the opposite direction to the current'. Such was the ingenuity of the design that 'the pairs

of piles...each...individually strengthened by a diagonal tie between the two piles' formed a 'structure...so rigid that in accordance with the laws of physics, the greater the force of the current, the more tightly were the piles held in position'.[13] This description suggests that trusses were created to stiffen the bridge. After the bridge was used for punitive raids and to demonstrate the power of Rome, it was completely destroyed so that it could not be used by attacking forces. Clearly Caesar was not convinced that his threats had entirely worked on the warlike tribes of Germania.

The second bridge was constructed in a similar manner and for similar reasons at Umitz and then partly dismantled. At about the same time, Vitruvius was writing his *Ten Books of Architecture*. Although his text touches on most aspects of building he says virtually nothing about bridges. That such an important civic and military work should be omitted is very strange, and suggests that Vitruvius's work was either incomplete or that parts are now missing. In contrast, Leonardo da Vinci tried his hand at the design of timber bridges, perhaps inspired by Roman precedent, with one surviving sketch of 1490 showing a complex trussed construction incorporating a two-tier passageway.[14]

In 1513 Fra Giovanni Giocondo published a scholarly rendering of Caesar's bridge in his edition of *Caesar's Commentaries*. Andrea Palladio, always keen to try his hand at the analysis and reconstruction of ancient buildings, included in his *Quattro Libri* of 1570 a very accurate interpretation of Caesar's account (Chapter IV, Book Three).

Palladio also, in his *Quattro Libri*, included an illustration (Plate VI, Book Three) of a bridge just completed to his own designs – at Bassano del Grappa in north Italy – that must in part have been influenced by Caesar's description of the Rhine bridges. Palladio's bridge is a most curious affair that crosses the River Brenta by means of timber beams supported on timber piles formed by logs set obliquely – somewhat as described by Caesar – to counter the current of the river. The bridge, roofed to protect both its passengers and its timbers from the weather, survived until 1748. It was then

rebuilt but again destroyed – this time during the Second World War – and has since been faithfully rebuilt to Palladio's original 1569 design.

A perhaps more remarkable design in the *Quattro Libri* – remarkable, that is, because of its pure utility – shows a series of variations for the construction of a bridge over the 35-metre-wide Cismone River (Plates III to V, Book Three). All the variations show trussed or triangulated timber structures – some slightly arched, others with flat carriageways – with individual timber members joined with wrought-iron straps and pins.[15]

Timber-built bridges became something of a speciality in those regions where wide rivers or gorges abounded and where timber, rather than stone or brick-clay, was in ready supply as a building material. Timber was the dominant construction material in much of the Himalaya region – for example, the roofed cantilever bridges of Bhutan and Tibet and in Japan, where a sensational and very beautiful

BELOW: The Kintaikyo Bridge, Iwakuni, Japan, was first built in 1673. The centre three timber spans – each a 35 metre width – has been rebuilt every 20 years and narrower outer spans every 40 years – initially without nails. All fully rebuilt in the early 1950s after wartime neglect.

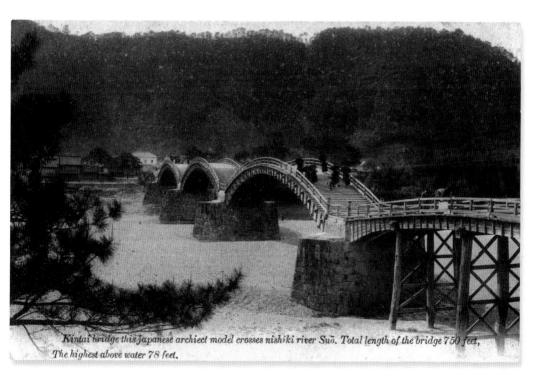

Kintai bridge this japanese archiect model crosses nishiki river Suō. Total length of the bridge 750 feet, The highest above water 78 feet.

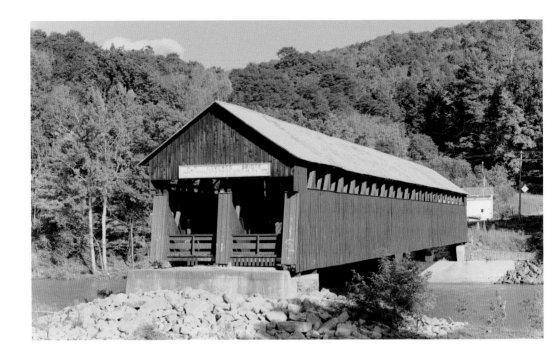

ABOVE: The Blenheim
Covered Bridge, New York
State, USA. Built between
1855 and 1857, it incorporates
a clear span of 64 metres.

example is the Kintaikyo Bridge at Iwakuni. Here five
steeply rising timber-built arches – with timbers wedged
and dove-tailed together – leap from stone piers, like a great
serpent. The bridge was built in 1673 but the timber arches
have been regularly rebuilt (originally without nails) in the
traditional manner.

Eighteenth-century Switzerland was also a place in
which timber bridges became something of a speciality.
Here the brothers Johannes and Ulrich Grubenmann, both
skilled carpenters, constructed a series of timber bridges
of pioneering form and large scale. Most have been long
destroyed, such as the one of 1757 at Reichenau that had a
span of 67 metres, but their Rümlang Bridge at Oberglatt
survives. Built in 1766, it spans 27.5 metres by means of struts,
trusses and arches. To help protect the structural timbers
from the weather, the carriageway is roofed.

Carpentry was also the solution when a bridge was
required in many regions of North America during the
first half of the nineteenth century and before the ready
availability of cheap iron. Some of these American structures

were of huge size and, through engineering ingenuity, achieved surprisingly long spans. For example, the bridge of 1812 across the Schuylkill River, just outside Philadelphia, had a clear span of 103.56 metres and so earned itself the name Colossus. The designer, Louis Wernwag, was in part able to achieve such a wide span by incorporating iron rods with the timber beams. In 1838 the bridge suffered the fate feared by all builders of wooden bridges: it caught fire and was utterly destroyed. The other thing greatly feared by the builders of timber bridges – especially those constructed with softwood – was rapid decay. Softwood can only survive the elements if regularly painted, a hard or very expensive thing to do with bridges, so American bridge builders tended to take up the other option – a shingle-clad roof over, and wooden walls around, the structural timbers and trusses.

The Colossus wasn't roofed, but a timber bridge built across the Schuylkill River a few years before had been. The Permanent Bridge in Philadelphia, designed by Timothy Palmer and opened in 1805, is regarded as the first covered bridge built in North America.[16] Covered bridges built of softwood, if properly detailed, with roof cladding maintained, and if fortunate enough to escape fire, can protect themselves from the weather and prove incredibly long lasting. The Permanent Bridge lasted until 1850. The oldest covered timber bridge surviving in the USA today is located at Hyde Hall, East Springfield, New York State, and dates from 1825.

As early as the 1840s, large-scale, covered bridges had become internationally recognised as something of a North American peculiarity. Charles Dickens, when travelling through the land in 1842, went to explore one crossing the Susquehanna River in Pennsylvania, and described it as 'nearly a mile in length...profoundly dark...interminable... with great beams crossing and recrossing it at every possible angle'. He admitted to being 'perplexed' and, due to the gloom and the echo of the 'hollow noises', like being 'in a painful dream'.[17] The bridge was indeed nearly a mile long, its carriageway supported on piers, and it was burned and destroyed during the Civil War.

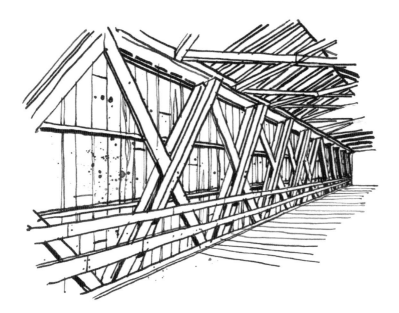

ABOVE: The timber-built truss structure of a mid-nineteenth century North American covered bridge. Its soft wood structural timbers are protected from the weather by timber boarding.

Blenheim Bridge, Schoharie Valley, New York State, built between 1855 and 1857, is a very fine surviving and early example of a timber-built covered bridge. It has a total length of 70.7 metres that incorporates a clear span of 64 metres – the longest single span of any wooden covered bridge in the world. The bridge is built of pine with its length formed by three trusses, with huge pine posts, braces and counter-braces, which are based on a prototype designed in 1830 by Stephen H Long, known as the 'long truss', and once much-emulated. The centre truss rises higher than the other two, and within it is enclosed a pair of arches – wrought of oak – rising from the lower 'cord' or carriageway up to the level of the roof ridge. The engineer-cum-carpenter of the Blenheim Bridge, a masterpiece of big-boned, heavy-duty timber construction, was Nicolas Powers from Vermont.

The Bridgeport Covered Bridge of 1862 over the South fork of the Yuba River near Grass Valley, California, incorporates a clear-span almost as long as that of the Blenheim Bridge – 63 metres. The Bridgeport Bridge includes two parallel trusses based on a design that was patented in 1840 by William Howe, a Massachusetts millwright. Howe trusses are designed so that – unusually

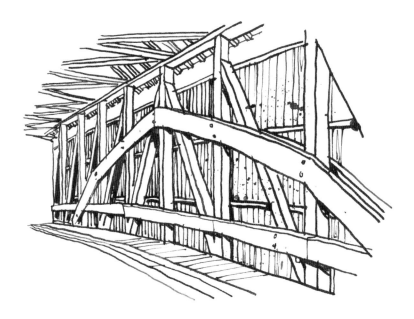

– diagonal members are in compression and vertical members in tension. The designer of the bridge, David Ingefield Wood, was seemingly unsure about the ability of the Howe trusses to bridge the wide span or to carry expected loads, so he beefed them up with wide and shallow timber arches. These arches are based on the Burr arch truss – a type designed by Theodore Burr in 1804 and patented in 1817 – which consists of timbers bolted together, squeezing between them the members of the truss. The arches, essentially an auxiliary and independent structural system, rise from huge granite blocks placed slightly below each end of the bridge to just below the eaves of its roof. These arches are expressed externally and give the bridge a powerfully engineered appearance. Other examples of the Howe truss survive in the Jay Bridge of 1857, in Jay, Essex County, New York, and in the 22-metre-long Sandy Creek Covered Bridge of 1872, in Jefferson County, Missouri.

The essential principle underpinning the Burr arch truss design was that the arch should carry the entire load of the bridge while the trusses, of king-post form, should keep the bridge rigid. Good examples of Burr arch truss bridges are found mostly in India and Pennsylvania, such as the

Baumgardener's Covered Bridge of 1860 with a 32-metre span, in Lancaster County, Pennsylvania. But fine early examples survive also in West Virginia – notably those at Philippi of 1852 and at Barrackville, of 1853, both designed by Lemuel Chenoweth. The longest automobile-carrying covered bridge in the US is the splendid 140-metre-long Cornish-Windsor Bridge, of 1866 in Cornish, New Hampshire incorporating a clear span of 62m.

Trestle viaducts

Characteristic in parts of North America was the practice of carrying railway tracks on often highly-elevated and prodigiously long timber-built trestle viaducts. Such things had been built in Europe during the early years of the railway age when speed and economy were required – indeed Isambard Kingdom Brunel was quite a master of the art, constructing over forty in Cornwall alone during the 1850s – but there was nothing to compare with the huge scale of the American creations. Trestle viaducts must have been, in the early years in the United States, truly astonishing and unprecedented things to behold – they must have convinced the innocent and those uninitiated into the wonders of the railway age, that smoke-belching and bellowing steam engines and such monstrous creations as the viaducts were all just part of the Devil's ride from hell. Studying early photographs of trestles – for many of the best are now long gone – it is still possible to capture some of the original drama of their first appearance.

Unlike traditional buildings, their close-packed structure gives them no obvious grace, and they often look impossibly bizarre or outlandish as they cross ravines or gorges that had lain pristine for eons and impassable to man. They possess instead a sort of crude, utilitarian strength and power that is almost sinister, as if they are bridges built for brute creation. For these reasons, the mightiest trestles are mesmerising to behold, awe-inspiring and tremendous examples of the emotions Edmund Burke explored in the mid eighteenth century in his *Philosophical Enquiry into the Origins of our Idea*

of the Sublime and Beautiful: 'The emotion caused by the great and the sublime...[the] terrible with regard to sight... is Astonishment...that state of the soul, in which all motions are suspended, with some degree of horror...'.[18]

Good examples are the Portage Viaduct, one of the 'wonders of the age' when completed in 1852; the vastly long Lucin Cut-off Viaduct across the Great Salt Lake in Utah, built with Douglas fir from 1902 to 1904, disused since the 1950s and now being dismantled; and the long-demolished Bloedel Donovan's Viaduct of 1920 over the Skykomish River, in King County, Washington.

Of course, long before the end of the nineteenth century, metal started to replace wood for viaduct construction, which resulted in a great reduction in structural bulk and increase in elegance. The Garabit Viaduct in France of 1884, is a supreme example (see page 264), but also memorable are the 625-metre-long and 92-metre-high Kinzus Viaduct of 1882 in McKean County, Pennsylvania, which was grievously damaged by a tornado in 2003; the Meldon Viaduct, Okehampton, Devon, England, built between 1871 and 1874; and the Lethbridge Viaduct, in Alberta, Canada, of 1909, which is the longest metal-built viaduct in the world.

Masonry

Pioneering brick-built bridges with carriageways supported on vaults were constructed in Mesopotamia from at least the sixth century BC – for example, the famed bridge across the Euphrates in Babylon. Stone vaulted and arched bridges, as well as stone lintel bridges are recorded in the Anatolia and Aegean regions from the second century BC. Possibly far older masonry bridges survive in the Peloponnese, Greece, where there are a number of what appear to be Mycenaean bridges dating from around 1,300 to 1,190 BC. A good example is the 22-metre-long Arkadiko or Kazarma Bridge, near Tiryns, that is constructed with cyclopean masonry in typical Mycenaean manner and incorporates a corbel arch. However, the earliest surviving masonry bridges, with verified histories and that represent a coherent body of work,

are those built by Rome (see pp 56). A good, typical and early example is the Ponte Fabricio, in Rome of 62 BC and restored AD 19 that crosses the Tiber to an island by means of two semi-circular arches, separated by a narrow higher arch to allow floodwater to pass without putting undue lateral pressure on the bridge. Other examples include the Ponte Milvio in Rome, of 115–109 BC, that carries the Via Flaminia into Rome on five wide semi-circular arches, and the Ponte d'Augusto, of AD 50, in Rimini. A fascinating Roman period bridge is the Romi or Sasani Bridge at Dezful, Khuzestan, Iran. It was constructed in AD 250 by Shapur I, ruler of the Second Persian Empire, who may have used Roman engineers captured when he defeated Emperor Valerian.

Although Roman structural theory – and aesthetics – preferred the use of arches of semi-circular form, the advantages of segmental arches were recognized (with the possibility of greater span they could bridge a river with fewer piers) and occasionally applied. For example, the now ruined Limyra Bridge, at Lycia in Turkey, that incorporates wide-span segmental arches – some up to 15 metres in span – to create a bridge with a very low height; the Alconétar Bridge across the Tagus, in the Extremadura region in Spain, built perhaps during Emperor Trajan's reign by Apollodorus of Damascus and now in ruins; and the also ruined Ponte San Lorenzo, Padua, of 47 BC, with very slender piers and spans of up to 14.4 metres. The sorry states of most of the Roman bridges incorporating segmental arches would suggest that this form was not particularly stable and certainly not able to take the buffets of time as well as the more robust semi-circular arched bridges.

A particularly intriguing early stone-built bridge is the Malabadi Bridge over the Batman River, Diyarbakir, Turkey. It was built around 1146 during the Seljuk period, has booths or hostels at either end, and rooms for travellers – indeed a caravanserai – located within its spandrels. Its main, central, arch is slightly pointed and has a span of 38.8 metres – at the time one of the longest in the world.

Of similar date, but very different in form, are the corbel arched bridges of Cambodia, such as the twelfth to thirteenth

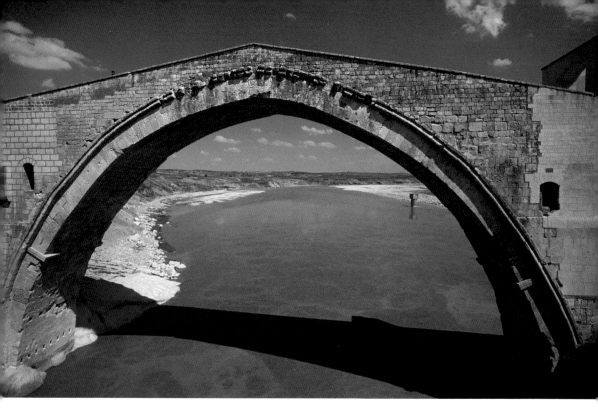

century Naga Bridge, at Angkor Thom, on which gods and
demons pull on a huge snake, stirring the ocean of milk as
in the Hindu creation myth. The longest of the type –
stretching 75 metres, is the Kampong Kdie Bridge in
Cambodia dating from the twelfth century. The corbelled-
out construction of the arches allowed only very limited
spans but, in consequence, created no hump or rise in profile
so such bridges made excellent flat and even causeways,
leading across lakes to temples, and fine places for the
display of sacred art.

In western culture, immensity of scale – particularly of
span – grew increasingly important as the practical demands
of bridge construction increased. This culminated with
the brick-built Maidenhead Bridge in Berkshire, England,
designed by Isambard Kingdom Brunel for the Great Western
Railway and completed in 1839. It incorporates a pair of
shallow segmental aches, each with a span of 39 metres,
making them the longest and flattest brick-built arches ever

formed. In 1902 the Rockville Bridge over the Susquehanna River was completed in Harrisburg, Pennsylvania and which – with a length of 1,150 metres, became – and remains – the longest stone-arched bridge in the world. This bridge – offering a vast, open and noble promenade across the river – would surely have delighted Charles Dickens as much as its now long-lost and 'profoundly dark' precursor across the river 'perplexed' him.

Metal

The age of all-metal bridge construction starts, to all intents and purposes, in England with the epoch-making Iron Bridge, in Coalbrookdale, Shropshire. Completed in 1779, it was the boisterous and precocious child of the Industrial Revolution. It was not the first bridge to use iron, nor was its design revolutionary – indeed its basic form is that of a masonry bridge and its cast-iron members are disposed much as in contemporary timber bridges. But it was the world's first all-iron bridge, it was the product of new technology – steam power and the efficient manufacture of strong cast-iron components – and it would usher in a new world of bridge construction.

The bridge was designed by Thomas Farnolls Pritchard with ironmaster Abraham Derby III and is, in many wonderful ways, a bridge between worlds. It marks the coming of the new industrial age of mass-production, yet it still possesses a Georgian elegance and regard for ornament. It is made of iron, yet its iron components are mortised, wedged and screwed together as if made of timber. It is a work very much of transition: Derby knew that it was essential for this new material to be used in compression – which is cast-iron's strength – not in tension, which is its weakness (see page 182). So the bridge is designed to ensure that, as far as possible, loads are transmitted vertically down and individual components are in compression.

The possibilities offered by this newly available construction material were soon appreciated by avant-garde architects and engineers such as Thomas Telford, who in 1795 specified cast-iron to form the troughs of the vast Pontcysyllte

canal aqueduct across the Dee Valley outside Llangollen, North Wales. The troughs, made with cast-iron slabs dovetailed together – like keystones in an arch of lintel – for greater compressive strength, sits on 35-metre-high, stone-built piers, each 16 metres apart. These are of slender, tapering form and of ingenious honeycomb construction (with stone laid in mortar containing ox blood as a hardener) to reduce weight and materials used. Within the cast-iron troughs water rises almost to their brims, and a railing and towpath are placed only on one side so that barges float high above the valley, enjoying unrestricted views, as if navigating through the clouds. The aqueduct was opened in November 1805 and is one of the most beautiful, robust and continuingly useful creations of Britain's early Industrial Revolution.

Key characteristics of cast-iron were that components made in the material were not only strong – which meant they could be slender in section and still possess greater strength than equivalent timber components – but also quick and cheap to produce. These characteristics ensured that the model offered by the Iron Bridge at Coalbrookdale was soon emulated. They also made it possible to develop a new commerce in export architecture, transporting British-forged buildings and bridges – reduced to flat-packs for ease of travel – to all corners of the growing empire.

One of the first and most significant developments of the Iron Bridge was the stupendous Sunderland Bridge across the River Wear in County Durham. It was started in 1793, completed in 1796, rose to a height of nearly 30 metres above the surface of the water (which had involved the design and erection of a superbly designed system of timber scaffolding), and had a span of 72 metres. Its promoters and designers were Rowland Burdon and Thomas Wilson. The huge arched bridge, made in an elegant manner out of pioneering material, was regarded as one of the technological glories of the age. But, sadly, glory proved only transitory, and due to gradual deterioration all was demolished in 1929. But the great bridge left more than a trace behind. Such was its fame, that copies were eagerly desired around the world and – thanks to the

character of cast-iron that favoured pre-fabrication – this desire could be fairly easily fulfilled with components cast to the required scale and then shipped abroad for assembly on site. And so, in 1800, crates of cast-iron arrived in Spanish Town, Jamaica which by 1810 – after the construction of substantial stone abutments – had been bolted together to form a reduced-scale version of the Sunderland Bridge. Known as the Rio Cobre Bridge, it is now the oldest iron bridge in the western hemisphere.

If the Rio Cobre Bridge is one of the most curious of iron bridges, then Isambard Kingdom Brunel's bridge masterpiece – the Royal Albert Bridge, Saltash, Cornwall – is one of the most stunning. The last great work of Brunel's career was completed in 1859, and all ornament and all reference to history has been dispensed with: it is a masterpiece in pure, raw, and beautiful function.

Vast trusses of 'lenticular' form span 139 metres between piers, the centre founded in a small rocky island, and rise 24 metres above high-water mark. The lenticular trusses incorporate massive tubular arches made from wrought-iron that rise above the track, with their ends tied with chains forming inverted arches. The object of this design was to prevent the trusses transmitting any outward horizontal thrust. It is fascinating to compare the construction of the Saltash Bridge with the near contemporary works of Robert Stephenson, such as the High Level Bridge in Newcastle-upon-Tyne, with which Brunel was very familiar (see page 213). The trusses on Stephenson's slightly earlier High Level Bridge in Newcastle-upon-Tyne (see page 190), perform in much the same manner as Brunel's 'lenticular' trusses and must, to a degree, have been an inspiration.

One of the particular problems Brunel encountered at Saltash was the digging of the foundations for the piers that rise from the riverbed. The solution he chose – 'pneumatic caissons' – was a very modern one that had not been tried and tested. The system had been used first by John Wright in 1851 for setting the foundations for piers for the bridge across the River Medway at Rochester. Pneumatic caissons were an

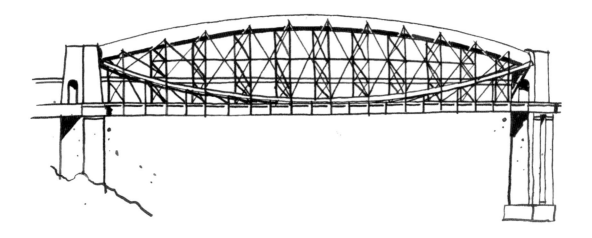

ABOVE: A lenticular truss of the type used by Isambard Kingdom Brunel for his Royal Albert Bridge, Saltash, England, completed in 1859. The large wrought-iron tube forming the top arch of the truss is tied, or restrained, by the lower, inverted, arch made of a chain fabricated of wrought-iron bars. This design means that the arched truss exerts no outward thrust.

intriguing and seemingly very sensible idea that utilized the potential of modern technology. Airtight caissons – essentially vast drums open at top and bottom – are wrought, towed into position, sunk so that their bottom edges sink into, and are sealed by, soft mud or sand. Then the tops, standing well above high water mark, are sealed, and compressed air pumped in to keep water and mud from entering. To retain air pressure inside the caisson, workmen were to enter and exit the sealed chamber by means of an airlock.

There was even a system devised for removing material – 'muck' as it was called – to the surface by means of a pit, filled with water to act as an airlock, via a 'muck tube' that was cleared by a crane fitted with a clamshell bucket. The water-filled 'muck tube' also helped to regulate pressure in the working chamber. Excess air pressure could escape through it and the tube could be used to prevent water pressure dropping – which was essential if water and mud were to be prevented from flowing into the caisson.

It was all very ingenious – the only problem was that the system killed or crippled people. The engineers didn't know anything about what happens to the human body when it toils within a compressed atmosphere, and they had no concept that

bubbles of gas can build up in the blood, and expand when a normal – decompressed – atmosphere is re-entered too quickly, causing not only great pain but serious, possibly terminal, physical damage. This distressing condition is also suffered by divers who ascend rapidly after spending too long a time at a great depth and has become known as 'the bends'.

Although this mysterious ailment was quickly associated with pneumatic caissons, indeed it became known as 'caisson disease', ambitious engineers did not abandon the use of this useful time-saving invention and in 1872 it even caused the disablement of the engineer Washington Roebling when supervising the construction of New York's Brooklyn Bridge (see page 287). When James Eads started construction of his epic railway bridge across the Mississippi at St Louis in 1867, he was under intense time pressure with loans only becoming available when specific construction targets had been achieved. So, naturally pneumatic caissons were the preferred option which, with men working up to 28 metres below water level, resulted in the deaths of fifteen men, the crippling of two, and serious injury to a further seventy-seven.

Due in part to these woeful sacrifices, Eads completed construction on time, and as it happens created one of the most significant bridges ever built. It crossed the river in three mighty arches, the longest with a span of 158 metres, and all constructed out of steel – which was the first time this material had been used so extensively in any major building. It was also the first time that a cantilever support system was used to aid bridge construction, with the arches being built outward from the piers, secured by guy wires, and used as platforms from which to continue construction until the two halves of the arch met.[19] This method reduced the need for expensive scaffolding but, more important, was – to all practical intents and purposes – the only way to build a large bridge across the wide, deep and fast-flowing Mississippi.

The opening of the bridge on 4 July 1874 was a gala event. The poet Walt Whitman was present and soon declared the bridge 'perfection and beauty unsurpassable'. A few days later, having had the aesthetics of his bridge so pleasingly praised,

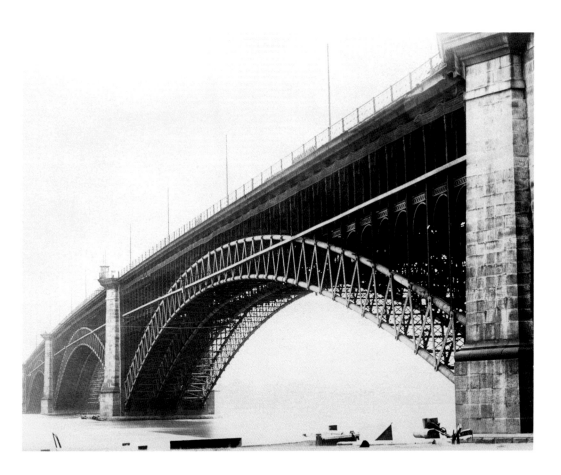

ABOVE: The Eads Railway Bridge across the Mississippi at St Louis. Started in 1867 to the designs of James Eads, the bridge pioneered the large-scale use of steel in construction and when completed in 1874 was the longest arch bridge in the world.

Eads demonstrated the solidity of the bridge to a wondering public by leading an elephant over its spans and then, realising this was perhaps not quite convincing enough, sent fourteen locomotives across the bridge, one after the other. The bridge (now known as Eads Bridge) was indeed a modern wonder. Popularly regarded as beautiful, evidently strong, and a record-breaker because its length of 1,964 metres made it the longest arch bridge in the world. Eads' bridge was in many significant ways a model for, and portent of, things to come.

EMPIRE

ROME, MORE THAN ANY EARTHLY POWER BEFORE
or since, expressed its might and its aspirations through
architecture and engineering. It took the architecture of
the past – of the Egyptians, the Greeks and the Etruscans –
and transformed it to suit its own needs and to realize
the demands of its growing empire. New functions such
as roadways and water supplies emerged, demanding new
types of buildings, and these could only be achieved through
a radically evolved understanding of the potential of
engineering. A series of spectacular developments took
place, notably the rapid refinement of structural systems
incorporating round-headed arches and domes, giving rise
to buildings of unprecedented scale and complexity in which
new materials such as concrete (see page 312) were used in
major roles for the first time. Roman bridges are a perfect
illustration of how awe-inspiring beauty can emerge from
innovative engineering.

Rome's breathtaking and groundbreaking contribution
to the development of architecture was characterized by an
ever-growing appreciation of the potential of engineered
structures in which the forces of nature were harnessed and
tamed to complete projects that would have been beyond
even the imagination, let alone the practical grasp, of earlier
generations. The resulting structures combined the cardinal

PREVIOUS: The Pont du
Gard, near Nimes, France:
an aqueduct built around
2,000 years ago and one
of the greatest surviving
monuments from the
Roman world. The stone
blocks projecting from
the pier serves as supports
for timber scaffolding
and centering during
construction and
maintenance.

RIGHT: The aqueduct in
Segovia, Spain, constructed
during the 1st century AD,
snakes through the town,
its conduit supported on
increasingly tall tiers of
arches as the ground level
falls away.

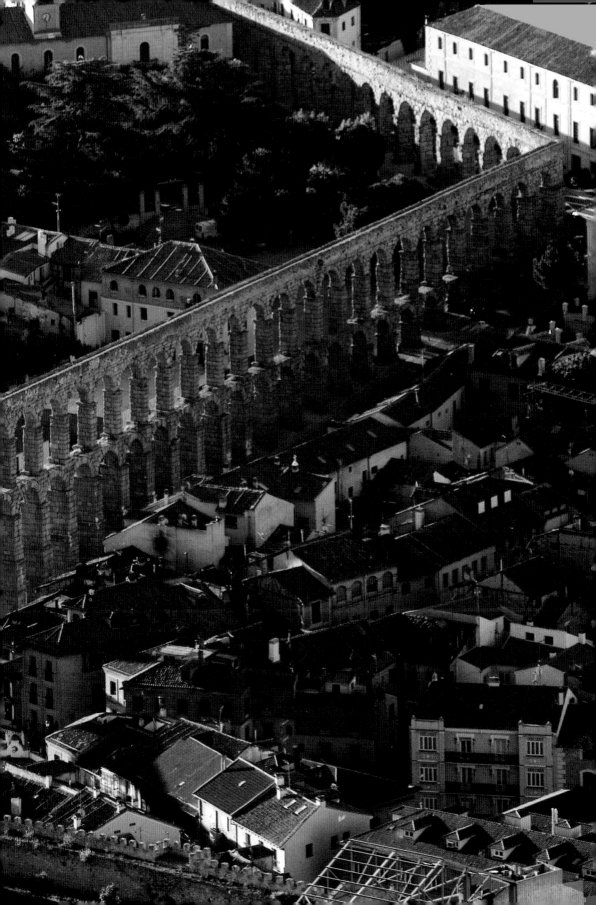

architectural virtues identified by the Roman architect Vitruvius over 2,000 years ago – 'commodity, firmness and delight' – by which he meant an architecture that simultaneously fulfils its functional requirements and is stable, while also being poetic and imbued with a power to inflame and engage the intellect.

Roman architecture, at its best combining sublime beauty with function, often played a vital role in consolidating and spreading Roman power and maintaining its civilization. This fascinating combination of characteristics is perhaps best expressed by the bridges and aqueducts that Rome created throughout its empire. Their roles as routes of communication and the means of supply were of vital importance to the well-being of the Roman world. Aqueducts brought a plentiful supply of water – essential for the Roman concept of civilized life – and roads transported goods and luxuries over great distances, allowed wealth creation through trade, and security through speedy troop movements. In addition to being functional objects, bridges and aqueducts were also intended, in their design and solidity, to express Rome's cultural aspirations and the longevity of its vision. Together, these intentions produced structures of intense beauty – a beauty that comes from the pure and powerful realization of functional demands and of the way in which the potential of available building material can be enhanced through design.

A remarkably large number of Roman bridges survive, in whole or in part, still fulfilling their original function within the former empire. They continue to astonish, inspire and delight, through their scale, fitness for purpose and often daunting engineering boldness. But there are four Roman bridges that haunt my imagination. They epitomize Roman engineering genius, in which sublime and utterly moving beauty is achieved by the almost ruthless observance of function. They are the essence of engineering, and also the essence of architecture at its best. There is little about their design and construction that is superfluous to function or to pertinent meaning. Their stones carry messages, about the power of engineered structure and about the seemingly

eternal power of Rome. In all these bridges each detail possesses an intensity of meaning and beauty: even those that appear ornamental are in fact calculated to add extra cultural or spiritual significance, raising purely utilitarian design into the poetic realm of architecture.

All of these structures lie outside of Italy. Two of them, the Pont du Gard in southern France near Nîmes and the aqueduct of Segovia in Spain, carried the very life-blood of Roman civilization: abundant water. The others, the Alcántara Bridge over the River Tagus in Spain, and the Pont Flavien, in Saint-Chamas, Bouches-du-Rhône, France, seem to have served a largely military, strategic and triumphal purpose marking the omnipotent presence and power of Rome. But each one, in its solidity and scale, seems to have been built in defiance of nature. And yet this is not quite so, for it is the essential paradox of engineering that the violence of the forces of nature can only be withstood by man-made structures that fully utilize the forces of nature. The fact that these structures survive after 2,000 years or so – with all significant damage being the work of man and not natural forces – demonstrates most succinctly how well these Roman engineers understood their work.

The Pont du Gard is a stupendous aqueduct located about 29 kilometres north of Nîmes. As its name suggests, it spans a valley through which the river Gard winds. It forms part of a conduit constructed to carry the waters of the Alzon some 50 kilometres to Nîmes and, rather appealingly, no one is absolutely sure of its date. The current consensus of opinion is that the aqueduct was started by Marcus Vipsanius Agrippa, the brother-in-law of Emperor Augustus in about 18 BC and that the Pont du Gard itself is around 2,000 years old, although some argue that it dates from the mid first century AD. But what is more certain is that the Pont du Gard is one of the most moving and awe-inspiring structures to survive from the ancient world. The first glimpse you get of it is a virtual assault on the senses: its scale is majestic, its form intensely pleasing and it soon becomes clear that most of the architectural details that it sports are not merely ornamental but are expressions of the means of construction.

The aqueduct has an overall length of about 262 metres and comprises three distinct tiers of structure. The lower tier is formed by six wide arches (each spanning a distance of something between 15.2 and 24.3 metres) which support a roadway. From this roadway rise arches similar in size to, and with their piers set over, those below. But this second tier is made up of 11 arches because the cliff faces forming the river valley taper dramatically as they rise higher. On top of the second tier sits the prime purpose for this astonishing structure: a stone-roofed conduit that carries the water to Nîmes. This conduit is supported on narrow-span round-headed arches – three to each wide arch on which they sit – of which thirty-five still survive. The rhythm and elegance of these arches is immediately striking. It was usual in Roman arched structures of this type for the piers to be one third the width of the span of the arch, a width that led to strong piers that could, if one arch collapsed, act as abutments to prevent the whole structure collapsing like a row of dominoes. But here the piers are spectacularly slender, just one fifth of the arch width. Clearly the men who designed and built the Pont du Gard had great confidence in their abilities, and in their creation. And they were right, through their daring they made not only a thing of strength but also of intense beauty. The Pont is incredibly pleasing to look at, its arches reading up from the water, one to one to three, are like a harmonic ratio. The pattern of arches gives an immensely satisfying appearance and feeling of strength, of an object built for eternity.

The vast lower arches, one upon the other, carry a more delicate structure and it's this delicate upper structure that is the business-end of this engineered marvel. Nothing here is for show: everything is designed and built to support the relatively small conduit running 48.7 metres above the river, constructed with a slight fall so that the water within it could flow serenely from Uzes to Nîmes.

This is indeed heroic architecture, the epitome of that produced in the ancient world. It's a thing intended to last and is built on a heroic scale to fulfil a seemingly modest function. Yet it carried one of the blessings of civilization

LEFT: An intimate view of Roman precision engineering: a vista along the conduit on top of the Pont du Gard. This is the only place in the structure where mortar was used – necessary to ensure water did not leak through the joints in the masonry.

– a ready supply of water – to thousands of people. It made cities habitable, farms verdant and people clean, healthy and happy.

As if the form, scale and proportions of the Pont du Gard are not enough to impress, its materials and techniques of construction are almost as remarkable. From the huge blocks of stone from which it is wrought, there are, here and there and in regular fashion, strange protuberances. These tell of the way the structure was made. The stones were cut at a quarry on the riverbank and carted to the site as massive cubes – some weighing 6 tonnes or more – and then hoisted into position using one of the variety of lifting machines Roman builders had at their disposal. But as with all arched and domed structures, the construction process and maintaining stability are problems.

Arches and domes are immensely strong forms – especially when rendered in solid masonry – for their very shapes become stronger as they bear the downward force of gravity, the 'dead' weight of their materials and the 'live' weight of any loads they might carry. This is a very direct example of strength through design. But by their very nature, these curved forms, although immensely strong, exert some of their load in a lateral direction. Domes and arches want to spread, and so have to be restrained by adequate abutments or buttresses. On the Pont du Gard this is achieved by the piers, which are ultimately restrained and stabilized by the immovable cliff faces, onto which they pass the weight they carry, giving them stability.

But another problem with arches and domes – especially when being built high and on a large scale – is stability during the construction process, before all the forms are locked in equilibrium and before the final keystone is in place. The favoured way in the Roman building world to achieve stability during construction was to support the incomplete dome or arch on a timber scaffold, shaped and engineered to carry the structure until it was complete and could carry itself. This scaffolding was known as 'false-work' or 'centering'. What's fascinating about the Pont du Gard is that completed elements of its structure – notably the piers

and the springings of the arches – served as part of the system of scaffolding that was used to help support those parts still under construction. So the stones protruding from the face of the piers supported timbers that formed part of a scaffold that allowed masons to work on the higher portions of the Pont. The same is true of the bold cornices at the springing level of the arches and the ribs that project from the 'intrados' or lower face of the arch. Both these details were not intended to be primarily ornamental but to provide a firm lodging-place for the timber centering required for the construction of the arches.[20] A number of these strange projections could have been removed when construction was complete, but it seems that the engineers here saw no need to remove the evidence of the construction process and, more to the point, everything could be used again, in various ways, for any necessary repair work. So, at one level and among many things, the Pont is a permanent scaffold carrying fixing points for use in its own future maintenance. This is an astonishingly far-sighted and very modern concept.

Equally ingenious as this designed-in system of maintenance, is the way in which the stones used in the bridge were cut and fixed together. The engineers realized that maximum strength would result from maximum precision, for if the individual stones fitted tightly together movement would be minimal. Precision was difficult to ensure, but the masons here achieved it to such an extent that the stones are laid without mortar (except in the conduit at the top), which was a huge bonus in itself, because without mortar to be washed away by rain, or blown by wind, or cracked by frost, there would be no need for regular re-pointing to keep the structure sound. The Roman engineers really were creating buildings to last for eternity. The ambition is incredible and the achievement massive. The world that created this mighty work has long gone, but its vision endures in work as steady and timeless as nature itself.

The scale and quality of the construction that the engineers and masons achieved can only be properly appreciated by considering for a moment the tools and

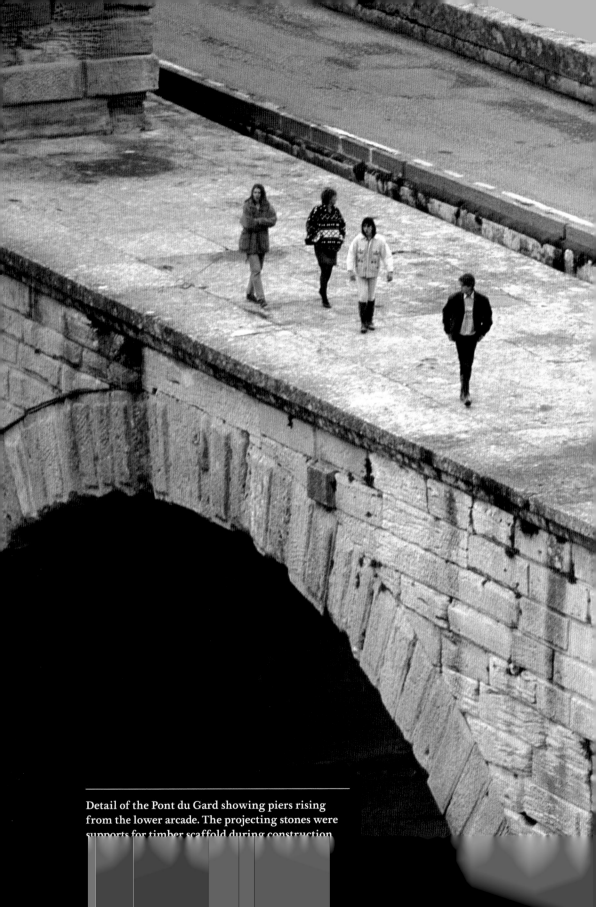

Detail of the Pont du Gard showing piers rising
from the lower arcade. The projecting stones were
supports for timber scaffold during construction

machines at their disposal. They had picks and chisels made from hardened iron for working stone, which were adequate, with skill, application and time, for cutting limestone and sandstone with precision. They also used water power to operate stone saws and lifting machines, though not to any great extent.'[21] Construction work, from cutting and transporting stones to raising them into place, was a very important part of the economy of the Roman state. It was a way of creating work and jobs, keeping people employed and out of trouble, and of getting money to flow through society. For example, Emperor Vespasian (AD 69-79) refused to let builders use water-driven hoists 'lest the poor should have no work.'[22] So in place of mechanical power, the Romans preferred – almost as a matter of state policy – to achieve lifting largely by muscle power, operating cranes or systems of pulley blocks hung from legs or poles and worked by winch or capstan. Using these devices, heavy stones were lifted by slings, or gripped by pincers or a kind of 'lewis', a lifting tool comprising metal bars inserted and wedged into a dovetailed cavity cut in the top of a block of masonry.

Metal was also used in construction, usually in the form of wrought-iron cramps or bars set in lead and then placed in cut recesses to bond stones together. As Vitruvius explains when discussing how to avoid the problem of crumbling mortar: '...leave a cavity behind the [facing wall]...on the inside build walls two feet thick...and bind them to the fronts by means of iron clamps and lead.' Work executed in this way, Vitruvius claimed, 'will be strong enough to last forever.'[23]

Vitruvius also had some specific things to say about aqueducts, reminding his readers of the importance of an adequate and reliable water supply and stating that for aqueducts or 'conduits' the masonry should be 'as solid as possible and the bed of the channel have a gradient of not less than a quarter of an inch for every hundred feet, and let the masonry structure be arched over, so that the sun may not strike the water at all.'[24] Vitruvius also recommended that, when the water carried in the conduit reaches the city it should be held in a 'reservoir with a distribution tank in three

compartments.' The system was intended to segregate water
used for different purposes and to prevent people tapping into
the main flow and stealing public water for private use.[25]
Vitruvius also recognized that water quality was very important,
so recommended that it was best to conduct water through
clay pipes rather than lead pipes because 'water from clay
pipes is much more wholesome than that which is conducted
through lead pipes, because lead is found to be harmful [and]
hurtful to the human system.'[26] The evidence for this was the
health of 'plumbers, since in them the natural colour of the
body is replaced by a deep pallor' caused by lead fumes that
'burn out and take away all the virtues of the blood from their
limbs.'[27] Vitruvius' recommendations seem to have been used
by the Rome official Sextus Julius Frontinus who in about
AD 80 wrote a treatise on the *Aqueducts of Rome*, in which
he described the condition of the city's water supply, actions
needed to prevent water leaks and theft, and, in general,
promoted Vitruvian theory.

'The sight of the aqueduct entering the town is among the greatest surviving urban scenes from the ancient world. It was dedicated to Hercules – the legendary founder of the city – and still seems the work of divine heroes.'

Extraordinarily enough, a physical example of Vitruvius' recommendations and theory survives to this day in Spain. The aqueduct in Segovia was built about 100 or so years after the Pont du Gard, perhaps in about AD 50–100 and, unlike the Pont du Gard, continues to fulfil the function for which it was built. Thanks to the skill and robustness of its construction, generations of maintenance, self-effacing reconstruction, and the soundness of Vitruvius' thinking, the conduit and aqueduct retains its Roman identity and still carries water 15 kilometres from the Fuente Frio River to the old city of Segovia. Much of this length is at or near ground level, but due to the terrain near the city, 800 metres of the conduit is supported on arches springing from piers up to 28.5 metres high.[28] Few things are more moving, in the world of ancient engineering, than to see and hear the water – after nearly 2,000 years – still coursing along its worn but serviceable granite conduit perched high off the gnarled, sun-baked and leaping arches of the aqueduct.

The aqueduct, and the conduit it supports, is an admirable machine for gathering and delivering water to an elevated city, the aqueduct's height above ground varying to accommodate the terrain and to keep the decline of the conduit as little as possible. When the water arrives in the city it is first collected in a tank known as *El Caserón* (the Big House) and from there runs along a channel to a tower known as the *Casa de Aguas* (the water house) where it is

allowed to decant and impurities settle. The reasonably pure water then travels nearly 730 metres, at a fall of only one-in-a-hundred, to an outcrop near to which the Roman city was built. Then the aqueduct, rising to its full height of 28.5 metres and comprising two levels of semi-circular headed arches, carries the water into the city, to what is now the Plaza de Díaz Sanz. As with the Pont du Gard, the stone blocks – in this case granite – with which the aqueduct is built are unmortared, their precise construction and weight being enough to keep all standing. Particularly satisfying is the masonry of the voussoirs forming the arches, which are a single block deep. They combine with the horizontal courses of the spandrels to form a perfect example of robust masonry construction, where every block is not just doing its job but is seen to be doing its job in a most reassuring manner. It is possible to ponder these stones for hours without getting in the least bored, wondering at the creation of poetic beauty through purely expressed function.

The sight of the aqueduct entering the town – a seemingly endless arcade of granite with the conduit perched high on the immensely tall and seemingly impossibly slender piers of the lower arcade – is among the greatest surviving urban scenes from the ancient world. It was dedicated to Hercules – the legendary founder of the city – and still seems the work of divine heroes. Goodness knows what the local people felt 2,000 years ago; this mighty work is the power of Rome personified – remorseless and eternal.

The Puente de Alcántara makes a telling contrast with the cyclopean Pont du Gard and Segovia aqueduct so that, together, they encompass the whole spectrum of Roman bridge building. In comparison to the massiveness of the latter two, the Puente de Alcántara possesses a lightness of touch as it springs across the void that it was created to tame. It is, in its daring elegance, the very epitome of engineered architecture.

The Puente de Alcántara is, arguably, the greatest of all Roman bridges. It doesn't have the widest span (that distinction belongs to the delicate first century BC Pont-Saint-Martin in the Aosta Valley, Italy whose central arch

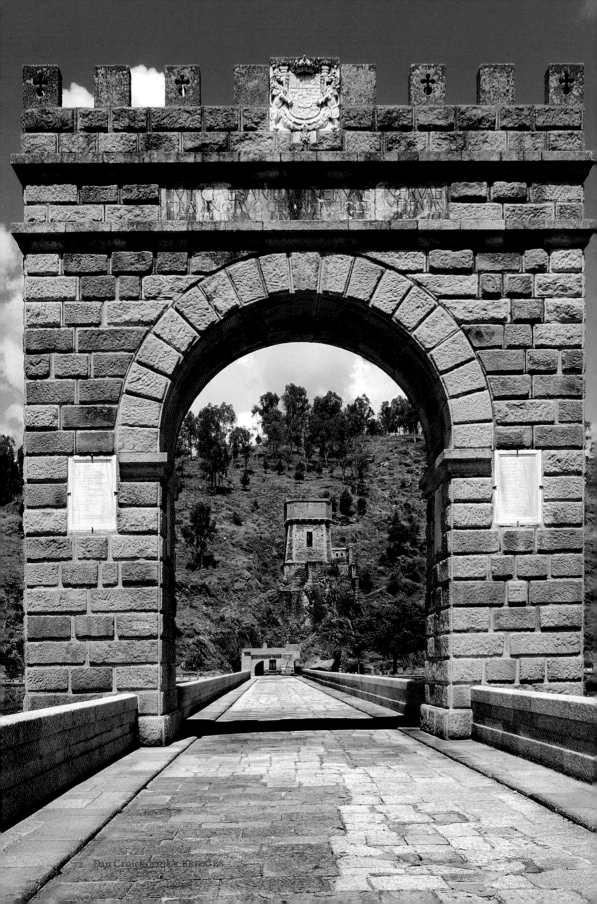

leaps 32 metres) but the Puente de Alcántara possesses an extraordinary harmony in its parts and – as with all great bridges – astonishes in its daring ambition. It is a monument to man's ability to tackle – and to solve in an elegant manner – the most daunting of structural problems. It rises 52 metres above the bed of the river, its two wide central arches have spans of 28.3 metres and 27.4 metres and its mighty piers – made of granite from a quarry over five miles away and laid without mortar – are each nine metres square, with some of the stones weighing 8 tonnes each.

Like the Pont du Gard, this is indeed a mighty work of man that nature has assailed in vain. All here possesses a sublime and sculptural beauty, there are virtually no classical mouldings used in its design, no details or forms superfluous to function. But the bridge is not simply a structurally supreme but spiritually arid utilitarian structure. It also possesses those details, ornamental and symbolic, that are purely poetic and that transform a great functional work into architecture. And most of these details have to do with the human story of the bridge, and its strategic function in the Roman Empire. At one level the bridge is a monument to the man who made it, and to the Emperor who ordered its construction. In the centre of the bridge is an arch, called by some a 'fortified gate' and by others a 'triumphal arch'. Both definitions are correct because it is both of these things, just as the bridge is both a triumph over nature and a key military installation. The arch made the bridge defensible, or rather made it possible for those who controlled the arch to stop the bridge from being used. Whoever held the arch controlled the road that the bridge gave purpose to. But an inscription on the arch also proclaims – in triumphal manner – that the bridge was built by Emperor Trajan in the fifth year of his reign, dating it to AD 103. The man who actually built the bridge gets a smaller shrine but a far more moving inscription. Opposite one end of the bridge survives a small votive temple, a place in which the god of the river, the valley – of the bridge – would have been venerated. It carries an inscription on a marble slab:

LEFT: The triumphal arch in the centre of the Puente de Alcántara, bearing a panel that proclaims the bridge was built in the fifth year of the reign of Emperor Trajan - so in around AD 103.

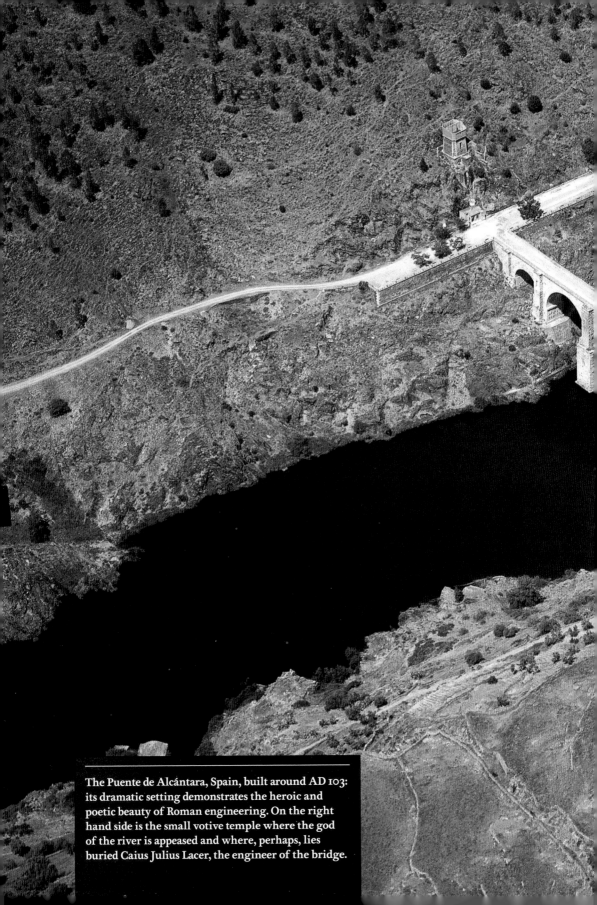

The Puente de Alcántara, Spain, built around AD 103: its dramatic setting demonstrates the heroic and poetic beauty of Roman engineering. On the right hand side is the small votive temple where the god of the river is appeased and where, perhaps, lies buried Caius Julius Lacer, the engineer of the bridge.

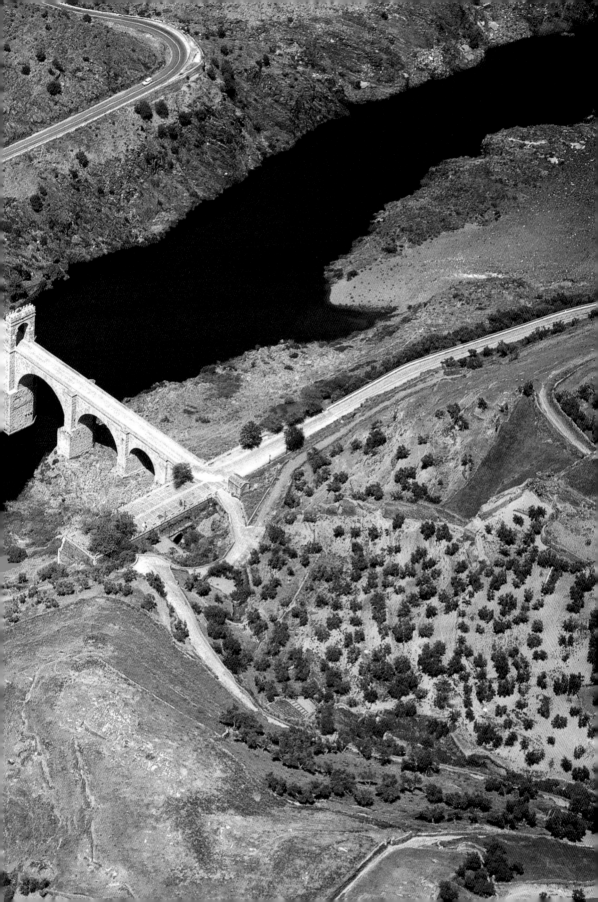

'IMP·NERVAE TRAIANO CAESARI
AVGVSTO GERMAMICO·DACIO·SACRVM PONTEM·
PERPETVI MANSVRVM IN·SAECVLA·MVNDI·
FECIT·DIVINA·NOBILIS·ARTE·LACER·

'I Caius Julius Lacer
have built a bridge which will remain forever.'

And remain it has. Indeed the bridge is so elemental a form
that it became part of the very landscape and imagination
of the succeeding generations that inhabited the region.
For centuries after the fall of Rome, the Puente de Alcántara
was abandoned – forlorn, desolate, unmaintained – but
nonetheless it stood and it was used. When the Moors came
to the north of Spain they saw it, they marvelled, and they
named it Al Kántarah, literally meaning 'the bridge'. This
is the defining bridge: there can be no rival. But the Moors'
admiration did not stop them breaking one of the smaller
arches in 1214 during their fighting with Christian forces,
nor did its antiquity and beauty stop French troops demolishing
one of the main arches in 1812 when retreating from Wellington's
army. Fortunately, the damage was repaired and the bridge
survives – a message from one world to another, a marvellous
repository of Roman genius that continues to serve the
purpose for which it was designed 1,900 years ago, that
continues to glorify the road of which it forms a vital link.

Well-built roads, passable all the year round and virtually
impervious to the elements, were almost holy things in
the Roman world, routes of trade and cultural growth, of
conquest and of defence, the veins of civilization. This high
status is reflected by a small and beautiful Roman bridge,
dating from the late first century BC, that by good fortune
survives in the south of France. The Pont Flavien at Saint-
Chamas stands astride the Via Julia Augusta – an important
route begun in 13 BC on the orders of Emperor Augustus to
link the commercially and strategically important cities of
Placentia (now Piacenza) in northern Italy with Arles in
southern France. At Arles, the Via Julia Augusta linked with

the far older Via Domitia that, dating from the second century BC, was the first Roman road built through Gaul and joined Italy to Spain. Placentia was, of course, linked by road to Rome, so the Pont Flavien – with its single stone arch of modest 12-metre span – formed a small but vital link on one of the key routes from Rome, via Arles and Nîmes in southern France, to Spain. This, plus the fact that the Pont Flavien stood within the zone of the cultural, if not political, frontier between Italy and Gaul, explains its extraordinary and ambitious design. Once seen, this exquisite bridge can never be forgotten.

In its small way, the Pont Flavien is a flawless evocation of Rome, a jewel of a creation, a wonder of preservation that is a window onto a long dead world. To reach the bridge you pass along a narrow and now abandoned stretch of the Via Julia Augusta and the first glimpse you get of the bridge is a pair of stone-built triumphal arches, miniature in scale but big in meaning and magnificence. They guard each end of the bridge and offer an extraordinary perspective to all who approach. The arch in front acts as a proscenium for the one behind: very dramatic and very theatrical, and surely a visual device to let the traveller know they had arrived somewhere very special, that they were now in the frontier zone. This pair of arches, that now look uncannily like the pylons of a nineteenth century suspension bridge, were surely intended to proclaim to all travellers heading west and north that Italy was being left behind, and to those heading south that they were now entering the inner environs of the empire, drawing yet nearer on the imperial highway to Rome itself.

The stretch of road between the arches is short, narrow and now pitted and rutted, scarred by generation upon generation of chariots and carts. But despite being only a stone's throw in length, this small stretch of road offers a vast leap into the past. To stand on this bridge at dusk is to hover in time. Here, the Rome of 2,000 years ago seems not so very distant a place, the triumphal arches being strange portals that goad the imagination. Each arch is dressed with Corinthian pilasters and carries full entablatures, the friezes

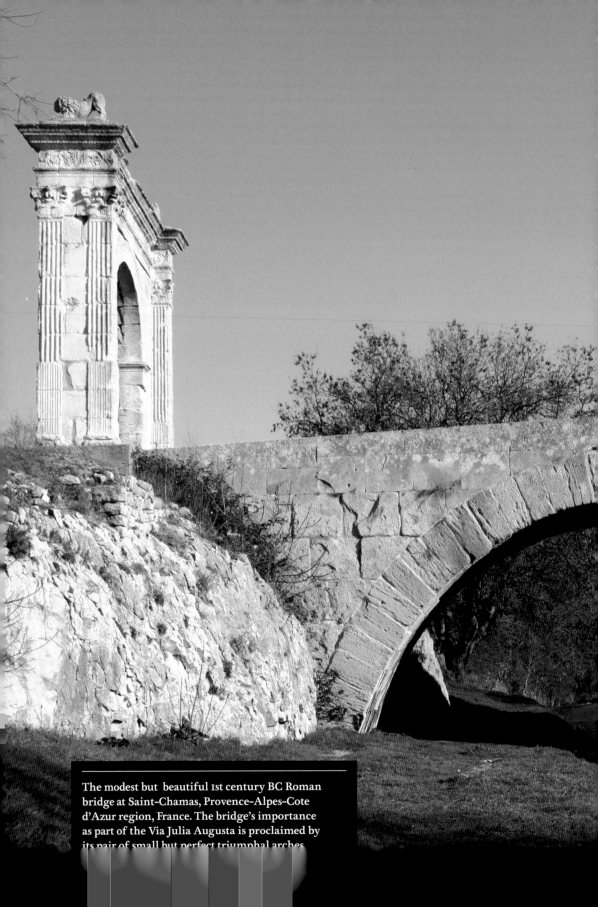

The modest but beautiful 1st century BC Roman bridge at Saint-Chamas, Provence-Alpes-Cote d'Azur region, France. The bridge's importance as part of the Via Julia Augusta is proclaimed by its pair of small but perfect triumphal arches.

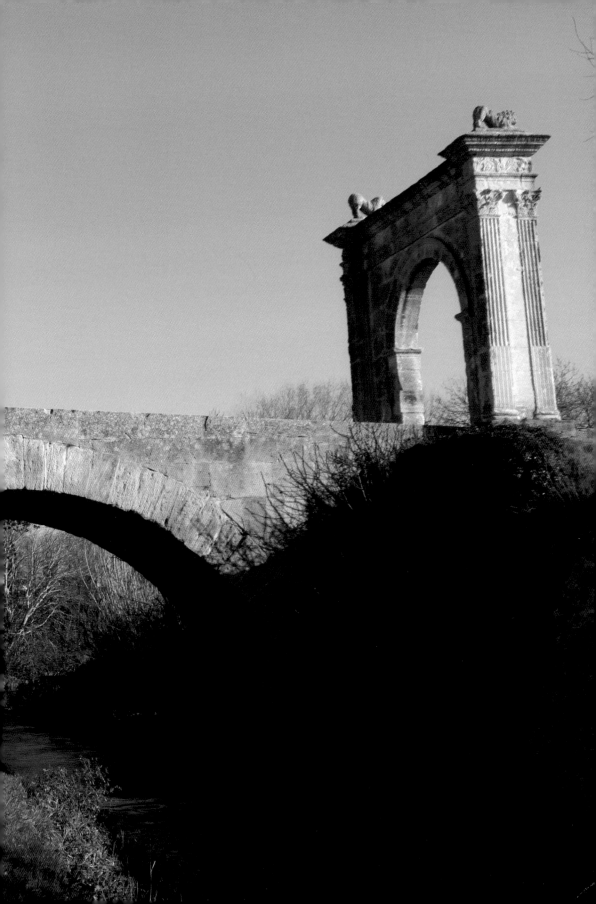

of which retain handsome swirls of stone-cut acanthus. This seems celebratory, but at the corners of the arches, set above the pilaster capitals, are carved eagles, surely representing the might of Rome, and above them, carved in the round, are lions drawing back on their hind legs and about to pounce. They seem to offer a fair warning to any traveller to behave or suffer the consequences.

On the bridge is carved an inscription that appears to date from the time of construction.

It refers to Lucius Donnius Flavos, a priest from Rome in the reign of Augustus, who is described as the bridge's builder. Builder perhaps, designer perhaps, but almost certainly the man who – as a priest – dedicated this work to the gods and called upon them to guard it. The highway was sacred and so too was this bridge: then as a gate to the Roman Empire or to Rome itself, now as an emotive and thought-provoking portal to the Roman past.

RIGHT: Detail of one of the triumphal arches showing the entablature with an eagle and a watchful guardian lion – surely calculated to remind travellers of the power of Rome.

TWO

PIETY AND POLITICS

IN MEDIEVAL CHRISTIAN EUROPE, BRIDGES WERE
built as pious works pleasing to God, as things of utility
and of beauty, as part of the defence system, and of course,
as routes of trade or conquest. The early fourteenth century
Pont de Valentré, across the River Lot at Cahors is all of these
things. I well remember, decades ago, my first glimpse one
summer evening of this tall-towered, stone-built bridge.
It was like something in a fairy tale: fantastic in form, pale,
ethereal. The bridge adjoins Cahors, indeed formed a key part
of its walled defences, but I saw it not against the town as its
backdrop. It strode purposefully and elegantly across the
wide and sluggish river against the background of seemingly
unchanged rolling and sun-bleached countryside. It was
utterly entrancing and, with its mesmerizing silhouette of
tall pyramidal-topped towers and pointed arches, it seemed
to sum up so many of the architectural and engineering
aspirations and achievements of the age in which it was built.

The twelfth and thirteenth centuries marked the great age
of masonry-built bridges in the medieval Kingdom of France
and in the English possessions in Aquitaine and Gascony.
In the late twelfth century, almost the entire western half
of France, from the English Channel to the Pyrenees was
in the possession of, or under the control of, the English
King Henry II, the first monarch of the Plantagenet dynasty.

PREVIOUS AND RIGHT:
The Pont de Valentré,
Cahors, France, started
in 1308. A very rare and
beautiful example of a
medieval bridge with
fortifications intact
including three towers
and cutwaters containing
fighting platforms and
narrow windows from
which passage of the
river could be effectively
controlled.

This was a time before the modern concepts of European nationalism were forged. The Plantagenets were a branch of the French Angevin dynasty, and the English royal court was an outpost of French culture. As well as being the King of England, Henry was also the Duke of Normandy and Gascony, and Count of Anjou, Maine and Nantes. Indeed in this feudal world, popular allegiances and identity lay with the regions, rather than with the larger world or the kingdom of which the duchies or counties formed part.

The complex balance of power and land ownership in France fluctuated constantly, and by the time the bridge at Cahors was started in 1308, English possessions in the west and south had dwindled to the area around Bordeaux and

BELOW: The Pont de Valentré at Cahors, France, photographed in 1851, revealing its state before the restoration of the 1870s when, among other things, battlements were reinstated to the tops of the cut-waters.

to western Gascony. But the situation remained fluid, particularly during the Hundred Years War that started in 1337. During these decades of intermittent territorial and dynastic conflict, control of vast areas of the land regularly changed hands with a dramatic – if relatively short-lived – increase in English possessions in the north and northwest following Henry V's victorious Battle of Agincourt in 1415.

Due to the wars that flared and smouldered in France, Cahors, although under French control, remained for most of the fourteenth century a more-or-less beleaguered frontier town. And the threat came not just from invasion by the English or by their French allies, but from the hordes of freebooting mercenaries and brigands that the decades of

conflict and chaos in France had unleashed upon the land.
So when the decision was taken to build the Pont de Valentré,
it was natural that it should not only be fortified to deny
passage across it to the enemies of Cahors, but also that it
should be incorporated into the town's defences. To conceive
it as a barbican or redoubt would greatly enhance the military
power of the town.

The designer of the Pont de Valentré, and those raising
finance for its construction, would have learned well the
lessons offered by other great masonry bridges constructed
in southwest and central France during the previous 150
years. The most influential would have been the mighty Pont
Saint-Bénezet, across the Rhône at Avignon (better known
as the Pont d'Avignon, and made famous by the fifteenth-
century nursery rhyme 'Sur la Pont d'Avignon') and the
bridge over the Loire at Orléans. Both had been started within
a few years of each other in the 1170s and both were seen as
great works for the glory of God and the benefit of mankind.

The Pont Saint-Bénezet at Avignon had a near mythic
origin that reveals the sacred nature of bridges in the medieval
mind. They were seen as examples of the way in which the
righteous and religious-minded could – with divine support
and blessings – harness nature and command the elements.
As with the Paradise Gardens of Islam (see page 118), bridges
were, to medieval Christians, a means of realizing heaven
on earth, of creating beauty, wealth and harmony. They
were works that were pleasing to God and links not just
between places on earth, but between this world and the
next. In addition, bridges had an even deeper meaning for
medieval Christians. In their faith, water was an important
agent of transformation from the material to the spiritual.
At baptism, holy water washes away sins and is part of the
ritual of initiation into the Christian Church. Christ himself,
perceived by Christians as the Son of God, had at his own
request been baptized in the River Jordan and this action
had pleased God (Matthew 13: 1–3). Given water and rivers
are central to the Christian faith, so too is the means by
which they are bridged.

> '**Donating money towards the construction of a bridge was deemed to be a noble deed that would reduce the time that, after death, the soul would have to suffer in purgatory.**'

Repeatedly in medieval France, clerics aided the construction of bridges in the same way that they aided the construction of churches and charitable institutions. In Toulouse, a testament of 1251 stated that money should be left to 'churches and hospitals and bridges and other pious and poor places', while in 1308, the year the bridge at Cahors was started, Pope Clement V granted for seven years an indulgence of 100 days 'to those faithful who, truly penitent and confessed, stretched forth a helping hand to the fabric of the bridge the Dominicans were building near Nîmes'.[29] So in certain circumstances, donating money towards the construction of a bridge was deemed to be a worldly action that would reverberate through the afterlife. It was a noble deed that would reduce the time that, after death, the soul would have to suffer in purgatory. In this way, it was equal to making donations to churches and to charities or to founding hospitals, almshouses or colleges.

The origin of the bridge at Avignon reflects the spiritual purpose of bridge construction, or so it is alleged. In the mid-twelfth century, a young shepherd named Bénézet is said to have had a vision in which God directed him to go to Avignon and inspire the building of a bridge across the dauntingly wide Rhône. The enterprise seems to have taken on the characteristics of a battle between good and evil, God and the Devil. When Bénézet arrived in Avignon and started to preach his crusade against the dark and turbulent waters of the Rhône, promoting the construction of a bridge, he was jeered and rejected. He is said to have then performed a miracle by casting a vast stone into

the river to help form the foundation for the first pier of the bridge. Whether this story is true or not is hardly the point. The fact that it has been told through the years confirms the medieval assumption that bridge building was indeed God's work and that any structural failures that took place – whether due to the elements, subsidence or faulty workmanship – were probably the work of the Devil. Construction of the bridge started in about 1175 and Bénézet, miracle or not, seems to have become one of the major promoters of the bridge, travelling for years after building began to raise donations, just as if raising funds to build a cathedral or for a crusade against the increasingly triumphant Saladin and the Islamic 'Saracens' in the Holy Land.

The Pont Saint-Bénezet was conceived as a stone bridge spanning some 900 metres by means of twenty-two wide elliptical arches that were influenced by surviving Roman bridges in the south of France and which actually incorporated reused Roman voussoirs. The river was wide and fast flowing, and there were constantly problems in constructing strong foundations for the piers from which the arches spring. Consequently, from time to time – and on an almost regular basis – piers and arches were swept away and had to be rebuilt. This must have been excessively frustrating for Bénézet. Most revealingly, when he was in Burgundy on a fundraising mission and heard of the most recent collapse, Bénézet declared that it was the Devil scattering the stones of the bridge.[30]

Presumably, to Bénézet the bridge was emblematic of the body of Christ beset by the forces of evil. Certainly the Bible makes such an analogy possible. The 118th Psalm (22–29) was seemingly a hymn sung by those processing to Solomon's Temple in Jerusalem, a structure of great importance to Jews, Christians and Muslims alike. The Temple is alleged to have been built to God's instruction and to embody divine truths about the nature of creation. The Psalm contains the enigmatic line, 'The stone which the builders rejected has become the head stone of the corner', and this, according to the New Testament, was a prophesy about the coming of Christ and an insight into His nature and destiny.

In Acts 4:11 Peter declares that Christ is the 'stone which was set at nought...which is become the head of the corner', and in Matthew 21:42 Christ echoes Psalm 118, asking, 'Did ye never read in the scriptures, The stone which the builders rejected...is become the head of the corner?' This made it clear that Jesus was the stone, that this was 'the Lord's doing' and 'marvellous in our eyes'. To Bénézet and his fellow twelfth century bridge-builders it certainly was marvellous. To build with stone was to build with the body of Christ, and to build bridges with such a divine material – hewn from God's great creation, from mother earth – was to build anew the great work of Solomon's Temple, to forge the celestial New Jerusalem on earth as prophesized in the *Book of Revelation*.

The bridge was completed in the late 1180s, perhaps in the very year, 1187, that Jerusalem finally fell to the Islamic armies of Saladin after nearly ninety years of bloody and turbulent Christian rule. Not, perhaps, an auspicious inauguration for this great pious work.

To proclaim its Catholic credentials, a chapel was constructed on a pier of the bridge. It was dedicated to St Nicholas, the patron saint of sailors, fishermen, merchants and prostitutes, and so perhaps calculated to cater for, and attract donations from, the majority of people using the bridge. The chapel eventually housed the tomb and body of Bénézet, who was made a saint after his death, not only for his bridge-building zeal, but also for his miracles of healing. The bridge was almost a monastic building, served by its own Order of Brothers and Sisters.

But this elated status could not save it from the fury of the material world. Arches were not only swept away by the river but destroyed during fighting in the thirteenth century. Now only a few piers and four arches of the medieval bridge survive, and these are mostly re-buildings of the mid-fourteenth century. One of these piers supports the chapel, a most picturesque sight, but the saint's body was removed in 1674 to save it from the raging elements that Bénézet had ultimately failed to subdue.

The sight of portions of Bénézet's piously Roman Catholic bridge being regularly carried away by the river may not have

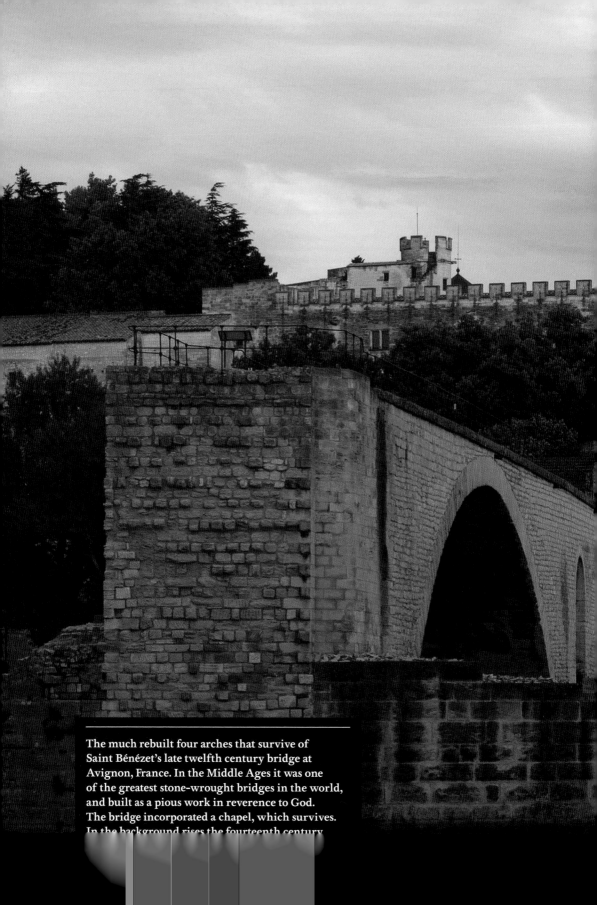

The much rebuilt four arches that survive of
Saint Bénézet's late twelfth century bridge at
Avignon, France. In the Middle Ages it was one
of the greatest stone-wrought bridges in the world,
and built as a pious work in reverence to God.
The bridge incorporated a chapel, which survives.
In the background rises the fourteenth century

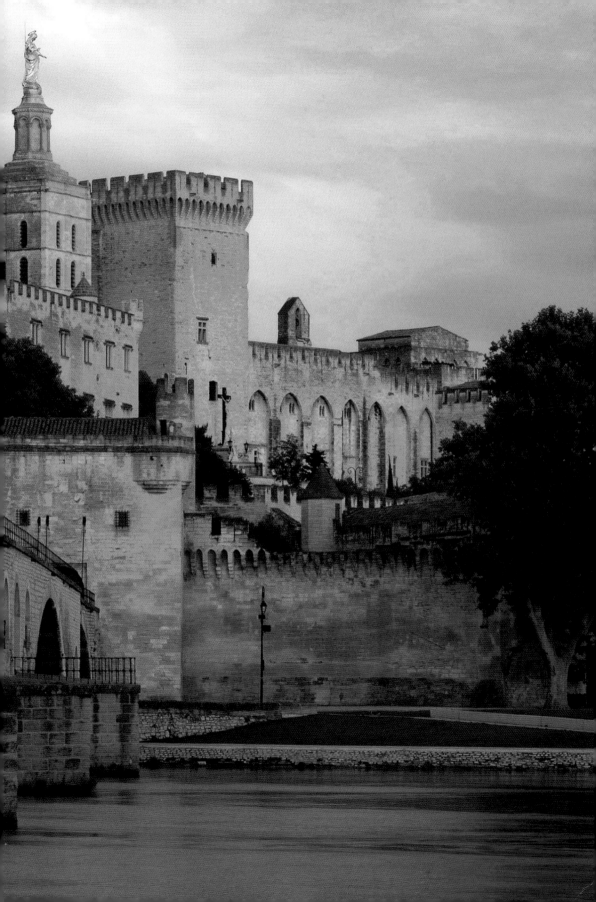

surprised or even upset some local observers. Avignon stood immediately to the east of Languedoc, a region that from 1208 suffered waves of religious persecution and was the location of the largest and most bloodthirsty Christian crusade outside the Holy Land. The victims were the Cathars who, although followers of Christ, were dismissed as heretics by the Roman Catholic Church. And this is not surprising. The Cathars, a Gnostic Christian sect established in Languedoc and Catalonia during the eleventh century, rejected the physical world of frail vanities with the transient pleasures and trappings of temporal wealth and power. All that was material was the work of the Devil, argued the Cathars, and actually or potentially evil. For them, that explained why the physical world was full of suffering, awash with pain that appeared bafflingly unjust, and why man existed in perpetual bondage to the Seven Deadly Sins and the temptations of the flesh.

For the Cathars there were two worlds and two powers. There was the physical realm ruled by the Devil, *Rex Mundi*, and there was the spiritual realm that was ruled by God, which was the true dwelling and birth right of the souls of enlightened or 'perfected' humanity. This Catharian vision of creation is suggested in the New Testament, where Paul declares that, 'the things which are seen [that is material] are temporal; but the things which are not seen [the spiritual] are eternal' (2 Corinthians 4:18) and when touching on the mystery of resurrection, he explains that there are 'celestial bodies, and bodies terrestrial' (1 Corinthians 15: 13–58). Paul goes on to reveal the possibility of a great transformation from the physical to the spiritual: a 'natural' or physical body can die and be 'raised a spiritual body'.

Most provocatively, and logically, the Cathars numbered the Catholic Church – with its opulence, luxury and worldly power – among the spawn of the Devil. This affront to Catholicism was compounded by the fact that the Cathars did not accept that Christ had ever been incarnate in the evil material world. Therefore he was not in his nature God and human combined and the crucifixion could not have taken

place, nor Christ's literal, physical, resurrection. To the
Cathars, the cross was not a symbol of Christ, sacrifice
and redemption but an obscene emblem of *Rex Mundi*.

Worldly rulers – including the Catholic Church –
perceived the Cathars as blasphemous revolutionaries that
were both offensive and threatening. So the peace-loving and
non-violent Cathars were hunted down, put to the question
by an inquisition of fanatical Catholic clerics, punished and
– in their thousands – killed, or driven into exile in remote
and secluded areas of southern France and in Spain. In 1209,
up to 20,000 Cathars were massacred at Béziers, following
a protracted siege, in circumstances that echo the wildest
medieval evocations of the sufferings of Hell. Clearly, for
the triumphant Catholics, the Cathars were the damned and
they were to suffer physical torments in this world as well
as in the next. The crusade continued for twenty years and
although it drove Catharism deep underground it did not
entirely eradicate the faith. Nor did the end of the crusade
mean the end of Cathar persecution. The last mass killings
took place as late as 1244 when 200 Cathar priests – known
as parfaits – were burnt at Montsegur.

There was another reason beyond religious intolerance
for the vehemence of the Cathars' persecution. Most of the
crusaders were Catholic French from the north and they
viewed the Cathars and people of rural Languedoc as
strange and foreign and the region as ripe for conquest and
exploitation. The consequence of the anti-Cathar crusade
was not just the destruction of an indigenous Christian
faith but the dilution of the culture and sense of identity
of the people of the south who, robbed of their autonomy,
were made subservient to the King of France and the
northern French.

Many people in the south of France, especially those with
Cathar sympathies, must have seen the bridge and Avignon
– and other great 'pious' bridges of the Catholic church – not
as the works of God but as the works of *Rex Mundi*, or at the
very least as expressions of the brutal conquest of their native
land by the French from the north. Great bridges like that at

'The bridge at Orléans epitomizes the history of bridges in the Middle Ages. It underwent siege, fire and flood... it had its own chapel, hospital, houses, shops, mills and markets.'

Avignon could be very political, as well as pious, architecture. This perception helps explains some of the strange stories, which we'll come to later, surrounding the role of the Devil in the construction of the Pont de Valentré at Cahors.

The bridge at Orléans over the Loire – started in about 1175 – was also a pious work with funds coming from donations. As with the Pont Saint-Bénezet at Avignon, the will to maintain and rebuild it endured through the centuries, only finally faltering in the mid-eighteenth century when its gaunt remains were almost entirely pulled down. Also, as at Avignon, the bridge at Orléans consisted of 22 stone-built arches springing from stone piers built on foundations rising from the riverbed and from a large sandy island roughly mid stream in the Loire. The bridge and its island were almost an entire world in themselves. On one of the piers stood the 'Belle Croix' and on the island stood the chapel of Saint-Antoine, both emblems of the bridge's pious origin and funding. On the island were also a charitable hospital and a market, both reached from the bridge. On the bridge itself, according to Bridge receipts of 1428–31, were seven buildings, mostly standing on the piers, and including the homes and workplaces of two rope makers, a baker, and a haberdasher.[31] In addition there was a series of mills powered by the water rushing between the arches. The hugely important role the bridge played in the life of Orléans meant that it was a prime target when in 1430, towards the end of the Hundred Years War, the city was besieged by the

English. A number of arches were broken down but, for the time being, the bridge survived. As Marjorie Nice Boyer explains in her authoritative book *Medieval French Bridges*, the bridge at Orléans 'epitomizes the history of bridges in the Middle Ages. It was built of masonry...and endowed by charity as a pious work. It underwent siege, fire and flood... its appearance emphasized the functions of a medieval bridge. It had its own chapel, hospital, fortifications, houses, shops, workshops, mills and markets'.[32]

The construction of the bridge at Orléans was also typical of the time. In France and England from the eleventh to thirteenth centuries it was usual to build bridge piers upon composite structures or footings called starlings or orgeaux. Now the name is used to describe wooden piles erected around or upstream of a bridge pier to help protect it from the current or floating objects. But in the twelfth century the name implied a more specific technique. At the time there were three basic methods by which the foundations or footings of bridge piers were constructed: starlings; the timber pile driven to a certain depth or until bed-rock was reached; and the cofferdam. The method chosen usually depended on the nature of the river and the terrain over which it ran, on the availability and type of local building materials, on the supply of labour, especially skilled labour, and on money. Also the ambition of the project could be crucial: was the bridge to be a great pious work, pleasing and honouring God in perpetuity, or was it to be a mere utilitarian affair? For the former, the foundations would almost inevitably be built of stone, for the latter, timber might well do, although even in the construction of stone bridges, timber and carpenters were of vital importance. Every stone arch had to be built off timber centering, which had to be skilfully constructed to sustain the weight of the stone before it could carry its own weight, and to withstand the violence of the elements. Constructing a large stone bridge often called for the felling of a veritable forest of trees.

The most complex approach to the construction of pier foundations below water level was the cofferdam, a technique that was perfected during the centuries of Roman bridge

building in the south of France, and the knowledge of which was no doubt passed from generation to generation of bridge builders and masons as one of the 'mysteries' of their trade. Then there was the use of timber piles, almost invariably chestnut logs for their ability to carry heavy loads and not rot when wet.[33] These would be driven into the riverbed by various types of muscle-powered pile-drivers. Upon the stable foundation provided by these timber piles, the stone piers could be built. But until the late thirteenth century, starlings were most commonly used.

Starlings were, essentially, small man-made islands from which the bridge piers would rise. The standard method of construction was to drive 4–5 metre timber piles into the riverbed, up to roughly half their length, to form an enclosure (so starlings could be very hard to construct where the riverbed was hard rock). It was obviously preferable to work during the time of low water so there was a distinct bridge-building season in medieval Europe, usually starting in mid June or early July, and extending through to the autumn and ceasing no later than 30 November, St Andrew's Day. Into this enclosure, earth and stone rubble were dumped, packed tightly and pounded down, until the starlings reached a height above water level. Then timber beams were laid across, levelled, and paved, and upon this 'island' the piers of the bridge were built.[34] The advantage of this technique was that it required little skill, few materials beyond those generally to hand, such as earth and rocks, and if conditions were favourable, the starlings could be completed relatively quickly. The downside was that the works were inherently unstable and vulnerable to being undermined by fast currents or flood waters, and needed much maintenance.

If the elements were kind then these little artificial islands could take root, held in place by the dead and live loads of the bridge they helped support and bulwarked by natural growths and accumulations of sand and silt. But more often, and certainly at first, the starlings demanded regular annual maintenance if they were to survive, with piles being replaced as and when necessary. In fact, the entire structure of the bridge required constant attendance and it became the

'In this way, the bridge became an elemental, almost living being and its maintenance became part of the rhythm of the life of the community in which it stood.'

responsibility of succeeding generations to maintain and, if necessary, rebuild it.

In this way, the bridge became an elemental, almost living being and its maintenance became part of the rhythm of the life of the community in which it stood – indeed, it changed and defined the life of the community. It not only provided access across a river and became a profitable focus of communications, but also, with its wide and regular piers and narrow arches, changed the very nature of the river for miles around. It slowed the river down, making it spread upstream beyond its banks and increasing the fertility of the land. As the constrained waters fought to pass between the bridge's piers, it created a mill race, and immediately below the bridge, riverbanks could be more habitable and less liable to sudden inundation.

From the late thirteenth century onwards, piers founded on driven piles become the preferred foundations, and this technique usually involved the construction of a cofferdam. There are several reasons for this, not least an advance in the technology of pile-driving and a growing preference for building structures that might take more time, money and skill to construct, but which were more robust and required less regular maintenance. Villard de Honnecourt's sketchbook, probably compiled in the 1230s and 40s, includes a drawing of a machine for sawing off 'the tops of piles under water so as to set a pier on them'.[35] It's reasonable to assume that de Honnecourt drew this because it was a novelty or represented an admirable and advanced construction

par chu fair om len bracemir
co ne roe sent larbre enda...
mer

par cest engien
ceo pon estacer de deus
une aie per une sols
aer lo S...

...si peo ourer a one roe
...u a one maison de bas
...li sunt trop cor-
...co prisie de ceste
...manire poel redret
...eir une maison
...one part e fi
...pie de sela·

technique. Perhaps by the mid-thirteenth century, starlings were viewed as one of the pragmatic and not very scientific 'mysteries' of the old building guilds, while the driving of piles and construction of cofferdams represented the emergence of a more technically reasoned approach to engineering and architecture.

In the fourteenth and fifteenth centuries, piles 3–4.5 metres long were driven into the riverbed by various types of machines. During the reconstruction of piers at Orléans in the late 1380s, two types of pile-drivers were used: the *Hye* and the *Engin*. The *Hye* was furnished with a windlass operated by about half a dozen men, and the *Engin* was a more sophisticated machine, comprising a 'ram' or large elm trunk that was suspended on ropes and leather traces, hoisted onto pulleys by up to 16 men, and then released onto the head of a pile to drive it into the riverbed. Both machines were operated from boats and the *Engin* could drive about eight piles a day.[36]

Documents recording repairs made in 1408 to a cutwater and pier of the eleventh century brick-built bridge at Albi, throw light on the construction and use of cofferdams in medieval France. Piles five metres long were driven into the riverbed (presumably using machines located on the bridge as well as in boats) and then piles of narrower diameter were driven within them to form two concentric enclosures. The tops of the timbers were fastened by crosspieces and then 'bart' (a type of clay mortar) was packed between the two rows of timbers to form a watertight wall. The water within the cofferdam was removed by teams of men using buckets, a slow, exhausting but sure system that was generally preferred to the pumps available at the time that were prone to mechanical failure.[37]

The main problem with cofferdams is that they were expensive to construct, needing large numbers of skilled men and machines, and it was always uncertain that the lavish investment would work. For example, a rocky riverbed could make the driving of piles – which had to be precisely and regularly located for the cofferdam to be waterproof –

LEFT: A page from Villard de Honnecourt's notebook, dating probably from the 1230s, illustrating various mechanical devices including, top left, a machine for sawing off 'the tops of piles underwater so as to set a pier on them'.

difficult and time consuming. Worse still, when the bailing-out of the cofferdam was nearly complete, the discovery of a powerful underground spring within the cofferdam could reduce all the work to nothing. But if all went well, then the cofferdam was a very sound, if expensive, investment. It permitted the construction of strong foundations and piers and meant that, for decades to come, the bridge would be safe and free from the constant financial strain of ongoing maintenance and rebuilding.

Another significant reason for the change in bridge construction techniques in the thirteenth century was the change in how bridge building was financed. The great pious works of the eleventh and twelfth centuries had generally been paid for by many small donations over numerous years, and so techniques like starlings, that required minimum financial outlay but regular small sums for continuing annual maintenance, were the most suitable. Also these bridges were, in their intentions at least, great public works free and open to all. But from the early thirteenth century in Western Europe, tolls and taxes, combined with donations, were increasingly the preferred options for raising building funds. If the tax-gathering and toll-collecting authorities were determined enough, then large sums could be gathered before and during bridge construction, making substantial amounts of money available at the onset for building techniques that were initially more expensive, such as piled foundations and cofferdams.

King Edward I of England was particularly keen on using local taxation to finance bridge building in his French lands. For Edward, bridges – like his mighty castles in the north of Wales – were part of a military system for expanding his conquests and holding subject territories. In the 1280s and '90s, Edward almost crippled England with his excessive taxation to pay for his castle building in Wales and his extended wars against the Scots, so it's hardly surprising that he was ready to impose harsh, even punitive, taxation on his French vassals. Although by the late thirteenth century, English possessions and power in France were on the wane,

'Increasingly bitter determination to end all English rule in France gave birth to a French sense of patriotism, nationalism and destiny expressed in the self-sacrifice of Joan of Arc.'

the English were not yet regarded simply as a foreign aggressor and exploitative occupying power. This perception only matured gradually during the Hundred Years War, when the increasingly bitter determination to end all English rule in France gave birth to a French sense of patriotism, nationalism and destiny, expressed most forcefully in the late 1420s through the endeavours and Christ-like self-sacrifice of Joan of Arc.

In the 1290s, the complex ties – dynastic, racial and feudal – between the English and French courts and peoples, were such that there was little sense of identity beyond that of individual villages, towns, counties or duchies. The intimate relationship between the English and French courts suggests why this was so. In 1299, when he was sixty years old, Edward took as his second wife the 20-year-old Margaret of France, daughter of the French King Philip III. Once the French and English courts were related through marriage, Edward received from Philip IV as a gift the lordship of Guyenne (a province of southwest France) and a few years later, he was confirmed by Philip as the rightful lord of Gascony.

So, given this accommodation between the English and French courts, it's natural that in the 1280s, Edward, in accord with the hierarchy and protocols of the feudal system, collaborated with the local French power structure to secure his tax revenues. For example, in 1283 the English crown resolved to construct a new bridge across the Garonne at Agen and to finance it through taxation and tolls. Acting under royal

orders the vice-seneschal of the Agenais called together a regional assembly to arrange finances for the bridge. Having secured the support of key local inhabitants, Edward I authorized a collection of a toll known as a *barragium* or *barra* to start the ball rolling. In addition to this toll, he implemented a hearth tax, the justification for which was a summation of the medieval argument for bridge construction. The work was to satisfy the king, please God, and add to the dignity and honour of the inhabitants of the town.

The foundation stone of the Pont de Valentré at Cahors was laid on 17 June 1308, at the start of the traditional bridge-building season, and was partially financed by a barrage, renewed by the French King Charles IV in 1323, to help complete the bridge.[38] The Pont de Valentré was conceived not just as a passage across the river Lot, but also as a fortified entrance to the town and an outer work of its defensive walls that commanded the Lot and the plain next to the town.

The bridge was furnished with three towers, each astride the roadway, providing accommodation for a garrison and defence and, at the town end, it was connected to a barbican, or fortified gate. The river is spanned by six arches that are, in the Gothic spirit of the age, of pointed form. Use of the Gothic style was not primarily to do with appearance or aesthetics but with function. As early nineteenth-century Gothic enthusiasts like the English architect A. W. N. Pugin observed, the 'true principles of Pointed or Christian Architecture' included the 'rules' that 'there should be no features about a building which are not necessary for convenience, construction, or propriety', and that, 'all ornament should consist of enrichment of the essential construction of the building'.[39]

The Pont de Valentré is a practical demonstration of these theories and testament to the strength and functional convenience of Gothic forms. Quite simply, pointed arches are potentially stronger and certainly more adaptable than semi-circular or segmental arches. With semi-circular arches the ratio between span to rise is fixed. The rise cannot be less than half the span, so if the span is long the rise will

RIGHT: The Pont de Valentré bristles with fortifications – battlements, slit-windows, covered stairways, machicolation-topped towers and cutwaters carrying fighting platforms.

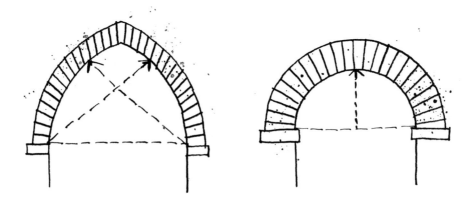

ABOVE: On the left, a
pointed arch formed by
two arcs with different
centres meeting at a point.
The ratio between width
and height – or rise – of the
arch is relatively flexible
and adaptable to different
conditions. Here the centre
of each arc is set at the
bottom of the arch. If the
crown of the arch is
required to be extremely
low a 'Tudor' or four-
centred pointed arch can
be formed.

On the right, a semi-
circular headed arch.
The ratio between its
width and height is fixed
– by its nature the arch
is twice as wide as high –
and cannot be adapted
to differing conditions
or requirements.

be high and hump-like – a thing not generally desirable
either visually or practically when the ideal bridge has a
carriageway as near as possible horizontal and level with
the land either side of it. A segmental bridge built in short
sections can help solve the problem, but if its span is too
wide and its curve too flat, then it is inherently structurally
unstable. It becomes vulnerable to any settlement of its
springings or piers and to exceptionally heavy loads or
seismic action.

A pointed arch, on the other hand, performs quite
differently. Its form is determined by two arcs that meet at
a central point and the curve, form and angle of these arcs
can be varied quite considerably, to achieve wide spans and
relatively low rises, without any significant structural
compromise. So the pointed arches at Cahors – each with a
span of 16.5 metres and only a shallow rise – are not to do
with style but are means of achieving strength within the
constraints of a specific physical location and building
material. The detailed design of the arches and piers also
possesses a pleasing functional elegance that, in the true
spirit of bridge design, reflects the forces of nature. The
elevations of the piers facing the flow of water are conceived
as cutwaters, deep in form and pointed in plan to help them
deflect and withstand and force of the rushing water, while
those facing downstream are more modestly flat-fronted.

The small putlog holes at the bases of the springing of the arches reveal something of the arch construction technique and the plans for their maintenance. Timber beams and struts, forming part of the form-work upon which the stone arches were fabricated, would have been anchored in these putlog holes, making the piers and arch bases part of a permanent system of scaffolding. The putlog holes would have also provided anchorages for any scaffolding required for maintenance or partial reconstruction of the bridge.

The desire to fortify the bridge so heavily reflects the political instability of the age and region. Cahors was a frontier town between the long-established and potentially warring French and English spheres of influence. Also, in the early fourteenth century, the Cathars remained a potential

BELOW: Putlog holes in use. Putlog holes are recesses in masonry left during construction and used as fixings for scaffold for initial building works or for maintenance. Often putlog holes were concealed after works by being filled and rendered over.

threat to Roman Catholic communities. Cathars were by conviction anti-violent but worldly princes who had supported them in the past were not averse to pursuing their spiritual beliefs by means of combat. Despite the fact that the Cathars had been officially suppressed in 1244 by the massacre at Montsegur, the cathedral of Sainte-Cécile in Albi was rebuilt in 1282 as a veritable fortress. Its massively powerful appearance declared the might and dominance of the Catholic Church and made it clear that it and the northern French were in Languedoc to stay.

But as with the towers on the bridge at Cahors, the cathedral suggests that the conquerors were nervous. Its tall outer walls are immensely strong, built of hard, well-fired brick, and thickened at their base to stop them being penetrated by battering rams. Windows are narrow and set high, and there is a massive west tower like a brooding castle keep. The whole thing was set within a well-calculated network of outer fortifications. It's hard to see this cathedral as a sacred building, rather it's an architecture bred out of terror and designed to instil terror.

This is the context in which the bridge at Cahors was conceived and perhaps goes a long way towards explaining its design. The paranoia expressed through its bristling fortifications must have seemed justified at the time. Two years after the bridge was started, the survival of a Cathar community in the region was apparently confirmed by further killings conducted by nervous Roman Catholic authorities and it was as late as 1321 that Guillaume Bélibaste – the last known Cathar priest in Languedoc – was executed. In these circumstances, the nervous citizens at Cahors in the very early fourteenth century would have viewed the construction of an unfortified bridge across the Lot and next to their town as an act of madness. To them it would have appeared to be a potential highway for invaders and tantamount to a dagger aimed at their vitals.

It was not only the citizens of Cahors who were nervous that a bridge leading directly into the heart of their town could be an invitation for attack. At the same time as the Pont

de Valentré was started, the townspeople at nearby Montauban (now in the Tarn-et-Garonne department) were obliged to replace their wooden bridge with a fine and expensive masonry bridge. The rebuilding was demanded by the French King Philip V, who charged royal officials with the duty of extracting tolls and taxes to pay for its construction. The bridge was completed in the 1330s and furnished with three strong towers that were occupied by a royal garrison. The bridge still stands but the towers have long gone, leaving the Pont de Valentré as the last intact surviving monument to the nervousness of urban bridge builders in fourteenth century Guyenne.

Indeed very few comparable fortified bridges survive in Europe, so it is now difficult to view the Pont de Valentré in its original context. Somewhat similar are the four tall, masonry-built, mid-thirteenth-century towers that stand astride the Ponts Couverts in Strasbourg, Alsace, France and which formed a crucial part of the city's defences. Originally the towers, each square in plan, were connected by a timber-built and roofed bridge (hence the name), of the sort represented by the still surviving mid-fourteenth-century Chapel Bridge in Lucerne, Switzerland, where a narrow, covered way is defended by a tall and polygonal masonry defensive tower, detached and centrally placed. Both these bridges relied – as did the Pont de Valentré – on garrisoned towers of substantial size for defensive strength. The Charles Bridge in Prague, started in 1357, retains three guardian bridge towers, but these are placed discreetly at either end, while the three wide segmental arches of Ponte Scaligero at Verona, built around 1375, are topped with battlemented brick walls that join directly with the outworks of the adjoining castle.

The late-thirteenth-century Monnow Bridge, in Monmouth, Monmouthshire, Wales is also fortified but – rather like some Roman examples (see page 113) – relied on a single, centrally-placed gate and portcullis, set within a squat gatehouse. A miniature fortress in itself, with large machicolations and a roofed fighting platform, the gatehouse

The Ponts Couverts, Strasbourg, France with
its mid-thirteenth century masonry towers –
essential parts of the cities defences – that originally
presided over narrow, timber-built covered bridges

was added to the bridge in the early fourteenth century to control and restrict passage as part of the town's defences, and as a convenient place to collect tolls from those using the bridge or entering the town.

The Pont de Valentré, finally completed in 1350, never had to withstand a destructive assault or siege. The English did not attack it during the Hundred Years War, nor did Henri of Navarre risk an assault on the bridge when in 1550 he laid siege to Cahors. Presumably, the bridge's obvious strength achieved that ideal of defensive architecture, deterring the enemy from even attempting an attack. But despite being spared military assault, the bridge did have to endure the elements over the years. During the 1870s, it was heavily restored under the control of architect Paul Gout, when many of its long-lost Gothic details were reinstated and its towers virtually rebuilt.

At this time, and very much in accord with the romantic spirit of the time, an obscure and apocryphal legend about the bridge was revived and given physical expression. Throughout Europe there are many medieval bridges that are, in one form or another, named the Devil's Bridge. Pont de Valentré is one of them. Usually these bridges are wonderful and unusual in some way, mostly of heroic design and typically including spans of prodigious width that in the past seemed almost beyond the power of man to create unless, of course, aided by the Devil at the cost of at least one human soul.

In France there is the twelfth century Pont du Diable at Olargues, Hérault and the fourteenth-century Pont du Diable at Céret, Pyrénées-Orientales. Both these are relatively small, stone-built bridges, nonetheless incorporating at least one arch of impressive span (that of Céret includes a majestic semi-circle that spans over 45 metres). The widest of these medieval single-arch prodigy bridges was that at Vielle-Brioude that had been started in about 1340 and crossed the Allier in a single 54.2 metre span. When it collapsed in 1822 it was believed to be the largest arch in the world.[40] In Italy, Borgo a Mazzano near Lucca, possesses a stone-built fourteenth-century bridge that serves the ancient pilgrimage route from France to Rome. The bridge is named the Ponte

RIGHT: The fourteenth century gatehouse set in the centre of the late thirteenth century Monnow Bridge in Monmouth, Wales. It is a miniature fortress, complete with portcullis and machicolations, that could be used to deny the use of the bridge to an enemy.

della Maddalena after a nearby chapel dedicated to St Mary Magdalene. But it is also, because of its minimal construction and very wide central span, called the Ponte del Diavola. The legend is not unique: the mason, to complete the Ponte del Diavola on time, had to call in the help of the Devil who, in payment, wanted the soul of the first living being to pass over the bridge. After completing the bridge in a single night, the Devil received his payment. The soul, however, was not that of a human but of the pig that the cunning mason had driven across the bridge. The same story is told of the bridge at Céret, but there the wage the Devil was tricked into accepting was the soul not of a human, or even of a pig, but of a cat. In Ceredigion, Aberystwyth, Wales, at the twelfth-century

ABOVE: The 'Devil's Bridge' at Céret, Pyrénées-Orientales, France – a fourteenth century bridge whose astonishing 45 metre span convinced many that it could only be the work of the Devil. It is one of many structurally daring medieval bridges in Europe for which the Devil was assumed to have been the chief engineer.

'The Devil was once again invoked to speed the construction of the bridge and the price the mason had to pay on completion was, as usual, his soul.'

Devil's Bridge (now with eighteenth and twentieth century bridges placed in a picturesque tier above), it was a dog that had to suffer. Here the Devil undertook, as usual, to build a much-desired bridge in a difficult site in return for the soul of the first living thing to pass across, which a wise old woman contrived to ensure was a hapless mongrel. In the Middle Ages bridge building was, it seems, such a daunting and audacious task that – in popular imagination at least – the enterprise had to be entrusted either to God as a pious work or to the Devil.

In the case of Pont de Valentré, the Devil was once again invoked to speed the construction of the bridge and the price the mason had to pay on completion was, as usual, his soul. But like his fellow bridge-builders who were obliged to have truck with the Devil, the Cahors mason possessed a useful amount of old-fashioned peasant cunning. I was told the story by a fellow I found loitering below one of the towers on the bridge. I took him for a resident of Cahors with a native passion for the bridge. He told me that just as the bridge was nearing completion the mason tempted the cock-sure Devil to enter upon a wager. The mason bet that the Devil could not deliver the water needed for the final batch of mortar to bed the last stone of the bridge – and since the mason gave the Devil a sieve in which to bring the water, the mason won and retained his soul. The Devil was furious, and every night in an act of revenge removed the last stone laid, so that the bridge was doomed never to be fully complete and the mason never to finish his task because each day he had to replace the

stone removed during the night. When Paul Gout saw the bridge in the 1870s, my informant told me, there were indeed missing stones in the towers, not the result of neglect said the locals, but of the Devil who had clearly over the years been gaining on the local masons.

Rising to the Devil's challenge, Gout replaced all the missing stones of the towers with the last stone bearing a carving of an industrious Devil pulling a stone out of the wall. My companion was clearly delighted by this and took visible pleasure in telling me that, in consequence of this carving – which he pointed out high upon the very tower rising above us – the Pont de Valentré is now popularly known as the Devil's Bridge. I observe that the Devil certainly seems to have been appeased, since no stones appear to be missing from the towers. My companion said that he believed he was.

RIGHT: The late nineteenth century carved Devil clings to a tower on the Pont de Valentré and tries – and eternally failing – to work a stone loose.

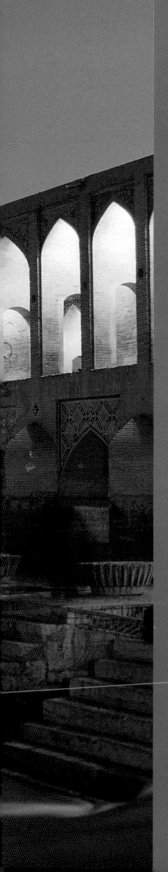

THREE

BRIDGES OF
PARADISE

MY FIRST JOURNEY TO ISFAHAN WAS IN SEPTEMBER 2004. I was in Iran making a series for BBC television called *Around the World in* 80 *Treasures* and I wanted to see a city long famed for its culture and architectural beauty. In 1597 Shah Abbas the Great (1571–1629) – since 1587 the ruler of the Safavid Persian empire – declared Isfahan his capital, and in the early years of the seventeenth century set about transforming an ancient and humdrum trading city into an evocation of paradise on earth. In particular I wanted see the city's central square – conceived as a verdant and well-watered paradise garden – and the mosques, markets and palaces gathered around it. I also wanted to see the city's bridges – the great emblems of Isfahan as a place of rivers, water and plenty in a vast region of desert and desiccation. In Shah Abbas's time Isfahan was a place of power, of milk and honey, a jewel-like oasis of sophistication and beauty set in a troubled, much fought-over and arid land. I wanted to see what survived.

I well remember my arrival. Much of the fabric of the city was ancient: mud-coloured courtyard houses, some with small domes and chimney-like air-scoops. But also much of the humble traditional architecture was being demolished – progress was on the march, sensible and beautiful mud-brick buildings being swept away for bland, predictable and placeless reinforced-concrete framed constructions clad with strident

PREVIOUS: The Bridge of Khaju in Isfahan, Iran was built in 1650 as part of Shah Abbas's late sixteenth century vision of Isfahan as a verdant paradise on earth. The bridge, a river crossing, a delightful promenade and shady place of rest for travellers is also part of the city's vital and complex irrigation system.

modern details. But then, suddenly, I turned a corner and was confronted by one of the greatest, most breathtaking, urban spaces on earth. A mighty oblong – 500 metres long and a third as wide – of exquisite gardens and water basins, framed by low arcaded buildings of sophisticated and simple design. This is the Maydan-i Imam (or Eman Khomeini Square but originally the Maydan-i Shah or Royal Square), the heart of Shah Abbas's city.

The proportion of the Maydan is a clue to its meaning, indeed to the meaning of Isfahan. Three to one is a key proportion found in the biblical descriptions of Solomon's Temple in Jerusalem, a structure sacred to Jew, Christian and Muslim. Supposedly built around 3,000 years ago, the Temple was executed by masons following instructions issued by God. It was believed to be the origin of architecture and beauty, and functioned as God's inspirational house on earth. When it was new the Temple contained – in its cubical Holy of Holies – the massively spiritually-charged Ark of the Covenant that had been wrought under God's instruction in the Sinai to serve as his earthly throne and to hold the Tablets of the Law that had been given to Moses. These, clearly, are the associations Shah Abbas was invoking. His city was the new Jerusalem, his Maydan the courtyard of the new Temple and he – in his strength and wisdom – the Solomon of his age.

I remember thinking that the Maydan did look like an earthly paradise, with its beauty, sense of calm order, verdant planting, and shimmering sheets of water. But Shah Abbas intended the Maydan, started in 1611, to convey other messages. It was to be a meeting place of worlds, a microcosm of his empire. At its northern end, set centrally among the arcades, is a tall gate leading to the Great Bazaar and the realm of commerce, of the material, of man. On the west side, the low arcades are punctuated by a tall, columned pavilion that leads to the Palace of Ali Qapu and the centre of royal power. On the east and west are two of the most stunning mosques ever made. The Shaykh Lutf Allah Mosque on the east is small and jewel-like, while the Mosque of the Imam to the south,

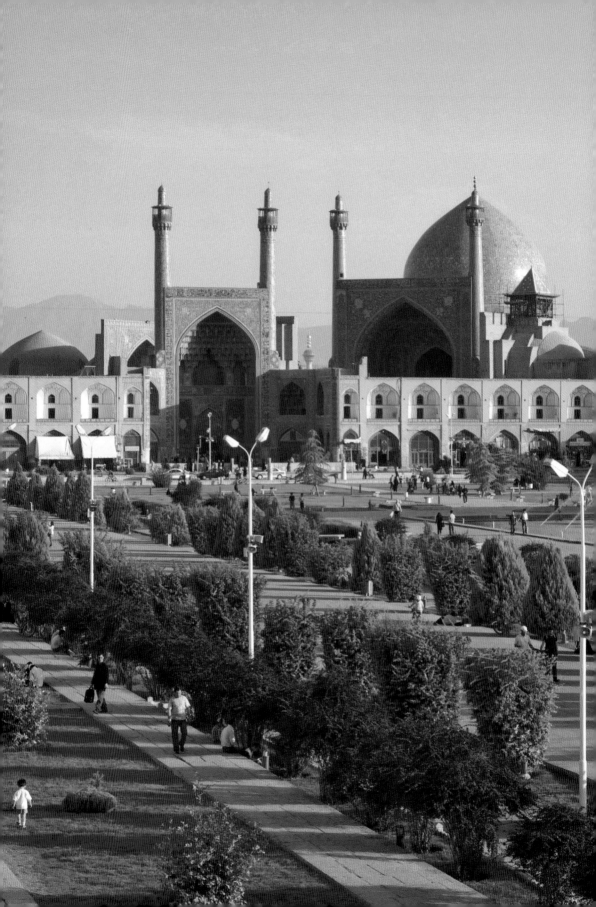

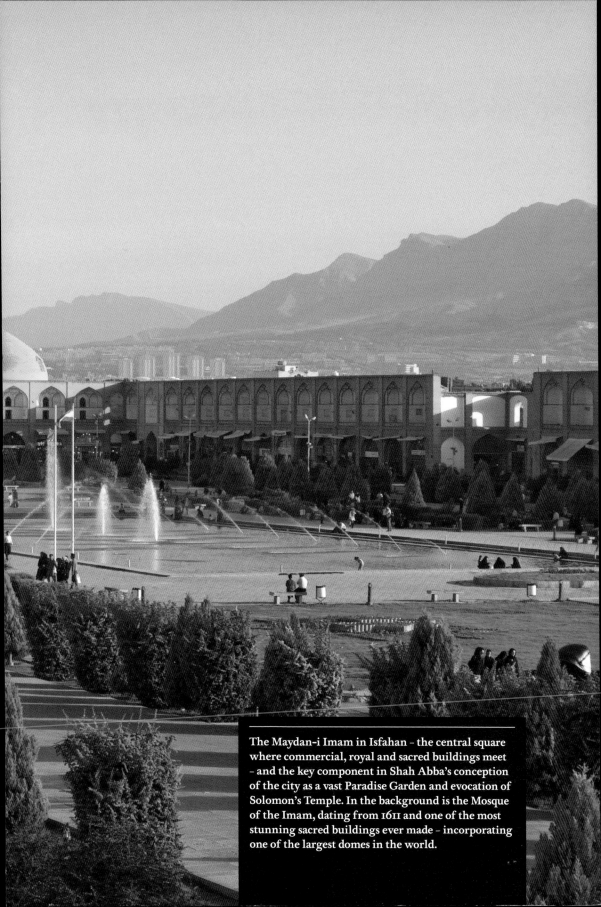

The Maydan-i Imam in Isfahan – the central square where commercial, royal and sacred buildings meet – and the key component in Shah Abba's conception of the city as a vast Paradise Garden and evocation of Solomon's Temple. In the background is the Mosque of the Imam, dating from 1611 and one of the most stunning sacred buildings ever made – incorporating one of the largest domes in the world.

entered through a gate that is the heavenly equivalent of the merchants' gate which it faces across the Maydan, is expansive and capped by one of the largest domes in the world. The Mosque of the Imam must have been intended to correspond with the Holy of Holies in Solomon's Temple in Jerusalem, the place where God abounds and sacred power rules. As with Lutf Allah Mosque, the geometry of the plan of the Mosque of the Imam contrasts with that of the Maydan and the grid-plan of the old city. You experience this difference the moment you cross the threshold from the world of man to the world of God. The plan of each mosque is diagonal to the grid of the city, for the main axis of each mosque is orientated not to man's creation but towards the sacred shrine in Mecca, towards the great stone within the Ku'ba that, Muslims believe, is the gift of God to Abraham and the repository of unfathomable spiritual knowledge and power.

The evocation of Solomon's Temple, combined with images of the gardens of paradise, makes Isfahan a spellbinding place that is a window into the very essence of Islamic belief and religious imagery. The paradise garden – with the rest, delight and beauty it offered to the faithful and the righteous – is one of the strong and recurring images of the Koran. And central to this image is water – synonymous with life and bounty in the arid land in which the Koran first appeared in the early seventh century. In a region of heat and sand, of parched landscapes and stunted vegetation, lush and fertile gardens and plentiful water were indeed the stuff of dreams. And where there is water, gardens and people, there must be bridges. So to the Islamic mind, bridges are one of the prerequisites of paradise.

The Prophet Muhammad, revealing what he claimed to be the direct words of God as he dictated the text of the Koran, was very precise when it came to the description of paradise. The *Book of Genesis* in the Old Testament, written perhaps 3,000 year ago, reinforced an ancient Middle and Near Eastern image of paradise when it described the Garden of Eden, one of the earliest evocations of paradise:

'And the LORD God planted a garden eastward in Eden: and there he put the man whom he had formed. And out of

RIGHT: Exquisite tile-clad entrance to the Shaykh Lutf Allah Mosque of 1617 on the Maydan-i Imam. The calligraphic tile-work proclaiming sacred texts on the drum of the dome, and the floral patterning, all reinforce the sense of the city as an Islamic Paradise Garden, a man-made homage to Divine beauty.

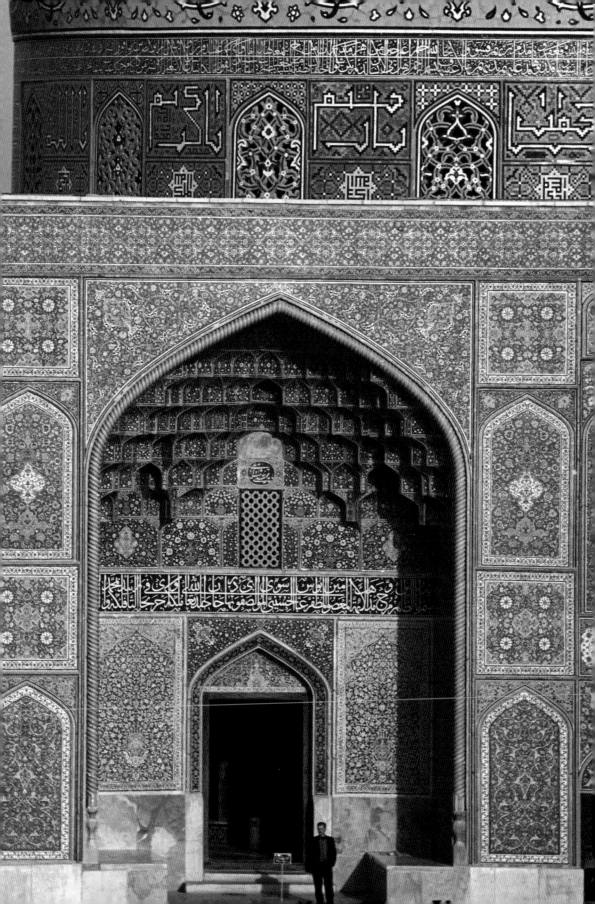

the ground made the LORD God to grow every tree that is
pleasant to the sight, and good for food; the tree of life also
in the midst of the garden, and the tree of knowledge of
good and evil. And a river went out of Eden to water the
garden; and from thence it was parted, and became into
four heads. The name of the first is Pison: that is it which
compasseth the whole land of Havilah, where there is gold;
And the gold of that land is good: there is bdellium and the
onyx stone. And the name of the second river is Gihon: the
same is it that compasseth the whole land of Ethiopia. And
the name of the third river is Hiddekel: that is it which goeth
toward the east of Assyria. And the fourth river is Euphrates.
And the LORD God took the man, and put him into the
garden of Eden to dress it and to keep it. And the LORD God
commanded the man, saying: 'Of every tree of the garden
thou mayest freely eat; But of the tree of the knowledge
of good and evil, thou shalt not eat of it; for in the day
that thou eatest thereof thou shalt surely die.'
(Genesis 2: 8-17).

This description was perhaps inspired by the verdant
landscape around the junction of the Tigris and the Euphrates
rivers just north of Basra in modern Iraq. Anciently the
Greeks had termed this Mesopotamia – the 'land between
the rivers' – and it was famed as a place of green and plenty
in a region of desert. The Koran embraces aspects of the Old
and New Testaments and so the numerous descriptions of
paradise within its pages develop this Old Testament prototype
and provide a blueprint for the creation of Islamic paradise
gardens and, as with Isfahan, paradise cities and paradise
bridges. Water, and the life and comfort it brings, is the
central virtue, along with harmony and balance suggested by
symmetry and primary geometry. 'Gardens underneath which
rivers flow' is frequently used to describe the blissful abode of
the faithful, and occurs more than thirty times throughout
the Koran.[41] And the Koran proclaims: 'Peace be to you [who]
have led good lives. Enter paradise and dwell in it forever'.
(Sura 39, verse 73). The words of the Koran, passed from
God to Muhammad by the archangel Gabriel, dictate how

Muslims should lead their lives, and the well-watered and shady garden is the ultimate reward. For 'those who fear God' proclaims the Koran, 'a garden refreshed with flowing water [where] the foods of its fruits are never ending and its shade is permanent'. (Sura 12, verse 3).

Picking up the imagery of the *Book of Genesis*, the Koran confirms that there are four main rivers in paradise: one of water, one of wine, one of milk and one of purified honey. This is the origin of the familiar Muslim quartered garden, in Persian *chahar bagh* or 'four gardens', each divided by four water channels and usually contained within an exclusive walled enclosure. This must also be the origin of the ancient ideal of dividing sacred cities into four quarters within their protecting walls. For example the Old City of Jerusalem was, and still is, divided into four quarters – the Muslim, Jewish, Christian and the Armenian quarters. The Koran also reveals, in its 108th Sura, that paradise contains a pool or fountain into which its celestial water gathers. Named al-Kawthar (the fountain of abundance), it is the source of immortality, for all in paradise who drink from it on Yaum al-Qiyamah (Judgement Day) will never hunger or thirst again.

So in the mind of Muslims, paradise had four quarters defined by rivers, shady well-planted groves, and an abundance of fruit trees. It also possessed ornamental architecture such as fountains and pavilions where the just could take their pleasure and repose. Everything here was harmonious and orderly: in its beauty and bounty, a reflection of the nature of God. It was in this spirit, to realize this vision, that Shah Abbas created Isfahan.

But as well as being a prayer and an evocation of paradise on earth, Shah Abbas's Isfahan was also a place in which to express worldly power. He wanted the city to impress foreign ambassadors, to house merchants, factories and craftsmen and – of great importance at the time – the vastly expanded city was to help hold together the sprawling empire. Built within a natural oasis set between the mountains and the desert, Isfahan was not only a natural halting place for merchants' caravans, but also a place of great strategic

'Shah Abbas settled his court in 1598 and
work on the paradise city started in earnest.
Within 50 years it had become the most
beautiful planned city in the Islamic world.'

potential. Its site stood in a commanding position halfway
between the key theatres of military operations: in
Mesopotamia against the Ottoman Turks and in Azerbaijan
against the Uzbeks.[42]

The fertility of the plain on which Isfahan sits had
been enhanced long before Shah Abbas's time through an
extensive system of irrigation. Indeed, the technical ability to
execute large and complex schemes of irrigation is one of the
key reasons why 5,000 years ago the region of Mesopotamia
became the 'cradle of civilization'. Lying at the foot of the
Zagros mountains, the plain of Isfahan was naturally well-
watered by the river Zayandeh ('the life-giving river') but
over time it was gradually improved by man's intervention.
Consequently, by the late sixteenth century, the old trading
city and oasis of Isfahan had six principal sets of canals or
irrigation waterways, with many secondary waterways
serving villages and farms for several hundred square
kilometres around.

When Shah Abbas settled his court in Isfahan in 1598,
work to create the paradise city started in earnest, and within
50 years it had become the most beautiful planned city in
the Islamic world. The new city was designed around the
Maydan-i-Imam with the long, wide and straight Chahar
Bagh Avenue (the 'Avenue of the Four Gardens') as its spine,
which led to the Zayandeh Rud, or river, and – via the early
seventeenth century Bridge of Allahverdi Khan – to the royal
garden of the Hezar Jerib, or the 'Thousand Acres'.

Within this new city, Abbas settled a community of industrious Christian Armenians and granted them complete religious toleration and municipal autonomy. He also encouraged the presence of Dutch and English commercial agents and so developed a trade with Europe that was mutually beneficial – economically and culturally – for both east and west. Abbas was particularly successful in promoting Persia's export of silk and carpets. Indeed it is from Shah Abbas's time that Persian carpets, once the rare and prized possession of European royal households and the very rich, became more commonly available. So Shah Abbas was, himself, a bridge – a connection between different cultures, between east and west, between the material world of trade and the spiritual world of faith – and his city, despite being placed in the centre of an arid land, had a garden at its heart and was furnished with waterways and bridges. So the bridge in Isfahan is a very special thing, an emblem both of the city and of its creator.

In fact Isfahan contains three important early bridges, and this number is probably not just a result of practical demands. In Islam three is a very significant number, for it is thought to display resolve and determination. Many important things, such as ablutions before prayers, are done three times, and sand or earth is thrown on a grave three times. One of the Hadiths states that God loves odd numbers, so three bridges probably has a powerful symbolic significance. Not all the bridges were completed during Shah Abbas's lifetime, although all were probably conceived by him, and certainly all form part of his visionary city.

The bridge that was completed in his lifetime is the Bridge of Allahverdi Khan that crosses the Zayandeh Rub (river) as a continuation of the Chahar Bagh, the principle street of the city. Named after the general who was in charge of its construction, it's also called the Bridge of Thirty-Three Arches (or Si-O-Se Pol). It is 14 metres wide and 160 metres long. The second bridge – Bridge of the Khaju (or Pole-i-Khaju) – was built in 1650 by Shah Abbas II, while the 146-metre-long third bridge – the Bridge of the Canal

(or Pol-i-Chubi) – was built in 1665. Of these bridges it is the second – the Bridge of Khaju – that is the most remarkable and memorable.

All three bridges were intended to delight as gates of entry to the paradise city, places of refuge and welcome to caravans of pilgrims and merchants that had toiled across the surrounding hostile land. None are fortified in any serious way, and from the start they were intended to be inhabited, with the Bridge of Allahverdi Khan incorporating a tea room within its arches.

When I first came upon the Bridge of Khaju, located on the old Shiraz road, I felt a delight no doubt akin to that experienced by weary travellers when they first saw it 350 years ago. It was clearly not only a bridge – a place

BELOW: The Bridge of Allahverdi Khan was started in 1602 and named after the general responsible for its construction. He had been born a Christian in Georgia, was captured by Shah Abba's armies and after converting to Islam rose high in the service of the Shah. This serene bridge, enriching the life of Isfahan, is his eternal monument.

of communication – but also a centre of communal life. Attracted, perhaps, by its architectural beauty and sense of quiet repose, as well as by its shady arches and cool water, the bridge was thronged with people, a hub of city life. They sat on it, in it and around it, talking, drinking coffee and smoking shishas. I joined them, a welcome new member of the community, and contemplated the structure before me.

The bridge is not a heroic piece of engineered construction. Here there are no Herculean arches of vast and terrifying span, no extraordinary use of materials. This bridge is not intended to astonish but to delight. It's an easy and level continuation of the roads on either side, with its straight 133-metre (436-foot) long road carried on twenty-three masonry-built arches. The arches are narrow in width

and topped by low, four-centred pointed arches of the form then favoured in the Islamic world. So no structural gymnastics. There did not have to be. The bridge did not have to leap high, with wide and clear spans, to allow high-masted ships to navigate the waters. Far from it. This bridge, like the others in Isfahan, was intended to be part of the city's carefully designed and controlled irrigation system. So as well as being a water crossing, it is also a dam, with sluice gates set between the arches so that water can, when required, be gathered upstream to fill the large reservoirs required to help feed the watercourse and irrigate the plants in Isfahan's paradise gardens.

This functional role of dam and sluice was turned to maximum ornamental effect. The piers between which the pointed arches turn are set on a terrace that stands above the level of the river downstream of the bridge. This terrace is connected to the lower water level by a series of steps, each placed so that as the water rushes through the bridge's arches, it cascades and flashes as it tumbles downstream. When the sluice gates are closed (or almost closed) and when water trickles through the bridge at a very low level, it is possible to stroll along the terrace, to sit on the steps, and even to wander through the brick-vaulted passageways within the bridge and beneath the roadway.

When I visited the bridge the water level was low, and I was able to explore its structure, penetrating this cool, damp, almost subterranean, aquatic world, created in a virtual desert terrain. It was impressive – particularly the vista within the passageways below the road. Here it was possible to see the full length of the bridge, the view framed, and apparently extended, by the rhythmic series of pointed arches that form the bridge's primary structure. As I looked, people wandered in and out, enjoying the cool, sitting on the stout horizontal stone walls that define the water course within the bridge and also brace the piers from which the pointed arches spring. It was a beautiful sight: simple, dignified and appropriately-engineered architecture, doing its functional job well and, in the process, creating a place to be inhabited and enjoyed by generations of people.

RIGHT: The Bridge of the Allahverdi Khan, a thing of beauty and a tranquil haven at sunset that encapsulates the civilised virtues of the court of Shah Abbas.

The arch-supported carriageway of the bridge supports another lighter, and more delicate, arcade. This is the way with the Isfahan bridges. These upper arches are also four-centred and pointed, but higher, and each arch is half the width of those below and more slight in construction. So the overall impression given is of the bridge becoming more ethereal, and more heavenly, as it rises from the turbulence of the primordial waters. As with the earlier Allahverdi Khan bridge, these arcades stand in front of solid screen walls, but the spurs of wall linking arches to screen are pierced by low, segment-headed openings which create yet more, alternative vistas along the bridge.

The elegant and rational structure of the bridge is its greatest ornament, its greatest intellectual pleasure. But it has other ornaments. These are perhaps more superficial and certainly less functionally necessary, but they help give the bridge a meaning beyond its functional excellence and, in a sense, transform it from a brilliant and practical structure into a work of poetic sacred architecture. The spandrels of both tiers of arches are ornamented with exquisite tiles. These are visually beautiful but they also carry a specific spiritual message. The Koran warns repeatedly against the tempting evils of idolatry, of the human weakness to create representations of God and then to worship them. And so, from the earliest days of Islam, the creation of images of any living beings was discouraged, just in case this might lead to idolatry. Instead of showing images of humans or animals, Islamic artists focused on portrayals of plants, since such motifs not only evoked admirable ideas of paradise and its gardens but also could have analogous meanings. For example, in the fifteenth-century Ottoman empire, the image of the tulip represented Allah, since the calligraphic representation of the names of both were nearly identical. And so, on the Bridge of Khaju, the tiles show both the abstract geometric patterns common in Islamic art and stylized plants, proclamations of this bridge's role in the earthly paradise of Isfahan.

Another connection with the paradise garden is the bridge's six pavilions or kiosks – three on either side. The

LEFT: Detail of the Bridge of Khaju showing construction of stone and mellow brick with tiles of paradise plants embellishing the spandrels of the low, four-centred (or pseudo four-centred) pointed arches.

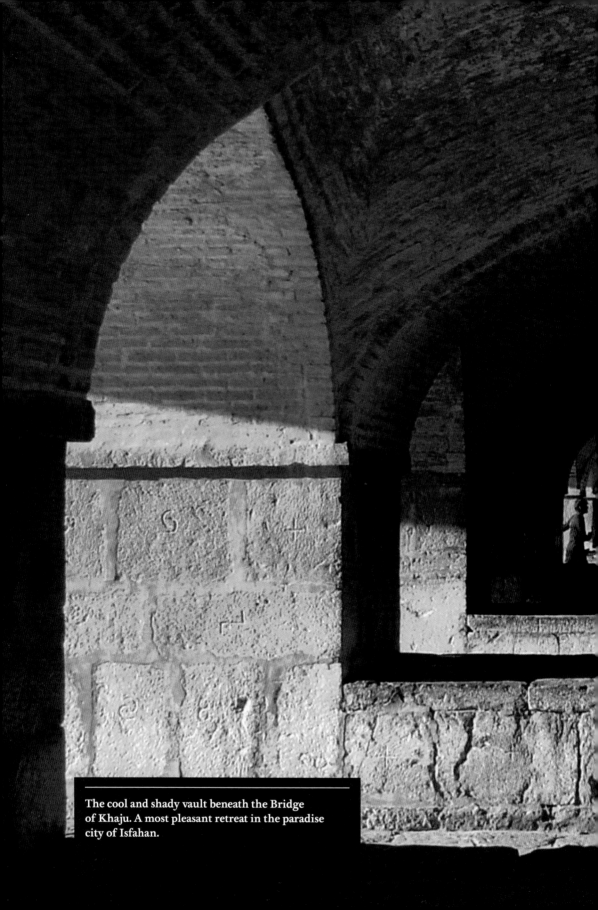

The cool and shady vault beneath the Bridge
of Khaju. A most pleasant retreat in the paradise
city of Isfahan.

largest two pavilions sit in the middle, with the remaining four kiosks placed at each end. The kiosks at the ends could function as watch-towers, defensive gates or caravanserai to offer immediate shade and refreshment to arriving merchants and travellers. The pavilions in the centre are called the Princes' Parlours and these provide beautiful platforms from which the prospects of the river and the paradise city can be viewed. But they also ensure that the bridge itself can be seen from the city and that its architecture plays a tangible role in the design of Isfahan's series of gardens.

In Islam, the paradise garden is not only an earthly model of the celestial paradise. Since its form and meaning was ordained by God through the text of the Koran, the paradise garden can be experienced as something more than a thing of divine origin and inspiration. It can also be seen as a microcosm of God's great creation, with its geometric design representing the forces of nature. Within this conception the garden's material aspects – its buildings, paths and planting – defined the abstract world of space, volume and direction. Structures placed within the centre of the garden, or at intersections of paths or roads, were perceived to generate an outward-thrusting or centrifugal force, while those on the perimeter of the man-made paradise, such as the pavilions on the Khaju Bridge, contained the outward thrust of energy and were thought, in turn, to create an inner-thrusting or centripetal force. So the paradise garden would be dynamic, and in a sense, breathe, with all working in harmony.[43]

It is also important to remember that in an Islamic paradise garden or city it was the space between material objects that was important. Tangible buildings may appear more important, but this is only so to the material-minded. It is the space they define that is thought to be charged with power, for space is the realm of God's existence. This emphasis in paradise gardens on the non-material is expressed in most poetic manner in the New Testament (a text used selectively by the Koran), where it is made clear that it is not the seen but the unseen world that is sacred. God dwells not in the material world but in the intangible – in light and colour,

RIGHT: A detail of 17th century tiles from a spandrel of one of the arches of the Bridge of Khaju – a beautiful image of the sacred flowers of the gardens of Paradise.

in proportion and volume: 'Look not at the things which are seen, but at the things which are not seen: for the things which are seen are temporal; but the things which are not seen, are eternal', (2 Corinthians 4:18). So the bridge and its pavilions must have been seen as playing an essential role in the function of the paradise city: terminating a vista, marking an important place like a star in the firmament.

I inspected the main bridges in Isfahan and at the Allahverdi Khan bridge I seated myself among the throng and enjoyed a Sisha. This bridge is a relatively simple affair, consisting of two tiers of stone arcades spanning the river. But it was to the Bridge of Khaju that I was drawn at the end of the day, to see dusk descending over the paradise city. I sat within one of its central pavilions, its interior enlivened by freshly-restored murals, and pondered the fate that befell Isfahan. Shah Abbas's vision of paradise survived – in its power and glory – for little more than a century.

After his death in 1629, later members of the Safavid dynasty sustained his vision of paradise on earth as the Bridge of Khaju attests. But it met a horrible end in the early eighteenth century when the region was invaded by Afghans from the northeast, and this sophisticated and beautiful paradise city suffered the hell of a brutal siege followed by savage massacre that resulted in whole districts of the city being obliterated. The anarchy that engulfed the Safavid Empire permitted encroachments into its territories by both Russians and Ottomans. The dissolution was halted – and

then reversed – by the genius of the military commander Nader Shah who, in 1736, usurped the Safavids and eventually extended the borders of his Persian empire into the Caucasus, Afghanistan and what is now Pakistan. He did not make the slighted Isfahan his capital but instead chose Meshed.

Nader Shah's assassination in 1747 and the rapid disintegration of his empire, impoverished by years of war, sealed the sad fate of Isfahan. This paradise was indeed lost, with visitors in the early nineteenth century reflecting on its mythic past and decayed splendour, its melancholic ruins inhabited by jackals and foxes. In these circumstances it is amazing that the city's seventeenth-century bridges survive – testimonies to the aspirations and achievements of Isfahan's Golden Age.

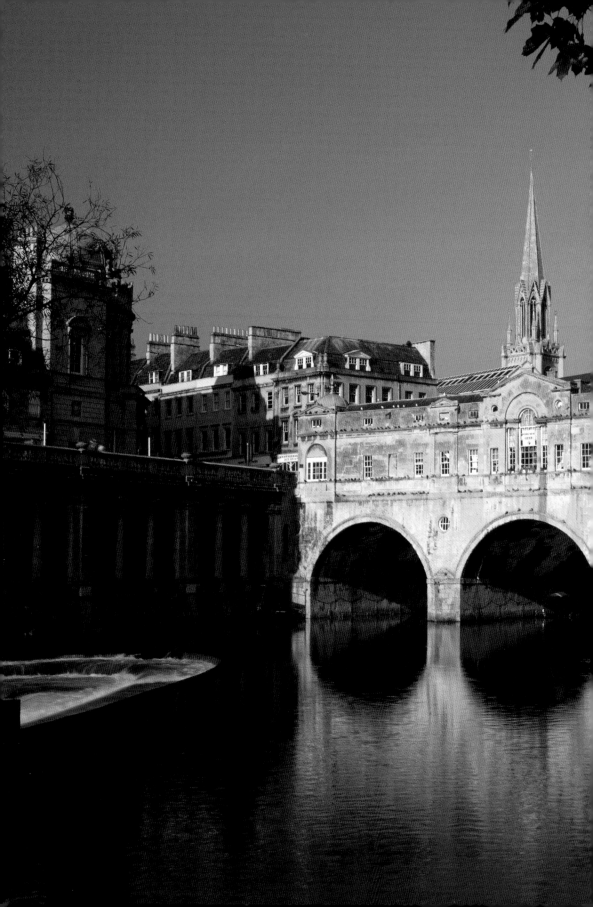

FOUR

INHABITED
BRIDGES

AS LONG AS BRIDGES HAVE BEEN BUILT THERE HAS been the desire to inhabit them. They have been the locations of shrines, chapels and fortifications but also of houses, shops and factories. Bridges are, after all, tempting slices of man-made real estate, perched conveniently over running water.

The great example is London Bridge, burned into popular imagination by the catastrophe of the Great Fire of 1666. It was constructed first out of timber on piled foundations in AD 55 by Roman engineers, then rebuilt on numerous occasions in timber, and from 1176 in stone – a mighty work that was as much an act of veneration to God as a functional structure (see page 148). From this time onwards London Bridge developed a history peculiar to itself. It had its own identity, trades, urban customs, and, with gates at either end, was a secure and self-contained town within the City. Indeed it had its own particular purpose, forming the gate into London from the south and the gate out of London for those heading south to the channel ports and the wider world. It was both functional and ritualistic in purpose. Roving armies wishing London no good could be blocked by the bridge and its southern gatehouse could display the heads of traitors, offering dire warning to all who thronged along its roadway.

The design and construction of the twelfth-century bridge was organized through a monastic guild, established

PREVIOUS: The Pulteney Bridge, Bath, England, completed in 1769, was inspired by Andrea Palladio's design of the mid sixteenth century for the Rialto Bridge in Venice.

by Henry II in 1163. Money was raised, in part, through the sale of indulgences. The man put in charge of the work was Peter de Colechurch, the 'Warden of the Brethren of the Bridge', who in 1173 proposed replacing the timber bridge, last rebuilt in 1136, with a more commodious and permanent work in stone that would honour the King, the City and God.

It would also cater for the pilgrims en route to Canterbury, most of whom were members of the immensely popular cult of the recently martyred and canonized Archbishop Thomas Becket. Becket was a determined defender of the rights and privileges of the Catholic Church from royal interference. His death in 1170 was provoked by the anger and exasperated utterances of King Henry who, by tradition, is said to have raged from his sickbed asking, 'Will no one rid me of this turbulent priest?'. Four knights present took this to be more than a rhetorical question and promptly set off for Canterbury, where they slew the cleric in his own cathedral. The construction of the new bridge – a key part of the pilgrim's route to Becket's shrine in Canterbury – was perhaps part of Henry's act of contrition and penance for his role in the death. It was also a sound business proposition because in the Middle Ages pilgrimage was big business, with much money spent en route on food, lodgings, trinkets and tolls. Pilgrimage was heavily encouraged within the country for the good of the national economy, helping money circulate and even attracting wealth from abroad.

The importance of the cult of Thomas Becket for the rebuilt London Bridge – completed in 1209 with nineteen narrow arches and a defensive gatehouse and drawbridge – is demonstrated by the fact that it incorporated a pilgrimage chapel at its centre, dedicated to the new saint. St Thomas's Chapel soon became one of the great sacred structures of the City. Larger than many a parish church, it could be approached by means of the bridge or by water through a river-level entrance. Water was central to Christian worship: the water of baptism washes away sins, Christ had been a fisher of men's souls and the fish – Pisces – the image of the early Christian Church. So it was only natural that this chapel – dedicated to

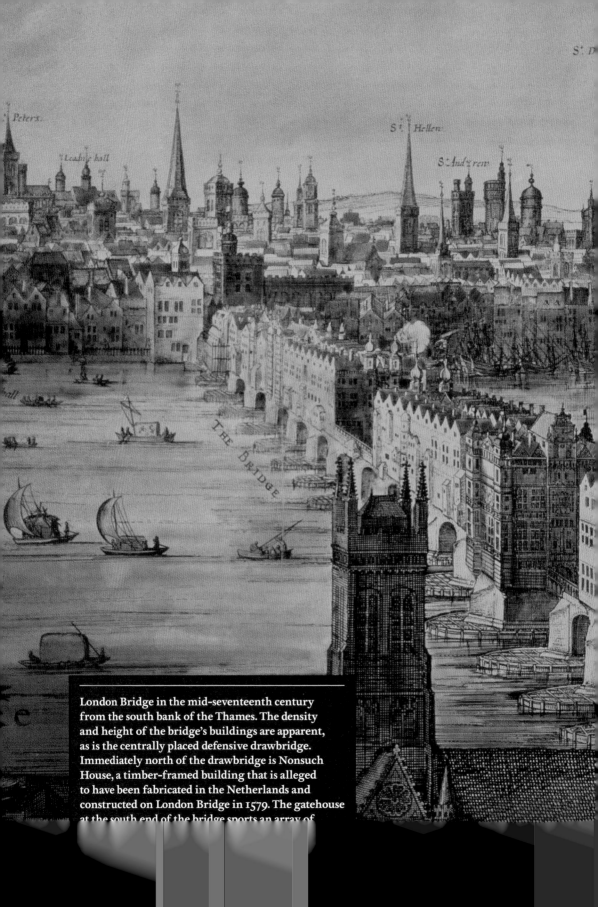

St. Peters.

Leaden hall

St. Hellen

St. Andrew

St. D

THE BRIDGE

London Bridge in the mid-seventeenth century from the south bank of the Thames. The density and height of the bridge's buildings are apparent, as is the centrally placed defensive drawbridge. Immediately north of the drawbridge is Nonsuch House, a timber-framed building that is alleged to have been fabricated in the Netherlands and constructed on London Bridge in 1579. The gatehouse at the south end of the bridge sports an array of

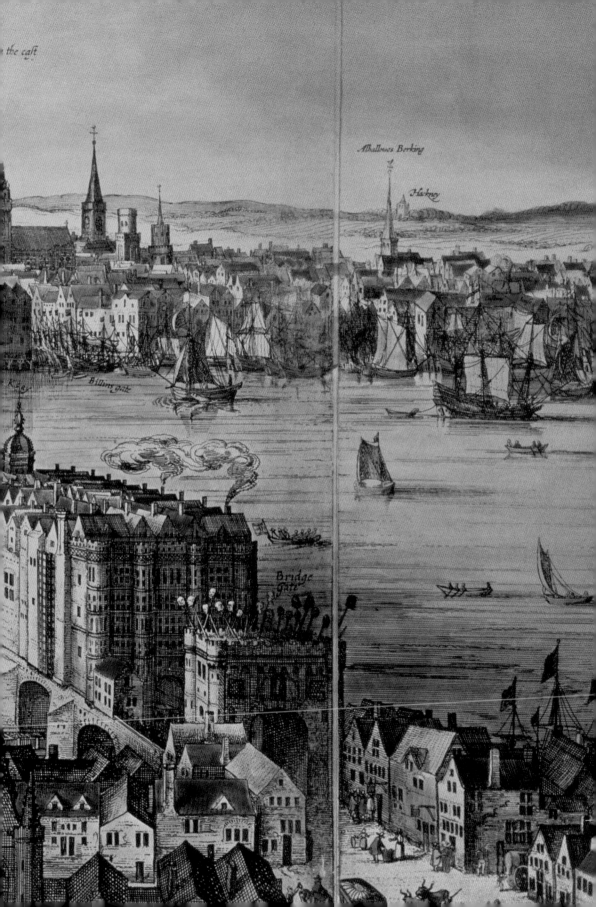

the eaft

Alhallroes Berking

Hackney

Billingate

Kay

Bridge gate

England's own new saint – should be entered from the
water and cater for the fishermen of the River Thames.

The bridge needed to do something special for these men
whose world it had transformed. The wide piers and barrow
arches of the bridge acted like a dam, slowing water and
creating dangerously strong currents. Only the brave, foolish
or very skilful would attempt to 'shoot the bridge', which
effectively severed water-borne intercourse between the
Pool of London and Thames-side village to the east, with
the City upstream of the bridge.

The bridge also transformed the nature of the Thames
near the City and, by doing so, changed life itself in London.
By slowing down the water flow it encouraged the Thames to
widen and become shallower at its peripheries, and to freeze in
winter. Thus the bridge gave rise to the City's famed Frost Fairs
when, for a few brief weeks most winters, Londoners inhabited
the surface of the frozen Thames.

During the reign of King John, from 1199 to 1216, money
was made directly from and for the bridge – essential for its
regular maintenance – by granting licences for the construction
upon it of houses and shops. Building upon the bridge became
a great money-maker for the City's Bridge House Estate,
which from its foundation in 1284 grew vastly wealthy over
the centuries from revenues and rents. With dense rows of tall
houses – many of prodigious design cantilevering far out over
the swirling waters – London Bridge also entered the realm
of myth and lore as the world's greatest inhabited bridge.

Of course, its place in the popular imagination remains
well-secured by the famous nursery rhyme 'London Bridge
is falling down', although the origins and meaning of the
song remain obscure. But Old London Bridge is long gone:
its buildings finally removed following an Act of Parliament
of 1756. Its remaining medieval masonry arches were
demolished in 1831, after the completion alongside it of the
new and superlative granite-built five-arched London Bridge,
designed in the mid-1820s by the great engineer, John Rennie.
This bridge has in turn been demolished, with its stones sold
in 1968 for re-erection in the newly founded Lake Havasu

City, Arizona, USA. In its place was built a most utilitarian structure, of pre-stressed concrete box-girder construction, that is essentially 260 metres of soulless five-lane motorway set between bottlenecks on each bank of the river. It now takes a supreme act of the imagination to stand on the east side of the existing London Bridge, among the roar of traffic, and conjure up an image of the tottering towers of the high timber-built buildings of Old London Bridge that, for over 600 years, stood and bustled just metres away. Some evenings, when you think of all the lives lived over the centuries in what is now just space, you cannot help but sense that somewhere here the ghost of the old bridge hovers, just out of reach.

What an astonishing sight it must have been. It is still hard not to bitterly regret its passing and to make do only with ancient images and an inflamed imagination. Old London Bridge now inhabits a world set between fact and fiction and it is almost impossible for us to tell one from the other. Not least because nothing quite like old London Bridge survives in the world, we have nothing to even infer what the experience of passing over it would have been like – the noise, sounds, smells, sights – the congestion. On bad days, when the whole world seemed to be trying to cross it, the short journey could take over an hour.

Sadly, ancient inhabited bridges have not fared well. In Europe all significant examples in France, Germany and Spain have long gone. Only in Italy is it possible to see inhabited bridges of some scale, quality and antiquity. The two notable survivors are the famed Ponte Vecchio in Florence and the Rialto Bridge in Venice.

The Ponte Vecchio surely possesses only a shadow of the splendour, and certainly the scale, of Old London Bridge. Nevertheless, it is a remarkable thing. It was built around 1345, perhaps to the designs of the painter Taddeo Gaddi, and crosses the River Arno with three handsome segmental arches – the widest of which has a span of 30 metres and the others 27 metres each.

The segmental arch was very unusual in European bridges in the Middle Ages, although familiar in China from at least

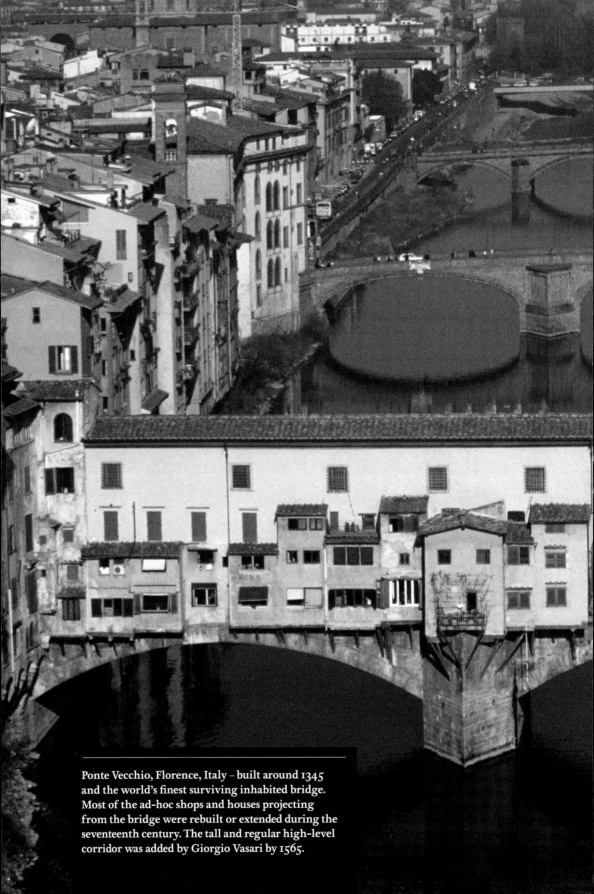

Ponte Vecchio, Florence, Italy – built around 1345 and the world's finest surviving inhabited bridge. Most of the ad-hoc shops and houses projecting from the bridge were rebuilt or extended during the seventeenth century. The tall and regular high-level corridor was added by Giorgio Vasari by 1565.

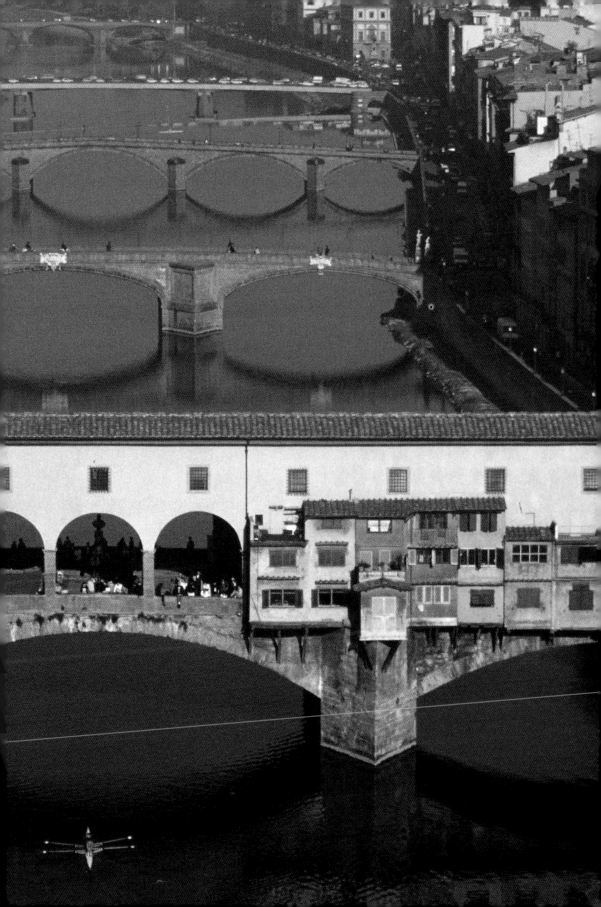

'Although the term 'bankrupt' may not have actually originated on the Ponte Vecchio – it could well have come into common currency due to the ups and downs of financial life on the bridge.'

the late AD sixth century as revealed by the remarkable stone and iron-built shallow arch of the Zhaozhou Bridge in Hebei province with a span of 37.3 metres (see page 10). In medieval European masonry bridges arches were generally either pointed, as at the early fourteenth-century Pont de Valentré, Cahors, France (see page 105) or of semi-circular form in the Roman manner. The advantage of wide segmental arches was obvious – a river could be bridged using fewer piers – but the technology and the theory was untested. So the bridge in Florence was brave and pioneering work.

From the start this novel arched structure supported multi-storey shops and houses that define a small piazza at the centre of the bridge, from which shopkeepers or travellers could enjoy the river view. From the mid-fifteenth century butchers mostly inhabited the shops, but proving a smelly and offensive trade to many of the grandees using the bridge, their occupation was stopped by decree in 1593 by the ruling Medici. With the butchers removed, the bridge was colonized by goldsmiths and jewellers, who still dominate its commercial activity. The floor area and number of shops also changed, mostly in the seventeenth century, when accommodation was extended towards the Arno, giving the bridge its characteristic, ad-hoc river elevations, with rooms jettied-out over the water and supported on struts.

The other major addition was the spacious corridor that runs straight, tall and true above the upper stories of the shops

on the east side of the bridge and that crowns a handsome three bay central loggia. This corridor – a somewhat strange and unlikely addition to the bridge – was added in 1565 by Giorgio Vasari on the orders of Grand Duke Cosimo de Medici to give him easy and secure communication between the Palazzo Vecchio and Uffizi on one side of the Arno, and the Palazzo Pitti on the other.

As with all inhabited bridges, myths and tales abound around the Ponte Vecchio. It seems that living and working over flowing water is more than human fancy can endure. Inhabited bridges become not just links between places – vital parts in mundane highways – but, more than any other type of bridge, they become links between the worlds of hard fact and fanciful imagination, between reality and fantasy, between the world as it is and – if history had a heart – as it should be.

The most curious story about the Ponte Vecchio is that the name – if not the notion – of bankruptcy was invented here. A merchant traded on the bridge by displaying his wares on tables – called *banco* – and if he could not pay his debts his *banco* was smashed – *rotto* – so that as an insolvent he could no longer trade, and perhaps lead others into financial difficulties. A merchant so dealt with was termed *bancorotto* or in Latin *bancus ruptus*. It's a nice story and even possibly true, but of course there are contesting claims for the origin of the term – including *bancarotta*, meaning broken bank. But perhaps there is no conflict between these claims. The modern concept of banking started in Renaissance Italy and presumably goldsmiths-cum-bankers did business from *banco* erected on the Ponte Vecchio, and no doubt numbers of them failed from time-to-time resulting in their places of business and symbols of office being ignominiously smashed. Although the term 'bankrupt' may not have actually originated on the Ponte Vecchio – since goldsmiths had not been in residence before the 1590s – it could well have come into common currency due to the ups and downs of financial life on the bridge.

Regardless of what did or didn't take place on the Ponte Vecchio during the financially experimental and volatile

Renaissance, what is certain is that the legal concept of bankruptcy spread from Italy to the rest of Europe. Tudor England, where trade and the merchant class were flourishing, seems to have been particularly receptive. The years in England immediately following the Reformation of the mid-1530s were a time of dramatic – almost revolutionary – social change, characterized by a welter of new laws. For example, legislation was used for the first time to curb those sexual activities that the newly established Protestant Church was not prepared to tolerate and which, as with life in Sodom of old, were deemed 'unnatural' and a dangerously provocative insult to God that might well invite divine retribution. Duly, a law of 1533 made sodomy a capital crime and thus put at risk the lives not only of homosexuals but of all whose lives led them to indulge in sex that a staid or perhaps puritanical cleric, judge or jury could deem 'unnatural'. It was a rum state of affairs for a country whose monarch was a serial bride-groom, given to the occasional bout of wife-slaughter. A few years after this anti-sodomy law came into being another was enacted – perhaps in the same moralising mood – that came down hard on bankrupt businessmen, who from 1542 could have their assets seized by their creditors. The modern financial world had arrived in England where it simply would no longer do for a trader not to be able to pay his debts on the nail.

While the role of the Ponte Vecchio as the fountainhead of the concept of bankruptcy is open to challenge, there is another story about the bridge that has a little more foundation. On the bridge, where it joins the north bank of the Arno, is a stone bearing a text from the *Paradiso* section of Dante Alighieri's *La Divina Commedia,* of c.1300. It marks the site near to where Buondelmonte de' Buondelmonti was murdered in 1215 on behalf of the Amidei, an ancient and noble family of Florence. Most enigmatically the text proclaims: *'O Buondelmonte, wrong you were to flee/the nuptials at the prompting of another!...How fitting for Florence to sacrifice/ a victim to the mutilated stone/ that guards her bridge to mark the end of peace!'* (Canto xvi, lines 140-7). What can this all mean?

RIGHT: Interior of the Vasari corridor of 1565 that crosses the Ponte Vecchio. It was added to provide a speedy, secure and agreeable architectural promenade for Medici grandees – initially the Grand Duke Cosimo – between their power-bases on each side of the River Arno.

Much is now lost in myth and fancy, but this murder seems to have been prompted by love and to have sparked-off the street fighting and feuding in Florence between the Guelph and Ghibelline factions. And in some mysterious way the bridge across the Arno – perhaps as a symbol of a connection between troubled worlds and times of chaos – apparently plays a key role. The Guelphs supported the power of the Pope in Rome while the Ghibellines supported the Germanic Holy Roman Empire. This was not just a political divide, but also one to do with family, geography and trade. Guelphs tended to come from mercantile urban families and the Ghibellines from rich and ancient families with rural power bases, such as the Amidei. For many, allegiances could be fluid and even fractured within one faction. For example, Dante was a White Guelph and was for years locked in bitter conflict with the Black Guelphs, who favoured absolute obedience to Papal control, and eventually secured Dante's exile from Florence.

Pitched battles were fought on a regular basis between the factions – Dante himself took part in the Battle of Campaldino in 1289 – with territorial control shifting. But, generally speaking, Guelph cities included Mantua and Perugia, while the Ghibellines held sway in much of Tuscany and central Italy, including Siena, Todi and Pisa. Contested cities numbered not only Florence and Milan, but also Verona. And that is of some significance because the conflict between Guelph and Ghibelline families within Italy's cities – and the emotions and dramas that it spawned – evidently fascinated William Shakespeare, who was inordinately fond of Italian history as a source of inspiration. The feud between the Verona-based families of the Montagues and Capulets in *Romeo and Juliet* must be partly based on the intimate urban clashes between the Guelphs and Ghibellines when neighbours and friends could suddenly find themselves in deadly conflict.

The origins of Shakespeare's *Romeo and Juliet,* written in the early 1590s, are complex.[44] But there are specific aspects of the Florentine history of the Guelph and Ghibelline struggle that seems to have caught Shakespeare's fancy. Indeed the man murdered on the Ponte Vecchio in 1215 – Buondelmonte

> 'In accordance with the Amidei's concept of honour, Buondelmonti died at the very spot, at the foot of the bridge, where he'd pledged marriage to his true love – on the anniversary of Christ's resurrection.'

de' Buondelmonti – can be taken as a prototype for Romeo. Buondelmonti was a boisterous young Florentine noble, who the Ghibelline Amidei decided should – in recompense for some minor slight – be brought into line and under control be being obliged to marry an Amidei girl. On the wedding day the Amidei gathered in the Piazza del Signoria awaiting Buondelmonti who arrived on time but – to the amazement of all – rode straight past them to the bridge across the Arno, where he pledged his troth to a girl he truly loved and whom, to compound the insult, was from the rival Guelph family of the Donati. The furious Amidei – stung by the dishonour – swore blood vengeance, which they took on the morning of Easter Sunday 1215 as Buondelmonti rode across the predecessor of the existing Ponte Vecchio on his way to marry the Donati girl. In accordance with the Amidei's concept of honour, Buondelmonti died at the very spot, at the foot of the bridge, where he'd pledged marriage to his true love. So, to those with an eye for romance and drama, the spirited young man died for love and truth on the very anniversary of Christ's resurrection. He, like Christ, was a victim of the evils of hatred, power-lust and prejudice, and perhaps, like Christ, Buondelmonti earned immortality for his suffering and unjustified murder – he certainly earned a mention by Dante. This heady mix seems to have been enough for Shakespeare so, it seems fair to say, *The Tragedy of Romeo and Juliet* owes its creation in part to the annals of Florence and to the bridge across the Arno.

ABOVE: A sketch of the Rialto Bridge, Venice, completed in 1591. The arcades house shops.

The Rialto Bridge in Venice is a very different architectural creation. There had been a bridge across the Grand Canal in the Rialto district since at least the twelfth century. But the existing bridge was started in 1588 following the search for a design that started in the early 1550s, when a number of leading artists and architects were invited to submit designs. The body issuing the invitation was one of those hazy and slightly sinister institutions of medieval and Renaissance Venice. During these centuries, the city hovered between being an admirable Republic headed by an elected Doge and a totalitarian dictatorship, and was usually and almost inexplicably a combination of both at once.

The body operated under the name of The Ten – the *Dieci* – and had been established in 1310 following the defeat of a conspiracy by a group of noble clans that had plotted to overthrow the Doge and the Republic and establish a dynastic

principality. The initial responsibility of the *Dieci* – the meetings of which were usually attended by the Doge himself and his key councillors – was to tackle treason and crimes against the Republic. But it also had responsibility for rebuilding and maintaining palaces and other buildings that were the property of the Republic, and for certain bridges of strategic importance, such as the Rialto, which until 1854 was the only bridge over the Grand Canal and the key link between the two main islands of Venice.[45]

When it came to seeking a design for the rebuilding of the Rialto Bridge, the *Dieci* went to the best men in Italy and, because of the high quality of the designs produced, this quest turned out to be an epoch-making affair that inspired bridge design in Europe for the next 200 years. Michelangelo, Andrea Palladio, Giacomo da Vignola, Jacopo Sansovino and – later – Vincenzo Scamozzi, all submitted designs. But all the designs involved replacing the existing timber bridge across the Grand Canal with a multi-arched structure that would have involved sinking piers beneath the water. These architects did not propose this because they were technically inept or timid, but out of a sense of propriety and a determination to echo Roman precedent. Surviving antique bridges appeared to be mostly multi-arched with piers being about one third the size of openings, and so to erudite Renaissance eyes this arrangement seemed to be a visual and structural ideal. Indeed the Florentine Leon Battista Alberti – a pioneering Renaissance pundit, theorist and architect – codified this ratio in his highly influential *Ten Books of Architecture* published from 1452.

Beautiful and classically correct these designs may have been, but they were not what the city was looking for. It wanted the canal crossed in one arch of the maximum height possible to ensure that navigation by even the largest galleys was undisturbed. To achieve this functional aim the city seems to have been prepared to sacrifice both beauty and the well-established Renaissance convention that bridges should be as Roman in look and as horizontal as possible (hump-backs being impossibly vulgar). So having consulted

– and rejected – the great men of the age, the City finally selected a local builder – the aptly named Antonio da Ponte – with a design that would surely have been a sore trial and provocation to the exquisite antiquarian classicists and refined aesthetes of the time.

Da Ponte envisaged a veritable hillock of a bridge, that rose nearly eight metres high to secure maximum clearance above water level, and that spanned the canal in a single 29-metre long segmental arch. The local man had, in the face of tough competition and with a design in defiance of accepted taste, made good. When all is considered, Venice might appear sadly parochial in selecting da Ponte's decidedly odd-ball design. But time suggests this is not the case. What was eventually built – with completion in 1591 – has long been regarded as charming and characterful, and is now a much-loved and enduring architectural emblem of the city. Indeed the view of the palazzi lining the Grand Canal, seen from water level and framed by the graceful arch of the bridge, is one of the most beautiful, defining and haunting views of the Renaissance city. But despite all this, there remains a tragic touch to the whole business, a whiff of melancholy, for the unsuccessful designs produced by one of the other architects – Andrea Palladio – gripped the imagination of succeeding generations of bridge builders who flattered through endless imitation and which have, in a sense, been proven by history to be the real winners.

Whatever one's reservations about the aesthetics of the bridge's hump-back form, there can be no doubt about its engineering excellence or about the vital role it plays in the life of Venice as a whole and the Rialto district in particular. To secure sound foundations for the abutments from which his wide arch spans, da Ponte had to sink around 6,000 timber piles into the ooze of the canal and its banks – a task that must have seemed endless, as many piles simply sunk without trace. When eventually these were successfully in place, he topped them with layers of stone and cement (see page 165) and with timber 'grillages', constructed in step-form for additional strength and to ensure that the stones of the

RIGHT: The Grand Canal, Venice, Italy with top, the arched and arcaded Rialto Bridge. Built between 1588 to 1591 to the designs of Antonio da Ponti, it is not the most elegant or classical correct bridge of the Renaissance but one of the most charming.

PASCHALE CICOGNA VENETIAR
E ANNO CHRISTI MDXCI
CONDITAE MCLXX
R A . . T . . B . V .
.
.

abutments could be laid precisely perpendicular to the arch's directions of thrust to achieve maximum solidity. The bulk of these abutments is impressive – massive haunches that by virtue of their heavy mass and solid construction resist the lateral thrust of the wide-span arch and prevent it spreading and deflecting.[46]

The bridge's main contributions to city life are that it is inhabited (it contains twenty-four shops), that it was conceived as part of the city's thoroughfare (it's a combination of miniature hill and arching flight of steps) and that it is incredibly decorative, being faced with marble and ornamented with fine carving. The shops were evidently part of the brief. Palladio's designs envisaged a mini-town of columned temples, terraces and porticoes crammed atop a three-arched bridge supporting no fewer than seventy-two

ABOVE: St Mark, a Patron saint of Venice with the lion at his feet, embellishes one of the four spandrels on the Rialto Bridge.

cell-like shops. In da Ponte's design the shops are placed within arcades fronted by a bold and balustraded walkway that projects-out over the canal, supported on brackets. The arcades are divided, when they reach the crown of the bridge, by a transverse passageway that is terminated by open and taller pediment-topped arches that offer, and frame, spectacular views along the Grand Canal. It is all pleasingly theatrical, with the bridge reading like a sliver of arching loggia or arcaded piazza. Da Ponte certainly, in true Vitruvian fashion, wanted to create a structure that was not only firm and commodious but also delightful (see page 161).

The carved stone imagery on the bridge is entirely religious and – much in the manner of medieval bridges (see page 162) – appears to be offering the work to God and calling on Him, the saints and the Virgin to protect the city, the bridge and all who use it. It is, in its way, an image of paradise – a thing of commerce, communication and the material world but also of the divine and the spiritual. Stone angels flutter about, along with the usual heads of sea gods and guardian lions, but the major narrative is the Annunciation, shown on the bridge's southwest elevation, with the Angel Gabriel on one spandrel and on the other the Virgin receiving the news from Gabriel of the imminent birth of Christ. On the spandrels of the other elevation are images of the two patron saints of Venice – St Mark and St Theodore of Amasea.[47]

This choice of religious imagery is most interesting. Venice, the pre-eminent Italian city of water-born trade, had long and extensive commercial contact with the Islamic world. Any visiting Muslim contemplating this bridge would have been gladdened and reassured by what he saw, and would have sensed the harmonious connections that were possible between Muslims and Christians who – in many key ways and despite centuries of conflict – did indeed share the same religion. The Virgin is venerated in the Koran as Maryam, the mother of Jesus and one of the best women ever born. But she is not regarded as the mother of the Son of God. Jesus himself is highly regarded by Islam as a great prophet but that is all. Any suggestion that he might be a god in his

own right or the Son of God is regarded as offensive and idolatrous by Muslims, since it seems to challenge the fundamental tenet of Islam (and of Judaism) that there is only one God, entire, indissoluble, omnipotent and unique. And Gabriel – as Jibrail – was the medium through which God revealed the text of the Koran to Muhammad. So a Muslim merchant proceeding north along the Grand Canal would have felt at peace – around him a spattering of palazzi inspired by Arab architecture and in front of him representations of two of the holiest beings in Islam. True, Muslims themselves would not make such things – all images of living beings are regarded as potentially idolatrous – but there would have been little offence that Christians should indulge in such pictorial sacred art in their own land. This particular choice of religious subject matter – including the carved dove in the centre of the bridge which is a fairly universal image of peace – would have been good for business and helped secure harmonious working relationships.

If the Muslim visitor, after passing beneath the bridge, happened to look back at the northeast elevation and spied the image of St Mark, he might have reminded himself to be aware of Venetian cunning. A story is commemorated in mosaic in one of the portals of the Basilica of San Marco that celebrates the theft of the body of St Mark from Alexandria in the ninth century by two Venetian merchants. To avoid the detection by Muslim guards of their precious booty, the canny Venetians hid the body beneath piles of pork, a meat abhorred by Islam. Naturally the guards stayed well away and the saint was carried safely to Venice. The lesson for an Islamic merchant was, I suppose, that in Venice all was as fair in the world of trade as it was in the acquisition of holy relics. If you would employ deception to do God's work, to what levels would you not stoop?

The reverberations of the Rialto Bridge competition were felt nowhere so much through the centuries as in England. During the seventeenth and early eighteenth centuries, the rational and outwardly-restrained classicism of Andrea Palladio was elevated in England to something akin to a national style. It seemed to reflect both the English character

RIGHT: The high hump-back of the Rialto Bridge – necessary like its single span to allow the largest galleys to travel the Grand Canal – means its wide central route has to be scaled by a flight of steps.

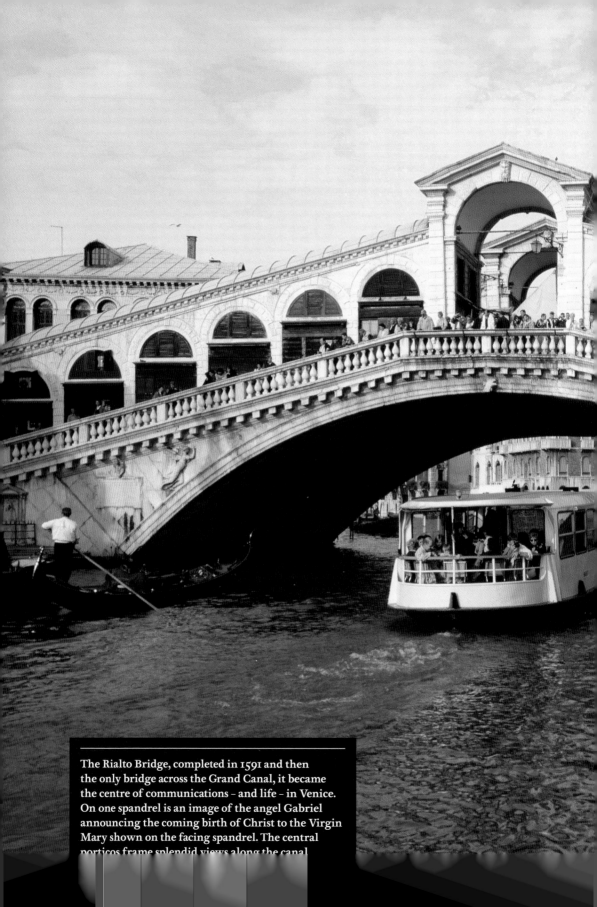

The Rialto Bridge, completed in 1591 and then
the only bridge across the Grand Canal, it became
the centre of communications – and life – in Venice.
On one spandrel is an image of the angel Gabriel
announcing the coming birth of Christ to the Virgin
Mary shown on the facing spandrel. The central
porticos frame splendid views along the canal.

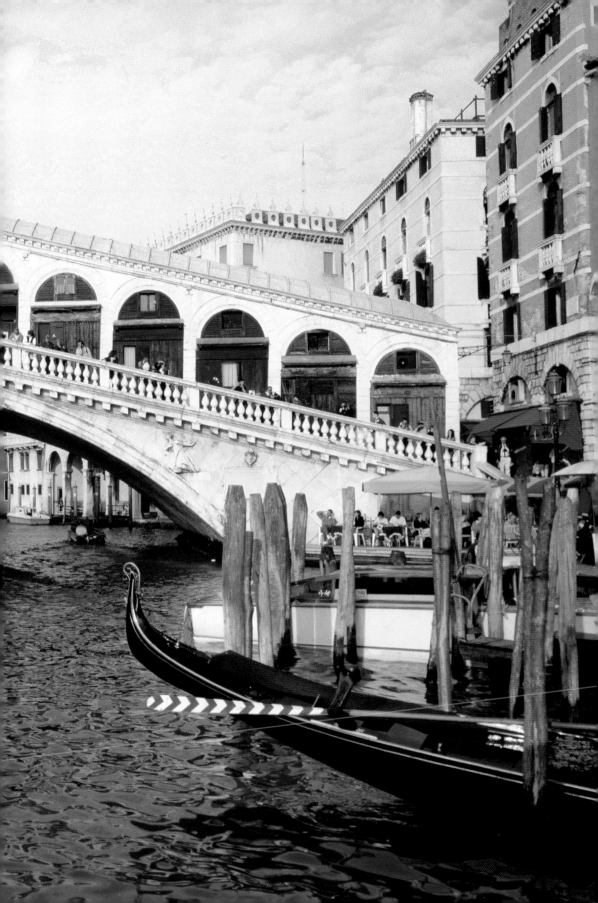

and the nation's artistic aspirations. Inigo Jones, the man who introduced full-blooded and coherent Palladian design into England in the very early seventeenth century, had something very pertinent to say on the matter: architecture should mimic the outward appearance of 'every wyse man' who 'carrieth a gravity in publicke places' while 'inwardly hath his immaginacy set on fire, and sometimes licenciously flying out'.[48] Nothing could better summarize Palladian architecture or, perhaps, an Englishman's humour and disposition.

Palladio's works – easily accessible to travellers on the Grand Tour and through Palladio's own lavish publication of 1570, the *Quattro Libri dell'Architectura* – were readily imitated in Britain. What remains fascinating is that Palladian architecture, as it evolved in early eighteenth century Britain, moved beyond mere hollow imitation to develop a powerful and distinct character. But even while this transformation was taking place, some more academically-minded architects and their clients set themselves the pleasant cultural and antiquarian diversion of building almost exact replicas in the nation's towns and cities of Palladio's prototypical buildings. And so it came about that finally, after two hundred years, Palladio's ill-fated designs for the Rialto Bridge actually came to be built.

The Earl of Burlington, a most influential Palladio fanatic, had acquired a collection of Palladio's drawings while on his Grand Tour in Italy from 1714 to 1719. The drawings, now in the possession of the Royal Institute of British Architects and lodged in the Victoria and Albert Museum, include views of buildings not included in the *Quattro Libri*. For example, one lively composition features a huge, centrally-placed Venetian window that was reproduced in the 1720s almost exactly by Burlington for a house in London's Mayfair, and that became a standard motif in eighteenth-century English Palladian design.

This cache of drawings and the plates of the *Quattro Libri*, coupled with the experience of Palladio's buildings, particularly inspired the designers of garden buildings. Temple-dotted landscapes were a pioneering fashion in early eighteenth

century England and Palladio's designs seemed a particularly appropriate source for inspiration. They carried the pleasing stamp of the genuine antique – most would have known that in his designs Palladio attempted the authentic evocation of Roman architecture – and helped conjure up the classical landscapes that contemporary taste so admired in the immensely popular paintings of Claude Lorrain and Nicholas Poussin.

Bridges were a much favoured part of the vocabulary of landscape design. They not only made splendid ornaments and places from which vistas could be enjoyed, but also provided useful routes for the traveller through the landscape, and even opportunities for the creation of accommodation. Soon after 1705 the audacious Sir John Vanbrugh had attempted the creation of just such a bridge when augmenting the park of Blenheim Palace in Oxfordshire. Wildly baroque in its detailing rather than Palladian, his bridge was of prodigious size and, with a wide central arch flanked by two much smaller ones, was to carry a Roman aqueduct-like arcade, have domed pavilions and contain within it thirty-three rooms. At least that's what the Duchess of Marlborough claimed, but she was by then exasperated by Vanbrugh's extravagance and apparent incompetence during the construction of the palace and could well have been exaggerating.[49] The construction of this vast inhabited bridge was stopped in its tracks with only a much-reduced version finally executed. The few cavernous rooms created within its massive bulk were never completed or inhabited and to this day remain as bleak testimonials to Vanbrugh's frustrated fantasy.

As for Palladio-inspired garden bridges nothing happened until about 1737 when, by some alchemy never yet fully explained, the Palladio-obsessed Earl of Pembroke and his like-minded architect Roger Morris came up with something wonderful and memorable at the Earl's family seat of Wilton House, Wiltshire. They appear to have taken Palladio's designs for the Rialto Bridge in Venice (published in Book Three of his *Quattro Libri*), reduced them in scale and to their essence, and combined what was left with other appropriate and characteristic Palladio compositions and details (taken from the *Quattro Libri,*

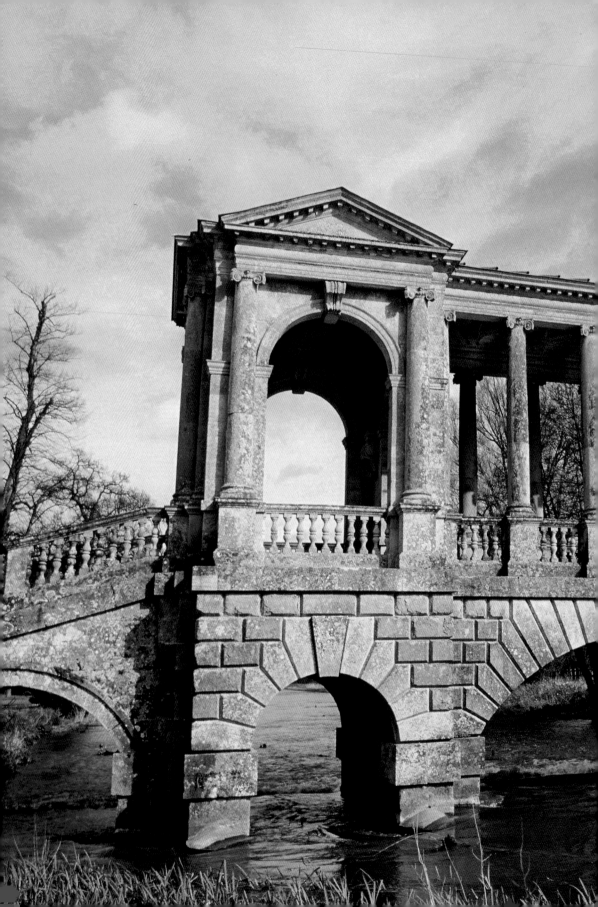

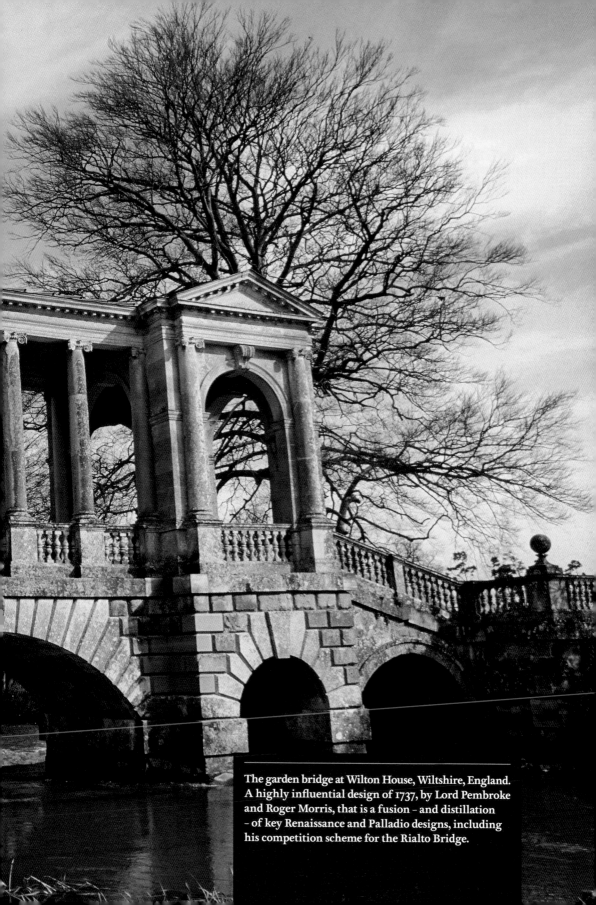

The garden bridge at Wilton House, Wiltshire, England.
A highly influential design of 1737, by Lord Pembroke
and Roger Morris, that is a fusion – and distillation
– of key Renaissance and Palladio designs, including
his competition scheme for the Rialto Bridge.

'If the Rialto design was ever to be built, it could only happen in a city and when a major bridge was required. Or, it could be brought to life in a painting, which is exactly what Canaletto did in 1747.'

possibly from Burlington's drawings and from completed buildings, and perhaps from Scamozzi's Rialto designs). They also seem to have added a touch of Alberti who includes an illustration of a flat, three arched bridge crowned by an Ionic-columned portico in his mid-fifteenth century *Ten Books of Architecture*, and states that 'some bridges even have a roof, like that of Hadrian in Rome, the most splendid of all bridges (Book Eight, chapter six).[50] The result is a bridge design that is arguably the quintessence of the Renaissance and of Palladio – or at the least of the Palladio loved by the early eighteenth-century English. The Pembroke–Morris design – of masonry construction – has three central arches like Palladio's Rialto design, end pedimented porticoes and is colonnaded and roofed so, like Palladio's bridge, it reads as a building.

The process by which these sources were distilled to create this compelling jewel-like bridge remains mysterious, but the result took English taste by storm.[51] A second, slightly altered, version was constructed in about 1738 in the landscaped park at Stowe in Buckinghamshire (perhaps under the direction of the architect James Gibbs and originally only one-sided), a third was built in the mid 1750s in the grounds of Ralph Allen's Prior Park, just outside Bath, probably to the designs of Richard Jones and John Wood, and a fourth – at about the same time but long demolished – at Hagley Hall, West Midlands.

A fifth stands in the park of Tsarskoye Selo, St Petersburg, Russia, and inspired by the bridge at Stowe, was built in the 1770s for Catherine the Great by Charles Cameron and John Busch.

The Rialto design published in the *Quattro Libri* was a massive affair that, along with central temple-composition and colonnaded porticoes at each end, contained seventy two shops set in six parallel rows. If the Rialto design was ever to be built, it could only happen in a city and when a major bridge was required. Or it could be brought to life in a painting, which is exactly what Canaletto did in 1747 when he produced a *capriccio* showing a number of Palladio's buildings collected alongside the Grand Canal in Venice, with the bridge taking centre place. The view was magical – and galvanising.

William Pulteney had been born in 1684 into a wealthy Leicestershire family, made the Ground Tour (where he no doubt received a good dose of Palladio), entered Parliament in 1705 as a Whig, and in 1714 married the beautiful Isleworth heiress, Anna Maria Gumley.[52] It was typical that such a cultured, interesting and discerning fellow as Pulteney should have a passion for bridges, particularly those designed by Palladio who had become something of a special hero for the Whig cause. In the early eighteenth century the Whigs were seeking to promote a culture and an architecture that was appropriate for Protestant England and a clear alternative to the Baroque, Francophile and faintly Catholic taste of the rival Tory party. It was the Whigs that in 1714 entered upon nearly fifty years of political supremacy in Britain, launching Palladianism as a national style, so it was only natural that Pulteney should be a stout neo-Palladian.

He was able to give this artistic bent expression in 1727 when he acquired the 600-acre Manor of Bathwick, lying across the River Avon from the city of Bath. The majority of the manor was in agricultural use, but Bath, just metres across the water and the focus of fashion, was undergoing one of its massive, and regular, building booms. There was clearly a fortune to be made if both banks of the river could be connected by an elegant bridge allowing the fields of

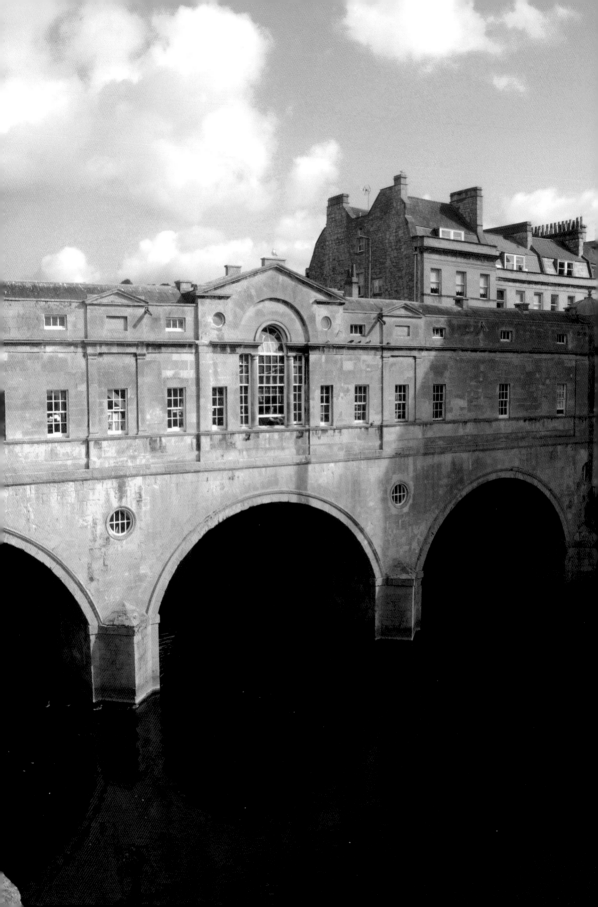

LEFT: The Pulteney Bridge,
Bath, England. Designed
by Robert Adam and
completed in 1769, it
is inspired by Andrea
Palladio's design of the
mid sixteenth century
for the Rialto Bridge
in Venice.

Bathwick to be covered with terraces. A plan was hatched for just such a bridge and, almost inevitably, the inspiration for its design was Palladio. But Pulteney died in 1764, nearly five years before work could start on site, and so sadly never saw Palladio's Rialto design finally leaping from the pages of the *Quattro Libri* to settle astride the banks not of the Grand Canal but of the Avon.

The architect for this conjuring act of creation was Robert Adam. He was a genius of design in his own right so Palladio's 200-year-old design was cunningly adapted to the site and times, and enlivened with elegant and fashionable neo-classical details. But for all that, the essential design with its three arches, wide piers, central pedimented pavilions flanked by rows of shops, is Palladio's Venetian vision. Despite serious later alterations and demolitions, the Pulteney Bridge – beautifully built of mellow Bath limestone – remains an extraordinary and moving thing to contemplate: a Renaissance evocation of a Roman bridge and the epitome of inventive classical design eventually brought to life in England's most Roman and most classical of cities.

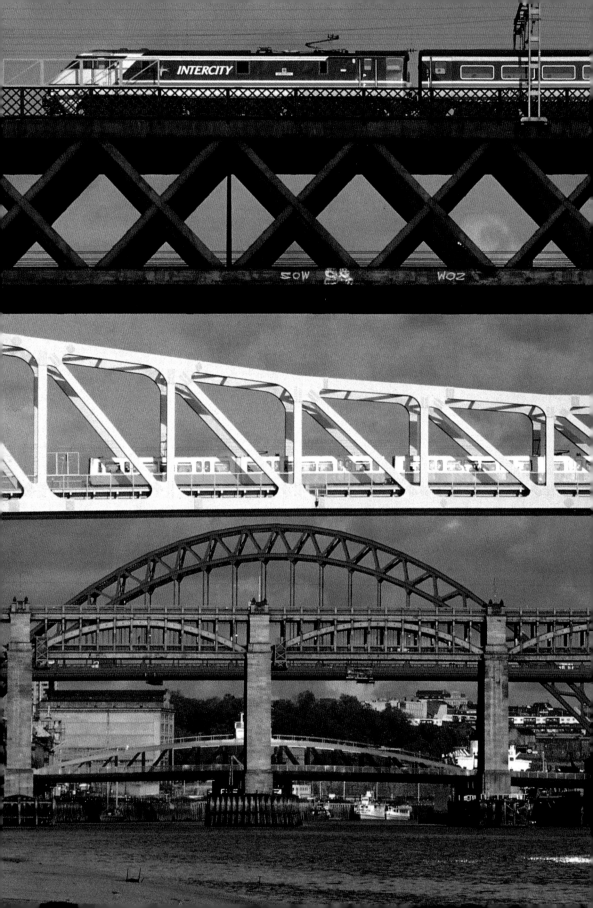

FORGING THE RAILWAY AGE

NEWCASTLE-UPON-TYNE REMAINS ONE OF BRITAIN'S
most visually exciting and finest cities – not least because of
its superlative bridges – despite all the violence that has been
inflicted upon it during the last forty years. I first experienced
the city in the mid 1970s when it had become a bye-word for
sleaze, and institutionalized and greedy corruption. This was
the consequence of a decade of misrule by the one time leader
of the city council T. Dan Smith, who had become embroiled
in peculiar financial arrangements with a wide range of
characters including the architect John Poulson, and Tory
minister, Reginald Maudling. Poulson was eventually jailed
in February 1974 for fraud and corruption, as was Smith
a few months later for accepting bribes. Maudling escaped
trial but was not unscathed by his association with Poulson
and Smith and by the late 1970s, when he died, had fallen
from Home Secretary and a potential leader of his party
to reclusive alcoholic.

In the mid 1970s a number of ambitious redevelopment
schemes for central Newcastle were working their way
through the planning system. I travelled north from London
to explore a scheme – then still partly in the design stage –
that surely would never have been proposed let alone approved
but for the cynical and rapacious atmosphere established by
ambitious, buccaneering and immensely influential figures such

PREVIOUS: The stunning
array of bridges of different
scales, dates, heights and
types, over the River Tyne,
Newcastle-upon-Tyne,
England. In the middle
distance, with its series
of bow-string trusses set
on high piers, is the High
Level bridge completed in
1849. Behind it is the vast
arch of the Tyne Road
Bridge, completed in 1928.

RIGHT: The Tyne Bridges:
Bottom the High Level
Bridge of 1849 showing
the railway tracks set above
the vehicle and pedestrian
carriageway; in the centre
the Tyne Road Bridge of 1928
and top, the cable-stayed
and rotating Gateshead
Millennium pedestrian
bridge, completed in 2001.

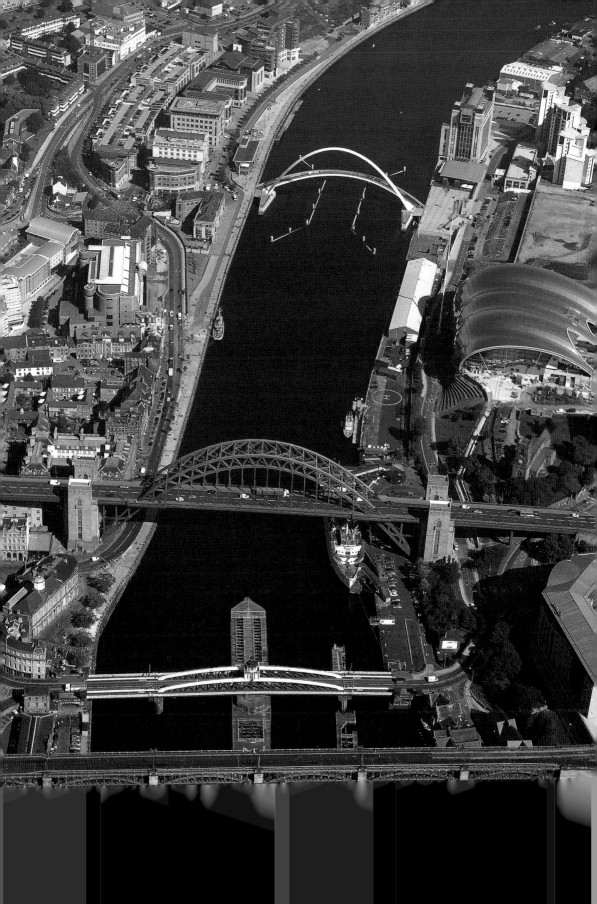

> ## 'Not only did Newcastle suddenly have wealth and power, its newly-rich leading citizens also quickly developed cultural ambitions and artistic taste.'

as Smith and his fellow local politician Andy Cunningham, also finally imprisoned.

The scheme I went to see – approved in full legality by the city's newly-sanitized politicians and planners working with eminent London-based architects – involved the demolition of most of one of the city's more significant architectural monuments, Eldon Square. Anyone who does not know Newcastle personally, or is unaware of its extraordinary building history during the first half of the nineteenth century, may not appreciate the enormity of this proposal. It's as if someone orchestrated the demolition of the Place Vendôme in Paris or the Plaza Mayor in Madrid. Neither one of these locations absolutely defines the city it stands in, but both are immensely important and their loss would greatly diminish the whole. Such was Eldon Square. It formed part of the crescendo of one of the greatest classically-designed streets in Britain, indeed in the world.

In the early nineteenth century something phenomenal happened in Newcastle, something that reflected its new-found status and that transformed an ancient market and industrial town into one of the great cities of the empire. Newcastle suddenly had great wealth – a product of Britain's Industrial Revolution. Its grip on world markets and Northumberland's happy accident of geology gave it an abundance of high quality coal, the vital and valuable life-blood of industrial production. But not only did Newcastle suddenly have wealth and power, its newly-rich

leading citizens also quickly developed cultural ambitions and artistic taste. They wanted their city to look the part, to reflect its changing fortunes. By another happy accident, in the 1820s the city possessed two men with astonishing vision, confidence and the ability to work together creatively to make the city's aspiring dreams come true.

Richard Grainger was born in Newcastle in 1797, the son of a quayside porter and a seamstress. He trained as a carpenter and by 1816 was operating as a general contractor. His first large-scale building job came in 1819 and was a success, permitting him to marry the daughter of a wealthy leather merchant. With her dowry of £5,000 Grainger was able to move into the risky but potentially profitable world of speculative building. Pursuing this process, he took building leases from landlords and financed the construction of buildings that he hoped to sell on to occupiers for substantially more than he had spent on construction, and in the process he hoped to make a profit.

From the start Grainger realized that architectural quality gave his developments added value and so collaborated with talented and fashion-conscious local architects like John Dobson. The pair started Eldon Square in 1824, as a speculation, and then utilized this development method during the following decades to create a new city centre. Their initial schemes were successful both artistically and commercially, but despite redefining Newcastle, all did not end well for Grainger. Later developments went wrong, he just averted bankruptcy in 1841 and when he died in 1861 his debts far exceeded his personal estate.

John Dobson, the other key man in this partnership, was ten years older than Grainger and, although born in northeast England, had studied in London so that when he set up practice in Newcastle in 1810 he was armed with first-hand knowledge of the most fashionable and ambitious city building schemes. He clearly kept abreast of architectural and planning developments in Britain's great classical cities – such as Edinburgh and Bath – as well as in London, so that his designs for Eldon Square possess a metropolitan sophistication.

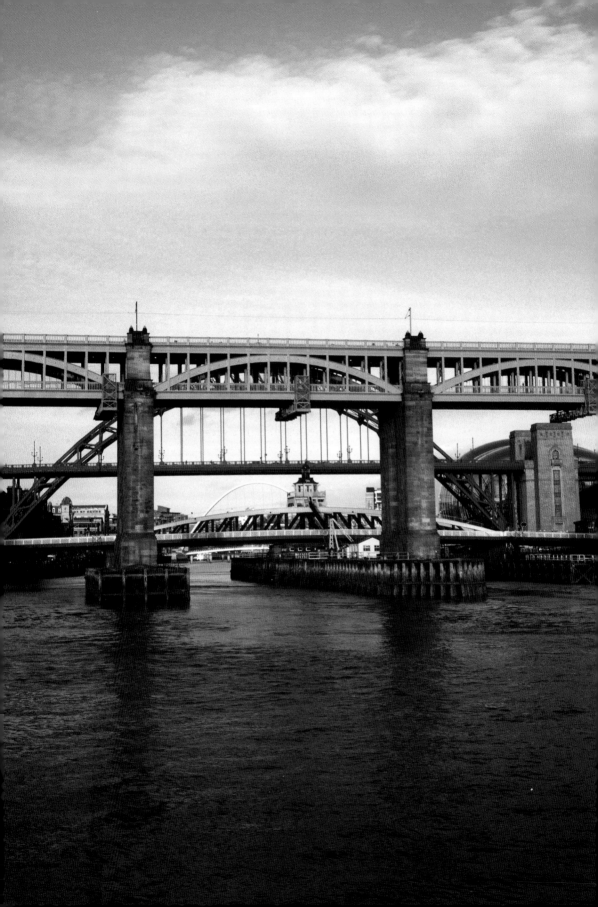

During the 1820s and 1830s Grainger and Dobson gave Newcastle a new and glorious heart. It was expressed in vivid architectural form and organized around Grey Street – named after Earl Grey who was the driving force behind the electoral reform act of 1832 – that rose and curved up from the old city along the Tyne into the sunny uplands of the fields above. The street, wide and lined with large stone-built and generously detailed classical palaces, expressed perfectly Newcastle's new wealth, pride and cultural aspirations. Broadly inspired by the architecture executed in London from 1812 under the control of John Nash for the Prince Regent, the buildings in and around Grey Street were better. London's Regent's Park terraces, Regent Street and Piccadilly Circus were clad in stucco and flimsy – even gimcrack – in their execution and detailing. But Grey Street, wrought of solid stone with robust and beautiful stone-carved detailing, was big-boned and built for eternity, destined to proclaim the glories of Newcastle until the end of days, such as the pyramids at Giza speak still of the glories of ancient Egypt.

No doubt Grainger and Dobson's noble scheme would have endured in its entirety for perpetuity if not for the machinations and depredations of T. Dan Smith and his colleagues who, to line their pockets, sought to whittle-away the city's greatest urban glory. The erosion of the urban masterpiece – the seeds of which were laid in the dark days of the city's mismanagement and claimed its first major victim in 1963 with the demolition for road works of Dobson's exquisite Royal Arcade of 1831 – was not terminated until only one side of Eldon Square survived, with the rest swept aside to make way for a massive shopping centre.

It was to survey the ruins of Eldon Square, and newly risen portions of the gigantic Eldon Square Centre, that drew me north from London. As my train approached the city I was, I remember, tense and gloomy. What horror was I to see, what despair was I to experience? Then, to my surprise, I was overwhelmed by an unanticipated experience. I must have travelled through Newcastle many times before on my way to Scotland, but perhaps on those earlier journeys I had been

LEFT: The central portion of Robert Stephenson's High Level Bridge, opened in 1849. The form of the elements demonstrate the structural forces at work and reveal the materials used. The bow-string trusses exert no lateral thrust on the slender stone piers because the horizontal force of the arches, carrying much of the load of the upper railway track that sits on their crowns, is restrained by the horizontal ties that carry the lower vehicle road. The arches – under compression from the weight of the track and trains – are made of cast iron, a material strong in compression. The horizontal ties, being stretched, are made of wrought-iron, which possesses good tensile strength.

lost in thought, dozing, my senses dulled. This time my nerves were tingling and my mind racing in anticipation of imminent events, and I saw things with a vivid intensity. No one who has not arrived at Newcastle from the south, in daylight and with mind alert, can know how startling the series of events can be. They unfold in quick succession and have a visual, indeed emotional, impact that can be almost overwhelming. You are travelling through industrial suburbs, dreary of aspect to most observers, then you suddenly pass over a chasm through which runs the mighty River Tyne with, laid out before you as in a diagram, a series of bridges of startling different types, designs, scales and heights. The prospect is wonderful, and enhanced by additions since my arrival nearly forty years ago.

I had come to Newcastle to see one great architectural wonder that had been brought to its knees and suddenly confronted another. Newcastle, like New York in some respects, is a city defined by its bridges. Like many of New York's bridges, they pass into and through the town at a high level and so lord it over the buildings that congregate around their footings. And, like New York, the bridges of Newcastle unite diverse places – there, most dramatically, it's Manhattan, Brooklyn, Queens and New Jersey, here it's Newcastle and Gateshead. Also, like most of the New York bridges, most of the Newcastle bridges were of radical and pioneering design when completed and, although superficially at odds with the scale, design and construction of the buildings through which they slice or over which they pass, they do not appear ugly, brutal or intolerably destructive and insensitive interlopers. Rather than appalling, the contrast inspires and excites.

This is initially puzzling, but then, of course, this is the power of bridges. Despite potential conflicts and contrasts, the human mind perceives the essence of bridge design, comprehends that they are heroic expressions of human endeavour. While the mighty bulk of the Eldon Square Centre will, while it lasts, symbolize nothing but self-serving commerce – made worse by the fact that it only exists through the destruction of architectural beauty –

the mighty Tyne bridges continue to represent human genius, the ability of man to work with nature to tame nature, to harness the potential offered by bold engineering and, by the application of new building materials and technology, to conceive and realize ingenious solutions to seemingly insoluble problems.

Now I've returned to look at the bridges in Newcastle. Much has happened in my life during the intervening years. I've been around the world several times and contemplated cultural and engineering wonders from pole to pole. But the power of the Tyne bridges remains. After all these years and all these experiences they still move, still almost shock in their daring scale and design. But of course I see them in a different light, now I can more fully appreciate their pioneering qualities, the ways in which they acted as prototypes for bridges built around the world.

There are now seven road, rail and foot bridges that run between Newcastle city centre and Gateshead. The newest is a showy, arched affair, incorporating a carriageway that tilts-up to allow river craft to pass beneath. Called the Millennium Bridge – it opened in 2001 – this design is in many ways more a self-conscious symbol than a functional object. The bridge was intended to act as a visual emblem of the city's regeneration, to unite the two banks of the Tyne and to get people into the newly created Art and Music Centre in Gateshead. The design, selected through a competition, is by architects Wilkinson Eyre working with engineers Gifford. It is an exquisite affair and has been commended by industrial designer James Dyson as a 'perfect' and 'beautiful structure' because 'you can see exactly how it works'.[53]

The Millennium Bridge is indeed an admirable example of bridge design, but it is puny in comparison with the two giants of the world of bridges that stand nearby and that overshadow it in every way. There are in fact only two bridges in Newcastle that really count, that really overwhelm, and these two bridges hold their own on the world stage: the High Level and the Tyne Road Bridge. Dyson has said: 'bridges, when they are properly designed, epitomise perfect

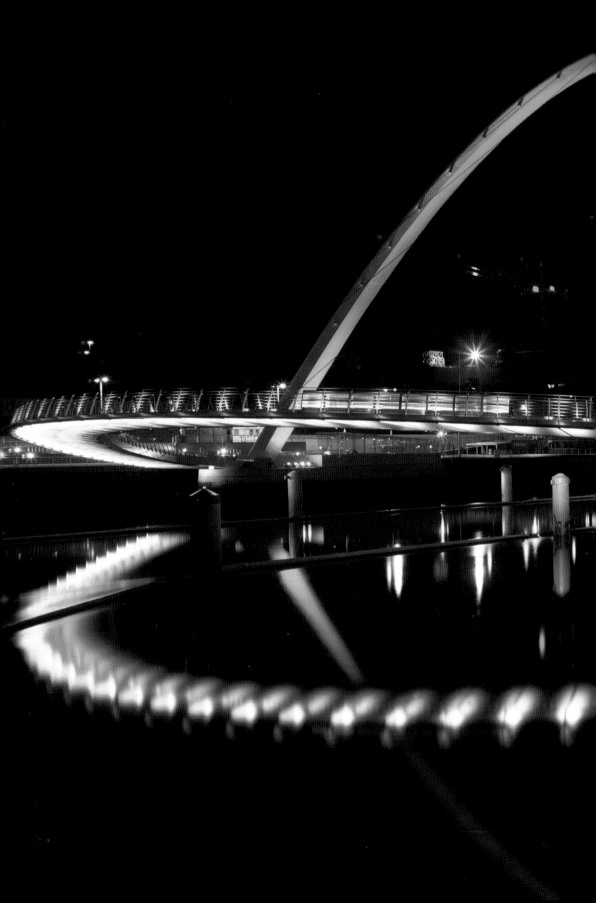

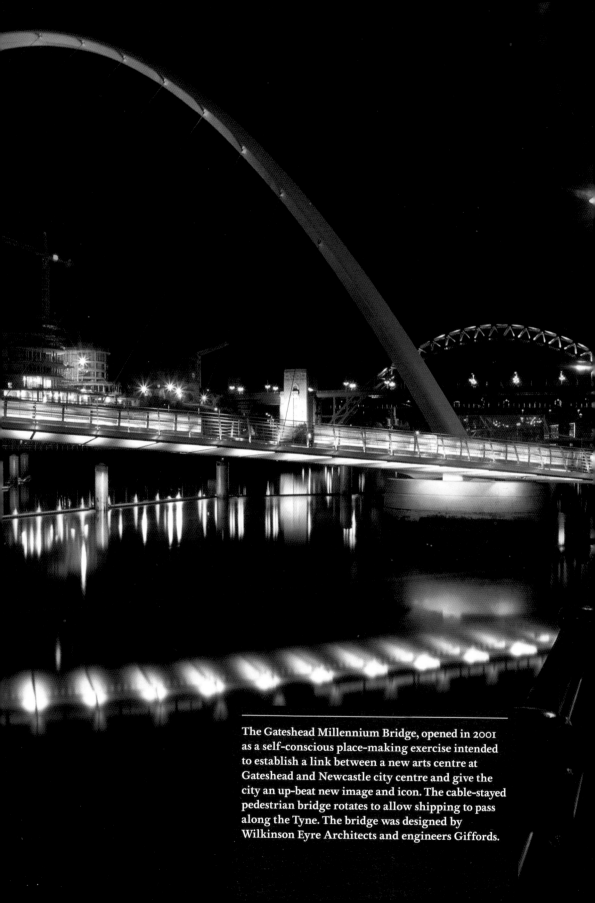

The Gateshead Millennium Bridge, opened in 2001 as a self-conscious place-making exercise intended to establish a link between a new arts centre at Gateshead and Newcastle city centre and give the city an up-beat new image and icon. The cable-stayed pedestrian bridge rotates to allow shipping to pass along the Tyne. The bridge was designed by Wilkinson Eyre Architects and engineers Giffords.

structure...when that purity is put into play...the results are extraordinary'.[54] Dyson is perfectly correct – the two great and heroic Newcastle bridges are in their different ways 'perfect' solutions to a specific set of challenges, with each using and developing the available technologies and materials of their different epochs. They are not only highly functional but also sensationally beautiful – utility and delight combined.

The High Level Bridge that was opened in 1849, has a total length of 407.8 metres (1,337 feet), and pioneered the idea of two tier bridges – an idea later developed in most spectacular fashion through a series of New York bridges, starting with the Queensboro Bridge that was completed in 1909 (see page 304). The top level of the bridge was to accommodate trains while the lower, covered, level was for road transport and pedestrians. The designer was Robert Stephenson, the son of the great railway engineer George Stephenson, who died the year before the bridge opened. The promoter of the bridge was George Hudson – known as the 'Railway King' – who ensured that the route of the 'East Coast Line' from London to Edinburgh should pass through York and through Newcastle. Hudson got the Newcastle & Berwick Railway incorporated on 31 July 1845 and, as part of the same Act, a great bridge was sanctioned over the River Tyne in Newcastle.

In the mid 1840s Robert Stephenson was a natural choice as designer. By this time he and his father were among the greatest figures of nineteenth century engineering, bridge building and railway design, and they were also local men. While living in Westgate Road, Newcastle in the 1820s, George Stephenson designed and constructed the Rocket that, built in 1829, was the world's first 'modern' locomotive and became the model for all subsequent steam-powered locomotives. George Stephenson was joined in business in 1823 by his twenty-year-old son Robert who, from the start, most ably assisted his father and soon took an increasingly creative role in the partnership. In 1824 Robert went to South America to work in Colombian gold mines, an experience that must have greatly extended his knowledge of both the world and of men, increased his

engineering experience and – perhaps most importantly – gave him confidence and a strong sense of independence. But three years later Robert was back in England and at his father's side to work on the Liverpool and Manchester Railway (the L&MR) which, when it opened in September 1830, was the world's first passenger-carrying railway, linking two cities on which trains were timetabled and hauled for most of their distance solely by steam-powered locomotives. Earlier George Stephenson had worked on the Stockton and Darlington Railway, in County Durham that had opened in September 1825 and, although conceived in 1821 as a means of carrying coal from pits to a quayside by horse drawn trucks was, by the time it opened, passenger carrying and, thanks to Stephenson, steam powered.

The Stockton and Darlington, in comparison with the proposed L&MR, was a very modest affair – really little more than a rural railway serving a colliery. The L&MR presented many more challenges and opportunities. It marked the moment when soon-familiar railway building types – stations, signal boxes, warehouses and terminals – were first considered in detail and constructed and when various types of specialized rolling stock were designed. The L&MR was an immediate and spectacular success, due largely to the Stephensons' heroic efforts. The railway was expected to make profits carrying raw cotton and other goods from Liverpool to the industrial giant of Manchester, known as 'Cottonopolis' because of the number of its cotton mills and by the mid nineteenth century the richest commercial centre on earth. The railway would also, of course, carry the woven cotton from Manchester to Liverpool for export around the world. This goods trade made the L&MR handsome profits as anticipated, but an unexpected bonus was the fact that the service's reliability and speed meant it soon acquired the prestige task of carrying the Royal Mail and brought in a large number of passengers whose ticket money added greatly to the company's funds. The railway age had indeed arrived, and the world changed forever.

The Stephensons' triumph with the L&MR was not without its moments of near disaster and disgrace. George

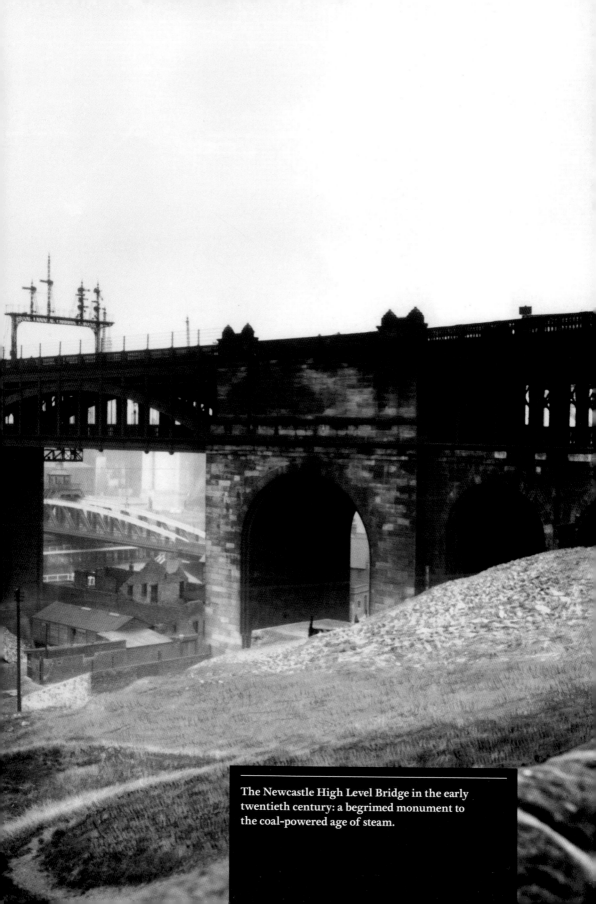

The Newcastle High Level Bridge in the early
twentieth century: a begrimed monument to
the coal-powered age of steam.

Stephenson's survey for the 56 kilometres (35 miles) of track, conducted in 1824 when he was engineer to the company, proved so defective that in 1825 the Bill needed to permit construction was thrown out by Parliament. This delighted the canal lobby, which rightly saw the arrival of the railways as a frightful challenge to its livelihood. George Stephenson, a man of humble birth and no formal education, had revealed himself to be unable to make the complex calculations required to achieve an accurate survey. For such work he had depended on his much better-educated, but now absent, son. John and George Rennie – the sons of the great engineer and architect John Rennie – supplanted Stephenson and conducted an accurate survey which, combined with a subtle campaign to placate leading members of the canal lobby, secured Royal Assent in 1826 for the second Parliamentary Bill to construct the railway. But now events took another dramatic turn. The L&MR could not agree terms with the Rennie brothers and George Stephenson was reappointed as engineer and soon joined by his son Robert.

After the success of the L&MR, George and Robert Stephenson were appointed as engineers, technical advisors and as suppliers of locomotives by railway systems throughout Britain and around the world – including Belgium, Russia, the United States, Germany and within the Austro–Hungarian Empire. Father and son were rapidly starting to personify the early railway age.

Their duties embraced not only the construction of railway track, buildings and locomotives, but also the boring of tunnels, and the design and building of bridges and viaducts. Bridge building and tunnelling increasingly became the most challenging aspects of railway construction around the world, as it became necessary to plough through peaks, excavate deep cuttings, construct high and long embankments and cross rivers and mighty gorges that had never been bridged before. The L&MR had indeed anticipated things to come. Although only 56 kilometres (35 miles) long, it incorporated the 2,057 metre (2,250 yard) long Wapping Tunnel in Liverpool (the first tunnel in the world to be bored below part of a major

city); a 3.3 kilometre (2 mile) long and up to 23 metre (70 feet) deep cutting through rock at Olive Mount; and sixty-four bridges and viaducts.

All but one of these bridges and viaducts was built of brick or stone, but that at Water Street Manchester utilized cast-iron, the avant-garde structural material of the age. Cast-iron had been used in most spectacular and pioneering fashion in the 1770s for the construction of the Iron Bridge in Shropshire – the first iron-made bridge in the world – and more generally from the mid 1790s to form stanchions and beams in mill and warehouse construction. Cast-iron was an attractive option for many reasons: because the ratio between its bulk and its strength was good (a cast-iron stanchion of only very small section was as strong, if not stronger, than a timber stanchion of vast girth); because of the ease and economy with which components could be cast, transported and assembled; and because of its perceived fire-proof qualities. But when it came to construction, cast-iron was an experimental material, its essential qualities untested by use and by time, and so its role in bridge design remained limited in the 1820s.

Its advantages could not be ignored, however, when it seemed that they could be utilized to solve a specific problem. At Water Street, limited headway was a problem and because cast-iron offered the required strength in the most minimal manner it was chosen over the use of a more bulky brick or stone construction. The Water Street bridge was not in fact designed by the Stephensons, but by William Fairbairn and Eaton Hodgkinson who cast the members at their foundry at nearby Ancoats. They tested their girders thoroughly before installation and all was well, but elsewhere the structural problems inherent to cast-iron soon became clear. Although regarded as a fire-proof material, cast-iron in fact performs poorly when heated, becoming fragile and liable to crack and fail if hit or doused with cold water. Also, although possessing great strength in compression it has little tensile strength. What this means is that cast-iron works well for the fabrication of columns or stanchions that carry weight

vertically down but is too rigid, and lacking in the necessary elasticity to be much good for horizontal beams or diagonal braces, which need to be able to flex to a degree without cracking as they transfer weight horizontally or diagonally.

This limitation in the structural strength of cast-iron was recognised from the start but neither fully understood nor the extreme seriousness of the problem generally accepted. Some who did understand the potentially dangerous flaws in cast-iron when used in certain structural roles promoted the use of wrought-iron, a material manufactured in a distinctly different manner and which has a different nature to cast-iron. Wrought-iron, unlike cast-iron, has flexibility and tensile strength and so is ideal for horizontal beams and diagonal braces. It had been used in a very limited manner in construction since at least the Middle Ages – for example to bolster stone arcades and to tie timber joints together – but its major structural use in architecture only started in the mid 1840s when the iron founder Richard Turner, working with the architect Decimus Burton, used wrought-iron braces and ribs in conjunction with cast-iron columns in the construction of the epoch-making Palm House in Kew Garden, London, which opened in 1848.

One man who did not in the 1840s fully appreciate the structural limitations of cast-iron was, it seems, Robert Stephenson. In the mid 1840s he designed a railway bridge across the River Dee in Cheshire for the North Wales coast line of the Chester and Holyhead Railway. The bridge, which was finished in September 1846 and opened to freight traffic on 4 November, had been approved in design by the Board of Trade inspector, Major-General Pasley. The bridge was constructed utilizing cast-iron girders, T-shape in section and inverted so that the flanges at the bottom acted as supports for the timber beams laid between girders. Each girder was made of three large sections dovetailed together. The three-piece girders – each about 30.5 metres (100 feet) long and each of which ran between masonry piers and abutments – were reinforced along their length by wrought-iron ties.

ABOVE: Sketch of a portion of a cast-iron T-shape girder of the type used in the construction of the Dee Bridge. Inverted – as shown – the long horizontal flanges were used to support timber beams that carried the rail track.

These somewhat pioneering methods and materials of construction were chosen by Stephenson because cast-iron was believed to be very strong in proportion to its weight and mass, could reach wider spans between supports than conventional masonry construction and was relatively speedy and economical to use. This meant that the required strength and span could be achieved in a most minimal, elegant and inexpensive manner, incorporating fewer vertical piers and less extensive foundations to carry the relatively lightweight construction. Major components could be pre-fabricated efficiently in factory conditions with the whole construction process being more controlled, less vulnerable to the vagaries of the weather and less labour-intensive. It all sounded good, but the product of this admirable thinking did not result in a safe solution to the particular engineering challenge of bridging the River Dee or to specific operational realities of running a mid-1840s railway system.

On 24 May 1847, part of one of the bridge's cast-iron girders broke while a train was passing across, causing a partial collapse of the bridge. Part of the train fell through the shattered carriageway of the bridge, killing five people and seriously injuring nine. The disaster caused a national furore and attracted intense interest from the public, the engineering profession and politicians. The result was a detailed inquiry, the first undertaken by the newly-established Railways Inspectorate. Within days of the disaster the lead investigator appointed by the Railways Inspectorate – Captain Simmons of the Royal Engineers – examined the broken parts of the bridge, ascertained that the bridge's cast and wrought-iron components were of high quality and that manufacturing flaws were not the culprits for the collapse. He conducted various tests, including driving locomotives across the surviving girders and noting the alarming extent to which they deflected, or bent, under the moving heavy load – an action that inflexible cast-iron could not accommodate without damage.

Within days, the aftermath of the disaster claimed another victim. Death was not the penalty now paid but disgrace. On

29 May, Major-General Pasley – the official who had declared the bridge safe – was dismissed as an inspector for the Board of Trade. But the bridge's designer, Robert Stephenson, survived – for the moment at least. In fact Stephenson had taken the offensive, seemingly at the request of the Chester & Holyhead Railway Company. If Stephenson had felt inclined to make an honest admission of a mistake he was persuaded not to do so by the solicitor acting for the railway company. Such an admission of liability could, Stephenson was told, prove fatal both to himself and to the company. Stephenson was evidently persuaded to take the view that his career could only survive if he escaped with no responsibility attached.[55] So he went for a whitewash – and it was a most provocative gamble. Two days after Pasley was dismissed Stephenson wrote a formal open-letter to the Directors of the Chester & Holyhead Railway to give it as his opinion that the collapse was caused by something neither he nor they could be held responsible for. He maintained that by chance or mishap the locomotive happened to derail while crossing bridge and that the force of its impact – huge given its weight and forward momentum – had caused the cast-iron girder to fracture.

Four days later, on 4 June, the coroner's inquest into the five deaths opened in Chester Town Hall. Witnesses were called to describe the circumstances surrounding the disaster, various explanations for the collapse of the bridge were tested and responsibility started to be apportioned. During the inquest it was quickly established that the disaster could have been avoided if warning signs had been properly understood and acted upon. A number of painters stated that when they were working on the newly completed Dee Bridge they observed large deflections of several inches when trains passed over. These observations had been reported but were either not passed on to Stephenson or were ignored. No one was sure which. In addition, it was reported that a short time before the bridge was opened for passenger use, a fracture appeared in one of the cast-iron girders near a joint. Stephenson was told about this but he concluded that the problem was a

faulty casting and a replacement section of girder was quickly made and fitted.

In the context of these revelations it is easy to understand why Stephenson's somewhat lame explanation that the collapse was caused by the derailing of the engine did not impress coroner or jury. Especially since Stephenson's claim was challenged by eye witnesses who insisted that they saw the girder break before the carriages plunged into the river, by the train driver and surviving passengers and, most pertinently, by the fact that the locomotive did not plunge through the bridge into the river, but never left the rails at all. In fact, it was used to summon aid after the collapse and give warning! One eye witness account, supported by others, was particularly revealing and compelling. Thomas Jones was a publican and milkman in Chester and gave evidence that he saw the train 'put my milk cans down and watched it cross the bridge' – trains steaming across minimal iron bridges were still quite a novelty in the mid 1840s. 'The train got to the furthest arch when I observed a crack open in the middle of the girder; the train and tender were about the centre; the crack opened from the bottom; the engine had passed the crack, and the tender was right upon it; the engine and tender went on, and I saw the tender give a rise up; the carriages gave a jump and fell backwards; the last carriage went down first according to my judgement; the next I saw was the large stones fall off the wall...I am certain the girder opened up from the bottom.' If this account was to be believed – and there was no reason why

it should not since it was supported by evidence from several other eye witnesses – then the failure of the girder, starting from below and after the train had passed, had nothing to do with an impact from a derailed locomotive. It was evident that something must have been wrong with the design of the bridge or with the choice of the materials used.[56]

Despite a growing evidence of a failure in design, Stephenson and the railway company managed to persuade four eminent engineers to speak on their behalf. Men who were usually in ruthless competition to secure commissions now worked together to defend not just an eminent member of their profession but by implication their profession itself and, of course, serve the needs of a railway company that could at some future date prove to be a bountiful employer. For example, Stephenson had been in bitter dispute with Joseph Locke – a long-time rival – but Locke came forward to defend the design of the bridge, despite the fact that he, like I. K. Brunel, distrusted the use of brittle cast-iron in bridge design, preferring timber or masonry.

Captain Simmons' preliminary findings were also heard and these tended to confirm that the design was at fault, an implication supported by Henry Robertson – the engineer of the Shrewsbury & Chester Railway – who broke ranks with his professional colleagues and stated roundly that the bridge had been badly designed and that far from strengthening it the wrought-iron ties had actually weakened the cast-iron girders by imposing severe local stresses.[57]

The coroner's jury not only summarily dismissed Stephenson's explanation of the collapse but the foreman of the jury, Sir Edmund Walker, argued that Stephenson should both be found negligent and be charged with manslaughter.[58] However, the coroner acted to cool things down and in his summing up excluded a direct charge of negligence against Stephenson – it would seem that evidence collected and examined so far did not justify such a mortal blow to the engineer's career. The coroner also made it clear that Stephenson was not being accused of manslaughter. But with the derailment theory dismissed as not credible there

remained only one serious contender for villainy: cast-iron. Although a robust material, cast-iron could – if used in designs that put it under intolerable or unexpected tensile strain – fail with dramatic ease and suddenness.

The jury, having stated that all the victims had died accidentally, then expressed its unanimous opinion on the design of the bridge and on cast-iron in general and in so doing sent forth through the nation a clarion call of warning:

'...the girder did not break from any lateral blow from the engine, tender, carriage or van, or from any fault or defect in the masonry of the piers or abutments; but from its being made of a strength insufficient to bear the pressure of quick trains passing over it... no girder bridge of so brittle and treacherous a metal as cast-iron alone, even though trussed with wrought iron rods, is safe for quick or passenger trains.'

Quite simply the span had been too wide to be bridged safely with a material as brittle as cast-iron when used in this manner. The jury concluded by issuing a warning and a call for urgent action:

'...we have in evidence before us, that there are upwards of one hundred bridges similar in principle and form to the late one over the River Dee... all are unsafe... We therefore call on Her Majesty's Government, as the Guardians of public safety, to institute such an inquiry into... these bridges as shall either condemn the principle or establish their safety to such a degree, that passengers may rest fully satisfied there is no danger, although they deflect from 1 to 5 inches.'

Ten days after the verdict and appeal of the coroner's court, Captain Simmons' report was published and the anger, anxiety and heart searching surrounding the disaster reached a new level of intensity as more and more detailed evidence was revealed. Some of this evidence was peculiar and much of it baffling and surprising. The coroner's jury had emphasized one strange anomaly of the age. While it was generally acknowledged that cast-iron, strong in compression but

brittle in tension, was hazardous for bridge construction it was, in fact, being used in abundance. Most engineers understood that if forces turned out not to work as calculated, then cast-iron could prove lethal. It was for this reason that Brunel rarely used cast-iron in structures where tensile strength was – or could – be needed, and it was why Locke preferred masonry for bridge construction.

So why, in this context of uncertainty, had Stephenson used so much cast-iron in his Dee Bridge? Certainly he was fully aware of its potential shortcomings, which was why – to compensate for them – he had added wrought-iron ties. These, with their greater tensile strength, had been intended to beef-up the cast-iron girders. This raised another question. Although this constructional technique of combining cast-iron girders with wrought-iron ties and tension rods was still experimental in the mid 1840s, such solutions had been used

ABOVE: The shattered River Dee Railway Bridge as illustrated in a newspaper immediately after the accident that killed five people. Was the disaster due to faulty design and the miscalculated and extensive use of cast iron? The bridge's engineer, the great Robert Stephenson, had some difficult questions to answer.

before and they appeared to be successful. Why had they not worked on the Dee Bridge? What had gone catastrophically wrong?

Soon answers to some of these questions, or at least possible explanations, started to emerge. For a start it was discovered that on the day of the accident the cast-iron girders had been made to carry a large and additional dead-load as well as the live load of trains moving across it. A bridge designed by I. K. Brunel at Uxbridge, London, on the Great Western Railway, had recently collapsed after timber elements caught fire. Burning coals falling from engines represented a great danger to all timber bridges, and the tracks on the Dee Bridge were in fact carried on oak beams running between the cast-iron girders and resting on their flanges. In the wake of the Uxbridge incident, and to protect the bridge from the risk of fire, Stephenson had ordered that the potentially vulnerable oak beams be covered with a thick layer of heavy track ballast. This ballast had been laid only a few hours before the disaster and so was a prime suspect for the cause of the failure. Had the added weight simply proved too much? This additional weight could indeed be a contributory cause, but when Captain Simmons' detailed report was published it suggested that the cause of the collapse was more complex – so complex that it is, in its details, still disputed.

Simmons delved into the very nature of cast-iron and found it very seriously wanting as a primary structural material. The character of the breaks in the failed girder, combined with the serious deflection he observed when locomotives passed over surviving girders, led Simmons to give it as his highly informed opinion that the main reason for the collapse was that the cast-iron girder had failed due to metal fatigue that was the result of repeated flexing. The 30 metre span Stephenson had created was simply too long. The design of the bridge was, as far as he was concerned, fundamentally flawed for it relied on cast-iron to perform in a manner that could lead only to collapse. And as for the wrought-iron ties, Simmons argued that they did not in fact reinforce the cast-iron girders at all. It now seems hard to credit, but apparently in Stephenson's design the wrought-

iron ties were fixed solely to the cast-iron girders rather than to, or between, the girders and solid masonry supports. Consequently, as Simmons pointed out, the ties did not restrain movement in any useful way but simply moved in unison with the flexing cast-iron girders.

In June 1847 Robert Stephenson's professional life was in the balance – indeed in a state of chaotic disturbance – at the very moment when he was embroiled in the design and construction of two large and demanding bridges that both embraced the use of bold and pioneering structural iron work. Just a few months before the completion of his ill-fated Dee Bridge, construction work had started – in April 1846 – on the 408-metre-long (446-yard-long) High Level Bridge across the River Tyne in Newcastle, and in June 1847 iron was being delivered to start construction of the 213 metre (700 feet) span of his Britannia Bridge across the Menai Straits in Wales. But, due to the disaster on the Dee, Stephenson found himself fighting to defend his reputation and, by implication at least, to defend his designs for Newcastle and for the Menai Straits.

Stephenson, and all concerned, must have realized that it was essential to identify the causes of the Dee collapse, to learn lessons and, if necessary and appropriate, to apply them to his current bridge-building projects, perhaps even to radically alter their design or materials of construction. Rarely can an engineer, when involved in the crucial and costly stages of the construction of such complex designs, have been in such a troubling position. Stephenson's very competence to do his job was under scrutiny in a most public manner, as was his knowledge of the potential and problems of pioneering technology. People must surely have been wondering if he really understood what he was doing. There must have been some loss of confidence, not least because Stephenson's bungled attempt to confuse the debate about the collapse of the Dee Bridge hardly suggested that he was willing and able to learn from what had happened.

In mid 1847 confusion reigned and no clear and agreed consensus had been reached as to the cause of the collapse of

the Dee Bridge and what courses of action should be taken to avoid its repetition. The profession of the structural engineer was suddenly in flux. The coroner's jury had been listened to and in August 1847 the Government set up a Royal Commission, chaired by Lord Wrottesley, to see what lessons could be learned from the Dee Bridge disaster and how to apply them to the whole question of the use of cast- and wrought-iron in the construction of railway bridges.

In June 1847, as Stephenson got on with the construction of the Tyne bridge, all that was clear – and generally accepted – was that the Dee Bridge disaster confirmed that cast-iron was no universal wonder-material and that, if used in situations where great tensile strength was needed, it would fail. And it was, as it happened, cast-iron that Stephenson was using in abundance for the construction of his High Level Bridge over the Tyne.

Stephenson seems to have remained determined not to concede liability for what had happened – indeed he remained an advocate for the use of cast-iron. What else could he have done? But despite his outward show of bravura and confidence to the point of hubris Stephenson must have been a chastened and wiser man. He must also have been a somewhat frightened man. What on earth would the Royal Commission conclude about contemporary bridge design and the use of cast-iron and – of course – about him, his professional ability and his bridges? Would the findings of the Commission bring his career to a humiliating end, would the Dee Bridge collapse prove to be his nemesis?

On my visit to Stephenson's High Bridge in late 2009 I tried to imagine the atmosphere on site in spring 1847, just after the Dee collapse when this Newcastle bridge was well underway. There must have been a sudden air of uncertainty, even panic. Cast-iron was one of the main structural materials for the bridge and it, along with the bridge designer, had been revealed to be, at the very least, fallible.

The bridge has recently been repaired and restored, with its iron work painted in a pale buff stone colour to match the colour of the sandstone piers on which the iron-built spans sit. This was the colour the iron was originally painted. Was

Stephenson, I wonder, trying to disguise from the travelling public – alarmed by the Dee Bridge collapse – the fact that this bridge also incorporated large amounts of suspect cast-iron, the material the coroner's jury had described only a few years earlier as a 'brittle and treacherous metal'.

I approached the bridge from the Gateshead side and saw first an entrance screen, somewhat reminiscent of a Roman city gate but made of cast-iron, and then coming more on to the alignment of the bridge, I was confronted by a stupendous vista, stretching over 320 metres. I looked down the 6-metre wide road – roughly half of the bridge's width – toward the heart of Newcastle city centre, and on each side were dramatic views along the pedestrian footpaths, each of which is roofed with semi-circular ribs and braces of iron which give the walkways the romantic look of vaulted passages. The geometry is powerful yet, in addition, the vista also bristled with intriguing authentic and delicate details – including street lamps – that are integral with the structure. It's a wonderful and thrilling view, a Victorian cast-iron dream. What more could you want? As I entered, a train rumbled above, travelling on the tracks laid over the road and then it veered to the left, onto a masonry viaduct. I walked along one of the pedestrian paths set between pairs of huge cast-iron arches connected and braced by cast-iron X-form frames. I relished the robust ironwork – essentially functional yet with small decorative flourishes – and wondered at the large sections with flanges bolted onto yet larger sections. Here, in the Gothic spirit much admired in the nineteenth century and explained and promoted by such theorists as A. W. N. Pugin, the honest expression of the methods and materials of construction are the great and true ornament. Every form and detail is primarily doing a practical job – ornament is, in the ideal Gothic manner, simply a consequence of function and construction. It is an amazing and moving experience to walk through a vast and complex engineered structure, to finger its massive parts, to see precisely how all fits together and to begin to fully understand how it works.

RIGHT: Cast-iron components, acting as braces, give robust strength to Newcastle's High Level Bridge.

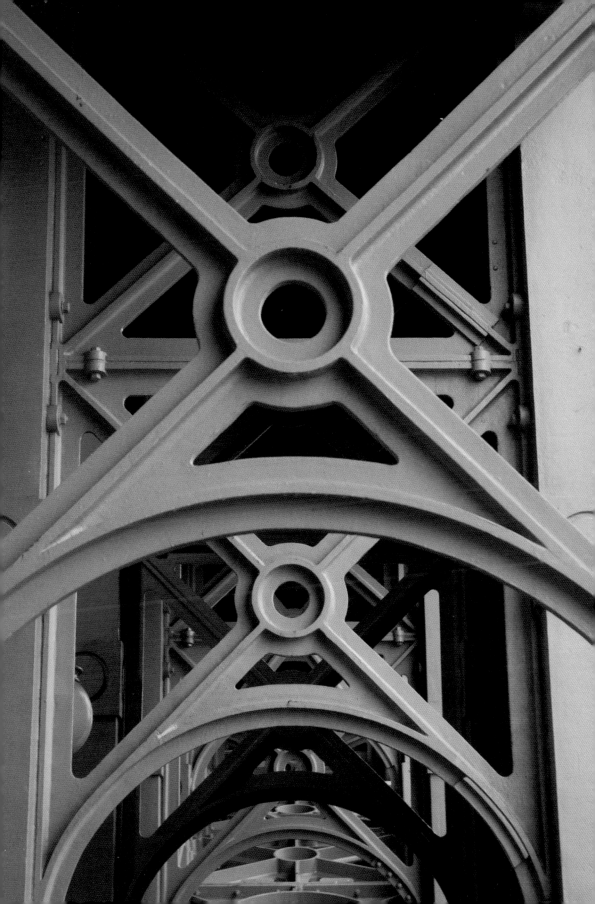

> ‘Stephenson was brooding on the use of
> materials before the disaster at the Dee
> Bridge, so could have chosen a combination
> of cast-iron girders and wrought-iron ties.’

When Stephenson started to design the bridge in late 1845, he was confronted by a wide range of structural possibilities, but seems to have quickly decided that the piers should be built of local sandstone with their construction made firmer, more economic and quicker through the use of newly developed technology. The tallest of the piers had to rise 44.5 metres (146 feet), all to measure 14 by 5 metres in plan and all were to rest on foundations formed with huge timber piles, each of which was to be 40 centimetres (13 inches) square in section and 13 metres (40 feet) long. When construction started the piles were driven through sand and gravel to the bedrock by means of a steam hammer recently invented by James Nasmyth, and then encased and capped with concrete. The works were carried out within piled cofferdams that, in a most economical and elegant manner, were to be left in place to serve as protection for the pier bases.

The first pile was driven in April 1846 and the piers were completed four months later when, on 29 August 1846, the new bridge was used for the first time by means of a temporary timber superstructure erected on the piles. The last permanent span was completed on 7 August 1849 and the bridge was opened by Queen Victoria on 28 September 1849.

As I walked through the structure of the bridge I pondered Stephenson’s thought process. He’d decided upon the material and manner of constructing the piers but he also had to decide how to build the spans between them, not least because this would have influenced the number and location of the piers.

He was brooding on this before the disaster at the Dee so could have chosen a combination of cast-iron girders and wrought-iron ties. As subsequent events made clear such a decision could have proved a disaster. Alternatively he could have chosen cast-iron arches spanning between piers. This was a simple solution but he rejected it because the masonry piers would have had to restrain the outward thrust of the arches and this could have led to catastrophe if the piers settled so that the thrust was not transferred directly to solid abutments. Instead – and most happily – Stephenson chose to design each span as a bow-string truss, a form of construction he had first used in 1835 for a bridge at Weedon for the London & Birmingham Railway.

In this design cast-iron components were used to form the bow or arch that spanned between stone piers but these arches – each with a span of 38 metres – were designed to exert no outward thrust on the piers or abutments because 'strings' formed by wrought-iron girders tied their ends. This bow-string form was particularly suitable for the bridge's function. The deck, 40 or so metres above the Tyne and carrying three lines of railway tracks, was supported by the crown of the arch and applied a downward load on its cast-iron members that, strong in compression, performed splendidly. The wrought-iron strings or girders, partly hung from the arches by wrought-iron bars, tied the ends of the arches together and also carried the road and footpaths.

Stephenson was almost manic in testing the quality of the ironwork that was produced locally by Hawks Crawshay & Sons who, with Stevenson, undertook much research to determine the best mix for the cast-iron girder work with each span erected and tested at the foundry before being taken to site.

The assurance of the high quality of its iron components and the wise nature of its design and construction with cast-iron used in compression and wrought-iron in tension must have been one of the things that kept Stephenson sane in mid 1847. He knew that here, on the Tyne, he most fortunately had not repeated the errors of the Dee Bridge and had every

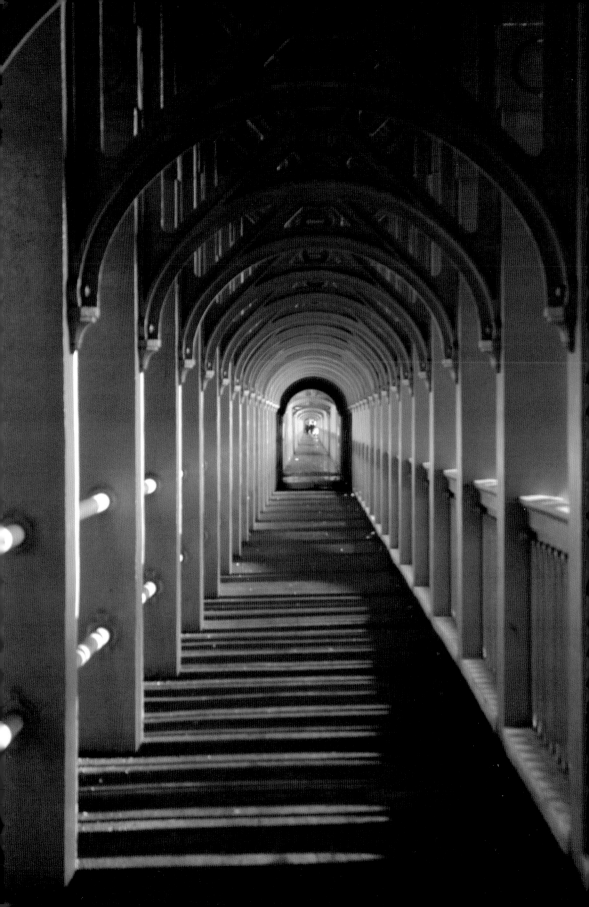

reason to believe that this bridge was of far greater strength and reliability and would not fall.

The day I walked across Stephenson's High Level Bridge, rain and sombre gloom was followed by sun and dramatic shadow. The transformation of the bridge from a thing of brooding beauty to a sparkling jewel was extraordinary. Dark recesses suddenly became dappled in light and revealed themselves as columned cloisters. Strong shadows and bright light suddenly defined the bridge's form. Immediately I could see it as a pure and honest – almost abstract – sculptural form. It was sensational.

In July 1849, less than a month before the Tyne bridge was opened by Queen Victoria, the Royal Commission reported its findings and conclusions about contemporary iron-built bridges. Many people had been interrogated, including Stephenson. He remained bullish. He admitted to the Commission that he, and several other distinguished engineers, were still intending to build bridges of similar design to that over the Dee and continued to maintain that the design was not intrinsically defective. Evidently he still believed, or was being persuaded, that to admit any liability would be fatal. As long as he could maintain doubt about the cause of the collapse the final verdict would remain open and the initial conclusion that Stephenson was not guilty of negligence, or responsible for the five deaths, would be sustained.

Stephenson also questioned the very function of the Commission. He told it that he thought the 'collection of facts and observations would be most valuable' but argued that he was 'quite sure' that the Commission's attempt 'to draw conclusions from those facts, and confine engineers, even in a limited way, to those conclusions... will tend to hamper the profession very much'.[59] The Commission's report did indeed condemn the use of cast-iron girders and trusses in bridge construction and confirmed that cast-iron when subjected to heavy moving loads and flexing would show fatigue and fail. By implication the Dee Bridge design was found faulty, and as a result scores of recently completed largely cast-iron bridges had to be reconstructed or substantially

LEFT: View of the pedestrian route across the High Level Bridge. Here honestly expressed structure is pure, almost abstract, ornament – a dream in Victorian cast-iron and light stretching seemingly to infinity.

strengthened. But Stephenson escaped. He was not singled out as negligent nor was he condemned. He had survived but, in the summer of 1849, his professional reputation was tainted. The successful completion and opening of the Tyne bridge helped a great deal but his work remained under close scrutiny. He could not afford another mistake.

While Stephenson escaped ruin in 1849, another leading member of the railway world did not. George Hudson – the inspiration and moving force behind the creation of the High Level Bridge across the Tyne – finally met, and was consumed, by his devils. The so-called 'Railway King' had lived the high life for a number of years, but it was on borrowed time. As a powerful and wealthy man, and as a former Lord Mayor of York and an MP, he was in an excellent position to perpetrate numerous frauds and deceptions over a long period of time in a still infant and largely unregulated industry.

But in late 1848 his world started to unravel. Quizzical and long-baffled committees of shareholders finally discovered that Hudson had embezzled money, sold shares to his companies at much higher than market rate to inflate their value, implied non-existent profits by paying company dividends out of capital rather than revenue, and paid money due to others into his own accounts.[60] The value of shares in Hudson's companies plummeted; he was obliged to resign from many of his directorships and to repay huge sums from his own resources. Perhaps worst of all, he became a national hate-figure and the focus of high Victorian moral outrage, the image of the evil reverse side of railway entrepreneurship, of corrupt greed and of wealth acquired by artifice and deceit. In 1849 Hudson was expelled from York city council, his name was removed from street signs and his wax effigy in Madame Tussauds melted down.

The nature of Hudson, his fraud, and his fate was, for many, emblematic of the grasping and amoral age. It seemed to offer an object lesson to any who cared to see it – indeed seemed to reflect a dark aspect of the age, much as did the contrast between the immense wealth created by the cotton boom in northwest England and the great poverty and

distress under which so much of the population lived. The German social scientist Friedrich Engels was shocked by the fact that among such wealth and technological progress there could be such poverty, disease, inequality and hopelessness. He wrote much of the *Conditions of the Working Class in England*, published in 1844, based on observations made in Manchester and the North West during his time spent there between 1842 and 1844, and communicated regularly with Karl Marx, who drew on Engels' findings when in 1848 he drafted the *Communist Manifesto*. Engels came to the conclusion that there was something sick at heart with the capitalist system; that it was brutally selfish, greedy, exploitative and jungle-like in its predatory nature. This bleak conclusion seemed to be reinforced by the publication of Charles Darwin's *Origin of the Species* in 1859, which raised the question of whether creation and humanity were really just random acts, and whether savage exploitation was a ghastly law of an uncaring nature. Was the creed of the 'survival of the fittest' – a slogan that was not coined until the early 1860s, but which perfectly expressed the nature of life in 'Cottonopolis' – really a law of nature and a justification for ruthless industrial exploitation?[61]

George Hudson fled to France, where he became embroiled in new financial difficulties, and returned to England in 1865 to fight the general election for a seat at Whitby – hoping presumably that acquiring parliamentary privilege would help him remain relatively safe from creditors. But this was a fantasy. On his return Hudson was arrested, imprisoned in the debtors' jail in York where he remained until a few remaining admirers raised enough money to secure his release and provide him with a modest annual income. In December 1871, this former magnate of the railway age died, leaving effects worth less than £200. This extraordinary tale of heady success rapidly followed by catastrophic failure is a hint at the fate that might have awaited Stephenson had he been found guilty in 1849 of the manslaughter of five people. The Victorians did not like to be let down by their heroes or to be shown the hollow,

selfish and tainted heart of their thrusting, ambitious and self-promotional age.

During the autumn of 1849 most of those involved in the world of engineering and railways must have taken the same walk that now thrilled me. They must, out of professional curiosity, have come to see Stephenson's latest and greatest work, and to ponder on its durability among other things. Apart from being an absorbing object in itself the bridge also offered views over the Tyne and over Newcastle that must have astonished at the time – indeed they still astonish. I stopped when about halfway across and looked to the east. In front of me was a prospect that included not just the city's other major bridges – dominated by the vast steel arch of the 1920s Tyne road bridge – but also a bird's eye view of Newcastle's quays that, in the 1840s, would have been bustling with maritime life.

From its opening, Stephenson's High Level Bridge became a vital part of the life of Tyneside – it carried people and transport, and transformed the manner in which the city could view itself. Like so many great urban bridges, it also became a place where life could end. As on the Golden Gate Bridge in San Francisco, I saw a telephone with a message from an organization offering to talk to people in despair. Nearby there was evidence that for some such offers come too late: a makeshift shrine, formed of a placard with scribbled sentiments, some dead flowers and a faded photograph of a young woman. My reverie brought to a sudden end, I scurried off the bridge into Newcastle. I now wanted to see it from afar.

I walked along the quay and past a group of ancient warehouses that huddle near the base of one of the bridge's piers, as if cowering in the presence of the huge and majestic being towering above. Near the warehouses survives one of Newcastle's traditional steep and winding allies. I climbed its steps to get views of the bridge, framed by foreground buildings. For a moment I could see it in its nineteenth century setting – a vast and modern structure cutting through and above the smaller-scale buildings of an old city centre – and grasp how it would have been perceived at the time, truly a wonder of the modern world.

RIGHT: Newcastle's High Level Bridge, completed in 1849: a mid-Victorian vision of the modern world soars above a Tyne-side alley framed by Georgian warehouses and cottages.

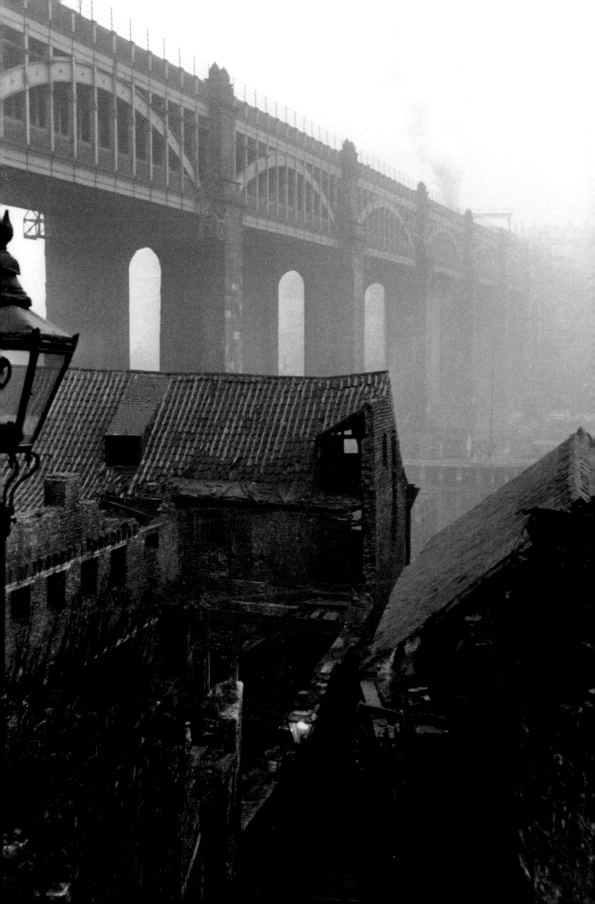

But surrounding the bridge, the world has of course changed mightily during the last 160 years. Looking along the bridge towards the centre of Gateshead I could see the sculptural reinforced concrete block of a huge multi-storey car park. It was designed in the 1960s by a one-time president of the Royal Institute of British Architects named Owen Luder and achieved a moment of fame when featured as a murder scene in the grainy gangster film *Get Carter*. Starring Michael Caine and released in 1971 the film picked up on the city's then grim reputation for crime and poverty and encapsulated the Newcastle of spivs, corrupt politicians and old-fashioned squalor that had been suggested to the British public by the bizarre antics of T. Dan Smith and his cronies. Now the emblematic car park, a 1960s symbol of progress and the motor age, is being demolished. Yet the mighty High Level Bridge – once challenged by the new transport policies the car park represented – endures, and looks better now than for many a year as it steams into the second half of the second century of its existence.

If Robert Stephenson's reputation still hung in the balance after the completion of the Tyne bridge things were soon resolved. On 18 March 1850 his Britannia Bridge across the Menai Straits was opened for public use and immediately hailed as a great success. And for this most challenging of bridges Stephenson had moved away entirely from the dubious technology he had applied ten years earlier when designing the Dee Bridge. Although the design of the Britannia Bridge had started a few months before the collapse of the Dee Bridge it is probably correct to see the final design as a response to the woes and worries that had beset him in the late 1840s. Stephenson had learned his lessons and applied them as the pioneering Britannia design evolved. This bridge was intended to vindicate him, to remove the tarnish from his reputation and it did. It was heroic and – more to the point – was of vastly strong tubular not girder construction and the material used not cast-iron but wrought-iron, making the Britannia the world's first major and largely wrought-iron built bridge in which design was

determined by detailed mathematical calculation.

Nearly ten years later, just before his death in October 1859, Robert Stephenson finally, and somewhat guardedly, admitted the errors of his Dee Bridge design. He observed that the 'objection' to the type of cast-iron girder combined with wrought-iron ties that he had used was 'common to all girders in which two independent systems are attempted to be blended and...should be avoided'. The excuse he offered was that such girders were used 'when no other means existed of obtaining iron girders of great span'. But this admission of fault was strictly limited because Stephenson maintained, to his dying day, that the Dee disaster was a rogue and inexplicable event rather than an unavoidable consequence of a series of unfortunate design decisions, for this 'melancholy accident' argued Stephenson was 'the only existing instance' of the 'failure' of such girders.[62]

This was no doubt true before 1859 – partly because such girders rapidly fell from use after the Dee Bridge disaster and after the use of cast-iron in bridges was generally discouraged by the findings of the Royal Commission. But cast-iron, when still used in a limited way and capacity, continued to cause problems throughout the second half of the nineteenth century – notably in the famed Tay Rail Bridge catastrophe of 1878. In this case, cast-iron lugs were put into tension when gusts of high wind loaded the structure of the bridge in a manner that it was not calculated – and indeed tragically unable – to resist.

Ultimately even the immensely strong Britannia Bridge was unable to escape a 'melancholy accident' and the end, when it came, was caused by one of the great and paradoxical enemies of iron. Both cast- and wrought-iron are forged in fire but neither can endure intense heat for long without deforming or, if doused with cold water, cracking. In 1970 two boys playing on the bridge accidentally started a fire on the top of one of the wrought-iron tubular spans. Debris and the coats of pitch with which the bridge had been waterproofed over the years blazed away and within hours the wrought-iron components of Stephenson's great bridge were destroyed

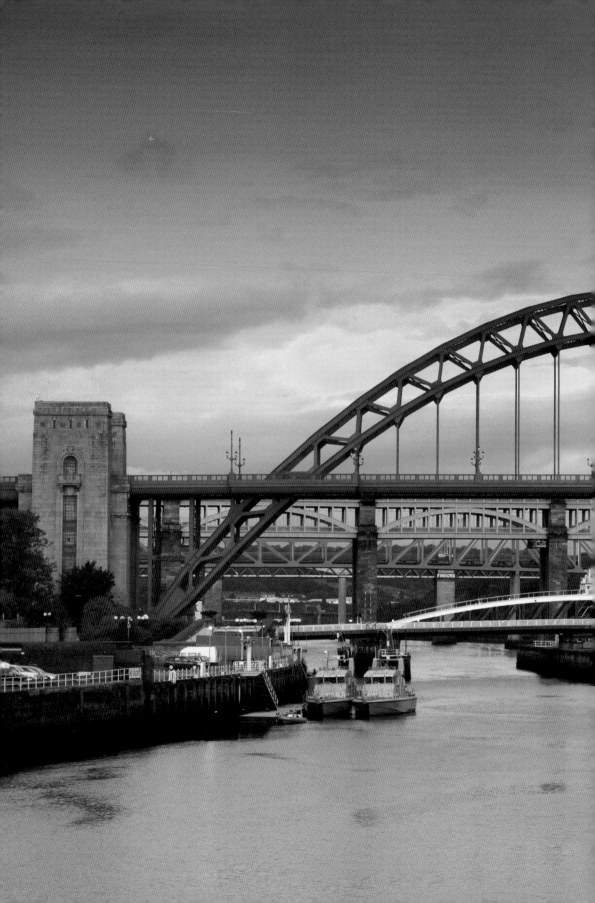

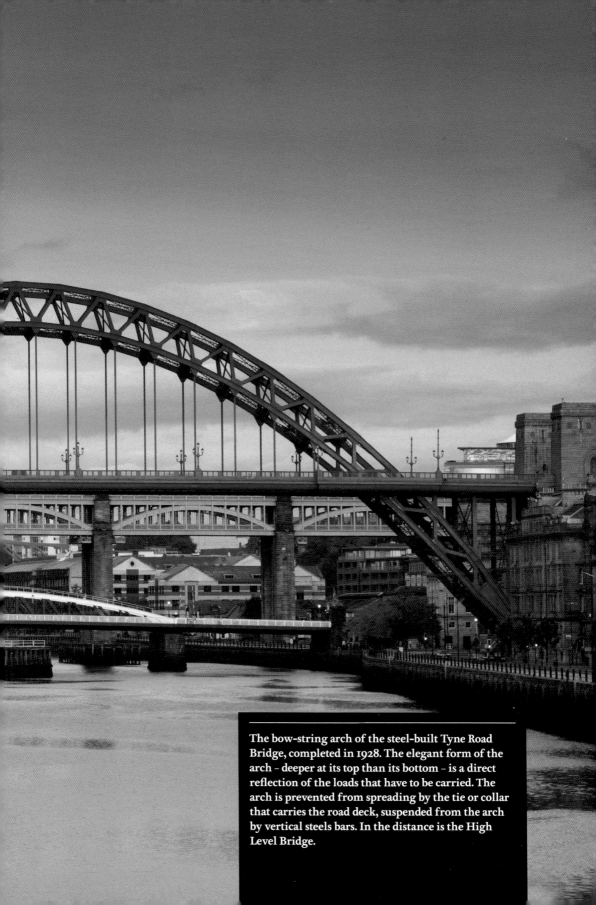

The bow-string arch of the steel-built Tyne Road Bridge, completed in 1928. The elegant form of the arch – deeper at its top than its bottom – is a direct reflection of the loads that have to be carried. The arch is prevented from spreading by the tie or collar that carries the road deck, suspended from the arch by vertical steels bars. In the distance is the High Level Bridge.

or damaged beyond repair. And that left Newcastle's High Level Bridge as the greatest surviving bridge of one of the greatest nineteenth century engineers.

My final view of Stephenson's enduring masterpiece was a point on the quay from which I could see it fully in the setting of the other city centre bridges. In the foreground lay the low swing bridge and – in the distance – the mighty Tyne road bridge, whose single great arch responds most happily to the geometry of Stephenson's bridge, in particular echoing the forms of the arches embedded in his bow-string spans. This visual resonance between these two great bridges is one of the things that makes the vista memorable. The other is the sheer swooping scale of the Tyne road bridge's huge 161.8 metre span.

The contract for the construction of the Tyne road bridge was awarded in December 1924, which was a significant year in the world of bridges because the contract for the structurally similar, although much larger, Sydney Harbour Bridge was awarded in March 1924. Ask most people which of these two bridges came first and they'll tell you that it was the Tyne bridge, because being smaller it was completed in 1928, over three years before the Sydney bridge. But the evolution of the design of the two bridges is overlapping and complex. The Sydney Harbour Bridge was designed by Ralph Freeman – based on the pioneering Hell Gate Bridge in New York, designed by Gustav Lindenthal and opened in September 1916 – and constructed by Dorman Long of Middlesbrough.

The Tyne road bridge was designed by Mott, Hay and Anderson – inspired by the designs of both the Sydney Harbour Bridge and the Hell Gate Bridge – and was also constructed by Dorman Long. To make the connection complete, Ralph Freeman acted as consulting engineer for the Tyne bridge. So this is very much a tale of three bridges around the world with the Tyne and Sydney bridges applying and refining Lindenthal's original bold conception.

Lindenthal's Hell Gate Bridge, built to carry a railroad across the East River onto Manhattan Island, utilized the tensile strength of steel to create a span of 310 metres by

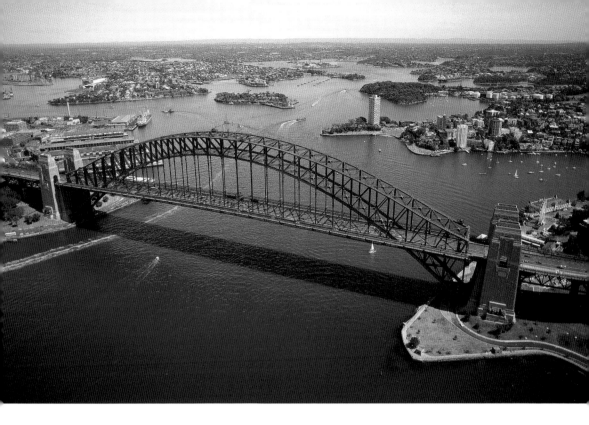

ABOVE: The Sydney Harbour Bridge, Australia: a mighty bow-string arch bridge conceived slightly before the Tyne Road Bridge but, due to its far larger scale, not completed until 1932 when it became not just a symbol of the city but of a nation. Note that the upper chord of the arch stops short of the abutment towers.

means of a vast bow-string arch or tied-arch bridge – the very structural form that Stephenson had used to create the spans on his High Level Bridge. In Lindenthal's design, as in Stephenson's, the outward thrust of the arch – formed by two parallel arches of matching size and structurally linked by lattice-work – is restrained by horizontal strings that carry the carriageway which, for added strength, is also suspended from the arch. But rather than restraining the arch at its base, the strings act more as collars, with the arch descending below them and apparently being restrained by masonry towers or pylons. In fact these towers are not required to counter the outward thrust of the arch – the strings do that most satisfactorily – and in Lindenthal's original design there was a gap of 4.6 metres left between the steel arch and the masonry towers. But it was felt that this gap might worry the public using the bridge, so Lindenthal added functionally unnecessary but visually reassuring girders to physically link

The Hell Gate Bridge, New York, designed by
Gustav Lindenthal, opened in 1916. This was
the prototype for the Newcastle and Sydney
bow-string arch bridges.

the arch to the towers. Lindenthal wanted his bridge to not only be strong but also to look strong and to achieve this he was willing to resort to a little visual subterfuge.

An added advantage of Lindenthal's bold arched design is the fact that the bridge looks most happily like a great if symbolic gate marking a ceremonial point of entry. This was clearly one of the reasons why this design was chosen first for Sydney and then for Newcastle, where passing below the bridges was akin to passing over a threshold. This is one of the main reasons, no doubt, why the Hell Gate/Sydney/Tyne form has been emulated at the Lupu Bridge, Shanghai, of 2003 with a 550-metre main span and at the Chaotianmen Bridge, Chongqing, China, of 2008 with a slightly longer 552-metre span. The emotional, artistic and structural attractions of this ideal bridge form appear universal and timeless.

The construction techniques of the Tyne road bridge also mimicked those of the Sydney Harbour Bridge. Because the water was deep at Sydney and because the harbour master at Newcastle insisted that navigation of the Tyne must not be interrupted during construction, both bridges had to be built off themselves. As the two ends of the arch and string advanced from each side of the Tyne they initially worked as vast cantilevers. Cranes were fitted at their ends to construct further sections until both sides met and finally – on 28 February 1928 – the arch was closed.

Walking across and around the Tyne road bridge is quite an experience. Its members are huge when you confront them head-on, notably where the arch breaches the road carried on the string and where its 'hinges' hit ground level. This bridge is not elegant but it is elemental, sublime – a huge, heroic and robust artefact, conceived and constructed to do a very specific job well and, with only minimal maintenance, to last in perpetuity. It is also more structurally and visually logical than its two precursors. At the Hell Gate Bridge the upper chord of the mighty arch bends up to bury itself in the flanking stone towers while the lower chord passes below the deck to join the base of the towers at ground level. At the

Sydney Harbour Bridge the upper chord flares out with the entire arch terminating just before the stone towers. But at Newcastle the chords of the arch do not flare out towards the base of the arch as in the other bridges, but run together, and both terminate at the base of the towers at ground level.

Some may think the artistic flaring of the chords on the Hell Gate and Sydney bridges is more beautiful than the ruthless logic of the Tyne bridge construction. It is, of course, a matter of taste – the ruthlessly rational versus the remotely romantic. But when it comes to an expression of strength as opposed to beauty I think the Tyne bridge is the winner. It is a work possessing the very power of nature itself – an incredibly strong form wrought out of an immensely strong material – in many ways the very image of the elementally powerful and perfect bridge.

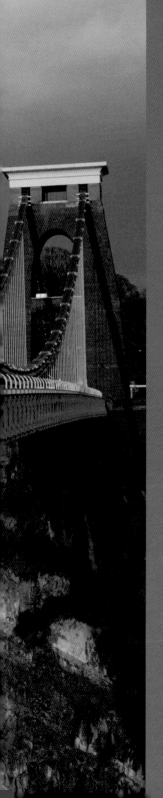

THE BIGGEST AND BOLDEST

SUSPENSION BRIDGES EPITOMIZE THE FINEST
qualities of bridge design – elegance, minimalist means of
construction, heroic daring – and awe-inspiring scale and
spans. It is a suspension bridge – the Akashi-Kaikyo Bridge
of 1998 in Japan – that with its 1,991-metre central span, is
currently the world record holder for the bridge with the
longest span. But these stunning creations have suffered serious
problems as the often-implacable characteristics of the forces
of nature have revealed themselves. A notable example is the
Tacoma Narrows Bridge in the USA, which, in 1940, wobbled
itself to destruction only a few months after completion, and
in the process exposed a new natural hazard – 'aeroelastic
flutter' – that awaits ambitious bridge designers. Here the
experienced bridge designer Leon Moisseiff had applied his
bold theory that the larger a bridge's span, the more lightweight
and flexible the bridge should be. Rather than stiffening a span
to resist environmental forces such as wind, the bridge would
just go with the flow. This brave approach produced amazingly
beautiful, minimal – and mobile – spans – as in the Golden
Gate Bridge, San Francisco, with which Moisseiff had been
involved in the mid 1930s but was, as the Tacoma Narrows
collapse revealed, horrifyingly and fatally flawed.

Suspension bridges – in which carriageways are supported
from above – are ancient in origin and one of the three basic

PREVIOUS: The dramatic
Clifton Suspension
Bridge, Bristol, designed
by Isambard Kingdom
Brunel in 1831, under
construction untill 1843,
ababdoned in 1851 and
completed - in a simplified
manner in 1864.

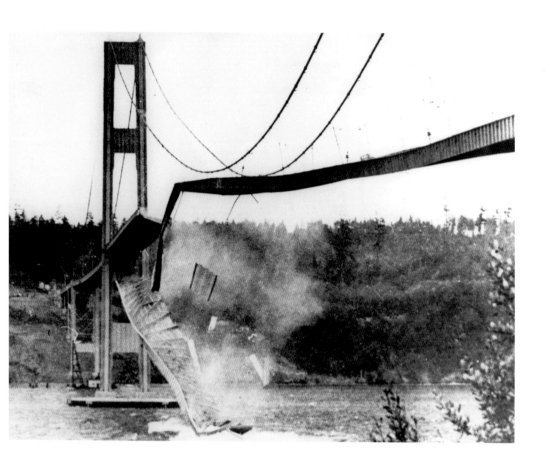

ABOVE: The Tacoma
Narrows Suspension Bridge
in the USA wobbled itself
to destruction in 1940
only four months after
it opened. A victim of the
phenomenon of 'aeroelastic
flutter' provoked by
environmental conditions.
The dramatic collapse
claimed one life – that of a
dog abandoned in a car when
his terrified owners fled.

types of bridges – the others being bridges with carriageways supported by arches or by horizontal beams of various types (see page 34). The earliest examples of suspension bridges were no doubt inspired directly by nature, suggested by walkways supported, or even created by, suspended vines or vegetation. So the idea would have emerged to create bridges, often of long spans, but by minimal means. No arches, vaults or massive beams necessary, just anchorages from which cables of various types could be fixed, and from which a walkway could be suspended. Ideally cables would also curve from above, perhaps draped over a structure, and descend in an inverted arc to join and add extra support to the walkway.

The obvious disadvantage of such simple, almost primitive suspension bridges is that they are far from stable in strong

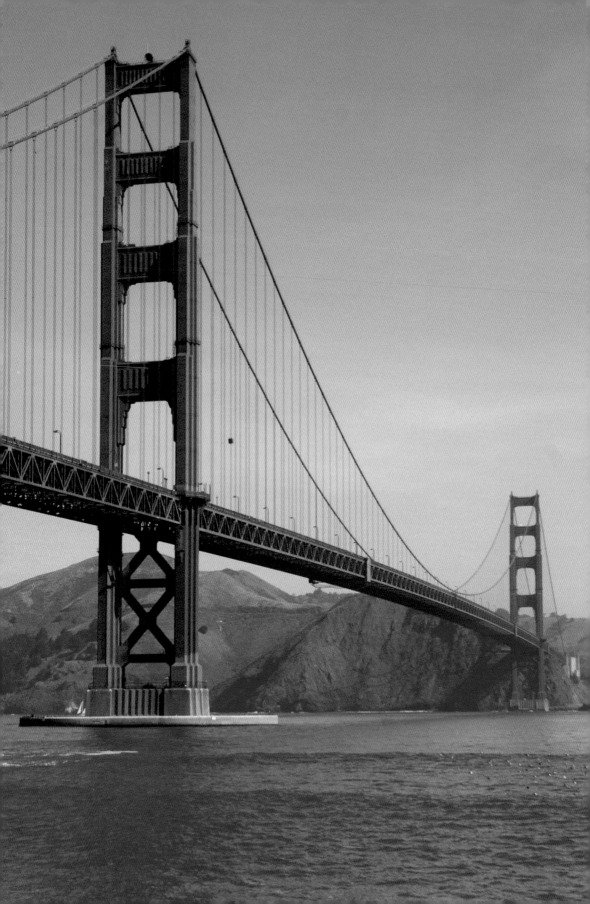

winds and cannot carry heavy loads. However, all this changed in the early nineteenth century when a sudden fashion emerged for the suspension bridge and when, as construction technology improved, it developed rapidly in its size, strength, load-carrying capacities and architectural pretensions.

Although a seemingly simple concept, the suspension bridge utilizes some complex and fascinating natural forces. In essence, a suspension bridge is composed of a pair of suspension towers or pylons, set at each end of the river or chasm to be bridged, through or between which traffic or pedestrians pass, and over which are placed the pair of cables. These cables are anchored firmly on the landward side of the suspension towers but hang between them. The carriageway is partly supported by its footings at the bases of each of the towers and – largely – by the cables from which it is suspended by means of vertical suspenders.

The cables used in suspension bridges take various forms and were, initially, rarely ever cables. In the very early nineteenth century they tended to be formed by wrought-iron chains; then by eye-bars – essentially short-lengths of wrought-iron bar articulated by swivel joints – and later, in the 1880s, after the pioneering example of the Brooklyn Bridge, by cables woven from steel wires (see page 287). In such designs the cables from which the carriageway is suspended, and which are being pulled down, are in tension, while the towers over which the cables are placed are being pushed down and so are in compression.

This basic structure has rarely been found entirely adequate, because by its nature, a bridge of this design is very flexible and prone to excessive deformation or movement, either from live loads such as traffic, or from environmental loads such as wind. So the tendency has been, in various ways, to 'stiffen' the deck with either girders or trusses. Nevertheless, despite its natural strength and such bolstering, very few bridge designers have dared to utilize the suspension principles for the construction of a railway bridge. The heavy weight and pounding movement of a train is self-evidently in conflict with the lightweight elegance and gentle, undulating, natural rhythm

LEFT: The Golden Gate Bridge, San Francisco, USA. When completed in 1937 it possessed not only the longest span in the world – 1,280 meters – but also one of the most stunningly beautiful. Its span is no longer one of the longest but the bridge remains one of the world's most beautiful and visually exciting.

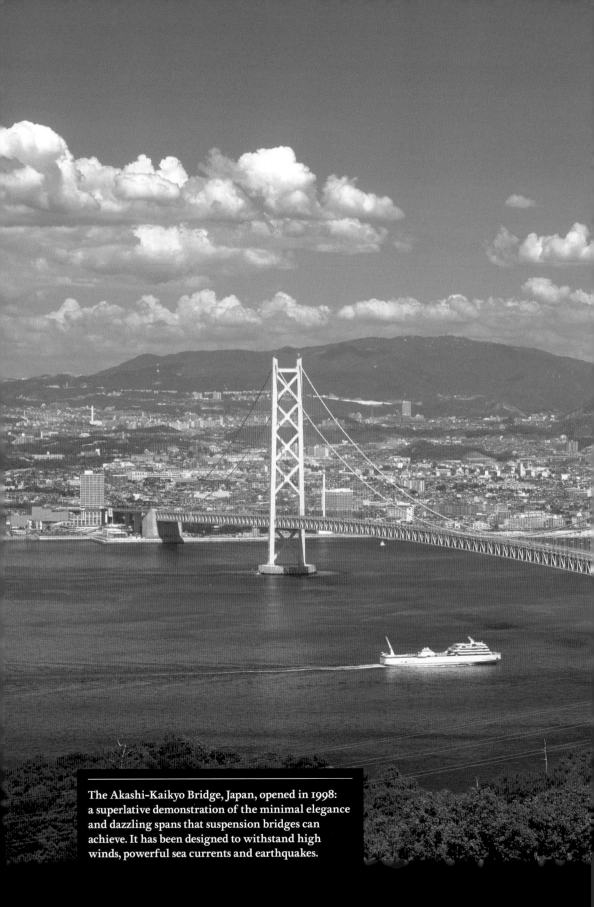

The Akashi-Kaikyo Bridge, Japan, opened in 1998:
a superlative demonstration of the minimal elegance
and dazzling spans that suspension bridges can
achieve. It has been designed to withstand high
winds, powerful sea currents and earthquakes.

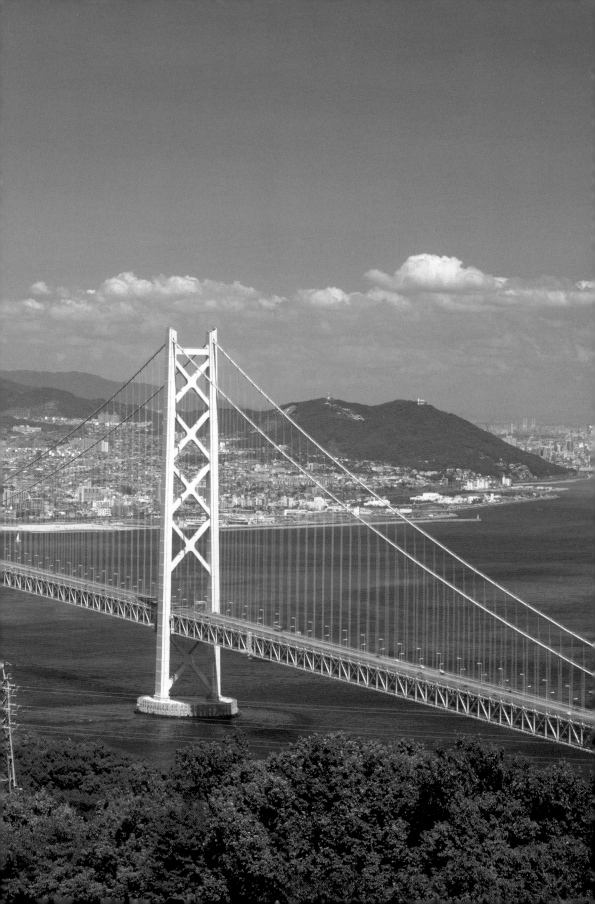

of a suspension bridge. When in 1848 Charles Ellet Jr. proposed a suspension bridge design to carry road vehicles and trains across the Niagara Falls there was an outcry from both the public and the profession. Most believed that a suspension bridge was not up to the job. The eminent engineers John A. Roebling and Leffert L. Buck were appointed as consultants and in 1855 a two-tier road and rail bridge was completed, with its longest span measuring 251 metres. But the bridge demanded constant maintenance and renewal of parts and was finally closed in 1897 when the weight of trains had increased beyond the bridge's load-carrying capacity. Few cared to repeat the experiment until 1992 when the massive Tsing Ma Bridge in Hong Kong was started. With a central span of 1,377 metres and completed in 1997, it also has two tiers of carriageway – one for vehicles and one for trains. Here bulk and mass counteract the motion of the trains whose weight is, by comparison, almost puny.

Most interesting of all, in terms of natural forces, is the shape formed by the suspended cables. It has long been known that a cable of a certain length suspended between two points set at the same horizontal level, forms an inverted arch shape under the influence of gravity that is immensely strong. The

BELOW: Sketch of a self-anchored suspension bridge in which the suspension cables are not fixed in land-based anchorages but to the carriageway.

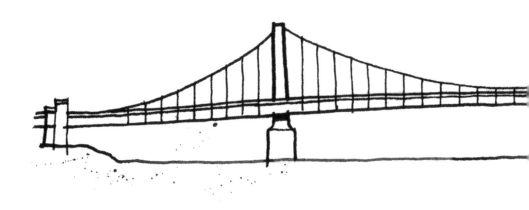

curved shape is called a called a catenary. If the catenary is copied and inverted it provides an excellent model for an arch to safely bridge the same distance. But contrary to popular belief, the cable of a completed and functioning suspension bridge does not actually form a catenary. It forms a shape equally strong called a parabola. A catenary is formed by a cable curving under its own weight, while a parabola is formed by a cable curving under its own weight *and* in response to the weight of the carriageway that is suspended from it.

Both these shapes not only promise strength if taken as structural guides but also possess an elemental beauty, which is akin to the more famed source of natural beauty that is deduced from geometrical forms and known as the Golden Section, or the ratio of 1:1.618. No doubt it is due to this intrinsic beauty and elegance that is at one with the beauty of nature – coupled with the possibility of achieving a heroically large scale – that has allowed suspension bridges to become the much-loved emblems of the city or community in which they stand. For example, the Brooklyn Bridge in New York; the Golden Gate Bridge in San Francisco; the Clifton Suspension Bridge in Bristol; and the Széchenyi Bridge in Budapest.

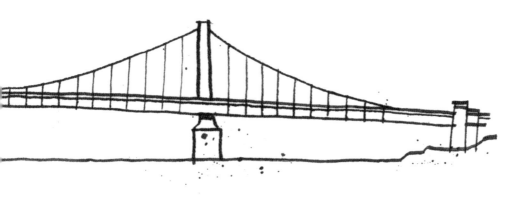

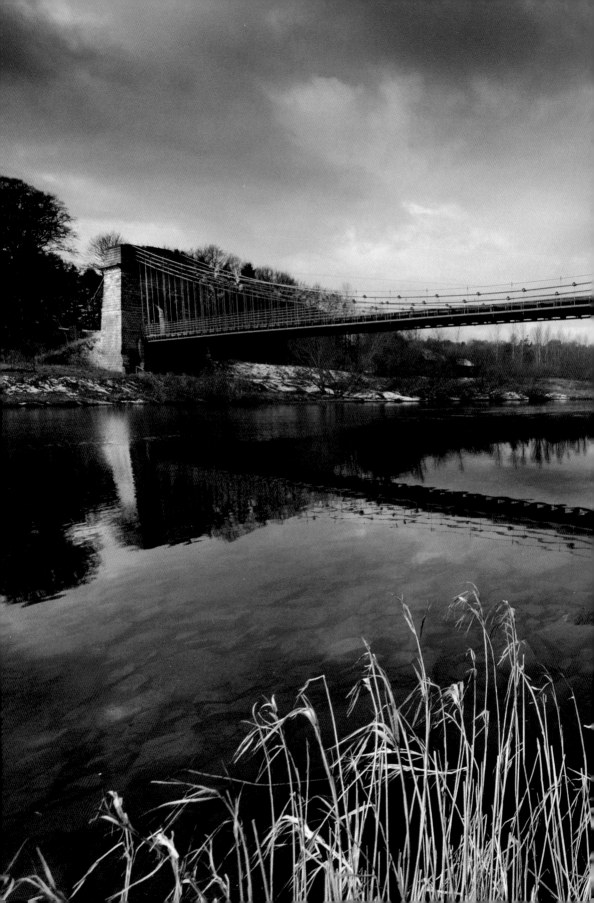

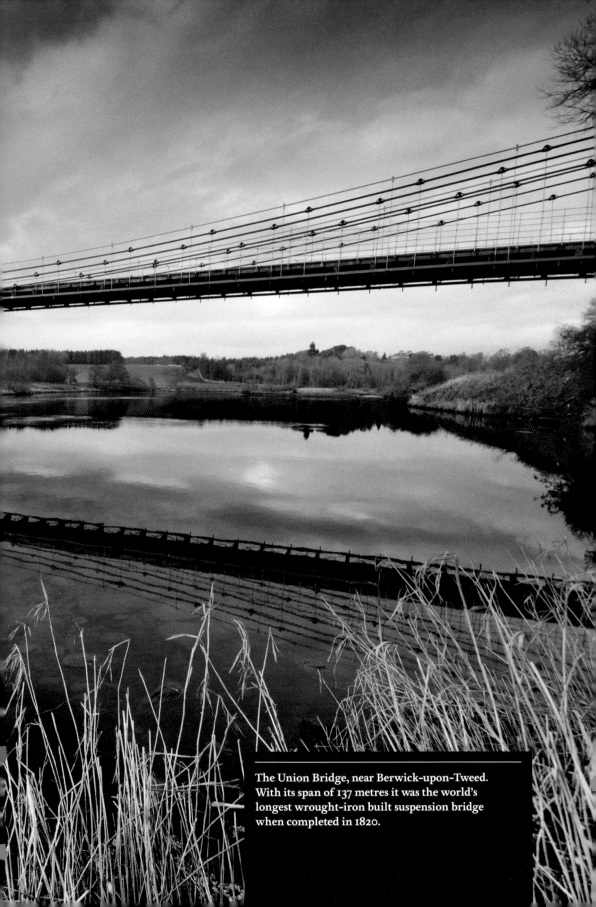

The Union Bridge, near Berwick-upon-Tweed. With its span of 137 metres it was the world's longest wrought-iron built suspension bridge when completed in 1820.

One of the earliest surviving suspension bridges in Europe – certainly in Britain – is the Union Bridge near Berwick-upon-Tweed. It was designed by Captain Samuel Brown of the Royal Navy, and has an impressive span of 137 metres which made it the longest wrought-iron built suspension bridge in the world when it was built in 1820. Originally the carriageway was suspended by three chains on each side, with each chain formed by linked bars of wrought-iron. Brown, no doubt fully aware of the flexible strength of the tall masts of sailing ships and the potential of a wrought-iron chain, designed his bridge to move with the wind, rather than to resist it, and gave his slender and lightweight bridge a capacity for movement that remains disconcerting.

At the same time that Brown was working on his bridge, Thomas Telford, one of the greatest engineers of the nineteenth century, was working on his suspension bridge for a site adjoining the thirteenth-century Conwy Castle in North Wales. This bridge, with small castellated gatehouses for towers and a cable formed with wrought-iron bars, was completed in 1826, making it one of the world's first two-lane vehicular suspension bridges. In the same year, Telford completed his suspension bridge masterpiece – the Menai Bridge across the Menai Straits in Anglesey, North Wales. The deck – set 30 metres above water level to allow sailing ships to pass beneath – was originally made of timber and was suspended from sixteen 'chains', each made of 935 wrought-iron bars. The span achieved was a massive 176 metres that was, most designers believed at the time, the maximum that could be achieved using suspension bridge technology. Applying Galileo's theory about the 'scaling problem' (see page 32), any further increase would involve chains of such massive size and weight that they would cause the structure to collapse under its own weight.

Yet one more suspension bridge was completed in 1826 that, I admit, is in many ways my favourite. The Bank Bridge in St Petersburg, Russia demonstrates the decorative potential – and rational elegance – of the type that so appealed to the sensibilities of the age. It was designed by Wilhelm von

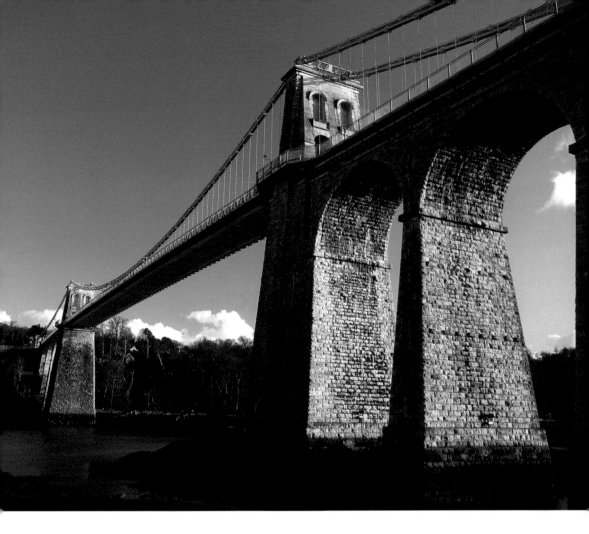

Traitteur, and has only a short pedestrian span across one of the city's canals, but glories in having its slender wrought-iron suspension bars anchored in the mouths of four large, bronze green-coloured cast-iron griffins, fitted with gilded wings of copper (modelled by Paval Sokolov). It is a perfect piece that captures and reflects the taste and wit of the times and city, looks superb in its neo-classical context – and continues to do a very useful job well and safely. What more could you want from a bridge? Particularly wonderful is the way four globular lamps protrude on slender arching bars from the heads of the four griffins. Who would ever have thought of such a thing?

While Traitteur's bridge acts as a fine and appropriate ornament within the streetscape of St. Petersburg, a suspension bridge design was unveiled in 1831 that would come to define a city. In 1829 it was resolved to build a bridge across the wide and dramatically steep and picturesque Clifton Gorge, on the very edge of the great port of Bristol in Somerset. A competition was held to find a design for a bridge and numerous designers submitted schemes – including Isambard Kingdom Brunel who suggested a suspension bridge with a massive central span of 359.6 metres. But the competition assessor – Thomas Telford – rejected all the designs and argued that those with prodigious spans were unbuildable since, in his view,

BELOW: The griffins of the Bank Bridge, St. Petersburg, Russia act as suspension towers and anchorages for this miniscule masterpiece of 1826, by Wilhelm von Traitteur, that crosses the city's Griboedev Canal.

no suspension bridge could have a greater span than the 176 metres of the central span of his Menai Bridge. Having rejected all of the competition designs Telford then submitted one himself. But despite its more attainable, modest span, the selection committee thought Telford's design too ugly and rejected it. So a second competition was launched with new judges, and in March 1831, Brunel submitted an amended design, with only a 214 metre central span, which was the chosen winner.

Work started in August 1831 on the foundations of the suspension towers, which were detailed to look like Egyptian pylons, but soon stopped due to severe riots in Bristol caused by the House of Lords' rejection of the second Reform Bill. The chaos, including looting and fire-raising, undermined commercial confidence and suggested that such an ambitious and expensive project as the Clifton Bridge was – for the time being at least – wildly optimistic and inappropriate. Work started again on the towers in 1836 but was woefully slow due to limited funds. It was not until 1843 that the suspension towers were completed – without most of their Egyptian details. Then, in 1851, the iron assembled for the suspension chains was sold and used in the construction of another Brunel Bridge – the mighty trussed-arch railway bridge at Saltash (see page 53). And so, it seemed, Brunel's first great suspension bridge would never be completed – its pylons, beautiful and powerful in a most abstract, if unintended way, stood as a mute monument to what could have been.

While this sorry story was slowly and painfully unfolding the ever-energetic Brunel had designed and completed a second suspension bridge. Called the Hungerford Bridge and crossing the Thames at Charing Cross, it was designed in 1841, completed in 1843, and had a 206 metre span that, no doubt to Brunel's great satisfaction, demonstrated in the most public manner possible that Telford was wrong about the inherent limits of suspended spans and wrong in his condemnation of Brunel's first Clifton Bridge design. The bridge, with Italianate towers in stark contrast to the Egyptian pylons at Clifton (when it came to architecture,

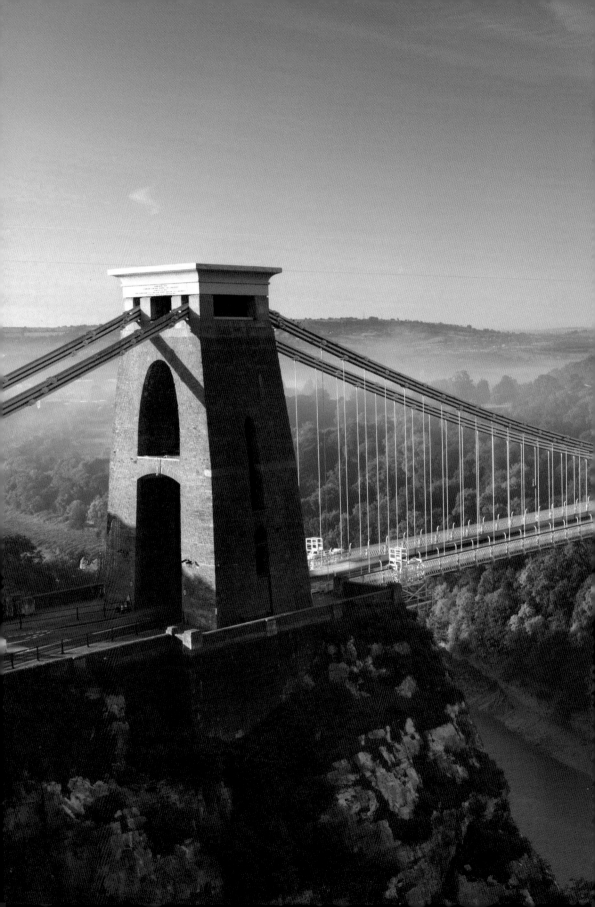

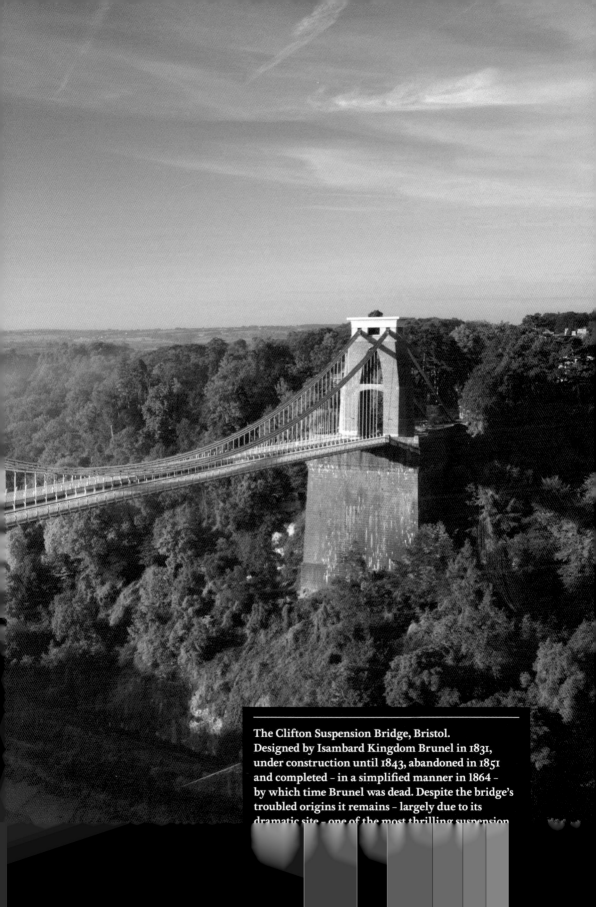

The Clifton Suspension Bridge, Bristol.
Designed by Isambard Kingdom Brunel in 1831,
under construction until 1843, abandoned in 1851
and completed – in a simplified manner in 1864 –
by which time Brunel was dead. Despite the bridge's
troubled origins it remains – largely due to its
dramatic site – one of the most thrilling suspension

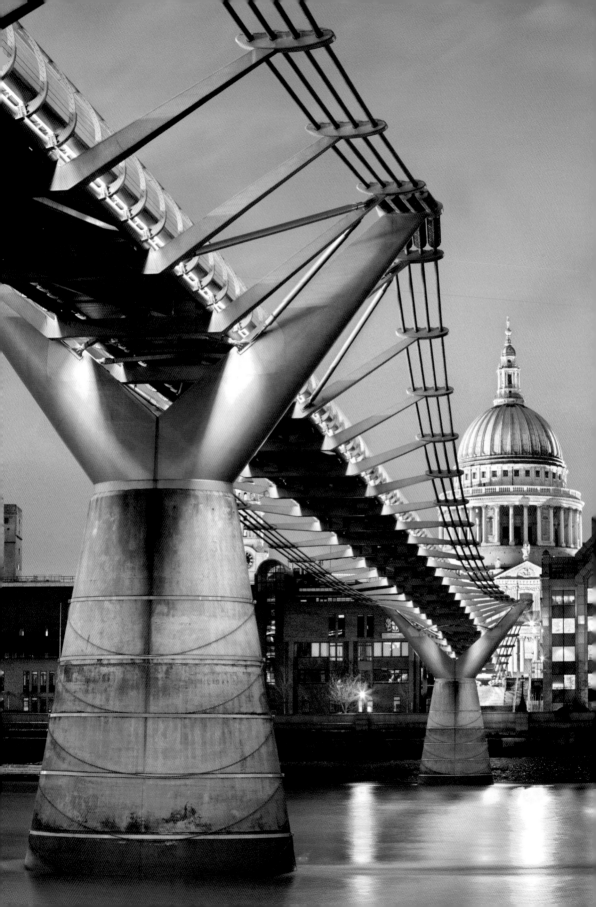

Brunel was ever eclectic and ornamental in his tastes), was swept away in 1863 to make way for Charing Cross Station.

Whilst Brunel was wrestling with the early, and generally ill-fated, construction phase of the Clifton Bridge, engineers in Europe were pushing suspension bridge technology forward. In 1834, Joseph Chaley's Grand Pont Suspendu, over the River Sarine in Fribourg, Switzerland was completed and incorporated a central span of 273 metres. This impressive length was achieved through the application of a new method of cable manufacture, devised by Chaley and the engineer Louis Vicat (a pioneer of concrete construction – see page 317), in which metal wires were woven in mid-air – known as 'aerial spinning' – to form the cables. Not only did this invention allow for the manufacture of very long cables, but it made manufacture quicker and cheaper. Chaley's Fribourg Bridge was fitted with four cables and survived for nearly 100 years, being finally replaced in 1924 with a concrete arch bridge.

Chaley built another suspension bridge (which survives) at Corbières, France, in 1837, with a span of 121 metres, and then took on a major suspension bridge project at Angers, France. Known as the Basse-Chaîne Bridge and completed in 1839 with a central span of 102 metres, the bridge became infamous in April 1850 – indeed almost brought the building of suspension bridges to a close in continental Europe – when it suffered a sudden and catastrophic collapse that resulted in the death of 226 people. The circumstances of the collapse are most curious and at the time revealed much about the still not fully understood structural nature of suspension bridges. Marching smartly in step, 478 soldiers began crossing the bridge, when suddenly, the 'dynamic load' represented by the rhythmical pounding of the column of troops caused something awful – and utterly unexpected – to happen. The bridge began to vibrate and twist in a corkscrew-like manner. In the process, a suspension cable was dislodged from its concrete anchorage and the astonished soldiers tipped into the river below. A subsequent inquiry determined that not only was the excellent 'in step' marching of the troops to

LEFT: The Millennium Bridge crossing the Thames into the City of London. Opened in 2000, it is an unconventional suspension bridge – with its suspension cables set partly below the level of the deck they support – and a key example of the international trend to create small bridges of exquisite design that help forge new connections, create pedestrian promenades and generate a sense of place.

blame for the disaster, but also that water had penetrated the concrete cable anchorage causing the wires to corrode. The latter problem could be easily dealt with – it was essentially a specific design failure – but the former was more puzzling, and suggested that the way people use suspension bridges could actually put them and the bridge in danger.

This problem was altogether more difficult to rectify, especially when, upon reflection, it was clear that not just smartly marching troops put suspension building at risk. In theory any large group could pose a threat, because once a bridge starts to sway, people tend to walk in step to match the sway. This helps them keep their balance, but the transfer of the momentum and rhythm from the pedestrians to the structure of the bridge can cause a potentially destructive 'resonance'. The immediate result of the inquiry was to order French troops to break step when crossing a bridge (a sensible precaution already followed in the British Army as it had been in the Roman Legions 2,000 years ago) and to impose a twenty-one year moratorium on the construction of cable suspension bridges in continental Europe. Curiously the problem resurfaced – in a most mild and non-fatal manner, with London's Millennium Bridge, designed by Arup, Foster and Partners and Sir Anthony Caro. Opened in 2000, it is a most unusual suspension bridge in which the cables are tensioned and are generally set below and beside rather than above the deck. Within a few days of opening the bridge was closed – and stayed closed for two years – because it wobbled in a most uncomfortable manner when large numbers of people walked across. As with the Basse-Chaîne Bridge, crowds set in motion a lateral vibration, or oscillating resonance, then fell into step in response to the sway in order to keep their balance and so accelerated the motion. The solution was to stiffen the structure and add dampers.

Just before the collapse of the Basse-Chaîne Bridge in 1850 three seminal suspension bridges – the Clifton Suspension Bridge, the Széchenyi Bridge in Budapest and Charles Ellet's the Niagara Falls Suspension Bridge – were under construction, recently completed or just getting under way.

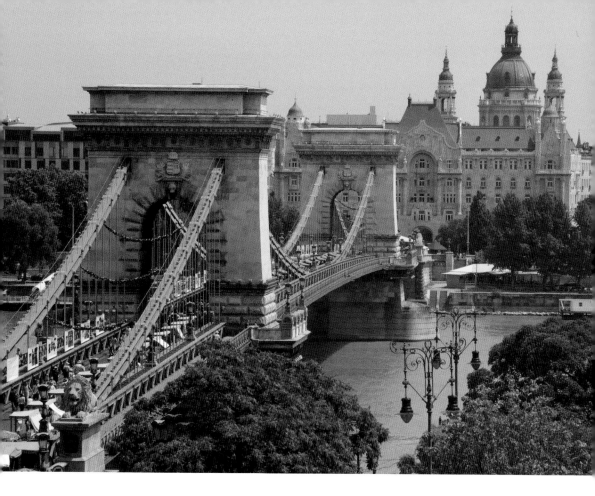

These three bridges were to take the type to a new level
of technical excellence and scale, and demonstrate the
meaning such beautiful and heroic bridges can have for
the communities in which they stand. Brunel's ill-fated
bridge at Clifton had promised to do this, but in Budapest
in November 1849 the Chain Bridge was completed and,
almost immediately, assumed a central role – functional
and symbolic – in the life of the city. The bridge had been
proposed in 1836 by István Széchenyi, after whom the bridge
was subsequently named, and its obvious and primary role
was to help confirm the twin cities of Buda and Pest – on
opposite sides of the wide River Danube – as one united
urban entity. It was also to encourage economic growth and,
as the first bridge crossing the Danube at this point, to form a

The Biggest and Boldest 245

key link between east and west. In addition it is evident that Széchenyi wished these important roles to be expressed in the design of the bridge – it was to be dignified, and while being modern in its form and function, it was also to possess the power and pedigree of the past.

The project was given to two men with the surname Clark – but unrelated – and both from the British Isles. William Tierney Clark had already built two suspension bridges over the Thames – the Hammersmith Bridge, started in 1825 and with a central span of 210 metres (replaced in 1887 by the existing Hammersmith suspension bridge), and a bridge at Marlow, Buckinghamshire built between 1829 and 1832 with a main span of only 72 metres long. Although significantly smaller in scale and aspiration than the Budapest Chain Bridge design, both these bridges acted as models for it – notably in the use of solemn Roman-type triumphal arches as suspension towers. The construction of the Chain Bridge was supervised by Adam Clark – an engineer from Scotland – and is a most admirable and beautiful construction, 376 metres long in total.

As soon as it was opened in November 1849, it won the hearts of the people from the twin cities of Buda and Pest. The pair of triumphal arches – separating the central span of 202 metres – is a particularly pleasing and appropriate touch, symbolizing the importance of the crossing and ennobling the act of using the bridge. Indeed so apposite and happy is the conceit that it is a trifle disconcerting that Clark merely transferred the idea to baroque and exotic Budapest from homely and suburban Hammersmith. The bridge did indeed fulfil all that was hoped for – it became a significant and unifying crossing of the Danube, bringing wealth to the combined cities, and an object of pride that engendered a sense of identity for the city and for Hungary. Consequently, given its role as national symbol, the bridge has played a significant role in many national events, including being severely damaged during the Battle of Budapest at the end of the Second World War. Perhaps most significantly it was a place of rally and celebration in 1989 as the people of the city

LEFT: The Wheeling Bridge, West Virginia, USA - completed in 1849 to the designs of Charles Ellet Jr. Its record-making span of 310 meters across the Ohio River received a severe buffeting from a storm in 1854 when cables were torn away and the public's confidence in heroic suspension bridges dampened.

demonstrated for freedom and independence in the face of
the collapse of Soviet-controlled Eastern Europe. The bridge
was, in stone and iron, the spirit and aspirations of the city
and nation personified. Few bridges have ever meant so much
for so many. Now, Budapest without its Chain Bridge, would
be unthinkable.

In 1847, just before Budapest Chain Bridge was completed,
work started on the second great suspension bridge of the
period – the Wheeling Bridge, spanning the main channel of
the Ohio River in West Virginia, and incorporating a main
span of 310 metres that made it, at the time, the suspension
bridge with the world's longest span. The engineer of this
epoch-making bridge was, again, Charles Ellet Jr. But in
1854, only five years after completion, the vulnerability
of suspension bridges to violent weather was once again
exposed. A windstorm destroyed the bridge's deck through
torsional movement and massive vertical undulations that
tore away cables. The response in the United States, as it was
in continental Europe after the Basse-Chaîne Bridge collapse,
was to stiffen-up the structure and add trusses. Elegance may
not be increased but solidity, mass and strength were.

Back in Britain, in 1864 the Clifton Bridge was finally
completed, four years after Brunel's death, by a consortium
of business men and engineers. The design was a reduced
version of what Brunel had intended years before, but,
somewhat touchingly, the wrought-iron bar chains used were
those fabricated for Brunel for his Hungerford Bridge that
had been demolished in 1863. At about this time suspension

bridges were – in theory at least – liberated from the need for strong ground anchorages for their suspension cables. In 1859 the Austrian Engineer Josef Langer had the idea of 'self-anchored' suspension bridges in which the main cables, having passed over the towers, are not anchored to the ground but to the ends of the carriageway. This solution allowed suspension bridges to be built high on piers and remote from land, or located where unstable soil made firm anchorages unlikely. Certainly the idea possesses a certain elegance, with the load of a bridge pulling against itself so that, in theory, the more load that is put on the bridge, the more secure the anchorages become. But the construction process is awkward – with extensive scaffolding required to support the carriageway during construction, since the supporting cables cannot come into structural play until the carriageway is complete – and the system was generally only applied for relatively small bridges where scaffolding was not a problem and loads were not great. The concept was patented in the United States in 1867 by Charles Bender and subsequently used for several bridges, notably the 'Three Sister' suspension bridges of 1924–28 across the Allegheny River in Pittsburgh, USA.

In theory the system could be applied to a large bridge where the weight and anchoring capacity of its carriageway would be adequate to support the heavy loads it carried. An example of this principle working on the large scale is the nearly complete eastern portion of the 7.18 kilometre long Bay Bridge in San Francisco, California, USA. The bridge – or 'Skyway' – comprising suspension and cantilever spans and truss causeways, was completed in 1936 to the design of Charles Purcell but its eastern portion is currently undergoing reconstruction following earthquake damage in 1989 and its vast, visually arresting 'signature span' – due to be opened in 2013 – is self-anchored and designed to be earthquake proof. Innovative details include 'sheer link beams' that protect the suspension tower by bending and contracting and absorbing the energy of a major 'seismic event', and sacrificial and easily replaceable 'hinge pipe

beams' that connect sections of carriageway, would absorb the energy of an earthquake and, like fuses, break and prevent the movement damaging the main structure.

As well as embracing the novel concept of self-anchoring suspension bridges, late nineteenth century engineers in the United States were also at the forefront of the promotion of other technical developments. For example in the mid 1870s, during the construction of New York's Brooklyn Bridge, Washington Roebling introduced the use of steel wire in the fabrication of suspension cables (see page 287). The completion of the Brooklyn Bridge in 1883, with its 486.3 metre central span, was followed by a number of other spectacular suspension bridges in and around Manhattan, notably the Williamsburg Bridge (by Leffert L. Buck and Henry Hornbostel) which, when it opened in 1904 had – at 490 metres – the longest span in the world (see page 280).

This record was lost in 1924 when the Bear Mountain Bridge in New York State was completed, with a central span of 497 metres, but it came back to the city in 1931 with the opening of the George Washington Bridge, soaring across the Hudson River to connect Washington Heights and the northern portion of Manhattan with New Jersey. The main span of the bridge measures 1,100 metres, is 38 metres wide, and after a second anticipated lower tier was added in the 1960s (soon nicknamed Martha in memory of Washington's long-suffering wife), the vehicle-carrying capacity of the bridge became enormous. It is now estimated that it carries 106 million vehicles a year, making it the busiest bridge in the world. Its engineer was Othmar Ammann, with architect Cass Gilbert (famed for the highly-ornate Woolworth Building) giving aesthetic advice.

Originally the bridge's pair of tall, steel-braced towers were to be clad in concrete and granite and be tricked-out with historicist details. But, due to the Depression, money was in short supply and the decoration of the towers was delayed. Then, after the opening of the bridge something unexpected happened – the public, and certain leaders of architectural taste, made it clear that they liked the bridge

'The Modern world had arrived and the old world of the Woolworth Building – when skyscrapers were cloaked as Gothic towers from fairyland – was on the wane.'

just as it was – the criss-crossing steels of the towers laid bare, their constructional secrets exposed for all to see. Times and tastes were changing. The Modern world had arrived and the old world of the Woolworth Building – when skyscrapers were cloaked as Gothic towers from fairyland – was on the wane. As the Modernist architect Le Corbusier wrote in his 1947 book, *When the Cathedrals Were White*: 'The George Washington Bridge over the Hudson is the most beautiful bridge in the world. Made of cables and steel beams, it gleams in the sky.... It is blessed. It is the only seat of grace in the disordered city. When your car moves up the ramp the two towers rise so high that it brings you happiness; their structure is so pure, so resolute, so regular that here, finally, steel architecture seems to laugh'. Such praise for their creation would have pleased Ammann and Gilbert, but also surely dismayed them. Much money was saved, the clients and critics were pleased, but what was being praised was not quite the bridge they had envisioned or designed.

In 1937 the Golden Gate Bridge in San Francisco had been completed. Although Le Corbusier would no doubt have found its jazzy Art Deco detailing superficial and unnecessary he would – like almost everyone else – have been amazed by its scale. Designed by Joseph Strauss and Irving Morrow with much engineering advice from Charles Ellis and Leon Moisseiff, the bridge was of unmatched ambition, scale and elegant beauty. It incorporated 227.4-metre-high towers of minimal bulk, a central suspended span of a staggering 1,280

metres in length soaring majestically nearly 70 metres above the Pacific Ocean. The Golden Gate possessed, until 1964, the world's longest span. The minimal form of the suspension towers was one of the most dramatic visual expressions of the structural theory underpinning the design of the bridge.

Moisseiff evolved what he called a 'deflection theory' in which the roadway of a suspension bridge was to be as thin in section and as flexible as possible so that it could move and bend with the wind rather than rigidly resist it. The aim was to reduce the stress transmitted via the suspension cables to the towers which, relieved of much of their stabilising role, could afford to be thin and light in appearance.

This theory worked well at the Golden Gate Bridge but, as we have seen, ended in disaster when Moisseiff subsequently applied it to the design of the Tacoma Narrows Suspension Bridge, in Washington State, USA, which in November 1940, in a most alarming and undignified way, flexed itself apart under high wind pressure, only four months after completion. Fortunately there were no casualties beyond a dog that, unhappily, was abandoned in a car by its fleeing owners. But still the collapse shocked and unsettled the nation and seemed almost a parable on human arrogance in the face of the forces of creation, and the hapless bridge a sort of modern-day Tower of Babel that, the Bible warns, had been built to 'reach unto heaven' and felled by God because of human daring and presumption: 'And the Lord said, Behold...now nothing will be restrained from them, which they have imagined to do', (Genesis 11: 4-8).

The collapse of the Tacoma Narrows Bridge put paid to Moisseiff's 'deflection theory', to his long and distinguished career (and perhaps to his life, for he died a broken man less than three years later). In its place, it introduced the alarming new problem for bridge designers named 'aeroelastic flutter'. At the time, this was a little-known natural phenomenon, a sort of ghastly semi-perpetual motion sparked by high winds initiating a vibration or 'flutter' that can accelerate a structure's natural rhythm of vibration to produce increasingly rapid periodic motion terminated by cataclysmic failure. This disaster

was a grim reminder that taking on the forces of nature can still, after millennia of experience, hold unpleasant surprises for ambitious bridge builders. It also illustrated most clearly what can happen when man falls short in his 'grasp' of the true and daunting realities of bridge design.

Despite such disasters as that which befell the Tacoma Narrows Bridge, suspension bridges have throughout the twentieth century and into the twenty-first century tended to get ever more daring, with their main spans getting longer and their scale increasing. In 1966 the Severn Bridge opened, linking England to southern Wales, with its longest span measuring 988 metres. The design, by Freeman Fox and Partners, is intriguing and unusual, for the suspension cables that connect the deck to the main cables form a zig-zag pattern and are fitted with dampers in an attempt to reduce vibration. The suspension towers are tall, slender, minimal and beautiful because they are made of steel. The bridge, like all great

BELOW: Sketch of the bridge across the River Severn, linking England to South Wales, completed in 1966. An unusual detail are the criss-crossing suspender cables, defining triangular shapes, that together with dampers were an attempt to reduce vibrations from thundering traffic and wind.

bridges, brought about transformations. It rapidly became an object of awe and wonder helping to put the ancient market and castle town of nearby Chepstow on the world map, and it did much to bolster the economy of the region, and southern Wales in general.

I remember it being built – I was a teenager and often visited the nearby Wye Valley – and can recall vividly the sense of pride the local community felt that such an emblem of progress and of modern technological know-how was rising among them. Perhaps things might not be quite the same now – that was the Sixties when optimism and a belief in the modern was the mood of the moment. But on the other hand, even in our more jaundiced and cynical age, the love for heroic bridges tends to endure despite the fact that other emblems of apparent progress – such as high-rise office towers – are seen as tainted.

In 1981 the Humber Bridge, linking Lincolnshire to Yorkshire was completed and, for a while, its 1,410 metre span made it a world record breaker (see page 13). In 1998 the Great Belt Bridge in Denmark (designed by Dissing+Weitling) opened with a main span of 1,624 metres and after that a sequence of suspension bridges, each competing to possess the longest span were completed in China. They were the Jiangyin Bridge of 1999 with a longest span of 1,385 metres, the Runyang Bridge of 2005 with a span of 1,490 metres and the Xihoumen Bridge of 2007 with a span of 1,650. But, in world stakes, these were all just competing for second place with the Akashi-Kaikyo Bridge in Japan retaining the world's longest span – 1,991 metres – since 1998. What this competition for supremacy has ensured is that the suspension bridge type has become the world leader in terms of vast scale and ambition. Whenever people now think of the essential bridge – huge, minimal, daring and defying nature – it is a suspension bridge that leaps to mind.

RIGHT: The suspension bridge forming the east portion of the Great Belt Bridge, Denmark, completed in 1998 and incorporating a main span of 1,624 metres.

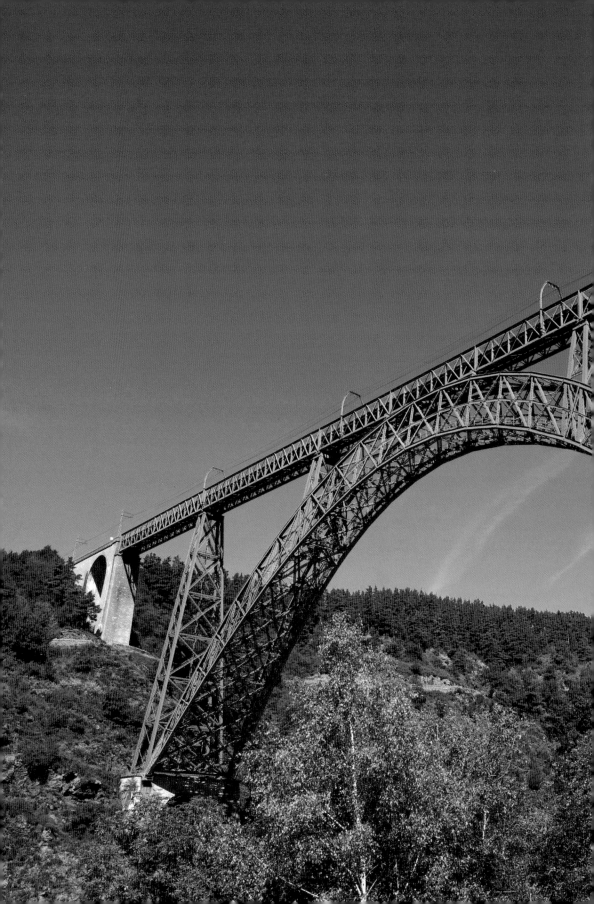

STRUCTURAL
PERFECTION

JUST ONE GLANCE AT THE GARABIT RAILWAY
Viaduct in Auvergne, southern France, is enough to make it
clear that you are in the presence of what is – in many ways –
the perfect bridge. It is breathtaking in its ambition, minimal
in the way that ambition is realized, seemingly ruthlessly
functional in its design with no concession paid to superficial
ornament, and, of course – it is utterly, ravishingly, sublimely
beautiful. The huge, yet delicately fabricated and almost
transparent, crescent-shaped arch, on the crown of which
is poised a horizontal sliver of track, is incredibly visibly
satisfying. The viaduct appears as pure engineering, its
perforated and skeletal form being, simultaneously, a diagram
of precisely calculated strength and – almost paradoxically –
a thing that is, almost impossibly immaterial and light.
According to the renowned biographer of great bridges,
David P. Billington, the viaduct epitomizes the points of
excellence that define the world's best bridges. Its design is
unusually 'efficient' because it achieves great strength with
little material, is exceptionally 'handsome', being light in
appearance and with a 'more integrated overall form' and
more 'visual sophistication' than the vast majority of bridges,
and it was unusually 'economic' in cost and construction time.[63]

 And then there's the setting. The rolling and mountainous
terrain of the Central Massif has always been a challenge to

PREVIOUS AND RIGHT:
The wrought-iron of the
Garabit viaduct has always
been covered in protective
red paint that makes a
stunning contrast with
the summer greenery.
Particularly moving is
the manner in which the
horizontal truss carrying
the rail track just kisses the
curving crown of the arch.

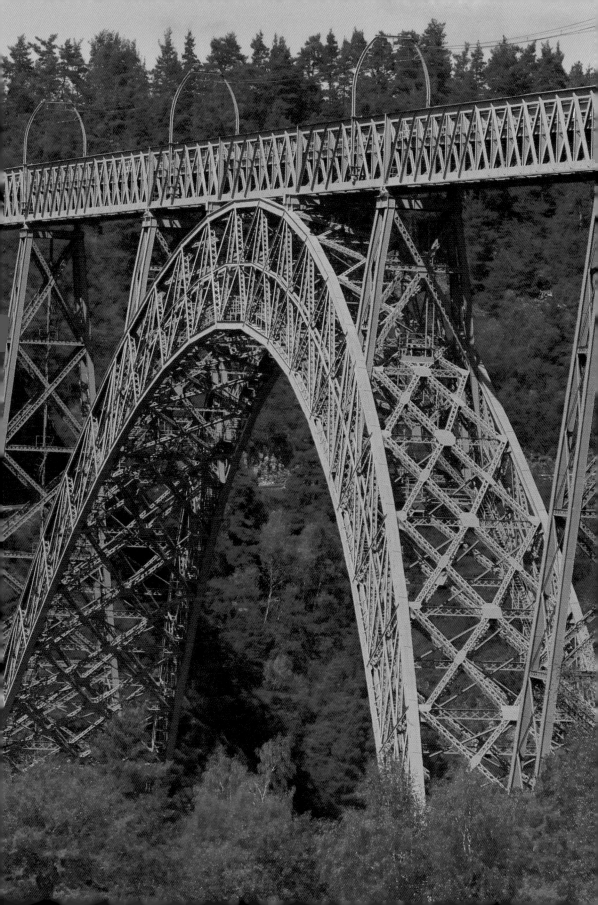

CHEMINS de FER du MIDI

L'AUVERGNE

VIADUC DE GARABIT SUR la TRUYÈRE

CIRCUITS D'AUTO-CARS

entre — St FLOUR — MILLAU — CARCASSONNE

bridge builders, especially in the railway age when the need for a constant, horizontal level was more critical than ever before. This bridge, with its vast leaping arch and its perforated metal structure offering minimal wind resistance, is clearly an inspired and particular response to the demanding location, with its deep gorge and potentially destructive winds. Everything about the viaduct – the surgical precision of its form and of its structural details, its rich red hue – proclaims that this is a great work of man, something that in its elemental grandeur adds to, rather than compromises, the beauty of its natural setting.

The Garabit Viaduct, built between 1880 and 1884, is undoubtedly a work of engineering genius, which is hardly surprising since it was designed by one of the greatest and most inventive engineers of the nineteenth century: Gustave Eiffel.

Eiffel was forty-eight years old and at the height of his creative powers when he – with structural engineer Maurice Koechlin – designed the viaduct. He had a well-deserved international reputation. In the 1870s he had designed – again with Koechlin – the metal armature of Bartholdi's Statue of Liberty, being fabricated in France but destined for New York, and had designed bridges and other iron structures around the world. And now Eiffel was to design his greatest bridge of all – and from it learn lessons that he would apply in 1887 when he designed and built his most famous metal structure – the Eiffel Tower in Paris.

The main elements of Eiffel's brief for the design of the Garabit Viaduct are apparent in the bridge he created. Not only did he have to span a mighty gorge but he was required to do it quickly and at minimal cost. This meant a design that was strong and fit for purpose, and that could be constructed in relatively easy and elegant manner and that used as little material as possible. This really was to be strength achieved through design rather than through bulk.

The roots of Eiffel's solution to this demanding brief can be found in a railway bridge – the Ponte Maria Pia – he had completed a few years earlier across the River Douro in

LEFT: From the very start the daring and dashing form of the Garabit Viaduct was embraced as emblematic of the novel excitement of rail travel in France.

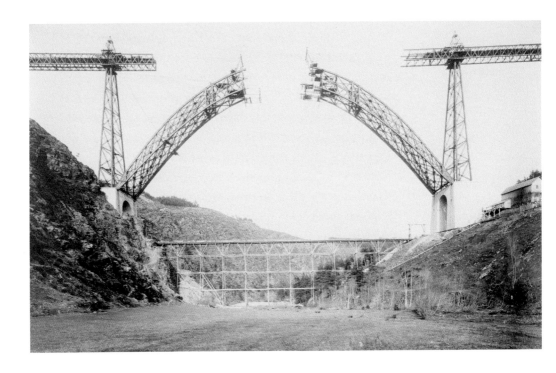

Portugal. In 1875 he had won a competition for the commission by producing a design – 'conceived' by his chief design assistant the engineer Théophile Seyrig – that was elegant, functional and 30 per cent cheaper than its nearest rival.[64] When the bridge was completed in 1877 it possessed a single arch that had a span of 160 metres and carried a trackway 124 metres above the river, making the bridge the highest and longest arch bridge then existing in the world.[65]

The arch was of truss type, which means that it was formed by a lattice of metal members that were designed and fabricated to be in both tension and compression (see page 32) under the dead and live loads of the bridge, with those in compression calculated to counterbalance those in tension. This ensured that the trussed arch, with its lattice of slender members, was in a state of structural equilibrium and not exerting a massive lateral thrust. Eiffel constructed the arch using wrought-iron, which possessed the tensile strength required by the design. Since the 1850s, cast-iron – immensely

ABOVE: The Garabit Viaduct nearing completion. The two halves of the crescent arch were built as largely self-supporting cantilevers, stabilised by cables. The lower temporary timber bridge proved a working surface and easy route of communication for workers and their families living on site. Part of the secret of Eiffel's great success was that he was a very skilful and highly professional building contractor as well as a poetic engineer of genius.

strong in compression but brittle and dangerously weak when used in tension – had generally been abandoned by bridge builders, and certainly never used for arches or ribs (see chapter 5). Without the ready and cheap availability of wrought-iron Eiffel could not have built this bridge. Wrought-iron had only became a structural material in the 1840s with the construction of the Palm House at Kew Gardens, West London, built between 1844 and 1848 by iron master Richard Turner with architect Decimus Burton.

The trussed arch was of two-hinged type, which means that the crescent-shaped arch was connected by two wrought-iron 'hinges' to the abutments from which it spanned. These are not hinges in the conventional sense, but joints that can deflect slightly, releasing stresses that can build up in the structural component.[66] These hinges gave the structure added flexibility allowing it to accommodate, rather than fail under varying and perhaps unexpected extra stresses and loads. In 1878 Théophile Seyrig, the engineer Eiffel worked with on the Ponte Maria Pia, described the nature of the bridge's main arch. It has, he wrote, a form that would be 'at the same time the most graceful and best suited to the load-carrying necessities'. Also, by choosing a crescent form with hinges at the supports 'the calculations were markedly simplified and all those who have once made complete arch calculations know that such an advantage is not to be disdained'.[67]

BELOW: Diagram of a two-hinged arch bridge, showing the carriageway supported from below with the arch springing from hinges that permit some limited movement.

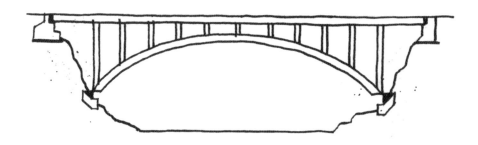

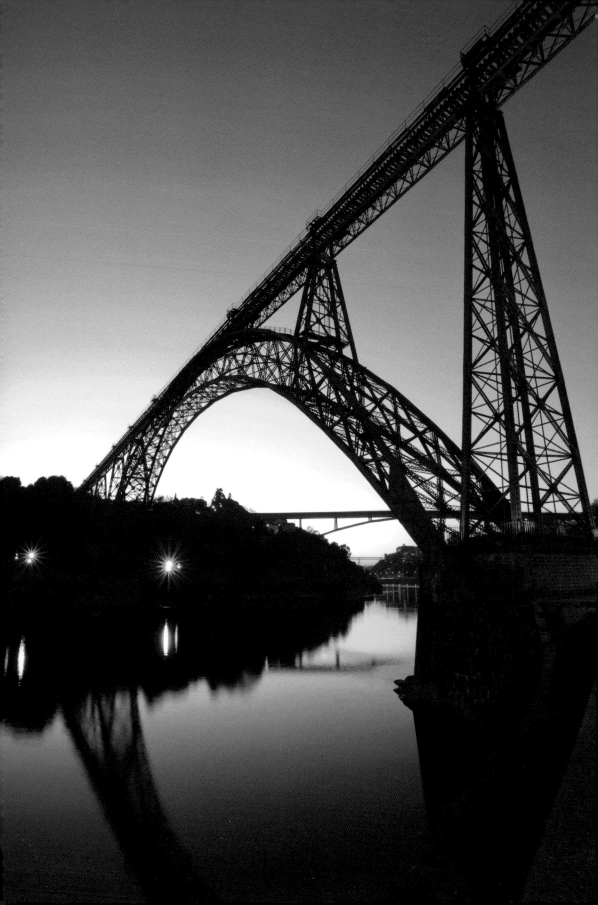

The Garabit Viaduct was, in every sense, a child of the Ponte Maria Pia, which not only inspired its design but also secured Eiffel the design commission. Léon Boyer, an engineer with the government's *École National des Ponts et Chaussées*, saw the Portuguese bridge and in December 1878 asked Eiffel if it would be possible to construct an arch of similar type to carry a railway across the valley of the Truyère River in Auvergne, at a height of over 120 metres. If this could be done, emphasized Boyer, vast sums of money would be saved because the proposed railway through the region could be constructed on a shorter route.[68]

Eiffel studied the problem with Koechlin and concluded that a viaduct of similar design was possible – only it had to be bigger, stronger, and altogether better. For a start the arch would have to be of greater span – 165 metres – and the structure would have to be as perforated as possible to offer minimum resistance to the vicious winds that occasionally ripped through the valley. For Eiffel more really was less. Rather than building bulky beams to resist the wind, he much preferred to let it whistle harmlessly through.

The structural system of the huge crescent-shaped parabolic trussed arch was to be essentially the same as at Ponte Maria Pia. It was to be narrow in width and deep at the top to give maximum support to the train track, and wide in width and shallow at the abutments to give maximum anchoring strength and to reduce the resistance the structure offers to the wind. The trussed arch, the pylons and the horizontal trussed girder they support were formed by interconnecting metal bars arranged vertically and diagonally to form a series of open triangles. These bars were placed so as to be pulled into tension and pushed into compression as trains passed over, and by resisting one another, create the desired state of structural equilibrium and harmony. The brilliance of the system is that – although light, minimal and economic in its use of materials – the viaduct is strong and rigid enough to take the notoriously demanding and very heavy live loads of moving trains.

LEFT: The precursor of the Garabit Viaduct: Eiffel's Ponte Maria Pia, Porto, Portugal, completed in 1877. As with the Garabit Viaduct, the crescent arch is narrow and deep at its crown in response to the live load of trains, and shallow and wide at its base to spread weight onto its foundations and give maximum anchoring strength. This reduces the surface area of the bridge and the resistance offered to wind. All in all, Eiffel achieved a form that is both beautiful and practical.

All, as in Portugal, was to be constructed in wrought-iron.
In the 1870s this was almost inevitable; but by the early 1880s
steel – just starting to be produced in large quantities at cheap
prices – was a possibility for large-scale construction projects.
It was specified for the cabling of New York's Brooklyn Bridge
and for the Forth Railway Bridge in Scotland (see page 36), but
in his choice of structural material, the avant-garde, daring and
pioneering Eiffel remained something of a traditionalist. Steel
had even greater tensile strength than wrought-iron and most
agreed it was generally a better building material. But it was
still not fully tested, something of an unknown. Perhaps for
this reason Eiffel stuck with tried and tested wrought-iron,
and even in 1887 chose to use it – riveted together – for the
construction of the 324-metre-high Eiffel Tower, then the
tallest man-made structure in the world.

The construction of the Garabit Viaduct started in
September 1880. First the masonry bases were built on which
sat the wrought-iron pylons and arch, with the first pylon
erected in 1882. The arch was finished in early 1884 and the
entire 565-metre-long bridge completed by late 1884. The
speed, given the scale of the operation, was astonishing. The
process of construction was also a logistical triumph. Housing
had to be built for the workers and their families, dining
facilities and even a school. Also accommodation for horses
and oxen was necessary, as was a low-level wood-built service
bridge linking the two sides of the gorge. The erection of the
great arch was undertaken much as with a cantilever bridge
(see page 262). Both ends of the trussed girder supporting the
trackway were constructed, and then between them rose the
arch. The incomplete portions of the arch were tied back to
the girders and their supporting pylons by means of cables,
until both halves of the arch met and it achieved structural
integrity and stability. Incredible accuracy of setting out
and fabrication was required to ensure that the 'bonding
holes' on each half of the arch were properly aligned when
they met, thus allowing the linking pins to be inserted.
The uniting of the two halves of the arch was achieved,
to Eiffel's delight, with mathematical precision.[69]

RIGHT: A stupendous
early illustration of one
of the 'hinges' forming
the junction between the
foot of the arch and its
foundation. Hinges are
bearings that are relatively
flexible and permit the
structure a limited amount
of movement without
structural damage. On
the left is a footing of one
of the pylons helping to
support the rail track.

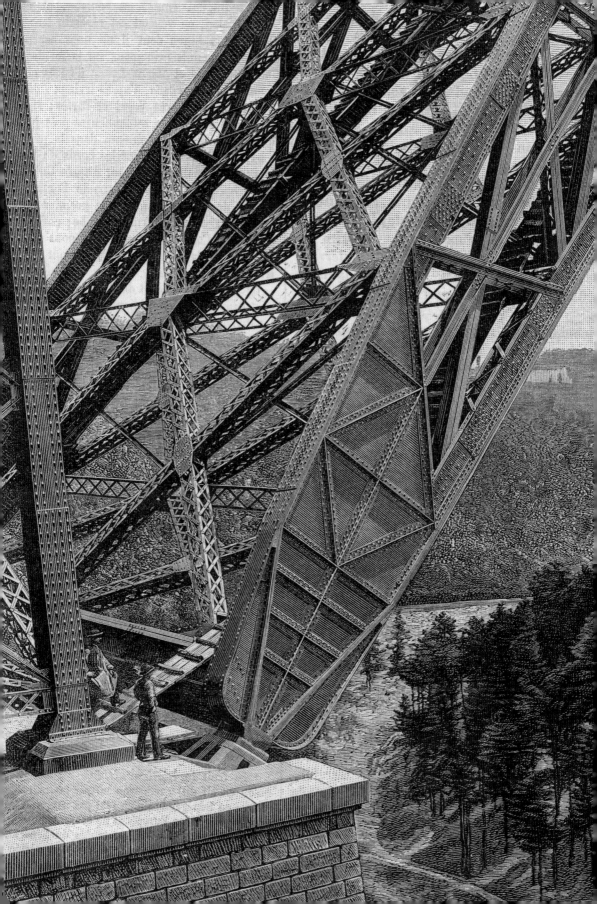

The bridge was, indeed, a piece of precision-made industrial engineering, its parts carefully wrought and assembled, with the completed bridge being, in a sense, a minimum-tolerance machine calculated to fulfil a specific set of tasks. It was a harbinger of the coming age of machine-like engineered architecture. The age of the engineer had truly arrived and bridge design was perceived as the activity that could bring him greatest glory. This is heady and romantic stuff that can confuse the real issues and challenges. Indeed the brilliance of the design of the Garabit Viaduct, and its efficient erection, can only be really appreciated when placed in the wider context. During its construction Eiffel's company was working on another viaduct, at Tardes, which was to have a massive central span of 100.05 metres. What happened here reveals the other side of the coin and the huge and often unpredictable difficulties that daring engineers like Eiffel faced on a regular basis. During a night in January 1884, while one end of the arch was cantilevered out to the height of 53 metres, a wind gusting at up to 162 kilometres per hour, threw 130 metres of the bridge into the valley 60 metres below.

Although driven primarily by functional, financial and logistical requirements, the Garabit Viaduct was also an aesthetic statement. But its beauty came not from ornament applied to structure but, instead, was a consequence of the ruthlessly honest expression of the material and methods of construction. This is the machine-aesthetic of early twentieth century Modernism, but nearly fifty years ahead of its time. It is no surprise that the Garabit Viaduct was venerated by the young Le Corbusier. In his epoch-defining manifesto – published in 1923 as *Towards a New Architecture* – Le Corbusier singled out the Garabit Viaduct, and the aesthetics of engineers like Eiffel, for special praise: 'the Engineer, inspired by the law of Economy and governed by mathematical calculation, puts us in accord with universal law. He achieves harmony'.[70]

For Le Corbusier architectural beauty was 'a question of morality': a 'lack of truth is intolerable' for 'we perish in untruth'. Architecture, dogged as he saw it by an irrelevant subservience to history and by superficial ornament that denied

'Le Corbusier singled out the Garabit Viaduct and the aesthetics of engineers like Eiffel for special praise: 'the Engineer puts us in accord with universal law. He achieves harmony.'

or concealed the means and materials of construction, was in 'an unhappy state of retrogression; whereas the 'Engineer's Aesthetic', expressed by such as Eiffel, was 'at its full height'.[71]

The Garabit Viaduct was not, however, a lone pioneer. The virtually contemporary Forth Railway Bridge in Scotland is just as uncompromising in the manner in which its creators also eschewed traditional ornament or familiar cultural or historicist references (see page 294). But the Garabit Viaduct has extra punch because its unadorned form also possesses tremendous elegance and structural minimalism. The Forth Railway Bridge is a wonderful, lumbering beast of a structure, over-designed in response to recent bridge disasters. By contrast, the Garabit Viaduct appears breathtakingly light and therefore almost unbelievably – even dangerously – bold.

A little more insight into Eiffel's aesthetic thinking can be gained by comparing the Ponte Maria Pia with the Garabit Viaduct. Looking at the two it seems clear that Eiffel wanted greater clarity so that what is happening structurally is expressed as visually clearly as possible. For example at the Ponte Maria Pia the horizontal trackway girder is integrated within the body of the arch. This is visually rather confusing. At the Garabit Viaduct the trussed girder carrying the rail track sits on the top of the arch. This is, to a degree, the result of a functional requirement because at the Garabit Viaduct the railway is higher above the valley than at Ponte Maria Pia. But the consequence – with arch and trussed girder being distinct – is a far more visually pleasing design. At the Garabit

Viaduct the design, in a most simple and direct way, is the honest expression of the fact that the arch carries the girder that supports the speeding trains that hurtle along it. In engineering, more than in architecture, truth is synonymous with beauty, and thus the Garabit Viaduct – an open and logical expression of its function and of the potential of the material from which it is wrought – is the pinnacle of excellence.

The Garabit Viaduct has proved an enduring inspiration and has spawned some remarkable progeny. The most stupendous is, in many ways, the New River Gorge Bridge

ABOVE: Detail of the Ponte Maria Pia, Portugal, of 1876 to 1877, showing the manner in which the horizontal trussed girder carrying the rail track is integrated into the structure of the arch.

near Fayetteville, West Virginia, USA, designed by the Michael Baker Company under the direction of chief engineer Clarence V. Knudsen. Like all great bridges it does more than just carry traffic across a chasm. It was completed only in 1977 but now defines the identity of the region in which it stands. This is not only because it possesses a beauty that appeals to even the most casual observer, but also because it is big – very big! Its stretches for 924 metres, its roadway rises 267 metres above the white waters of the New River – making it the second highest bridge in the United States – and it possesses a main arch that spans 518 metres, the longest steel-made arch bridge in the world at the time of its completion. When the thick mist hangs low in the river valley and the bridge appears to be floating above the clouds, it is easy for all to appreciate the sheer boldness and daring of an undertaking that seems to challenge – and become one with – the might of nature itself.

Although the New River Gorge Bridge surpasses the Garabit Viaduct in scale it falls short when it comes to visual subtly. The Garabit Viaduct appears to be, essentially, a machine-like functional object, yet Eiffel as well as being a great engineer was also a great artist. So the viaduct possesses many touches that, although inspired by practical demands, serve the more poetic ends of pure beauty. In contrast the New River Gorge Bridge seems a utilitarian monument to function, pure and simple. For example, its arch does not vary in width and depth as – in most pleasing manner – do the arches on Eiffel's two bridges. Rather than being supported by skeletal metal pylons the girder of the New River Gorge Bridge – as it extends beyond the arch – is supported by simple, utilitarian metal posts linked into pairs by braces. Perhaps most telling, the trussed girder does not sit neatly and satisfactorily on the crown of the arch but is carried just above it by means of metal struts.

Also radically different is the material from which the New River Gorge Bridge is built. Rather than being constructed of wrought-iron or even regular steel, it is made from Cor-ten. This is a wonder material of the 1960s, a steel alloy that does

> 'Now bridges are about more than crossing the void in an elegant, safe and economic manner. They can be potent symbols, gestures of defiance or of place making.'

not corrode in any normal way but gradually develops a protective layer of mellow-coloured rust that – in the right conditions – constantly renews itself. At a stroke Cor-ten – also known, for obvious reasons, as 'weathering steel' – meant that one of the great liabilities, and potential charms, of metal bridge construction was eliminated: paint.

From the late eighteenth century, when metal was first used on any scale for bridge construction, it was always necessary to use paint on a regular basis to protect the metal from atmospheric corrosion. Red lead paint was regarded as most effective, hence the famed red appearance of many bridges, including the Forth Railway Bridge and the Garabit Viaduct. By contrast the New River Gorge Bridge presides over a vast and beautiful landscape wearing a patina of mottled and deep hued rust, with all its separate members carefully welded together, so that while bearing a powerful likeness to the late-nineteenth-century works of Eiffel, it is very much a child of the 1960s and 1970s.

The New River Gorge Bridge's world dominance in terms of scale was eclipsed only in June 2003, and in a manner that suggests size continues to matter in the world of bridge building. Now bridges are about much more than just crossing the void in an elegant, safe and economic manner. They can also be potent symbols, gestures of defiance or of place making. The record for the longest steel arch span was grabbed in 2003 by the Lupu Bridge in Shanghai, China – a 'through-arch bridge' or tied-arch bridge with a main span of 550 metres.

But in what appears to be a private war in China between cities seeking record-breaking bridges, the Lupu Bridge was ousted in January 2008 as the world's biggest through-arch-bridge by the Chaotianmen Bridge, across the Yangtze River at Chongqing. Its main span measures 552 metres and it is currently the longest in any arch bridge in the world – but for how long?

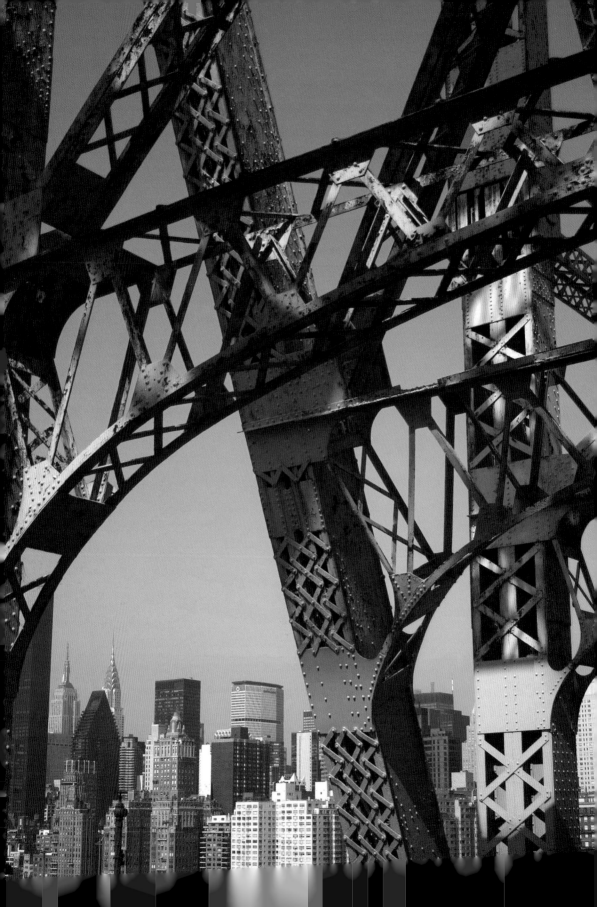

DEFINING PLACES

THE BRIDGES OF NEW YORK ARE AMONG THE GREAT
engineering wonders of the world. They, collectively and
almost in themselves, encapsulate the history of bridge design
and construction during the last 150 years. They are characterized
by massiveness of scale, boldness of vision and an almost
bloody-minded ruthlessness when it came to realization.
Often they are raw, even brutish in the manner in which
they thrust themselves from the fabric of Manhattan Island
and across the Hudson and East Rivers. Some are supreme
examples of their kind, such as the Brooklyn Bridge, but
all helped shape the city of New York. They allowed the
city to define and expand its life and to wed Manhattan to
neighbouring communities in Brooklyn, Queens and further
afield on Long Island and to New Jersey. And all, in their
varied ways, not only possess character, but stunning, and
awe-inspiring beauty.

 To pass over any of these great New York bridges – to
walk past them, under them, over them – is to feel tangible,
visceral, excitement. It comes, I suppose, from the thrill
of their scale, the unornamented character of their steel
construction, the elemental force and power they so evidently
possess as they challenge and tame the forces of nature and
the way they feel so much part of the fabric of the city. They
are poetic, magnificent – they engender not just wonder but

PREVIOUS: Queensboro
Bridge, New York. Opened
in March 1909, this is an
extraordinarily bold bridge
from which the view
of Manhattan is quite
breathtaking.

RIGHT: Workmen 'lashing
the stays' of the Brooklyn
Bridge as the 'Great Work'
nears completion.

FRANK LESLIE'S
ILLUSTRATED
NEWSPAPER

Entered according to Act of Congress, in the year 1883, by Mrs. Frank Leslie, in the Office of the Librarian of Congress at Washington.—Entered at the Post Office, New York, N.Y., as Second-class Matter.

No. 1,440.—Vol. LVI } NEW YORK—FOR THE WEEK ENDING APRIL 28, 1883. [Price, 10 Cents. $4.00 Yearly. 13 Weeks, $1.00

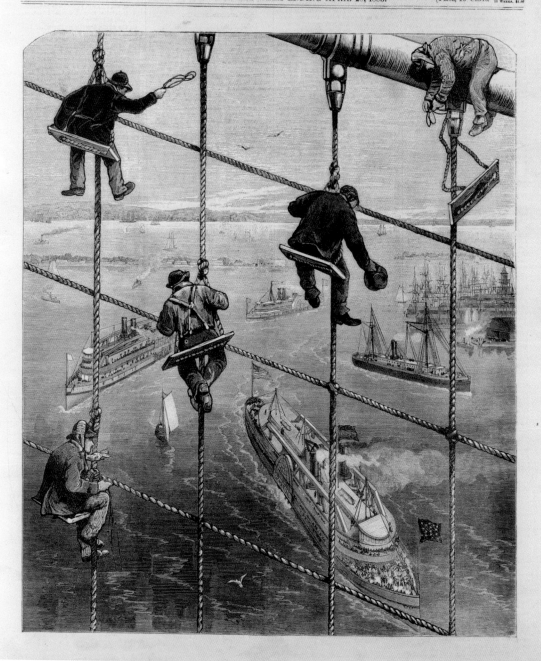

almost a sense of terror. They are, in the eighteenth century sense, sublime: 'awful' and 'terrible', seemingly almost dangerous. None is more so, in its strange and unsought-for beauty, than the Queensboro Bridge. In 1925, F. Scott Fitzgerald, in *The Great Gatsby*, wrote: 'The city seen from Queensboro Bridge... is always the city seen for the first time, in its first wild promise of all the mystery and the beauty in the world'. He was right. The view of the city – of Manhattan – from its bridges is almost invariably stunning – by day a city of close-packed towers sculpted by the sun, at night a firmament of sparking lights reaching up to the heavens. But it is not just the views of Manhattan from its bridges that impresses, but also the bridges from which the views are gained. In their vast scale and bold design, they are bridges quintessentially of the city and add much to the beauty, thrill and visual power of the city-prospects they offer.

Queensboro Bridge, designed by the engineering genius Gustav Lindenthal and architect Henry Hornbostel and which opened in March 1909, has – like most New York bridges – a rich story of extraordinary human enterprise and endeavour, encapsulating great highs and lows of triumph and disaster. It has a stupendous span and is utterly heroic in its aspirations and achievement. It transformed the nature of life in New York by making the vast area of Queens across the East River readily accessible to the centre of Manhattan. But its construction cost a colossal $18 million, involved a disastrous construction failure and claimed the lives of fifty men.

A bridge was first proposed for the site in 1838, to link the then largely uninhabited mid-portion of Manhattan with Long Island City via Blackwell's Island, as Roosevelt Island was then called. Perhaps unsurprisingly this early scheme came to nothing since the demand for such a colossal and expensive undertaking was not pressing. In 1867, after the Civil War and a massive expansion in the scale, wealth and importance of New York, the idea was raised again and a company formed to secure money. But still the time was not right and the project finally collapsed in the 1890s when the company went bankrupt. Ironically, just as this private

LEFT: The visceral power of the Queensboro Bridge: traffic entering the mighty maw of this beast of a bridge. Originally trains rattled along this upper level with road vehicles below. The steel-wrought segmental arches above the road frame a sensational perspective across the river, while the deck offers stunning views across the city.

enterprise failed, the demographics of the city changed and a crossing of the East River at the mid-point of Manhattan suddenly became of vital importance for the life and prosperity of New York.

Queens had been established in 1683 as one of the twelve counties of New York, and it grew gradually as a semi-independent, largely rural community. But as New York boomed after the Civil War, development pressure was focussed on Queens. On 1 January 1898, the majority of Queens County was established as a New York Borough but the only link this new portion of the city had with Manhattan was by ferry or the distant Brooklyn Bridge. Something had to be done. So in 1903 plans for a bridge linking Queens directly with Manhattan were formulated by the city's newly founded Department of Bridges. This Department was led by Lindenthal, who in 1902 had been appointed Commissioner of Bridges.

Born in Brno (now in the Czech Republic) in 1850, Gustav Lindenthal was a largely self-taught engineer who rethought traditional structural problems and generally came up with bold, novel and relatively lightweight and economic solutions. For example, when designing railway bridges he argued that the weight of heavy trains should not just be added to the dead load weight of the bridge. He pointed out that a train, as it moves across a bridge, displaces its load evenly along the structure so that not all the bridge has to be designed to sustain all the weight of the train all the time. The application of this principle led to quicker, cheaper and more minimal railway bridges.

When design work started on the Queensboro Bridge, New York already possessed a number of ambitious bridges – recently completed or nearing completion – that were recognized as being among the most challenging engineering projects of the age. Lindenthal had been involved with several of these. He had overseen the construction of the stunning Williamsburg Bridge – a suspension structure designed by engineer Leffert L. Buck and Hornbostel that was started in 1896. When it finally opened in December 1903, the bridge

BELOW: The Manhattan Bridge under construction in March 1909. The photograph shows how the carriageway was constructed using the suspension cables for support. The bridge's engineer, Leon Moisseiff, explored his famed and ultimately ill-fated minimalist 'deflection theory' during the design of the Manhattan Bridge by constructing towers of extremely narrow profile – to offer minimal wind resistance – but stiffened with perforated steel bracing.

had cost $24 million and, with a main span of 490 metres and an entire length of 2,227 metres, was the longest suspension bridge in the world, until 1924 when the Bear Mountain Bridge was completed.

Lindenthal was also involved with engineer R. S. Buck in the 1902 redesign of the Manhattan Bridge that had been proposed in 1892 to cross the East River from the Bowery in Manhattan to Flatbush Avenue in downtown Brooklyn.[72] The suspension design that was eventually opened in December 1909 was designed by Leon Moisseiff, who went on to act as consultant engineer for San Francisco's Golden Gate Bridge and to design the Tacoma Narrows Suspension Bridge that was opened in 1940 and then collapsed in spectacular manner later that same year, a victim of a terminal 'flutter' in its slender and minimal structure brought on by gusting wind. Moisseiff's Manhattan Bridge had no such problem. It was ambitious in its scale – its main span stretches 448 metres – but Moisseiff designed it before his quest for engineering

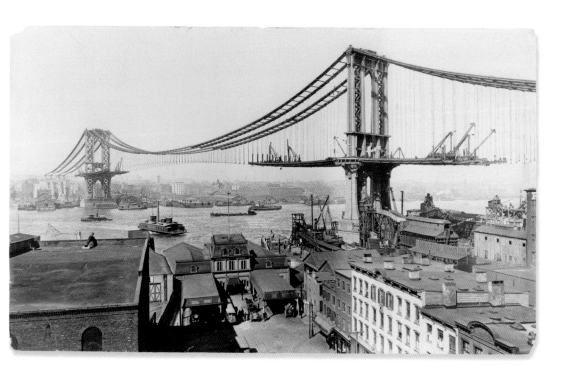

minimalism reached extremes. The Manhattan Bridge is no-nonsense stuff, an exemplary piece of heavyweight industrial design that looks, and is, immensely strong. It was the last of the three great pioneering suspension bridges across New York's East River. Although Lindenthal played a role in the design and construction of two of these three great bridges – the Williamsburg and Manhattan bridges – he had no involvement in the first, and the greatest of them all – the Brooklyn Bridge.

The making of the Brooklyn Bridge is one of the great all-time construction epics – a tale of huge daring, of the development and application of pioneering technology and of very personal tragedy and triumph. It is a story that seems emblematic of human endeavour. For most of the nineteenth century there was no bridge between Manhattan and Brooklyn. They started life as virtually independent towns but had gradually become one city that was, most inconveniently, separated by a wide and often tempestuous sheet of water. By the 1860s most New Yorkers believed the East River had to be bridged. But how? It was wide, windy and it was essential that it remained navigable for tall-masted sailing ships. Any bridge built would have to be long, high and extremely strong.

In 1868 John Roebling, a German-born engineer, came up with a design. He had designed and constructed three suspension bridges and believed the principle was the only solution that could give the city the type of long and high bridge it needed. He met opposition at first. Many people believed that such a bridge – with its long carriageway merely suspended on metal cables – was intrinsically too slight for the task. But Roebling persisted and by June 1869 his design was completed.

Then the first of a series of extraordinary mishaps struck. While John Roebling and his son Washington were standing on the end of the Fulton Ferry pier in Brooklyn, surveying the proposed construction site, John Roebling had his foot crushed as a ferry docked. Within a month he was dead. The project could well have faltered before work had even started. But the young and inexperienced Washington was determined

'The making of Brooklyn Bridge is one of the great all-time construction epics – a tale of huge daring, of pioneering technology and of personal tragedy and triumph.'

to carry on his father's visionary project, on which he had worked as an assistant, and within weeks he was appointed Chief Engineer.

Washington Roebling started construction in January 1870 and his first major task was to build the foundations, below the riverbed, from which the bridge's two tall towers would rise. The foundations were dug using huge timber-built caissons that were constructed on the riverbank then launched like ships, towed to the site where the foundations were to be dug and then sunk. When in position, air was pumped into the caissons and workmen entered them to start digging the foundations. Spoil was extracted by means of shafts filled with water to act as an airlock and construction of the masonry piers was commenced on the roof of the caisson, with the weight of the towers pushing the caissons deeper into the riverbed and making them more airtight. It was all very ingenious and also – in its large scale – all very experimental.

The first mishap for Washington was almost his last. A fire broke out inside the caisson near the Brooklyn shore and Washington took charge of extinguishing it. A desperate struggle followed. If the caisson was too weakened by the fire, the masonry of the tower above would crash through it. But fighting the fire was difficult because the flames were fanned by the high-pressure air entering the caisson. Eventually Washington decided to flood the caisson. This desperate action prevented catastrophe but, just when all seemed safe, he collapsed. Building bridges on unprecedented scale, across

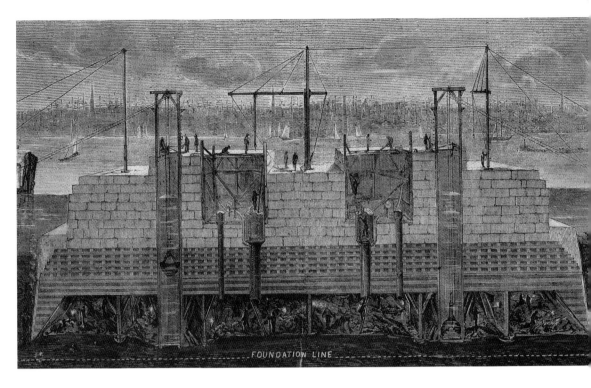

FOUNDATION LINE

wide tracks of water was dangerous indeed because it unleashed forces of nature that were barely even known about, and certainly little understood. What laid Washington Roebling low was called, at the time, 'caisson disease'. It had struck before during bridging operations involving construction deep below water level and was a thing of terror for all involved. Men climbed out of the caisson and some, occasionally and suddenly, were struck with mysterious inner pains and even paralysis. At the time people simply didn't know that the human body needs to adjust when taken from a high-pressure atmosphere to normal air pressure. The condition, caused by gas bubbles forming in the blood stream, is now known as 'decompression sickness' or 'the bends', but in the 1860s it was regarded as one of the many risks faced by those audacious enough to defy nature by constructing bridges of unprecedented size across wide tracks of deep water.

His intimate acquaintance with the painful and mysterious 'disease' – and the large number of workers being taken ill or

ABOVE: The foundations and stone piers of the Brooklyn Bridge under construction in the early 1870s using pneumatic caissons, pumped full of air under pressure to ensure that mud and water did not seep into the workings. An inspired idea except that working in sealed chambers filled with compressed air tends to kill and cripple.

quitting the site in panic – shook Roebling. The excavation for the Brooklyn tower reached bedrock in 1871 after an excavation of 13.5 metres, the caisson was filled with concrete and the foundation was complete and strong.

But things were proceeding very differently on the Manhattan side. After digging an excavation 18 metres deep, bedrock was still not found. If he went on digging, men would suffer and die; if he stopped before reaching bedrock, the foundations might not be sound, the tower could shift, and the completed bridge would be in danger of sudden collapse. Seemingly recovered, Roebling went back inside the caisson, inspected the soil, took samples and made tests. Finally he concluded that the hard-packed sand and gravel, although not as firm as bedrock, could take the weight of the tower. When the excavation was 22 metres below water level, work was stopped and concrete pumped into the caisson.

Time proved Roebling right in his calculation, the tower has not moved but the hours he spent in the caisson proved nearly fatal. His 'caisson disease' returned – worse than before – and he was left partly paralysed and bed-ridden. He never returned to the bridge, but extraordinarily he remained in charge of its construction – aided by the binoculars with which he could view the bridge from his bedroom window and by his wife.

Emily Roebling was, by any standards, a remarkable woman – which was just as well for the future of the bridge. Her husband was bed-bound but he was not going to give up control of a project that had been dear to his father and had become an obsession with him. He believed he could continue if a reliable means of communication was established between his sick bed and the construction site. Fortunately Emily Roebling was also fixated on bridge design and undertook to be the conduit of communication. This was a brave decision to make. The bridge was, in many respects, the most ambitious ever undertaken, so the responsibility was enormous and – to make things worse – Emily had to operate within the traditionally male-dominated world of engineering and in an age when women were excluded from the professions and had very limited independence.

Initially she appeared to be just a go-between – carrying information from the bridge to her husband and his instructions back to the construction team – but it soon became clear that she was far more than a mere messenger. She was observing conditions on the site, carrying back her appreciations of problems, and helping her husband make decisions. Quite simply, if Emily had not been willing and able to function in this manner, making shrewd and intelligent observations, Roebling would not have been able to continue as Chief Engineer. Increasingly it was his wife who was supervising the construction of Brooklyn Bridge.

ABOVE: Emily Roebling, working with her bed-ridden husband Washington Roebling who had been crippled while toiling in a pneumatic caisson, became effectively the executive engineer for the Brooklyn Bridge. Without her shrewd intelligence it's unlikely the bridge would have been completed in the pioneering and majestic manner the Roeblings had envisaged.

Emily was not, of course, trained an as engineer but after her marriage to Roebling she had travelled with him through Europe as he studied new techniques of bridge construction. She had evidently learned much herself.

When the second of the two towers was completed in 1876, the cables had to be slung between them, and from these cables the carriageway would be hung. Up until now wrought-iron chains or eye bars had been used for suspension cables but Roebling wanted to use steel, which possessed more tensile strength than wrought-iron and which it was now possible to produce in the required quantity and to the required quality at a reasonable cost. The cables were pioneering compositions with steel itself being used for the first time in a major structural capacity only a few years earlier in James Eads' bridge in St. Louis (see page 55). Each cable was 40 centimetres in diameter and was made out of 19 strands bound together with steel wire, and each strand was itself formed out of 278 steel 'wires' each about 6 millimetres thick. The strands were spun together to form the cables, forming strong and elegant catenary curves from each of

BELOW: Diagrammatic sketch of one of the Brooklyn Bridge's suspension cables. Each cable was made out of steel wires bound into strands that were in turn, bound together with steel wire to form the 40-cm diameter cables.

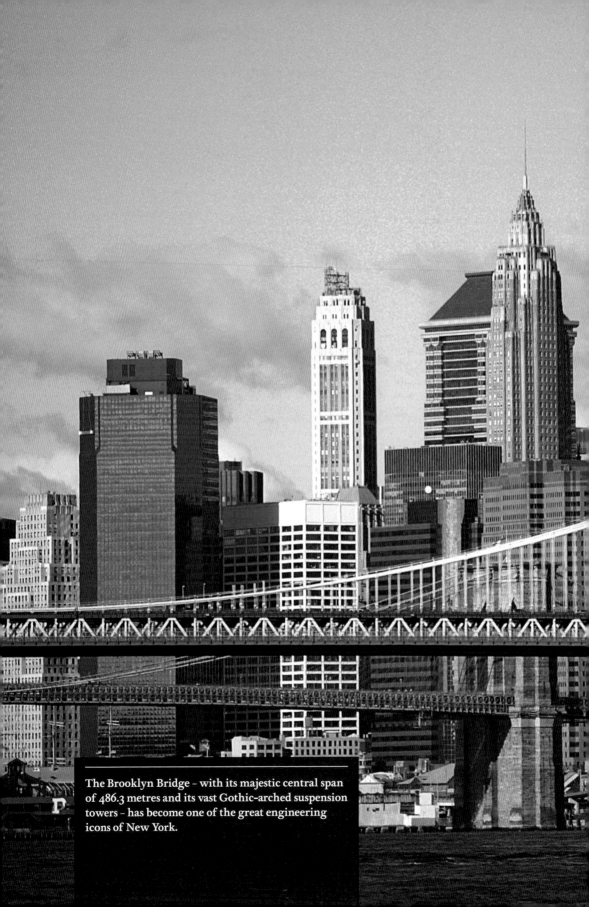

The Brooklyn Bridge – with its majestic central span of 486.3 metres and its vast Gothic-arched suspension towers – has become one of the great engineering icons of New York.

'The stupendous Gothic arches frame the city making New York appear, in certain lights and vistas, like an animated stained glass window of almost unimaginable scale.'

the towers, with the ends of each cable eventually placed firmly in the ground under an 'anchorage', each of which weighed 54,431 tonnes.

After many trials and tribulations the bridge was eventually opened in May 1883. With its total length of 1,825.4 metres and central span between towers of 486.3 metres, the bridge was, when completed, around 50 per cent longer than any other suspension bridge in the world, and its towers the tallest structures in the western hemisphere.

But the bridge was not just about scale. The Roeblings wanted to give New York not only an engineering masterpiece that was safe, functional and fit for purpose, but also an ornament, a thing of breathtaking and sublime beauty that would raise the spirits of the thousands of people who, each day, crossed between Brooklyn and Manhattan and who passed below the bridge on ships entering and leaving the East River.

The soaring limestone towers, the height and strength of which were vital to the function of the bridge, were each conceived as a pair of pointed arches framed by tall piers. These were in the spirit of the mid-nineteenth-century Gothic revival and were intended to give what could otherwise be no more than a ruthlessly engineered construction a conscious cultural pedigree. So travellers hurtling across the bridge were to pass through a pair of huge Gothic portals, like vast medieval city gates or cathedral doors, through which they would glimpse stunningly framed views of the city. Passing through these portals – on

walkways raised as high as possible to offer pedestrians the best possible views of the city and harbour – must have been an astonishing experience in the 1880s, and it remains one of the most thrilling urban experiences on earth. The stupendous Gothic arches frame the city making New York appear, in certain lights and vistas, like an animated stained glass window of almost unimaginable scale.

Immediately the huge scale, daring, and cutting-edge technology of the bridge was perceived to define the boundless energy, pride and aspirations of New York. But it all came at a price. At least twenty men beside John Roebling died to create what was arguably the most beautiful and revolutionary bridge the world had ever seen, and it had cost the colossal sum of $21 million.[73] Some of the construction problems and accidents that the Roeblings had to face could not have been fully anticipated or avoided, for such challenges are in the nature of pioneering construction projects. But some could. The contractor, in an effort to claw back money, supplied steel wire for the cabling that was inferior to that specified. This was an outrageous, and possibly catastrophic, piece of roguery and by the time it was discovered much cabling had been spun and positioned. To redo the work would cost much time and money.

Roebling set to work to analyse this unexpected and unlooked for problem and to calculate its impact on the design and solidity of the bridge. His response to the findings was pragmatic. The inferior wire could stay – it made the bridge, calculated Roebling, only four times stronger than necessary rather than the six he had aimed at. But he added additional cables to the structure, notably the diagonal cable stays from the towers to the deck. These were added to stiffen the structure but are not essential, although, as it happens, they do add to the visual delight of the bridge, creating pleasing lattice patterns and shadows as they cross the vertical suspension cables that link the curving main cable to the carriageway.

On the first day of use it was calculated that 1,800 vehicles and 150, 300 people crossed the bridge. But then something extraordinary happened which has never been fully explained.

Having embraced the new bridge with pride and enthusiasm and having flocked across it, the city suddenly lost its nerve. One week after opening, as people were streaming across the bridge, a rumour got hold of the crowds. Where it originated remains unknown, but suddenly the people on the bridge heard that it was about to collapse. The speed with which panic spread suggests that most users of the bridge had to screw up their courage to cross and expected disaster to strike. There was a stampede to get off the bridge and twelve people were crushed to death. The bridge, of course, did not collapse or fail in any way and confidence was restored, not least because in May 1883 the renowned P. T. Barnum, in an inspired act of self-promotion, led a parade of twenty-one elephants across the bridge to demonstrate its strength and stability.

So New York's first three great bridges were of suspension type. The fourth would be different in conception. The hint of things to come lay within the structure of the Manhattan Bridge. Its main span of 490 metres is suspended from cables but the approaches leading from land to the suspension towers derive no support from the cables above them. They are cantilevered constructions – and this was the principle employed in the Queensboro Bridge.

Suspension bridges can be the most daring and visually thrilling of bridge designs – lofty, minimal, supremely elegant, and with breathtakingly wide spans. But, to my mind, cantilevered bridges are the most exciting, the most satisfying to contemplate. At their best and biggest they are the great beast of bridges, often raw, almost brutal in design and construction, and which in their engineering both utilise and in spectacular manner defy the laws of nature.

The cantilever bridge is a variant on the three basic types of bridge, each based on a natural prototype: the beam bridge that is in essence like a log across a stream; the arched bridge that is like a natural rock formation; and the suspension bridge that is inspired by hanging vines and creepers. The cantilever is, in a sense, a more complex and engineered version of the beam bridge. Although originating in ancient Asia, the cantilever type was only used in the West in any

significant way from the mid nineteenth century and reflected the potential offered by new materials such as wrought-iron and steel. It was inspired by the new perceptions of the natural world – in particular the engineering of mammal skeletons – that were a result of new scientific inquiry.

In a typical, large, late-nineteenth-century cantilever bridge, tall towers support horizontal cantilevered carriageways. Together these towers and carriageways – wrought typically out of a lattice-work of mutually supporting and bracing metal components – form a structurally integrated truss in which each carriageway, thrusting in opposite directions, is counterbalanced, one against the other. This is the simple, basic and elegant principle of cantilevered bridges: to use weight to balance weight; to create a state of poise or equilibrium by perfectly pitting one load or thrust against another. Cantilevered carriageways are linked by suspended spans and the weights of these spans counterbalance each other until the bridge heads at either end are reached. Then the loads are balanced by approach works and structural equilibrium achieved.

An early and outstanding example of this type of construction is the Forth Railway Bridge in Scotland. Designed and built between 1887 and 1890 its engineers – Sir Benjamin Baker and Sir John Fowler – were inspired by the structural possibilities offered by steel (just then made legal in Britain as a primary building material) and by the cantilever principles found in the skeletons of large mammals. D'Arcy Thompson, in his book of 1908 entitled *On Growth and Form*, argued that the pioneering structural solutions of the age were generally inspired by nature and analogous with anatomical designs. He observed similarities in the structures of bones and made-made girders and columns, and pointed out that the design of the Forth Railway Bridge exemplified the pure, functional beauty that comes from the application of rational, mechanical – and natural – design principles. He pointed out that the steel tubes used in the bridge correspond to the structure of strong cylindrical plant stalks (in fact the bridge's tubes even have strengthening rings added to their joints as in bamboo – one of the strongest vegetable structures), and

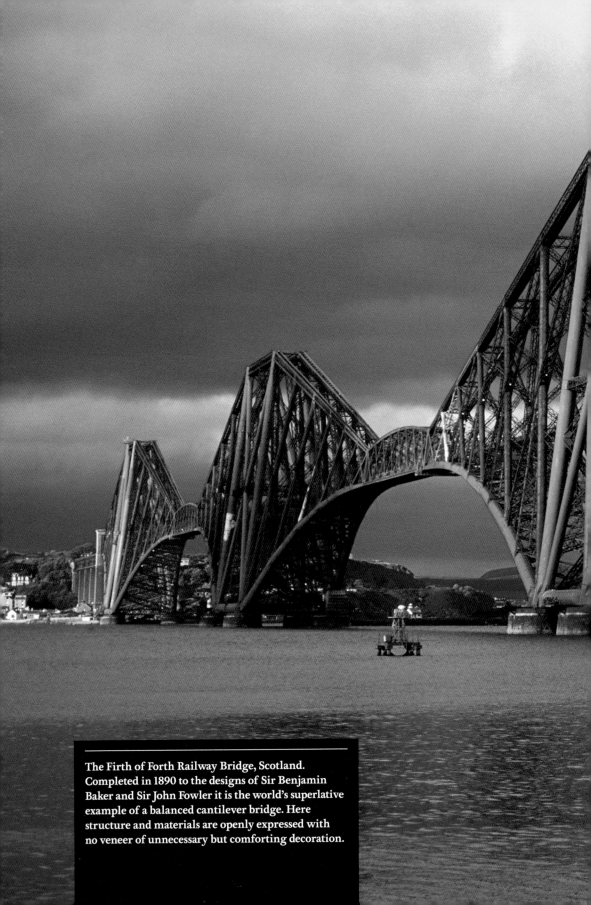

The Firth of Forth Railway Bridge, Scotland.
Completed in 1890 to the designs of Sir Benjamin
Baker and Sir John Fowler it is the world's superlative
example of a balanced cantilever bridge. Here
structure and materials are openly expressed with
no veneer of unnecessary but comforting decoration.

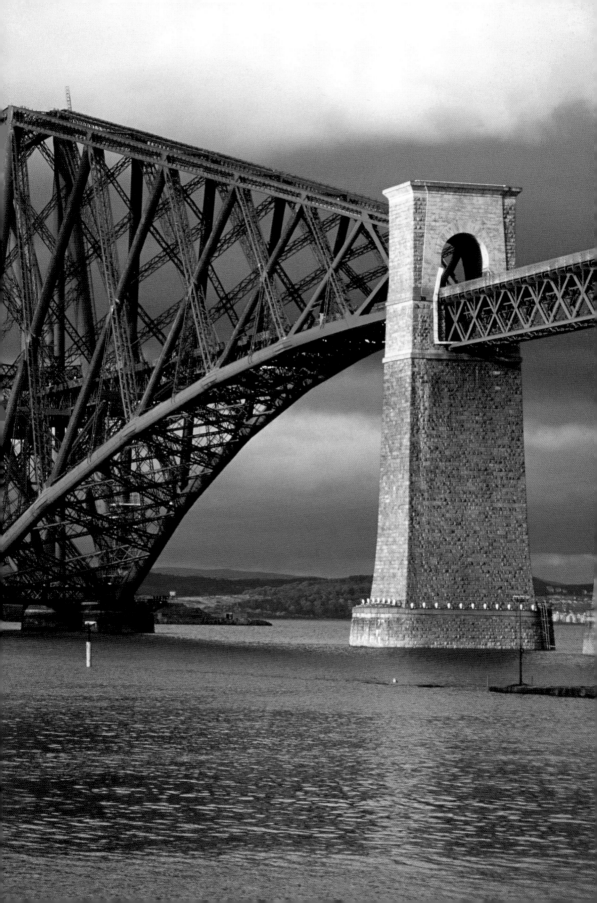

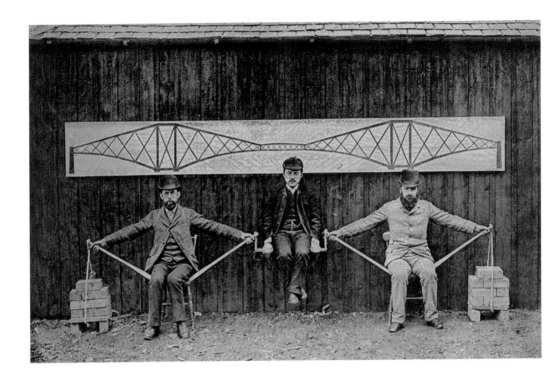

that the bridge's double-cantilevered trusses emulate the quadruped skeletons of a horse or bison.

A charming photograph made during the construction of the Forth Bridge explains its structural principles very clearly. The photograph shows three men, seated in a row. The two end ones have their arms outstretched but pointing down, and in each of their hands they hold sticks – the same length as their arms – that point diagonally down to rest on the seats of their chairs. The shape each man makes with his arms and sticks echoes the lozenge shape of the Forth Bridge's cantilever trusses. Between these two men sits the third, on a plank attached to the inner ends of the sticks. He represents the load of a train on the suspended span between the cantilever trusses. The weight of the man on his span is counterbalanced by stacks of bricks suspended by strings from the far ends of the outer sticks. These bricks represent the balancing weight of adjoining abutments or spans. Particularly revealing is what, under this system of

ABOVE: A photograph from the 1880s demonstrating the structural principle of the balanced cantilevers of the Forth Railway Bridge. The men to left and right represent the trusses of the bridge – their arms being in tension and the sticks they hold being in compression – and the man in the centre represents the load of a train on the suspended span.

weight and counterweight, is happening to the arms of the men and their sticks simulating the trusses. Their arms are in tension, being pulled down by the load, while the sticks are in compression being forced down by the load. And so it is, in general terms, with the cantilever trusses on the bridge itself – the main upper members are in tension and those below the track are in compression.

Completed a few years after the Brooklyn Bridge, the Forth Railway Bridge is different not just in the structural principle applied but in its visual appeal, aspirations and punch. Roebling, with his Gothic arches and ornamental additions, wanted a modern bridge that also bore the respectable veneer of history so that it would be both ornamental and culturally acceptable within the conventions of the time. The Forth Bridge makes no concession to superficial beauty or history. Its form is the simple and functional expression of its means and materials of construction. We can now see that abstract and elemental beauty which comes from the honest expression of its function. But in the 1890s Baker and Fowler were a little too far ahead of their time when it came to aesthetics. The perceptive D'Arcy Thompson appreciated the utilitarian beauty of the Forth Bridge but many did not.

William Morris, the doyen of Arts and Crafts ornament and a champion of the revived Gothic style, appears to have been bewildered by the bridge. For him it seemed to come from another world, which, in a sense, it did – the future. William Morris was used to a world in which even the most pioneering or revolutionary building types – such as railway terminals or London's structurally ambitious Tower Bridge started in 1886 – had been habitually tricked out with historic detail or forms.

London's Tower Bridge is a pertinent example. Completed in 1894 it was of ambitious design, combining bascule and suspension principles and built using a steel frame, yet disguised by Sir Horace Jones and Sir John Wolfe Barry to look like a pair of Tudor gothic stone towers. This counterfeit history Morris could understand, he believed it gave an essentially utilitarian and modern object a sense of dignity

and culture. What he simply could not comprehend was a massive engineered structure displayed in its raw, naked, functional glory without even a nod to the concealing decencies of ornament. In his deep cultural confusion Morris could do no more than dismiss the Forth Bridge as the 'supremest specimen of ugliness'.[74]

Smaller and traditional cantilevered bridges, of the type found in large numbers in China, Tibet, Bhutan and Japan, possess two 'anchor arms' that extend towards each other from opposite sides of the river or gorge to be bridged, and are linked by middle spans. Typically the anchor arms of these bridges reduce the width of the chasm to be bridged by cantilevering stone slabs out from the bridgehead. These projecting stones support timber beams that project yet further and in turn are cantilevered. Additional beams can be added, each lighter than those below and projecting yet further, with the uppermost and furthest projecting timbers finally being linked by a horizontal span. A good, and larger than usual, example of the traditional Asian cantilever is the remarkable Shogun's Bridge at Daiya-gawa, Nikko, Japan that spans 26 metres and is the oldest known cantilever bridge dating back to the ninth century AD (some sources even claim the fourth century) but rebuilt in 1638 and again in 1902. It is a curious design incorporating a pair of hewn stone piers and lintels, strengthened by stone ties, which support cantilevered beams linked by a central suspended timber span, with all timbers shaped to form an elegant segmental arch.

The Queensboro Bridge was not the first modern, wide-span and multi-truss cantilever bridge built in the United States. In 1877 the engineer Charles Shaler Smith built what – at 342 metres – was the world's longest cantilever bridge, incorporating a maximum span of 84 metres. It was designed to cross the deep gorge of the Kentucky River at Dixville and in the Paris Exposition of 1878 was promoted as a prime example of American engineering ingenuity. A few years later, in 1883, came Charles Conrad Schneider's 276-metre Michigan Central Railroad Bridge over the Niagara Gorge (with a main span of 151 metres and closed in 1925), followed

RIGHT: London's Tower Bridge, started in 1886. A modern, steel-framed, counter-balanced bascule drawbridge, but stone-clad and detailed to look like a pair of Gothic gatehouses in deference to the neighbouring Tower of London.

by the Poughkeepsie Railroad Bridge in New York State, completed in 1889. The mighty and now disused and generally abandoned Poughkeepsie Railroad Bridge is particularly exciting. It has an overall length of 2,063 metres and incorporates seven main cantilever spans, the longest of which is 168.6 metres long. The bridge was designed by Charles Macdonald and Arthur B. Paine and enlarged and strengthened in 1906 by Ralph Modjeski.

These early American examples of cantilever bridges were inspired by Heinrich Gerber's pioneering Hassfurt Bridge of 1867 over the River Main in Germany – incorporating a main span of 38 metres and the world's first large and modern cantilever bridge. All of them utilized the potential inherent in this type of design to solve very specific site problems. One of the beauties of the cantilevered bridge is that it can

– in theory – be constructed with no 'falsework', which means it can be built without any expensive or complex scaffolding or other systems of temporary support. A cantilever bridge can be built off itself – a thing not generally possible with traditional beam or arched bridges. Also, the superstructure of a cantilever bridge, especially when its main elements are connected by flexible 'hinges', is able to adjust if abutments or piers move due to faults in the construction of foundations or miscalculations about the stability of the soil. These admirable characteristics mean that a cantilever bridge is eminently suitable to cross wide and deep gorges or to cross wide, deep or turbulent bodies of water.

While these early American cantilever bridges have their moments – particularly the vast and now gloomily obsolete Poughkeepsie – none in my view are as visually exciting and historically fascinating as New York's Queensboro Bridge. The stupendous presence of this bridge first really impressed itself upon me early one morning. New York is so well endowed with huge-limbed and sensually overwhelming bridges and, on the usual dash around the city, it's easy to take these extraordinary creatures for granted. You rush over or under them, then suddenly get the most sublime glimpses of them from afar – towering in an almost terrifying manner above neighbouring streets and buildings – or unexpectedly find yourself among the often strange lives that struggle in their shadows. The underused land below the elevated approaches to New York's bridges is among the oddest places in the city, twilight no-man's-lands where humanity huddles or pursues unlikely activities. Bridges are indeed emblems of the world. They have their sunlit upper sides where all is activity and life, but they also have their dark and melancholy underworlds where shadow, stillness and decay dominate.

It was while in a state of morning calm that I suddenly saw, as if for the first time, the Queensboro Bridge. I was staying in a Manhattan hotel just to the north of the bridgehead. I had arrived late at night and in the morning when I opened the curtains I was, unexpectedly, confronted

by the bridge, seemingly only a few metres away. Its vast and steely structure filled the frame of the windows – abstract, mighty and evidently towering above me and disappearing to left and right, into infinity. There was bridge as far as the eye could see. I was awestruck, mesmerised by this incredible skeletal, sculptural object – sombre and terrible of aspect. I strained to see the top of the bridge's clearly no-nonsense and hugely strong lattice of steel girders and beams and was surprised to just about make out what appeared to be ornamental Gothic spirelets on top of the towers. Charming if somewhat odd, no doubt the contribution of the architect Hornbostel and a perhaps unnecessary attempt to make the bridge's unashamedly exposed engineering muscle look culturally respectable.

The bridge, although abuzz with scurrying humanity intent on its all-consuming urban business, seemed itself to be of another, eternal world. It seemed not just immense but indestructible, strength incarnate. When all else is gone, I thought, the bridge will still be here. I rushed off to join the throng and very soon found myself on the bridge, jostling my way to Queens. This was an incredible experience itself. In the manner of Robert Stephenson's High Level Bridge at Newcastle-upon-Tyne (see page 182) the carriageway of the Queensboro Bridge is a two-tier affair. On the upper level of the carriageway, set within the 18.2 metre wide cantilever trusses, is a deck that originally carried four railway tracks. To each side of the railway deck are cantilevered decks for pedestrians. Below the rail deck were – initially – six road-lanes for vehicle traffic set within what is essentially an elongated, lattice-framed, steel cage that extends from one bank to the other. And travelling along this lower deck is, especially on sunny and clear days, a very sensory experience. There's noise and smells – and of course tremendous views across the city of the sort that so impressed F. Scott Fitzgerald. But there are also extraordinary plays of light and shade, as shadows cast by the bridge's steel members flash in hypnotic rhythm across the windscreen and within the vehicle. The upper deck, now with a bicycle lane, is even more visually

exciting for above it is a lattice work of segmental steel curves that, seen in perspective, appear to form a vast vault framing a distant view of the city. Having experienced the bridge in such dramatic manner I had to find out more about its story.

My first discovery – being more of an observation really – is that the Queensboro Bridge is like no other great cantilever bridge. Its huge towers support cantilevered sections that connect one to the other with no intermediate suspended spans. There is one tower anchored to the Manhattan shore, another anchored to the Long Island shore at Queens, and these meet the pair of towers built on Roosevelt Island without the need for any linking suspended spans. So there are just two massive cantilever sections, with spans of 300 and 360 metres from island to both shores, with a 192-metre-long dash across the island on a carriageway set within the pair of central towers. These towers, as with the trusses on the Forth Railway Bridge, are well-calculated combinations of steel members in compression and in tension – from some the carriageways are suspended and so these members are in tension while others support the carriageways and so are in compression.

When completed the Queensboro Bridge was not only a supreme example of the science – and art – of the engineer but was also, with its total length of 1,135.2 metres between anchorages and with a total length of 2,270 metres including approaches, the longest cantilever bridge in North America and the one designed to carry the heaviest loads. It lost its title as the longest cantilever bridge in 1917 when the Quebec Bridge (Pont de Quebec) was completed.

This bridge possesses the longest cantilevered carriageway ever built (549 metres formed by a pair of 177 metre cantilevers connected by a 195 metre suspended span) but also one of the most tragic histories in the annals of modern bridge construction. In 1907 one of the cantilever arms and part of the central section of the Quebec Bridge collapsed four years into construction killing seventy-five workers. The Supervising Engineer, Theodore Cooper, was replaced by an engineering triumvirate including Maurice Fitzmaurice who had worked on the Forth

The Queensboro Bridge, New York. The majority of its mighty span of 1,135.2 metres between shore anchorages is formed by two massive cantilever sections, connected directly to each other and without the conventional link of suspended spans. The central cantilever truss stands astride Roosevelt Island.

Railway Bridge, and construction was started on a revised design. But in 1916 its central section collapsed while being raised and a further thirteen workers were killed. The bridge, when finally completed, did indeed set world records both in number of dead workmen (eighty-eight in all) and in the length of its cantilevered span, but it didn't have an epoch-making look. Indeed it appeared to be a somewhat ungainly version of the Forth Railway Bridge. So although the Quebec Bridge robbed the Queensboro Bridge of its record for length of cantilever it didn't even begin to challenge it in the beauty stakes or emulate its peculiar visual magic.

The Queensboro Bridge does, of course, have its own dark stories. Most of the fifty men who died during its construction were killed when an incomplete section of cantilever collapsed during a windstorm. The problem of sudden and cataclysmic collapse beset cantilever bridges when the attempt to utilize one of the major assets of the type – the ability to erect without the use of expensive scaffolding – was compromised by natural circumstances or faulty construction procedures. The completion of the Queensboro Bridge was also delayed by a steel strike and an upsurge of unrest among the workforce. Union agitators – in protest against the open-shop, non-union preference of the contractors, city officials and the 'Committee of Forty' (as a group of influential pro-bridge Long Island business interests was called) – even attempted to dynamite a portion of the bridge. More delays came after the collapse in 1907 of

part of the cantilever of the Quebec Bridge. The contractors at the Queensboro Bridge were suddenly gripped by uncertainty, indeed near panic. Could the same thing happen in New York? Redesigns of details were ordered and so much additional steel added that Hornbostel declared in dismay that the bridge looked like a blacksmith's shop!

When the bridge was finally completed in 1909 its name had been changed from the Queensboro Bridge to the Blackwell's Island Bridge after the island (now known as Roosevelt Island) on which the central towers sit. Then it became known as the 59th Street Bridge and only regained the name Queensboro Bridge after the end of the Second World War. It seems that in the early years of the bridge's construction much of the city's Irish community living in Queens and Manhattan – who were very influential members of New York's construction industry – objected to the use of Queens in the name of the bridge because it brought back painful memories of British rule in Ireland.

Something else changed. By the time the bridge was completed Lindenthal had been replaced by George E. Best as the city's Bridge Commissioner, a victim of New York's ever-complex internecine politics. So the bridge was opened among fireworks organized by the Committee of Forty and the Mayor George B. McClennan paraded across while the man he had ousted and who was the single person most responsible for this stupendous erection – was consigned to the shadows. But Lindenthal did not remain in obscurity and seven years later, with his Hell Gate Bridge also crossing New York's East River, he created another pioneering and even more influential masterpiece of bridge design (see page 220). Nor, of course, was the Queensboro Bridge the last word in cantilever design. It was superior to the later Quebec Bridge – despite the Canadian bridge's longer cantilever and suspended span. But I have seen later cantilevers almost as moving and none more so than the Howrah Bridge in Calcutta (or Kolkata), Bengal, India.

One of the world's great sights is the spare and utilitarian steel structure of the Howrah Bridge, towering high above

the Ghats and warehouses alongside the River Hooghly and host to the teaming life of the city that flows across the bridge day and night. Connecting Calcutta to Howrah, which contains one of the busiest railway stations in the world, the volume of traffic across the bridge is almost unimaginable – it is currently estimated that the bridge is used by up to a quarter of a million pedestrian journeys per day and by nearly 150,000 vehicles.

The bridge was started in 1937, to designs of British engineers Rendel, Palmer and Tritton, who made a point of employing Indian-forged steel. The first major job was to sink the pair of caissons on the riverbank needed to construct the below water foundations for the bridges' piers. These caissons were – and remain – the largest sunk caissons ever constructed within land. Everything about the bridge is heroic. Its carriageway – suspended below the massive steel frame with its startlingly abrupt end terminations – stands high above the river so that it does not interfere with navigation. Its central cantilevered span measures 457 metres – substantially longer than the Queensboro Bridge's maximum cantilever span of 360 metres and not far short of the Forth Railway Bridge's maximum span of 521 metres and the Quebec Bridge's 549 metre span.

Perhaps more impressive still is the speed of construction. The vast pair of cantilever arms was completed by mid-summer 1941 – construction urged on by the military requirements of the war – with the suspended span in place by December. All the steels were riveted together, as had been the practice at earlier bridges such as the Forth Railway Bridge. This was a good technique because the rivets – inserted and hammered while hot – shrunk when they cooled and helped pull the different components together to make all work as a continuous structure. But it was also a labour-intensive practice, requiring rivets to be heated on site, and by the Forties this technique was giving way to nuts and bolts. The Howrah Bridge must be one of the last large steel structures in the world to have been fabricated using rivets.

It was opened for traffic in February 1943 and, like all great bridges, helps define the city in which it stands. It now has a spectacular sister bridge across the Hooghly: the Vidyasagar Setu which is a 823-metre-long, cable-stayed affair opened in 1992 and incorporating a maximum span equal to the 457-metre span of the Howrah Bridge. But there is no question which bridge is most beloved in the city, and which remains the source of greatest pride and sense of identity.

WORKS OF
ART

TWENTIETH-CENTURY ENGINEERS COULD CREATE
works of contemporary abstract art – minimal and beautiful –
that, like the works of Pablo Picasso, evoked the pioneering and
inventive spirit of the age. Bridges could also show the artistic
potential of new materials that permitted the realization of
unprecedented structural forms. The bridges of the early
twentieth century could look like bridges had never looked
before, and do things that bridges had never dared do before,
because they were made in new ways from new materials.

All this is revealed by the first sight of the Salginatobel
Bridge, near Schiers, in Switzerland. It leaps across a precipitous
Alpine gorge, its minimal and shallow parabolic arch –
constructed with three hinges to permit inevitable movement
– spans 90 metres to allow a narrow road to wind on its
way along the mountainside. It is quite simply beautiful:
its simple form emotive and expressive of strength and
daring. It is abstract sculpture of the highest quality – not
least because of its plastic quality and apparently seamless
construction. Instead of metal parts riveted, bolted or welded
together, it is made of concrete, cast in moulds and reinforced
with steel rods to create a single monolithic form. It is not
ornamented in any way, nor its surface coloured or painted,
but its structure is boldly expressed and its colour is that of
its material of construction.

PREVIOUS: The elegant and
precision-made simplicity
of the Salginatobel Bridge,
Schiers, Switzerland, in its
rugged mountain setting.
The bridge, constructed of
reinforced concrete, was
completed in 1930 to the
designs of Robert Maillart.

Reinforced concrete was the new material of the age, and
it is the material that gives the bridge its minimal look,
its strength, and its contemporary, sculptural character.
The designer of the bridge – completed in 1930 – was the
Swiss-born engineer, Robert Maillart, the creator of nearly
fifty bridges between 1900 and his death in 1940. He was one
of the greatest masters of reinforced concrete construction
and well able to realize its potential to offer simple, planar
abstract forms that best expressed the Modernist artistic
aspirations of the age.

But Maillart, although an expert structural engineer, was
– like Gustave Eiffel (see page 261) – also an artist tempering
functional requirements and consequences with aesthetic
sensibilities. At Salginatobel, as Maillart later admitted,
the bridge 'cannot lay claim to complete sincerity of form'
because if the forces at work were accurately reflected and
most directly responded to, then the underside, or soffit,
of the bridge's arch would take the form of two 'lenticular'
(lentil-shaped) biconvex surfaces meeting in a point.[75]
Maillart the artist intervened to deny pure structural logic,
creating a gentle curve of beautiful and harmonious form
in striking contrast with the rough and fragmented mountainous
landscape. The bridge was to be an essay in man-made harmony
and balance, within the rough, massive and terrible creation

BELOW: Sketch of the
Salginatobel Bridge
with its three-hinged
segmental arch.

of nature. It was to be a work of engineering art realized in a material that gave pre-eminence to pure form.

Although reinforced concrete was a new structural material in the early twentieth century, concrete itself has an ancient and noble history as a building material. It seems to have been used first, in any significant quantity and manner, in the second century BC by Roman engineers. They perceived that it possessed a number of very useful qualities and as a sort of liquid stone capable of being cast to create huge monolithic forms, it made construction both quick and cheap, and when used skilfully allowed the realization of unprecedented building forms – for example the vast cast concrete dome of 43.3 metre diameter over the Pantheon in Rome.

But what exactly was Roman concrete? Known as *opus caementicium*, like modern concrete, it consisted in its basic form of an aggregate and a hydraulic cement or binder that hardened because of a chemical reaction and not by the process of 'drying out' after being mixed with water. To avoid confusion, it is worth remembering that cement is the dry powder used to bind the constituent aggregates of concrete into a solid and viable construction material, either by the use of water or additives. Roman aggregates included chips of rock, ceramic tile and brick rubble; binders included gypsum and lime. Building lime – used well before Roman times – was made by baking limestone in a kiln and then pounding it into a coarse dust that was then mixed with the other ingredients of the concrete. Alternatively the baked limestone could be thrown into water where a chemical reaction caused it to break down to form a thick putty-like paste. This lime-putty was ideal for certain building operations, particularly when mixed with sand for rendering lime-stone, brick or mud walls to make them more weather resistant.

Roman concrete could also possess a very remarkable quality. If mixed with *pozzolana* – a volcanic sand or binder rich in alumina and silica that was gathered from around Vesuvius near Naples – concrete would set hard under water. This made concrete an indispensable material for the construction of harbours, quay walls, aqueducts,

and in the foundations and piers of bridges. This special type of concrete, and the method of mixing it, is described by the Roman architect Vitruvius, writing in the first century BC in his *Ten Books of Architecture*. For structural mortars for use in buildings he recommended the use of *pozzolana* from the sand beds of Puteoli near Naples, or from Rome, mixed with water and lime in the ratio of one part lime to three parts *pozzolana*. For underwater works he recommended one part lime to two parts *Puteoli pozzolana*. Concrete was generally regarded by the Romans as unsightly and was either clad with metal (as originally with the dome in the Pantheon), with stone, or with brick.

The structural use of concrete faded with the Roman Empire and the secrets of concrete manufacture and construction were forgotten. Burnt lime continued as a building material, mostly as a binder in lime mortar or in lime render, but possessing

BELOW: Detail of the dome of the Pantheon in Rome. Cast around AD 126 in monolithic mass-concrete. The concrete would originally have been clad – and concealed – by an ornamental veneer of bronze panels.

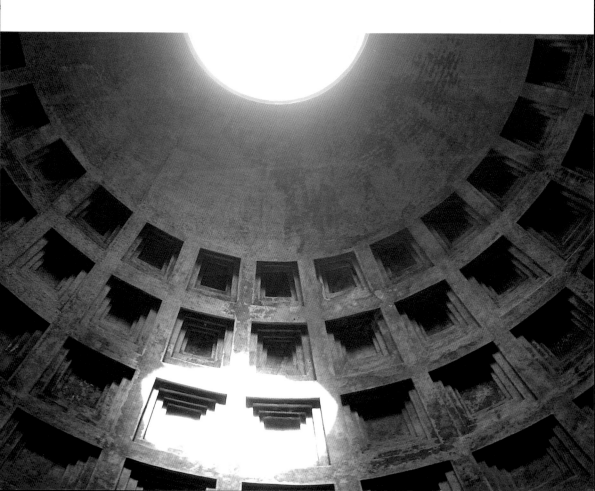

little inherent tensile strength, lime mortar could not be used in a structural role but only for gluing brick or stones together to help create solid and weather-proof structures. But during the eighteenth century in Europe, much was rediscovered about the ancient Roman world – and this included concrete and hard and quick-drying cement. Experiments with the use of lime (as opposed to cement) concrete were made in late eighteenth century France and Britain. These usually incorporated equivalents of *pozzolana* and were not vary daring or widespread, generally being confined to footings for foundations, as in John Rennie and Robert Smirke's repairs of 1816 to London's Millbank Penitentiary.

Things developed somewhat differently, and more dramatically, with cement. In 1799 a substance named 'Roman cement' was patented in Britain by James Parker but, rather confusingly, contained no material used anciently by the Romans. Rather it was a 'natural cement' made by burning

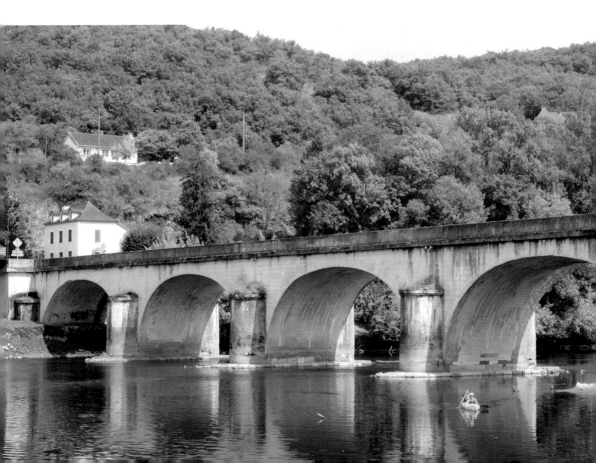

septaria (rocky nodules found in some clay deposits), grinding it to a dust and mixing with sand. The result was a hard, quick-setting mortar that was used both as a bedding for masonry and as a render. The success of Roman cement led others to experiment with novel mortar mixes, and in 1824 Joseph Aspdin invented what he termed 'Portland cement'. It was an invention rather than a discovery because it was the product of selecting and mixing various materials together to create a very strong, quick-setting cement. So essentially, if somewhat paradoxically, it was an *artificial* natural cement. This early Portland cement bears little relation to modern 'ordinary Portland cement' which, in its essential mix, dates from the early 1840s and was developed by Aspdin's son William. This improved version of Portland cement contained a material named *alite* (tricalcium silicate, a key crystalline mineral active in Portland cement) that allowed it to harden quickly.

In France, Louis-Joseph Vicat had developed a similar material, slightly earlier, and between 1812 and 1824 was able to use it to build, at Souillac over the River Dordogne in the Midi-Pyrénées in France, the world's first bridge incorporating concrete made with a cement based on a hydraulic lime-mix cement rather than on *pozzolana*.[76] Vicat's bridge is a curious one-off, ahead of its time, but the development in Britain and France of the type of cement he used set the stage for the return in the 1850s of concrete as a significant and popular structural material.

In the first decades after 1850 concrete was used without any form of internal reinforcing. It was merely poured into timber form-work or moulds to create monolithic structures. This in situ cast 'mass concrete' had great compressive strength and allowed large structure to be made quickly and cheaply. Concrete seemed a new wonder material and, in parallel to mass concrete construction, an industry soon evolved for the manufacture of factory-made pre-cast concrete components. But soon it was all too apparent that there were significant problems. The material could crack easily due to differential movement and drying (even when expansion joints were

frequently employed), and only those forms were achievable that required little tensile strength.

Despite these limitations, bridge designers could not resist the potential offered by this new building material and technology. There was truly a concrete renaissance. One of the earliest and most spectacular manifestations of this concrete renaissance in bridge design is the very long and multi-arched Grand Maître Aqueduct carrying the waters of the Vanne over the valley of the Yonne, in France. Built between 1867 and 1873 to the designs of engineers Belgrand, Humblot and Huet, it was – and remains – the largest and most impressive above-ground nineteenth century use of mass concrete.[77]

Almost as impressive is the slightly later, and more rugged, Glenfinnan railway viaduct next to the waters of Loch Shiel, Lochaber on Scotland's West Highland Line between Fort William and Mallaig. The viaduct, comprising twenty-one semi-circular arches, springing between elegant piers, was built between 1897 and 1901 under the control of engineers working for the contractor Sir Robert McAlpine. The viaduct remains a most impressive and emotive work, both because of the almost eerie contrast between its sustained, sinuous and repetitive industrial form, and the sublime beauty of the remote Highland landscape; and because of the visually-powerful evidence of the manner in which it was wrought. The concrete was poured into timber form-work so much of the surface of the viaduct is board-patterned, and bears the texture of wood grain. This gives it a tough, rough, very contemporary sculptural feel, and also acts as a most immediate reminder of the novel process of construction.

Another reminder of the construction, and of the new hazards it introduced into the building process, is the incident that took place at the similarly constructed but smaller Loch Nan Uamh Viaduct, further along the line near Arisaig. When a cartload of concrete was being poured from a high level into the form-work framing a pier, the horse attached to the cart backed-up so that cart, horse and driver all fell into the mix. The driver was, with difficulty, extracted but the horse and cart remain entombed within the pier.

RIGHT: The graciously sinuous Glenfinnan Viaduct next to the waters of Loch Shiel, Scotland. A poetic essay in mass concrete, realised between 1897 to 1901, set in happy contrast with the sublime landscape and demonstrating vividly that, in certain and sometimes strange circumstances, modern industrial construction can add to natural beauty.

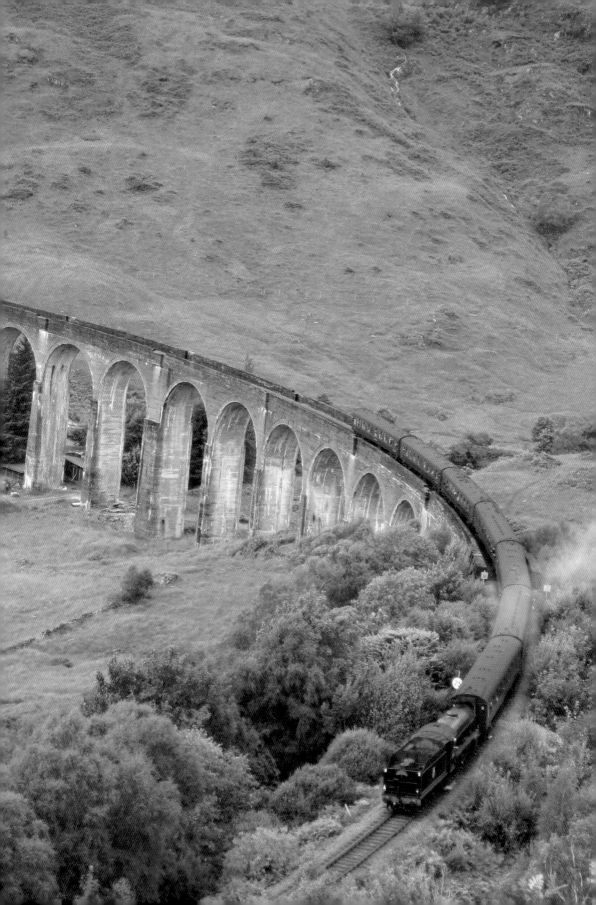

Although mass concrete was used – almost invariably for economy of speed and money – to realize large and technically demanding aqueducts and viaducts – it remained a minority material, generally regarded as too ugly to be used in any large or visible way in prominent or pretentious structures. Mass concrete mega-structures were rising in isolated splendour to fulfil utilitarian functions in remote locations and would continue occasionally to do so into the early twentieth century, for example in the three-arched Wansford Bridge in Cambridgeshire, built in 1925–28 by engineer Sir Owen Williams with architects Simpson and Ayrton. But meanwhile, hugely significant developments were taking place that would transform the building world and catapult concrete into pre-eminence.

Along with steel, concrete was, in its new manifestation, to become from the early twentieth century the material-of-choice for most medium to large-scale buildings in most parts of the world. The new idea was to give concrete significant tensile strength by reinforcing it with metal bars. Since the early nineteenth century, various innovative designers had played with the idea: for example, Marc Brunel – the father of the great bridge builder Isambard Kingdom Brunel – tested the concept in 1832. During the construction of his Thames Tunnel – the first in the world to be built in a city beneath a large body of water – he had experimented with the construction of an arch with bricks laid in Roman cement and reinforced with hoop iron. Brunel managed to get his arch to achieve a cantilever of 18.3 metres (60 feet).[78] This was an impressive achievement, and suggested that for much arch construction of the future expensive timber centering could be dispensed with. This experiment did not launch a consistent programme of research into means of reinforcing concrete made with Roman cement. But developments did take place during the first half of the nineteenth century, if only slowly and in a haphazard way.

For example, by the mid 1860s it was established that iron and concrete had similar coefficients of expansion, suggesting that an iron-reinforced concrete structure would

not develop cracks due to the two materials moving in very different ways. This was extremely significant, for cracks in such a structure could be catastrophic due to the fact that concrete and metal are not in many ways compatible materials. Concrete can employ water in its manufacture and, if cracks open, it will let moisture enter its inner parts. Moisture is, of course, the great enemy of many metals, especially iron, causing it to rust and, in the process of corrosion, to expand. Such expansion would unleash a vicious cycle leading to an increase in the number and size of cracks and so to accelerate corrosion and shatter the concrete cover. Although this problem was anticipated it was, for many early metal reinforced concrete structures, to prove near, or actually, fatal in practice.

During the 1870s and 1880s developments were pushed forward through a series of patented systems, perhaps the most notable early example being those taken out by a Parisian gardener named Joseph Monier for farm equipment and flowerpots made of concrete reinforced with round iron bars.[79] Monier was not only a maker of flowerpots, however. He was also a designer of bridges, and in 1875 – at Chateau de Chazelet, Indre, France – he constructed a charming pedestrian bridge of simple girder type with a span of 13.8 metres. The structure may be modest but it was epoch-making – the world's first bridge to be made out of metal-reinforced concrete.

Monier's patents were taken up in 1884 and disseminated by the German contractors and engineers Conrad Freytag, Philippe Josseaux and Gustav Adolf Wayss, who substituted steel reinforcement for iron, and went on to experiment with, and promote, various structural materials for reinforced concrete.

In France from the early 1890s, the self-educated builder Francois Hennebique, pioneered the large-scale use of reinforced concrete through a constructional system patented in 1892. His system integrated all the separate key constructional components of a building, such as beams and columns, into a single monolithic, reinforced concrete structure. He also introduced the concept

that it was best to place the steel reinforcing rods at the lower surface of a horizontal floor slab – where their tensile strength would be best utilized – while the concrete would be thickest on the upper surface where compressive strength was more important.

This strategy, although employed in a modern building system was, in a sense, as old as architecture itself. The stone lintels that form part of the 4,500 year-old trilithons at Stonehenge work in much in the same way. Their upper surfaces are in compression, which is to say under compressive stress, due to their own weight and the force of gravity, while their lower surfaces are, as it were, stretched, and thus under tensile stress. Over 7,000 structures were erected using the Hennebique system during the decade after 1892. The huge majority were designed and constructed by architects, engineers and builders who licensed the use of Hennebique's system, but he did design a few structures himself including – as chance would have it – an important bridge.

Erected between 1899 and 1900, the Camille-de-Hogues Bridge at Châtellerault, Vienne, France, is logical, generally devoid of superfluous historicist ornament and is – in pioneering Modernist manner – a fairly honest and direct expression of its materials and methods of construction. The bridge crosses the river in three wide and shallow segmental arches (the widest with a span of 52 metres) that carry a road supported both by the crowns of the arches and by thin, reinforced-concrete piers that occupy their spandrels. All in all, the bridge possesses an elegant lightness of form that would have been virtually, if not absolutely, impossible to achieve in masonry and very difficult to match in metal. Even more astonishing as a pioneer of reinforced concrete construction, is the massive Tunkhannock Railway Viaduct, designed by Abraham Burton Cohen, in Wyoming County, Pennsylvania, USA. It was built between 1912 and 1915 and, rising 73 metres in height above the bed of the river it crosses and stretching 724 metres in length, it carries the rail track on a series of wide arches. For fifty years it was the biggest concrete bridge in the world.

Hennebique's system of reinforced concrete construction was the logical perfection of a simple method – metal members

placed in position, usually within formwork, and then concrete poured over them and agitated as required so to ensure all set firmly to achieve a strong monolithic character. But there was another approach, one that was described as belonging 'to a universe unknown to classical structural materials'. This observation was made in 1949 by Éugene Freyssinet, one of the key pioneers of what became known as 'prestressed concrete', a material which in its concept, admitted Freyssinet, presented peculiar difficulties to those unfamiliar with the 'new universe' of modern building technology.[80]

The object of prestressed concrete is straightforward: to overcome the relatively low tensile strength of conventional reinforced concrete which, by its nature, had to deflect (often with slight cracking) before the steel reinforcing rods could do their job of providing more tensile strength.[81] This

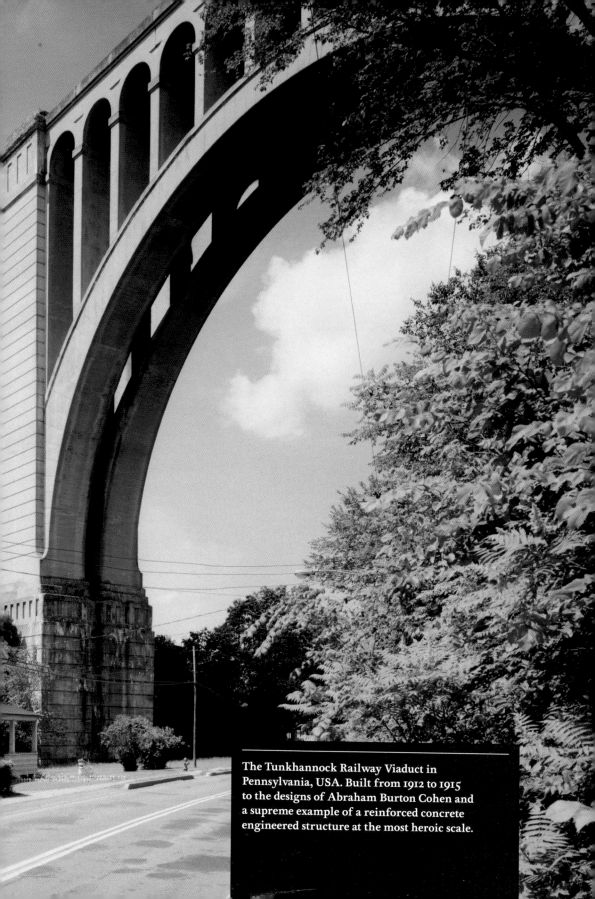

The Tunkhannock Railway Viaduct in
Pennsylvania, USA. Built from 1912 to 1915
to the designs of Abraham Burton Cohen and
a supreme example of a reinforced concrete
engineered structure at the most heroic scale.

enhanced strength was to permit the construction of beams, floor-plates and bridges with longer spans than was possible with conventional reinforced concrete. The means of achieving this, Freyssinet and his fellow pioneers concluded, was not to attempt to upgrade the concrete mix or increase the size or number of steel reinforcing rods, but to revolutionise the means by which reinforced concrete was manufactured. Structures made with prestressed concrete were usually not formed with concrete cast in situ – that is, poured on site as was usual with conventional reinforced concrete – but were mostly made from components cast under specially controlled conditions in a factory. These precast components, for example beams or panels, were then to be delivered to the construction site. So, unlike conventional reinforced concrete that resulted in monolithic structures, prestressed concrete heralded the arrival of prefabricated concrete construction with components assembled and fixed together on site.

These prestressed concrete components have a very novel character. Steel rods or tendons are pre-tensioned in factory conditions and then concrete is poured over them. Common ways to do this are to heat and thus expand the steel rods, clamp them, and then cover them with concrete; or to tension the steels by jacking them between two end anchorages before covering them with concrete. When the concrete has hardened the tension on the rods is released and transfers to the concrete – with which the rods are integral – giving the component additional tensile strength.[82] To make things a little more complicated to understand, prestressed concrete components can also possess a structural character that inverts nature, in a sense reverses the Stonehenge lintel effect. Compressive force can be at the bottom of the lintel not the top, and tensile force at the top not the bottom, so in a sense, a lintel's structural strength is springing upwards, cleverly limiting the possibility of deflection and countering the forces – gravity and load – that naturally press down upon it.

A post-tensioned form of prestressed concrete was also evolved, which permitted it to be cast in site. In this system the steel rods are tensioned after the concrete has hardened,

usually by leaving their ends projecting from the concrete and threaded so that tensioning turnbuckles can be applied. The rods then transfer their tensile strength to the surrounding concrete.[83]

Freyssinet, who initially worked in the *École National des Ponts et Chaussées*, designed and constructed a number of bridges using this revolutionary material. His first early significant bridge was the Pont le Veurdre, in the Auvergne, constructed in 1910 and subsequently destroyed in September 1944 during the Second World War. It comprised three arches – raised, connected and prestressed using jacks – one of which achieved a span of 72.5 metres, the longest yet for a concrete bridge. During the construction of this bridge, Freyssinet discovered the alarming propensity of concrete to 'creep' or deform over time if placed under undue stress. This phenomenon manifested itself at the Pont le Veurdre when the arches started to sag. Freyssinet's solution was to jack them back into shape and repair and fill using concrete. It worked, but Freyssinet evolved a more scientific approach to the problem of creep, and developed a system of working with prestressed concrete, taking out a patent in 1928.

Freyssinet's largest and longest concrete bridge is that over the Elorn River, near Brest, France. Known as the Plougastel Bridge, or the Albert-Louppe Bridge, it was built between 1922 and 1930, and has three spans, each of 188 metres. Part of the bridge was destroyed by the retreating German army in 1944, but was subsequently repaired.

In the same year that this heroic structure was completed Robert Maillart also completed his masterpiece, the Salginatobel Bridge, which is arguably the epitome of the stupendous and sublime structural and aesthetic possibilities offered by reinforced concrete.

The design of the Salginatobel Bridge rested on the ruins of an earlier bridge. In 1905 Maillart constructed a revolutionary reinforced concrete bridge over the River Rhine at Tavanasa in Switzerland, which possessed a slender structural form – comprising a 51-metre arched span – that could not have been achieved in masonry, metal or unreinforced concrete. For the

first time in bridge design reinforced concrete found its own voice, established its own aesthetic. But in 1927, during a catastrophic and unprecedented avalanche of rock from a hill above, the bridge was swept away. Maillart's response was not to shrug-off responsibility and simply blame the loss on the unexpected violence of nature but to re-evaluate the design, to discover how it could have been better and stronger, to see what lessons could be learned and work out how to apply them in future projects. First the strength and endurance of the ruined concrete fragments was established, then Maillart pondered the form the bridge had taken. Maillart had a brilliant understanding of reinforced concrete and he based his design for the replacement bridge on that knowledge. He saw that the 1905 design had been influenced by traditional masonry design with heavy abutments and a stone block at the crown, and he decided to break away from tradition and design an entirely new kind of bridge.[84] Maillart submitted his radical design for a new bridge – and it was rejected. Presumably the local population and authorities had – for the moment at least – lost any faith they might have had in the wonder material, reinforced concrete, and in minimalist modern design.

This failure is a reminder of the extraordinary conditions under which Maillart and his fellow pioneers worked. They had not only to tackle unforgiving nature and discover the potential of the new materials and forms, but also to contend with the taste, prejudices and non-comprehension of the time. Glance at a photograph of Maillart in the 1920s and he appears the epitome of convention – stout, bald, sombre-suited with generous upswept and somewhat old-fashioned mustachios – the very image of petty bourgeois respectability. But within was another man, burning with an ambition for the modern, the daring, the new and unknown. It is an extraordinary contrast. Unfortunately for Maillart, most of his contemporaries not only looked like him but also looked what they were – timid and tied by tradition. To realize his more challenging projects Maillart had to take on accepted notions of taste. Exposed concrete and bare functional forms were

LEFT: The Plougastel Bridge over the Elorn River, near Brest, France. Built between 1922 and 1930 in prestressed concrete to the designs of Éugene Freyssinet and one of the earliest large bridges built from a 'new universe' of structural materials.

naturally a great shock to the conventions of the early twentieth century, when neo-gothic and Arts and Crafts sensibilities still dominated and when the expectation of clients and citizens was for more elaborate designs.[85]

Maillart was undaunted by this rejection and remained firmly locked in embrace with the Modern. In the summer of the following year – 1928 – a bridge was proposed for a difficult and remote site high up in the Graubünden canton. It was needed to allow a new narrow road, intended to link the high village of Schuders to the valley town of Schiers, to cross the deep ravine of the Saliga brook. Maillart realized that some of the ideas he had developed for the rejected Tavanasa design could be applied to this project. A competition was held, he submitted a scheme in September 1928, and by mid October it was clear that he – with his chosen builder, Florian Prader – had won. The design was seminal. As Maillart's biographer, Billington explains, it shows that 'Maillart's vision had shifted away from stone images' and that reinforced-concrete structure had 'emerged from its adolescence'. Maillart had finally 'achieved a design that belongs to a new world of forms', and that 'expressed the essence of the reinforced-concrete bridge'.[86]

In a sense, Maillart's design for Salginatobel is a summation of all his previous bridge designs, indeed it's a declaration about how bridges should be designed in the modern world – one freed from the shackles of history and liberated by the potential of new constructional materials. Maillart's first significant reinforced concrete bridge, outside the remote little Swiss town of Zuoz, was designed in 1900. This was an obscure location where radical structural and aesthetic experimentation did not fall completely under the withering control of official agencies that were, according to Maillart's friend Sigfried Gidion, the great forces for 'public dullness'.[87] But even so, Maillart was obliged to demonstrate that concrete was cheaper than a steel-truss bridge and appeal to the prejudices and pride of the dignitaries of the Canton by arguing that 'because concrete outwardly resembles stone, [the bridge] will have a simple but elegant appearance and

'Maillart's design for Salginatobel is a summation of all his previous bridge designs, indeed it's a declaration about how bridges should be designed in the modern world – one freed from the shackles of history.'

will unquestionably bring honour and embellishment to the community'.[88] The Zuoz Bridge was duly completed in 1901 and demonstrated what was to become a cardinal principle of Maillart's bridge designs: that strength should come not from mass but from form, and if the form was appropriate and finely calculated it could also be minimal and economic of materials and construction time.

Maillart also developed the idea of box-construction in which the bottom curved slab of the bridge's arch – its soffit – was connected to the short vertical walls of the arch which themselves were connected to the top roadway. This honeycomb-like structure, with a hollow centre, was very strong and also far lighter than conventional masonry construction. All elements were, in Maillart's vision, to be fully integrated; nothing was to be superfluous or mere decoration. As Andrew Saint has observed: 'he ceased to look upon the arch as supporting the deck of the bridge, and thought of the whole as a hinged, hollow box in which all the elements acted together and redundant parts were pared away, to the gain of economy and aesthetics alike'.[89]

But this first pioneering design was not entirely freed from the inhibitions imposed by history. The bridge still, as with traditional masonry bridges, had solid spandrel walls forming the haunches from which the arch springs from the abutments. This was not only structurally unnecessary but a potential problem because large planes of concrete have

a pronounced tendency to develop cracks. In his next major
bridge, at Tavanasa, the spandrel walls were abandoned
and the arch fully exposed. By the time the Salginatobel
Bridge was designed, over twenty years later, Maillart had
refined and focused his ideas to the point where he was capable
of producing a bridge that was a breathtaking synthesis of
rational engineering and sophisticated aesthetics – a work
both of elegant engineering eminently fit for its purpose
and a work of abstract art.

He chose a three-hinged arch design – with flexible
junctions at both bases of the arch and in its centre – largely
to allow the bridge to move without undue stress if the ravine
moved. And of course, he chose the simple, shallow,
parabolic arch because of its inherent strength and suitability
for bridge construction, and because this form achieved

ABOVE: The Salginatobel
Bridge, completed in 1930
to the designs of Robert
Maillart: a monolithic
form – that realizes the
full structural and artistic
potential of reinforced
concrete – springs most
elegantly across a gorge
near Schiers, Switzerland.

maximum contrast with the fragmented and rocky landscape.[90] These are practical decisions, but also artistic ones, and give the composition a visceral visual power that is immediately apparent: the stark white bridge leaps across the ravine, liberated from all those elements associated with masonry bridges – massive abutments, spandrel walls, parapets made unnecessary by the inspired application of the potential of reinforced concrete. All is light, seemingly transient, sublime; seeing the bridge for the first time sends a shiver through the body, it conjures up a sense of terror, and inspires awe. In such a seemingly fragile manner, man has taken on, and beaten, the elements.

The lightness of touch displayed by the completed bridge is, of course, the consequence of decades of hard work, and of triumph over the usual parsimony that dogged so many of Maillart's projects. Maillart, working once again with Prader, had won the competition for the commission in October 1928, but almost immediately the Canton made it clear that it wanted the least expensive option without approach arches. So the main problem was to realize the vision within financial as well as practical constraints. Having won the competition Maillart got down to detailed design. First he had to imagine the problem of bridging the gulf that stood before him and then consider all the options offered by his own design genius, his desire for economic and elegant construction, and by the potential of reinforced concrete. He also had to take into account the natural forces of gravity which acts vertically, and wind which mainly acts horizontally. These forces shaped the form chosen by Maillart with the parabolic arch providing the most efficient means of transferring to the abutments the entire gravity load – the weight of the structure and the traffic – of the bridge. Maillart paid much attention, of course, to the precise form of the 90-metre main arch, exploring advantages of different ratios of arch span to arch rise, settling in the end for a rise of 13 metres in the 90 metre span.[91]

Through all these studies, it is clear how Maillart explored the crucial relationship between forces and forms, calculated

the dead loads of the bridge, the effect on it of the live loads it would carry, and how the strength of the structure under gravity could be compromised by horizontal wind loads. All the solutions had visual consequences, many subtle but some highly visible given the spare nature of the proposed structure. For example, a horizontal, or rotating movement, of the hinges at the two ends of the arch was partly countered by making the base of the arch, and the flanking cross walls it adjoins, flare out and move upwards. The effect of this practical decision was to give the bridge an incredibly three-dimensional sculptural feel.[92]

By early 1929 Maillart had completed his calculations and the detailed design, and in early June construction started. The initial stage of construction was, in many ways, the most crucial. The walls of the rocky ravine had to be prepared to receive the foundations of the arch's abutments and the scaffolding erected that would support the first phase of construction. Miscalculations here could cause immense problems later.

Maillart had designed a scaffold system that would be as efficient and minimal as the bridge itself. The wooden centering formed an immensely high arch that took as its profile the shape of the arch's soffit of the proposed bridge. It was also a very lightweight structure because Maillart intended that the scaffold should carry only the thin, curved, reinforced concrete slab forming the bottom of the hollow-box arch. Once the concrete for this slab had been poured into the mould and hardened, it would form the work surface off which the rest of the bridge would be built. It was an elegant idea that would save time and money, but it depended on skilled and precise initial work that, in turn, depended on close and expert supervision.

Maillart turned up on site in late June to work alongside the centering constructor, Richard Coray. All went well at first but then, inexplicably, the experienced Coray fell about 40 metres from the top of the scaffold into the ravine below. This seemed an ill-omened catastrophe. Not only was Coray confined to hospital for weeks (where he would eventually

recover) but the completion of the scaffold was delayed to the point where the concrete could not be cast in autumn as planned, but had to be delayed until after winter. Still, the brilliance of Maillart's design and planned construction process made it possible for this ghastly start to be accommodated within the proposed timescale and the bridge was completed and opened as planned in the summer of 1930.

Almost at a stroke, the beauty of the Salginatobel design was universally acknowledged, and elevated Maillart from mere engineer to artist and master of the intriguing world of emotive abstract forms. In David Billington's perception, the Salginatobel Bridge 'summarizes [Maillart's] career in one powerful image... and expresses in its history the ideal that all structures should be efficient, economical, and elegant'. The bridge also touches on things deep, mysterious and universal. The way in which the 'ideal takes form' is, Billington rightly observes, 'always in part a mystery and the designer who can do it works a kind of magic'.[93]

Each person who views the Salginatobel Bridge will, of course, extract their own brand of pleasure from it. Some will see it as pure and brilliant engineering, others as superlative abstract sculptural form that is the epitome of well-calculated strength and seems to express the essence of efficient and elegant bridge design. Most observers, I should think, will admire the bridge because its sheer abstract artistic beauty appears to derive from its engineering excellence. Its beauty is a consequence of its absolute fitness for purpose achieved by the most elegant and minimal means. So, in a sense, a great work of art has been achieved almost by chance – has been forged out of a determination to apply a logical system of appropriate structural principles to meet the objective demands of function and to achieve the strength and stability that bridges must, by their very nature, possess. It is this fusion of demands that makes engineering such a compelling subject. A painting or a work of sculpture has a limited palette of requirements beyond beauty and the power to inform, inspire, startle or delight. A great work of engineering must do all these things and also work, as a functional object, in the great and unbending world of nature.

Viewed simply as a sculptural object, the bridge is visually intriguing. Like all great sculpture it exists in the round and dominates space. But what becomes apparent, if you study the bridge from different viewpoints, is that not only does it offer delight but also it seems to change in its very nature as perspectives shift. The elevation of the bridge when seen from the adjacent valley (that view best known from publications), appears to realize Maillart's ideal: the profile of the bridge is light and delicate. But viewed from an acute angle the bridge takes on a significantly different appearance. When seen in elevation, the piers that support the approach roads on either side of the arch appear daringly slender, and the bridge seems to be composed more of space than of structure. But viewed from afar and from certain angles, these individual piers seem to be set in pairs. Then as the viewpoint changes again, the piers reveal themselves as slab walls, with certain elements flaring outwards towards the base of the arch implying great strength and giving the structure more substance. This is not a visual flaw that contradicts Maillart's vision, rather it enlivens the experience of seeing the bridge, offers visual excitement as it composes, decomposes and recomposes itself as you travel to, around, over and away from it.

The Salginatobel Bridge is certainly one of Europe's great creations of the twentieth century, immensely rewarding to see both as a work of engineering and as a mighty three-dimensional work of art. But, as with so much cutting-edge, avant-garde and partly experimental work, it has not been without its problems. Even Maillart in the 1920s did not, it seems, fully appreciate the power of the potentially inherent structural flaw of reinforced concrete to cause mayhem. Almost by its nature, a monolithic concrete structure will crack, if only a little, allowing water to penetrate that in turns causes metal reinforcing to rust, expand, and enlarge cracks that allow yet more water to penetrate – thus starting a destructive cycle leading remorselessly to terminal calamity.

The problem was made worse by the fact that, in the desire to create slender and elegant forms, pioneers in the use of

'By its nature, a monolithic concrete structure will crack, if only a little... thus starting a destructive cycle leading remorselessly to terminal calamity.'

reinforced concrete reduced the depth of the concrete cover over the steel reinforcing rods. They tended to calculate the minimum thickness of cover needed for structural strength and did not worry too much about the minimum cover needed to accommodate cracking and still protect the metal reinforcing from the weather. The consequences of this problem did manifest themselves at the Salginatobel Bridge where durability became an issue. Poor drainage and shallow concrete cover made extensive repairs necessary in the mid-1970s and again in the 1990s, when much of the original concrete was replaced and portions of the bridge reconstructed. But, it must be said, Maillart's bridge had endured nearly fifty years of extreme weather before major repairs became necessary – not bad for any structure – and the inherent strength of the design, with is mighty parabolic arch of superlative form, meant that the bridge's functional excellence was never undermined.

Maillart continued to design and build bridges for ten years after Salginatobel, the most memorable being his small and jewel-like Schwandbach Bridge of 1933 near Berne, Switzerland. This has a polygonal span of 37 metres and a deck, curved in plan, supported on a series of reinforced concrete cross-walls that appear to be almost impossibly slender. All is finely calculated with each member being positioned and exactly the size it needs to be to do its job. Here nothing is hidden, nothing is done just for theatrical effect. This bridge is a mature masterpiece of great confidence

by an artist who has learned much from earlier projects such as Salginatobel and has moved on towards an utter and sublime minimalism. At Schwandbach all that is functionally unnecessary or made redundant by the power of a superlative and immaculately engineered design, is pared away to achieve the Modernist ideal, so succinctly expressed by architect Mies van der Rohe, that 'less is more'. Mies took this phrase from a poem of 1855 by Robert Browning, entitled *Andrea del Sarto,* that also, perhaps by chance, contains a thought that is uncannily apposite for such ambitious pioneers as Maillart who, in a sense, had to imagine their unprecedented and daring bridges as the prelude to actually designing them. As Browning put it: 'a man's reach should exceed his grasp, Or what's a heaven for?'

In the decades immediately after the completion of the Salginatobel Bridge in 1930, reinforced concrete became one of the major materials for bridge construction. It appeared immensely strong and durable, was relatively cheap, allowed quick construction and could be used for most types of bridge. It was used by engineer S. Haggbom between 1942 and 1943 to build the then widest arched bridge in the world – at Sando, Sweden – where a vast reinforced concrete arch spans 264 metres, reaching a height of 39 metres, over the Angermanälven River. The age of the reinforced concrete and steel mega-bridge had arrived.

RIGHT: The Schwandbach Bridge, near Berne, Switzerland. Designed by Robert Maillart and completed in 1933, its curved carriageway is supported by reinforced concrete cross-walls of incredibly slender form.

MODERN
MEGA-BRIDGES

DRIVING ACROSS THE 2,460-METRE-LONG MILLAU
Viaduct – for drive you must – is one of the great bridge
experiences of the world. When mist lies heavy in the valley
of the Tarn in southern France, over which the viaduct passes,
you find yourself flanked by tall masts – one at 344 metres is
loftier than the Eiffel Tower – and motoring, 270 metres
high, amongst the clouds, seemingly into infinity. Bridges
can make you feel like a god.

The viaduct is a vivid reminder that the immense and
essential excitement of great bridges comes – first and
foremost – from the skill with which they do an intensely
practical and often most daunting job. There is little that
is arbitrary, or wilful about the design and construction
of a great bridge. They are, in a sense, huge and precisely
engineered machines that respond with brilliance to the
forces of nature. This they do through the application of
one of the three basic bridging solutions – arch, girder or
suspension – often enlivened and given endless fascination
through a myriad of permutations and variations, most of
which reflect available construction materials and evolving
technology. From the satisfactory solution to the practical
challenges and from the achievement of functional
perfection comes everything else that makes bridges
memorable – including, on occasions, incomparable grace

PREVIOUS: The Vasco da
Gama Bridge – across the
River Tagus near Lisbon,
Portugal, was completed
in 1998 to the design of
Armando Rito. Its length
of 17.2 km – incorporating
a 420 meters long cable-
stayed span – makes it the
longest bridge in Europe.

and beauty. Fine bridges are the marriage of art and science, of architecture and engineering, of the practical and the poetic. They are the perfect expression of those qualities that over 2,000 years ago Vitruvius argued were the hallmarks of all architecture and constructions of excellence – 'firmness, commodity and delight', (see page 60).

The Millau Viaduct, opened in 2004 and designed by Michel Virlogeux with Norman Foster, is a fascinating variation of the traditional suspension bridge. It is a cable-stayed structure in which the deck is attached directly to the towers by a series of diagonal cables, rather than to an arching cable descending from the towers and anchored in the ground.

This system has strengths and weaknesses. In cable-stayed bridges the towers or pylons are the primary load-bearing structural component: they operate under compression as a fixing point for all the cables supporting the deck so there is no need – as in suspension bridges – to construct firm cable anchorage on land. The freedom from this obligation can be a great benefit, because the construction of firm anchorages can be difficult if the soil conditions are unfavourable and anchorages have been known to fail – as at the Basse-Chaîne Bridge in France in 1850 (see page 243). In addition, cable-stayed bridges possess greater structural rigidity than suspension bridges so that deformation of the carriageway under the load of traffic or the environment is reduced. Also cable-stayed bridges can be built by cantilevering out from the towers, with cables acting as temporary then permanent support to the carriageway, and so are generally economic of time and money to construct. Another advantage is that the cable-stayed bridge can possess only one tower or – as displayed by the Millau Viaduct – the system can be easily extended by the addition of extra towers as required.

On the other hand suspension bridges – with their usual requirement for solid ground anchorages at the end of each cable – are almost invariably restricted to two towers. However exceptions are possible, by the use of 'self-anchored' suspension bridge technology for example (see page 232), or

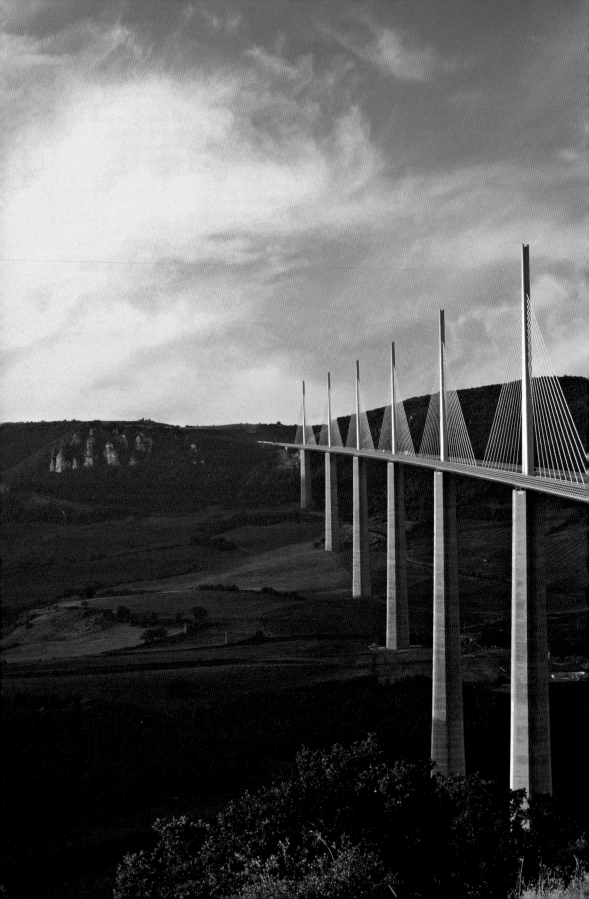

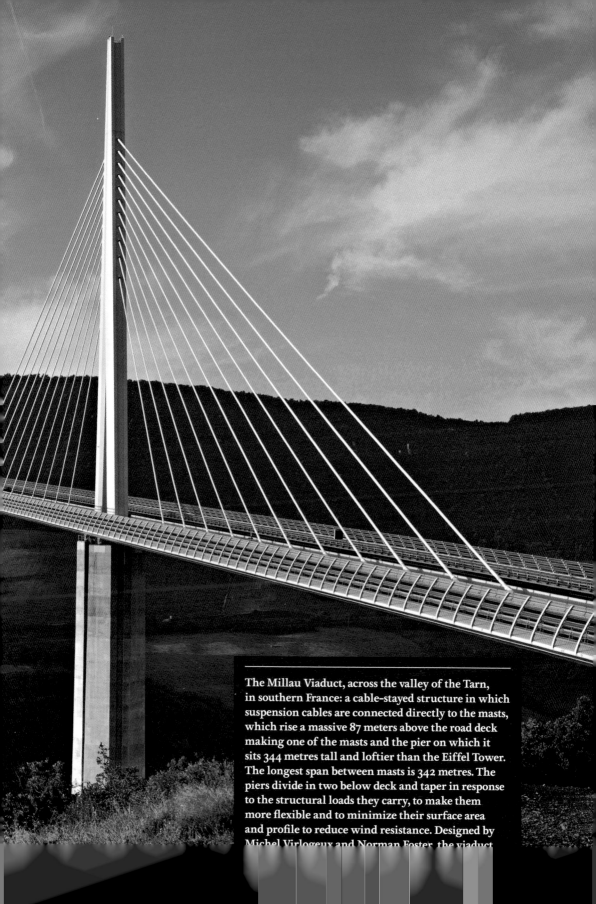

The Millau Viaduct, across the valley of the Tarn,
in southern France: a cable-stayed structure in which
suspension cables are connected directly to the masts,
which rise a massive 87 meters above the road deck
making one of the masts and the pier on which it
sits 344 metres tall and loftier than the Eiffel Tower.
The longest span between masts is 342 metres. The
piers divide in two below deck and taper in response
to the structural loads they carry, to make them
more flexible and to minimize their surface area
and profile to reduce wind resistance. Designed by
Michel Virlogeux and Norman Foster, the viaduct

through ingenuity. The west portion of the Bay Bridge
in San Francisco, California, built to the designs of Charles
Purcell and opened in 1936, is a suspension bridge with four
towers – essentially a pair of suspension bridges set end to
end – with a joint span of 700 metres. The ends of the cables
descending from each of the end towers are anchored in the
ground (to the east on Yerba Buena Island), while the ends
of the cables descending from the two middle towers are
anchored on a man-made island in the bay.

A potential weakness of the cable-stayed bridge type
is that, while they can achieve spans that are greater than
those of cantilever types they cannot match those reached
by suspension bridges. This is partly because the cables in
cable-stayed designs do not work with maximum efficiency
or effectiveness. In suspension bridges all is simple and
logical. Suspension cables hang vertically, operating in
tension, as they carry the load of the carriageway below
them, and suspension bridges require little scaffolding or
false-work during construction with their cables acting as
supports for working platforms. With cable-stayed bridges
things are a little more complicated. Although their cables
can be used during construction some invariably are added
late in the construction process so more scaffold is needed,
and since the supporting cables are fixed directly to the
towers, they are set diagonally and so pull to the side. This

BELOW: A cable-stayed
bridge of 'Fan' type in
which the cables supporting
the deck all connect to the
pinnacles or upper portions
of the towers.

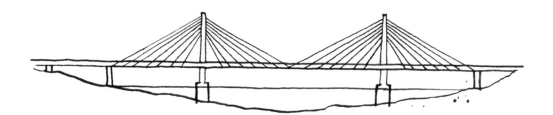

creates a horizontal compression force within the carriageway that, in consequence, has to be of a bulkier form than in a suspension bridge.

The responses to this inherent structural complication of the cable-stayed design – and to other structural challenges – have produced cable-stayed bridges of two basic types, each appropriate to different sets of circumstances. The 'Harp' type, in which the cables are set parallel and attached at different points to the tower (as in the Millau Viaduct), and the 'Fan' type where the cables all connect to, or pass over, the pinnacle, or upper portion, of the tower. These basic types are capable of inspired adaptation, as revealed by the Octávio Frias de Oliveira Bridge in Sao Paulo, Brazil. Completed in 2008, it comprises two curving roads – that pass over and under each other to form an X-shaped crossing over the water – which are both 'stayed' or suspended by cables radiating from a single X-shaped concrete pylon 138 metres tall. All is astonishingly sculptural – truly a bridge conceived and built in three-dimensions – and only possible through the inventive application of the cable-stayed structural system.

The quintessence of cable-stayed bridges is, perhaps, Santiago Calatrava's Jerusalem Chords Bridge that was completed in Israel in 2008. It has a cantilever span of 160 metres that is stabilized by cables radiating from a slender 118-metre tall pylon that is now the tallest structure in

BELOW: A cable-stayed bridge of 'Harp' type in which the cables are set parallel and attached at different points to the towers.

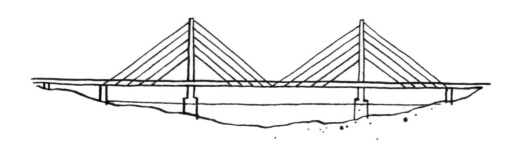

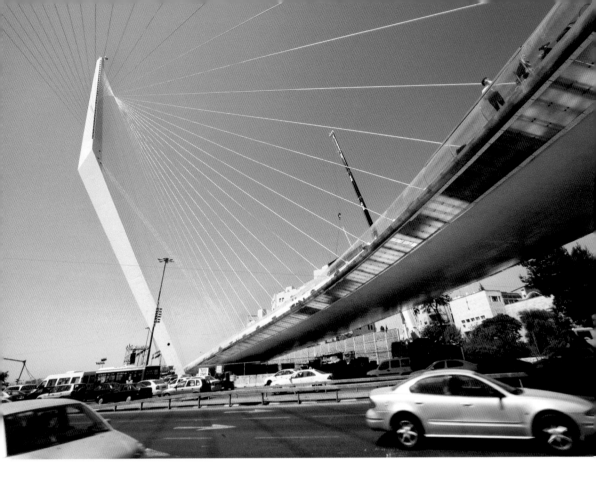

Jerusalem. This dismays some who feel that Jerusalem's strong traditional character does not need to be challenged by such a lofty interloper, but others appreciate its powerful symbolic character and call it 'David's Harp' – a significant association for the Jewish residents of the city.

In bridge design size is, very much, an issue. As Galileo pointed out in the early seventeenth century, when discussing the length and bulk of beam bridges, scale can only increase to a limited extent before a structure breaks under its own weight (see page 32). But the repetitive potential of cable-stayed bridges, used in conjunction with suspension or cantilever structures, viaducts and pioneering new technology has led to the construction in recent decades of bridges with extraordinary lengths, indeed bridges bigger in every sense than the world has ever seen, and that put even Roman

ABOVE: The Chords Bridge, Jerusalem, completed in 2008 to the designs of Santiago Calatrava. It is a complex form of cable-stayed structure in which cables radiate from a 118-metre high mast or pylon.

aqueducts in the shade (see page 56). This is the age of the mega-bridge – a time when, more than ever before, cities and regions realise that the acquisition of a big bridge, preferably of visually dramatic form, puts you firmly on the world map.

For example the Hangzhou Bay Bridge, China, completed in 2007, has a length of 35.5 kilometres and incorporates a 448 metre-long cable-stayed span. It is the longest trans-oceanic bridge in the world – stripping the title from the 32.5 kilometre long sea-spanning Donghai Bridge at Shanghai, completed in 2005 and also with a cable-stayed section – but is nearly 3 kilometres shorter than the 38.4 kilometre long Lake Pontchartrain Causeway, dating from the 1950s, in Louisiana, United States. The 8.2 kilometre long Sutong Bridge across the Yangtze River in China – completed in 2008 – has, at 1,088 metres, the longest cable-stayed span in the world, followed by the 1,018 metre span of the cable-stayed Stonecutters Bridge of 2009 in Hong Kong. Both these will be overtaken by the 1,104-metre main span of the cable-stayed Russky Island Bridge, Vladivostok, Russia, which is due for completion in 2012.

When bridges get to this massive size, and incorporate different structural systems, confusion sets in over definitions. Are they true bridges, or causeways linked by bridges or simply viaducts or raised carriageways of great length? For example, what exactly is the 54 kilometre long Bang Na Expressway in Thailand that, completed in 2000, is of box-girder construction consisting of sections of 42 metre span, but which crosses no significant stretch of water? And is the 79.7 kilometre long Weinan Weihe Grand Railway Bridge, Xi'an, China, completed in 2008, essentially a raised railway track? A consensus has yet to be reached by those authorities that define, measure and compare the vital statistics of the world's bridges. Seemingly more certain of their identity as bridges are the Manchac Swamp Bridge, in Louisiana, USA, that was completed in 1979 and straddles its way across over 36 kilometres of swamp with its concrete trestles resting on piles sunk nearly 78 metres into the water-logged land; the Confederation Bridge at Cape Jourimain New Brunswick,

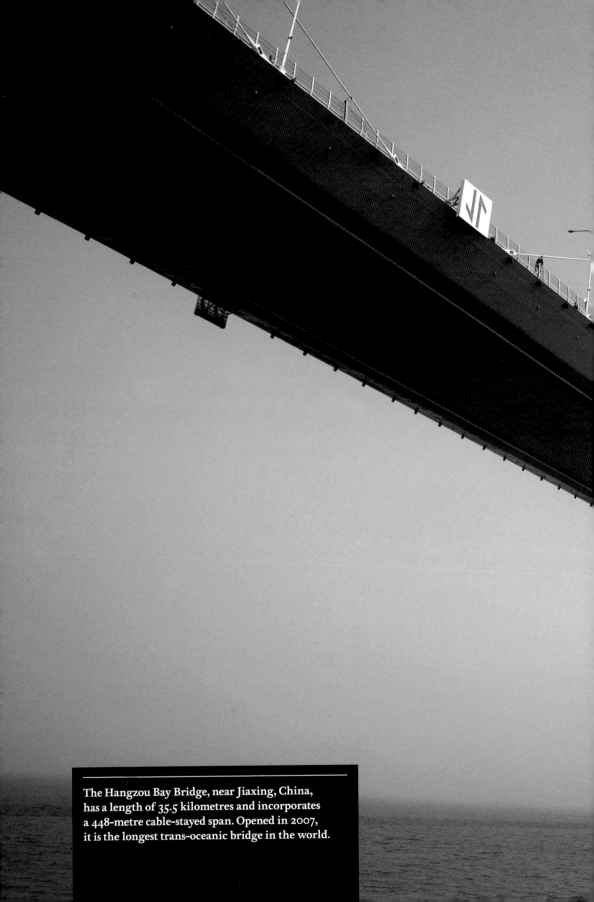

The Hangzou Bay Bridge, near Jiaxing, China,
has a length of 35.5 kilometres and incorporates
a 448-metre cable-stayed span. Opened in 2007,
it is the longest trans-oceanic bridge in the world.

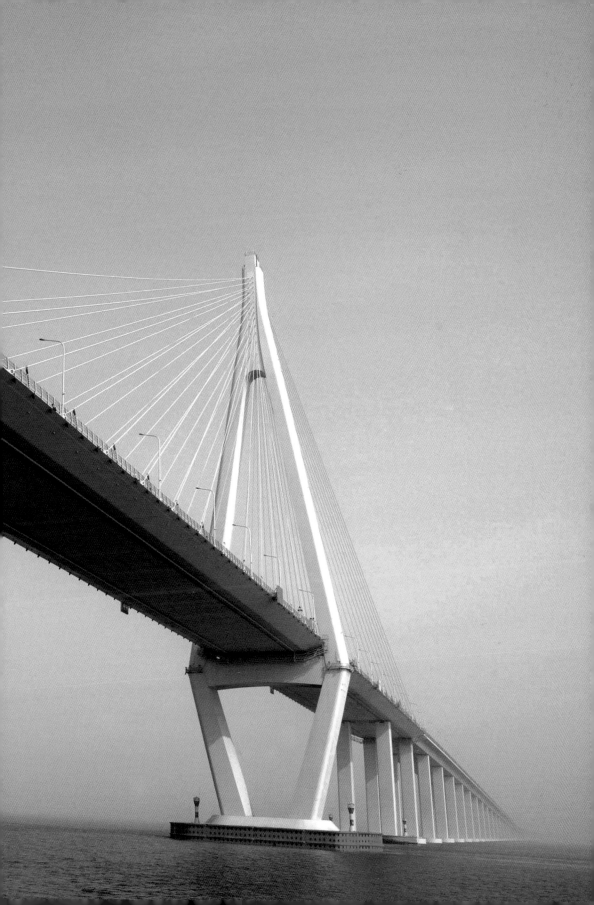

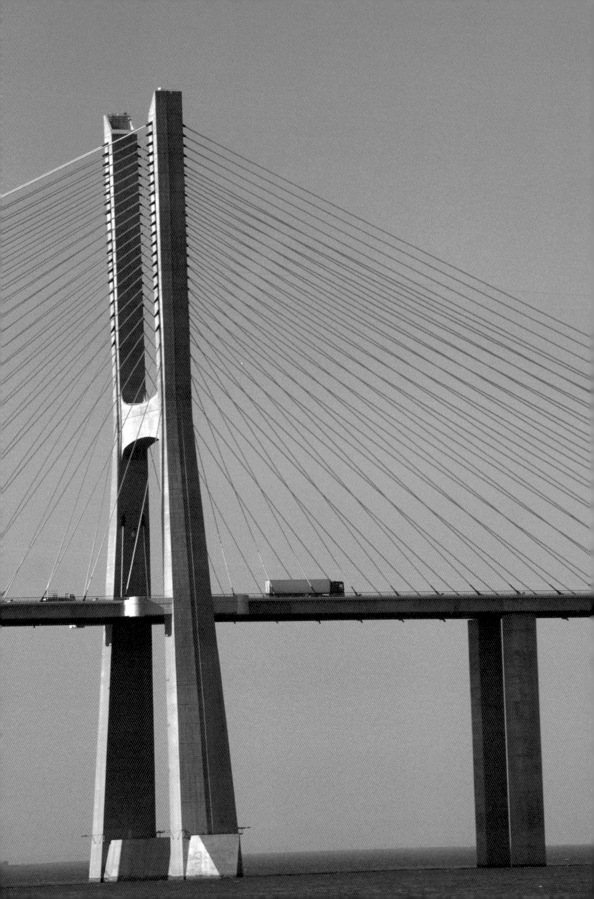

Canada that was opened in 1997 and stretches 12.9 kilometres across water with an infinite series of post-tensioned concrete box-girder spans; and the Yangcun Railway Bridge in China that was opened in 2007 and measures 35.8 kilometres.

There can be no question about the status of the Vasco da Gama Bridge over the River Tagus, near Lisbon, Portugal or the Öresund Bridge that links Malmö, Sweden to Copenhagen in Denmark. Both are, beyond any doubt, superlative bridges. The Vasco da Gama Bridge, designed by Armando Rito and completed in 1998, has a length of 17.2 kilometres (making it the longest bridge in Europe) and is formed by snaking viaducts that frame a majestic cable-stayed span of 420 metres. The Öresund Bridge stretches 7.8 kilometres across and below the Öresund Strait, and also includes a cable-stayed section supporting three spans, the longest of which has a span of 490 metres. The crossing includes a tunnel section through and from an intermediate island, an added complication and cost made necessary by the requirement to allow an unobstructed flight path to Copenhagen airport and a clear route for shipping. The bridge, completed in 2000 by engineers Arups and Gimsing and Madsen with Georg Rotne, possesses an almost hair-raising and breathtaking beauty. In a most audacious and minimal manner, it seems to float as much as thrust its way across the wide and often hostile body of water – a white sliver of quintessential bridge.

I saw the bridge first while travelling on a ship with companions who were not, alas, given to glory either in the wonders of nature or of the man-made world. But the sight of this bridge – its boldness, scale and undeniable beauty (derived from its clear utility and fitness for purpose) – grabbed their attention, compelled them to stare in silent and goggle-eyed astonishment. Through the centuries, despite everything, man's wonder of bridges – particularly the large and the minimal – has not faltered.

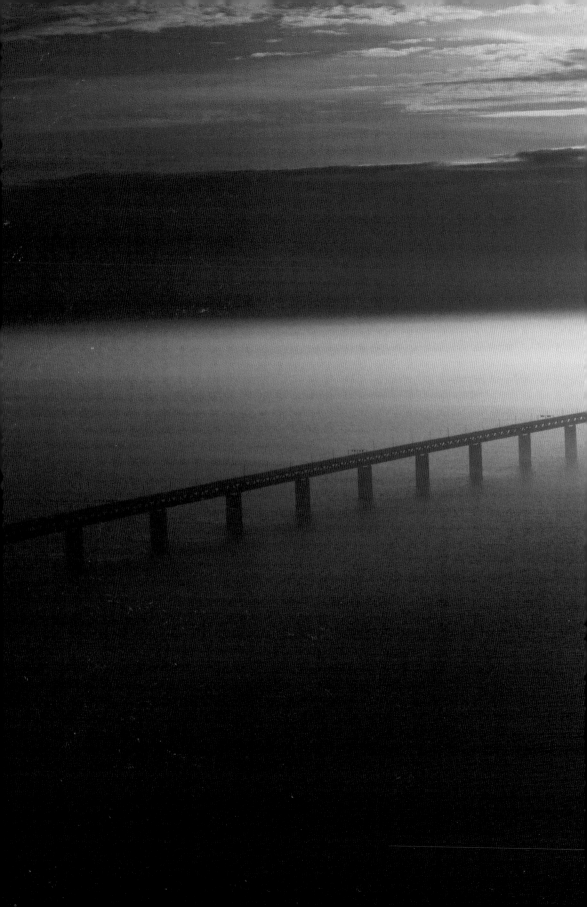

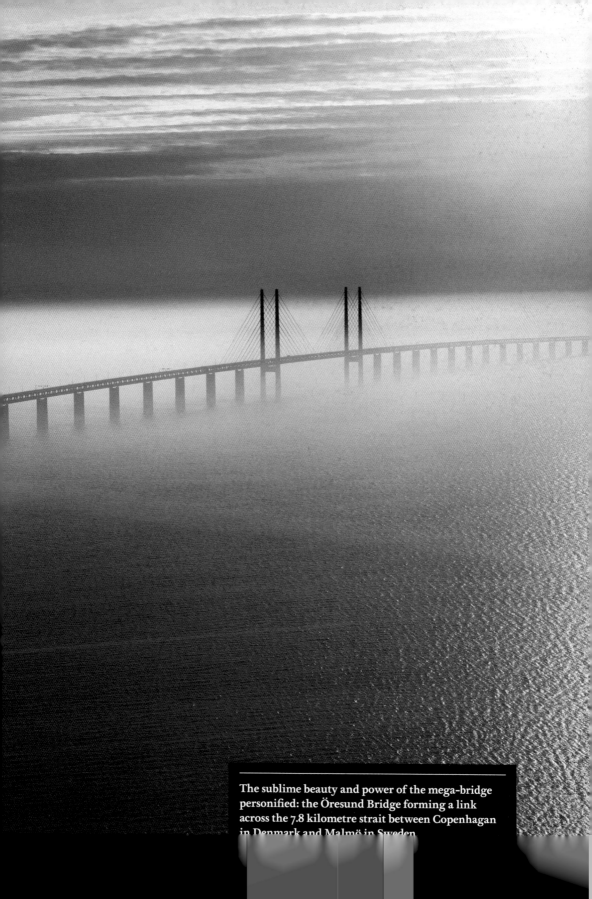

The sublime beauty and power of the mega-bridge
personified: the Öresund Bridge forming a link
across the 7.8 kilometre strait between Copenhagan
in Denmark and Malmö in Sweden.

NOTES

1 see Ronald G. Knapp, *Chinese Bridges* (Oxford University Press, 1993)

2 Philip Larkin, 'Bridge for the Living' (1980–81) in Anthony Thwaite
 (ed.) *Philip Larkin: Collected Poems,* (London, Marvell Press, 2003),
 pp. 188–9

3 Composed 2 September 1802, en route to France, published in
 Poems in Two Volumes, 1807

4 *The Marriage of Heaven and Hell,* c1790–3 where Blake writes
 of 'cleansing the doors of perception.'

5 Robert Lebel, *Marcel Duchamp,* trans. George Heard Hamilton
 (London, Trianon Press, 1959), pp. 77–8

6 Andrew Saint, *Architect and Engineer* (Yale University Press, 2007),
 pp. 282–3

7 Andrew Saint, p. 283, Michael A. Sells, *The Bridge Betrayed,* 1996:
 'the one Ottoman monument that remains intact in areas occupied
 by Serb nationalists today is the sixteenth-century Visegrad bridge on
 the Drina that Andric made famous, Serb nationalists chose the same
 bridge as a killing center for Muslims in the Spring of 1992.' (p. 50);
 The Guardian 11 August 2005, G2 pp.1-3

8 Trans. Edward Fitzgerald

9 Philip Larkin, 'Bridge for the Living' in Thwaite (ed.), pp. 188–9

10 N. J. Dawood trans. 1959, *The Koran,* (London, Penguin, 1999), pp. 417–8

11 Judith Dupre, *Bridges,* (Black Dog Publishing, New York, 1987), pp. 12–3

12 The bridges are described in *Caesar's Commentary on the Gallic War*
 (first in book IV with a technical description, second in book VI.)

13 Julius Caesar, *The Conquest of Gaul* (Harmondsworth, Penguin, 1965),
 pp. 116–7

14 Cod. B. Fol. 23r, Paris

15 Bruce Boucher, *Andrea Palladio: The Architect in his Time* (New York,
 Abbeville Press Inc., 1994), pp. 204–15

16 Dupre, *Bridges,* p. 49

17 Charles Dickens, *American Notes,* quoted in Dupre, *Bridges,* p. 60

18 Edmund Burke, *Philosophical Enquiry into the Origins of our Idea of the
 Sublime and Beautiful* (1757), ed. Adam Phillips (Oxford University
 Press, 1998), p. 53

19 See Calvin Woodward, *The History of the St. Louis Bridge,* (St Louis,
 G. I. Jones & Company, 1881)

20 Colin O'Connor, *Roman Bridges* (Cambridge University Press, 1993), p. 173

21 As recorded by Ausonius: 'As he turns his mill—stones in furious

revolutions and drives shrieking saws through smooth blocks
of marble' in O'Connor, *Roman Bridges*, p. 45

22 Suetonius, Vespasian, p. 18

23 Book Two, chapter 8, paragraph 4, from Vitruvius: *The Ten Books
of Architecture*, ed. Morris Hickey Morgan, (New York, Dover
Publications, 1960), p. 51

24 Vitruvius: Chapter 6 in Book Eight is entitled 'Aqueducts,
Wells and Cisterns' – see paragraphs 1 and 2

25 *Vitruvius*, Morgan, p. 244

26 See paragraphs 10 and 11

27 *Vitruvius*, Morgan, pp. 246–7

28 Dupré, *Bridges*, pp. 14–5

29 Marjorie Nice Boyer, *Medieval French Bridges: a History*,
(Cambridge Mass., 1976), p. 54 and pp. 91–2

30 Boyer, p. 124

31 Boyer, p. 130

32 Boyer, p. 140

33 Boyer, p.144

34 Boyer, p. 84

35 *The Sketchbook of Villard de Honnecourt*, ed. T. Bowie, 1959, p. 130,
plate 60 (CXLV), Boyer, p. 143

36 Boyer, pp. 151–3

37 Boyer, p. 154

38 Boyer, pp. 94–5

39 A. W. N. Pugin, *The True Principles of Pointed or Christian Architecture*,
(London, J. Weale, 1841), p. 1

40 Boyer, p. 156

41 John Brookes, *Gardens of Paradise* (London, Weidenfeld & Nicolson,
1987), p. 17

42 G. H. Hossein Arab, *Isfahan*, (Yassavoli, Tehran, 1996), p. 11

43 Brookes, *Gardens of Paradise*

44 Obvious sources include Ovid's tale of Pyramus and Thisbe from his
2,000 year old *Metamorphoses*, Luigi da Porto's *Giuletta e Romeo* of 1530,
Arthur Brooke's 1562 verse *Tragical History of Romeus and Juliet*
(probably based on an Italian story by Matteo Bandello) and William
Painter's prose stories in the *Palace of Pleasure* volumes of 1566 to 1575.

45 Richard J. Goy, *Building Renaissance Venice* (Yale, 2006) and Deborah
Howard, *The Architectural History of Venice* (Yale, 1980)

46 Umberto Franzoi and Daniel Wheeler, *The Grand Canal* (Verona, Vendome Press, 1994)

47 Dupre, *Bridges*, pp. 26–7

48 J. A. Gotch, *Inigo Jones*, (London, Methuen and Company, 1928), pp. 81–2

49 Dan Cruickshank, *The Story of Britain's Best Buildings*, (London, BBC Books, 2002), pp. 110-145

50 See Joseph Rykwert, Neil Leach and Robert Tavernor, *Leon Battista Alberti: On the Art of Building in Ten Books* (Massachusetts, MIT, 1988), p. 262

51 Nikolaus Pevsner merely observes that the bridge was 'designed on the pattern of a Palladian drawing' in *The Buildings of England: Wiltshire* (London, Penguin, 1963), p. 585

52 Anna was the daughter of a fashionable cabinet and mirror–maker and famed for her beauty if not her mind or morals. Alexander Pope was to chide her in verse for being 'fantastic, vain and insolently fair' and suggested that she take a look in one of her father's mirrors, 'Wherein she might her haughty errors trace, And by reflection learn to mend her face.'

53 Frank Manders and Richard Potts, *Crossing the Tyne* (Newcastle-upon-Tyne, Tyne Bridge Publishing, 2001), pp. 80–2

54 *Crossing the Tyne*, p. 82

55 L. T. C. Rolt, *George and Robert Stephenson: The Railway Revolution* (Harmondsworth, Pelican, 1978), p. 302

56 Quoted in Peter R. Lewis and Colin Gagg, *Aesthetics versus function: the fall of the Dee bridge*, 1847, (Department of Materials Engineering, Faculty of Technology, The Open University, 2004).

57 Rolt, p. 302

58 Rolt, p. 302

59 Rolt, p. 304

60 Charles McKean, *The Battle for the North* (London, Granta, 2006), p. 49

61 'Survival of the fittest' was first coined by Herbert Spencer in *The Principles of Biology*, 1864

62 Rolt, pp. 303–49

63 David P. Billington, *The Tower and the Bridge: The New Art of Structural Engineering* (New York, Basic Books, 1983), p. 282

64 Saint, *Architect and Engineer*, pp. 162–3

65 Dupre, pp. 56–7

66 Esmond Reid, *Understanding Buildings* (London, Longman, 1984), p. 18

67 Théophile Seyrig, *Pont sur le Douro*, p. 755, Billington, *The Tower and the Bridge*, pp. 70–1

68 Bernard Marrey, *The Extraordinary Life and work of Monsieur Gustave Eiffel*, (1974), trans. Bert McClure (Paris, Graphite, 1984), pp. 57–60

69 Marrey, p. 60

70 Le Corbusier, *Towards a New Architecture* (1927), trans. with an introduction by Frederick Etchells (London, Architectural Press, 1947), p. 7

71 Le Corbusier, p. 17

72 Dupre, p. 65

73 Henry Grattan Tyrrell, *Artistic Bridge Design*, (Chicago, M. C. Clark Publishing Co, 1912), p. 273

74 Dupre, p. 59

75 Robert Maillart, writing on the Construction and Aesthetics of Bridges in *The Concrete Way*, May–June 1935

76 Saint, p. 208

77 Saint, p. 215

78 Saint, p. 217

79 Saint, p. 217

80 Preface in J. Barets, *Le beton precontraint* (Paris, 1950), p. 7; see David P. Billington, *The Tower and the Bridge*, p. 194

81 Reid, p. 12

82 Reid, p. 12

83 Reid, p. 12

84 David P. Billington, *Robert Maillart: Builder, Designer and Artist* (Cambridge University Press, 1997), pp. 136-7

85 Saint, p. 359

86 Billington, *Robert Maillart: Builder, Designer and Artist*, pp. 136-7

87 Dupré, p. 71

88 Billington, *Robert Maillart: Builder, Designer and Artist*, p. 17

89 Saint, p. 348

90 Billington, *Robert Maillart: Builder, Designer and Artist*, p. 139

91 Billington, *Robert Maillart: Builder, Designer and Artist*, p. 138

92 Billington, *Robert Maillart and the Art of Reinforced Concrete* (Massachusetts, MIT, 1990)

93 Billington, *Robert Maillart: Builder, Designer and Artist*, p. 142

GLOSSARY

Abutment The end supports of a bridge that carry the load from the carriageway to the ground. Also called buttresses.

Anchorage A fixing – usually formed with concrete, at either end of a suspension bridge – into which the cable ends are embedded. (See Suspension bridge.)

Aqueduct A man-made water channel or conduit with sections elevated on arches so as to accommodate undulating terrain and carry water with minimal fall from its source to its required destination.

Bascul A moveable type of cantilever bridge that opens by rotating on an axis, with its carriageway counterbalanced.

Beam bridge A bridge comprising a rigid horizontal member – solid or of truss construction – that carries a transverse load and is supported by abutments and or piers.

Box-beam *See Box-girder.*

Box construction A constructional system in reinforced concrete in which all sides of an arch are connected by a short inner-wall to form an integrated honeycomb construction that is lightweight but extremely strong.

Box-girder Rectangular girder constructed of four sheets of metal to form a long box that is light but strong. Also called a box-beam.

Bow-string arch bridge *See Tied-arch.*

Burr arch truss A type of timber truss invented in the USA in 1804 by Theodore Burr, who patented it on 3 April 1817, incorporating multiple kingpost trusses bolstered by being combined by a timber arch passing through the individual trusses and reaching from one end of the bridge span to the other.

Buttress *See Abutment.*

Caisson	A prefabricated cofferdam, usually with sharp lower edges allowing it to sink, under weight, into the riverbed, that is used to construct, and become part of, the foundations of a bridge's piers.
Cantilever bridge	A bridge formed by trusses that project as cantilevers from piers and which are linked by suspended spans and ultimately counter-balanced by abutments.
Catenary	A curve formed by suspending a cable between two points set at the same horizontal level. The profile of the arch described is potentially very strong if applied in construction.
Centering	*See Falsework.*
Chord	The top or bottom members of a truss between which the vertical posts and diagonal braces are located. In an arched truss the top chord defines the curve of the arch.
Clapper-bridge	A primitive or very simple bridge formed by stone slabs laid horizontally and spanning between abutments and stone piers.
Corbel arch	Formed by successive courses of corbels, acting as cantilevers – on facing walls – with each course projecting over that below until the crown of the 'arch' is formed.
Cornice	Part of the system of classical architecture. By the Roman period there were five 'Orders' of architecture ranging from the simple Tuscan through to the progressively ornate Doric, Ionic, and Corinthian, to the Composite Orders. Each Order possessed its own sets of proportions, ornaments and attributes but all included plinths, columns, capitals and entablatures of varied proportion, profiles and ornamentation. All entablatures comprised three elements that, from the bottom, are the architrave, the frieze and the cornice. Although largely symbolic and ornamental by the Roman period the entablature –

like many elements of the Orders – was functional in its origin. The cyma, or serpentine, mouldings of the cornice were originally placed at the eaves of the pitched roof and contrived to throw rainwater off the walls below.

Crown
The highest point of the curve – the top – of an arch. Sometimes marked, embellished or strengthened with a keystone.

Culvert
A tunnel carrying a stream or drain beneath a road or railroad.

Cutwater
A pointed projection at the base of a bridge pier that deflects the flow of water and thus helps protect the pier from the pressure of floodwater. Also called break-waters.

Extrados
The upper or outer curve of an arch.

Falsework
A temporary system of support – sometimes including scaffolding – required to stabilise a permanent structure during construction and before completion.

Girder-bridge
Formed by straight, horizontal beam-like elements supported on abutments or piers.

Hinge
Bearings that connect part of a bridge to either another part or to the foundations. A hinge is designed and fabricated to be relatively flexible, allowing some rotation to accommodate expansion or contraction of the bridge's structure caused by thermal or seismic movement or due to flexing in response to varying loads and stresses.

Howe truss
A type of timber truss patented in 1840 by the Massachusetts millwright William Howe in which vertical members are in tension and diagonal timbers, that slope up towards the centre of the truss, are in compression.

Keystone
Wedge-shaped block at the crown of an arch – curved or slightly cambered – to consolidate its structure.

Impost
The horizontal course – often decorated or expressed – from which an arch or vault springs or rises.

Intrados
The lower or inner curve of an arch.

Lenticular truss	A lens or lentil-shaped truss incorporating an upper arch (or chord) that curves down to end points where it connects to a lower arch – inverted but of similar dimension – that curves up to the same end points. The upper arch is prevented from spreading by the lower arch, which is in tension. One type of lenticular truss consists of an arched upper chord (in compression) tied by 'eyebar chains' formed of wrought-iron bars or links in tension. A good example is the Royal Albert Bridge, Saltash, England (designed by I. K. Brunel and opened in 1859). Here the upper chord is formed by a curving wrought-iron tube. In this bridge type the horizontal compression and tension forces are balanced so horizontal forces are not transmitted to the supporting piers and the trusses can be fabricated on the ground and then floated and raised into position on the piers.
Orgeaux	*See Starlings.*
Oscillation	The movement of a suspension bridge, usually as a result of environmental action such as wind.
Piers	Vertical supporting structures on which girders, arches or trusses sit.
Pneumatic caisson	A caisson including a working chamber filled with compressed air to stop water entering.
Putlog holes	Holes left in a wall to allow the insertion of beams to help support scaffolding to permit construction and maintenance.
Prestressed concrete	A material formed by pouring concrete over metal bars that have been expanded and anchored. When the concrete has set and the bars released, they compress the concrete as they seek to return to their original length, and give the material tensile strength.
Reinforced concrete	A material formed by concrete hardening around embedded wrought-iron or steel rods, bars or mesh. The material – combing the compressive strength of concrete with the tensile strength of wrought-iron or steel – is capable of sustaining heavy loads and resisting severe stresses.

Resonance	A condition in which the structure of a bridge is subjected to an oscillating force that has a frequency close to its own natural frequency. The condition can be caused by various forces – including wind pressure and the repetitive rhythm of marching feet – and can have structurally unfortunate, even destructive, consequences.
Shear	A sliding force, usually generated by one layer of material sliding relative to another layer.
Soffit	The visible underside of an arch, beam, vault or any exposed architectural element.
Spandrels	A quasi-triangular area defined by the curve of an arch, a horizontal line projecting from its crown and a vertical line rising from its springing. Also known as the haunch.
Springing	The base of an arch, the place where an arch or vaults starts to rise, curve or 'spring' from the horizontal and vertical impost on which it sits.
Starlings	Medieval method for the construction of footings or foundations of bridge piers by creating 'islands' mid stream formed by vertical timber piles, earth, stone and horizontal timber beams. Also closely-driven piles placed near a pier to act as cut or break-waters. Also called orgeaux.
Suspension bridge	A bridge in which the carriageway is suspended from cables – of various materials and construction – that drape over towers and are fixed to the ground in anchorages.
Three-hinged bridge	A bridge that has a hinge at its crown as well as at its abutments.
Through-arch bridge	*See Tied-arch.*
Tied-arch bridge	An arch bridge in which the horizontal and outward forces of the arch (or top chord) are borne in tension by a horizontal tie (or bottom chord) that has to work well in tension (so made for example of wrought-iron or steel). The bottom chord can be a collar set above the deck or the deck itself, both of which can be set well above the base or springing of the arch. This design eliminates the outward

thrust of the arch on its supporting piers or abutments allowing tied-arches to be placed safely on tall piers, and to withstand subsidence. Also known as a through-arch bridge, or bow-string arch bridge because the lower horizontal tie or chord is like a bow-string in relation to the arched upper chord. The bow-string through arch bridge design was patented in the USA in 1841 by Squire Whipple. A good example is Shaw Bridge, Claverack, New York, a double-span Whipple bow-string arch bridge with a 49 metre span, made of wrought-iron and opened in 1870.

Torsion A force that twists a structure or a structural member.

Trestle viaduct A carriageway, usually a railway, set in closely placed legs strengthened by systems of diagonal, horizontal and vertical struts of various designs. Of timber or metal construction. Not suitable for bridging wide rivers since spans are small but ideal for elevating a carriageway at a great height and for a long distance when time and money are short.

Triangulated truss A truss in which rigidity is achieved by the use of struts and ties – of timber, metal or reinforced concrete – disposed to form triangles.

Triumphal arch A formal gateway – usually incorporating a tall semi-circular headed arch and embellished with texts and iconographic or emblematic sculpture – placed astride a road or bridge and commemorating a heroic event or individual. Roman in origin.

Truss A rigid structural framework – rectangular or arched in form – usually formed of timbers or metal, bridging a space with each end resting on supports at regular intervals.

Trussed arch *See Truss.*

Two-hinged arch An arch hinged only at its abutments.

Voussoirs A wedge-shaped block – usually of stone – forming part of the curving structure of arch or vault, its sides coinciding with the radii of the arch.

BIBLIOGRAPHY

Andric, Ivo, *The Bridge on the Drina*, trans. Lovett Edwards
(New York, Macmillan, 1959)

Arab, G. H. Hossein, *Isfahan* (Yassavoli, Tehran, 1996)

Billington, David P., *Maillart's Bridges: The Art of Engineering*
(New York, Princeton University Press, 1979)

——, *Robert Maillart and the Art of Reinforced Concrete*
(Massachusetts, MIT, 1990)

——, *Robert Maillart: Builder, Designer and Artist* (Cambridge
University Press, 1997)

——, *The Tower and the Bridge: The New Art of Structural Engineering*
(New York, Basic Books, 1983)

Boucher, Bruce, Andrea Palladio: *The Architect in his Time*
(New York, Abbeville Press Inc., 1994)

Boyer, Marjorie Nice, *Medieval French Bridges: A History*
(Cambridge Mass., 1976)

Bracegirdle, Brian and P. H. Miles, *Thomas Telford* (Newton Abbot,
David & Charles, 1973)

Brindle, Steven, *Brunel: The Man who Built the World*
(London, Weidenfeld & Nicolson, 2005)

Brookes, John, *Gardens of Paradise* (London, Weidenfeld & Nicolson, 1987)

Burke, Edmund, *Philosophical Enquiry into the Origins of our Idea of the
Sublime and Beautiful* (1757), ed. Adam Phillips (Oxford University
Press, 1998)

Cook, Martin, *Medieval Bridges* (Princes Risborough, Shire, 1998)

Le Corbusier, *Towards a New Architecture* (1927), trans. with an
introduction by Frederick Etchells (London, Architectural Press, 1947)

——, *When the Cathedrals were White: A Journey into the Country of the*

Timid People, trans. F. E. Hyslop (London, Routledge, 1947)

Cossons, Neil, *The BP Book of Industrial Archaeology* (Newton Abbot, David & Charles, 3rd edition, 1993)

Cruickshank, Dan, *The Story of Britain's Best Buildings* (London, BBC Books, 2002)

Curl, James Stevens, *Dictionary of Architecture* (OUP, 1999)

De Mare, Eric, *Bridges of Britain* (London, Batsford, 1975)

Dupre, Judith, *Bridges* (New York, Black Dog Publishing, 1987)

Franzoi, Umberto and Daniel Wheeler, *The Grand Canal* (Verona, Vendome Press, 1994)

Gout, M. Paul, *Histoire et description du Pont de Valentré à Cahors* (Lot) (Paris, J. Brassac Files, 1880)

Goy, Richard J., *Building Renaissance Venice* (New Haven and London, Yale University Press, 2006)

Haupt, Herman, *General Theory of Bridge Construction* (New York, D. Appleton & Company, 1851)

Haw, Richard, *The Art of Brooklyn Bridge: A Visual History* (London, Routledge, 2008)

Hopkins, H. J. A., *Span of Bridges: An Illustrated History* (Newton Abbot, David & Charles, 1970)

Howard, Deborah, *The Architectural History of Venice* (New Haven and London, Yale University Press, 1980)

Knapp, Ronald G., *Chinese Bridges* (Oxford University Press, 1993)

Larkin, Philip, 'Bridge for the Living' (1980–81) in Anthony Thwaite (ed.) *Philip Larkin: Collected Poems* (London, Marvell Press, 2003)

Lebel, Robert, *Marcel Duchamp*, trans. George Heard Hamilton (London, Trianon Press, 1959)

Leonhardt, Fritz, *Bridges: Aesthetics and Design*
(Massachusetts, MIT Press, 1984)

Manders, Frank and Richard Potts, *Crossing the Tyne*
(Newcastle-upon-Tyne, Tyne Bridge Publishing, 2001)

Mann, Elizabeth, (illus. Alan Witschonke), *The Brooklyn Bridge*
(New York, Miyaka, 2006)

Marrey, Bernard, *The Extraordinary Life and Work of Monsieur Gustave Eiffel: the Engineer who Built the Statue of Liberty, the Porto Bridge... the Garabit Viaduct...the Eiffel Tower Paris*, trans. Bert McClure (Paris, Graphite, 1984)

——, *Les Ponts Modernes: 18e-19e Siècles* (Paris, Picard Éditeur, 1990)

McCullough, David, *The Great Bridge* (New York, Simon & Schuster, 1972)

McKean, Charles, *The Battle for the North: The Tay and Forth Bridges and the 19th Century Railway Wars* (London, Granta, 2006)

O'Connor, Colin, *Roman Bridges* (Cambridge University Press, 1993)

Palladio, Andrea, *I Quattro Libri dell'Architettura* (1570), English ed., *The Four Books of Andrea Palladio's Architecture* (London, Issac Ware, 1738)

Pevsner, Nikolaus, *The Buildings of England: Wiltshire* (London, Penguin, 1963)

Plowden, David, *Bridges: Spans of North America* (New York, The Viking Press, 1974)

Prade, Marcel, *Les Grands Ponts du Monde: Hors de l'Europe*
(Poitiers, Brissaud, 1992)

Pugin, A. W. N., *The True Principles of Pointed or Christian Architecture* (London, J. Weale, 1841)

Rastorfer, Darl, *Six Bridges: The Legacy of Othmar H. Ammann*
(New Haven and London, Yale University Press, 2000)

Reid, Esmond, *Understanding Buildings* (London, Longman, 1984)

Richards, J. M., *The National Trust Book of Bridges* (London, Jonathan Cape, 1984)

Rolt, L. T. C., George and Robert Stephenson:
The Railway Revolution (Harmondsworth, Pelican, 1978)

——, *Thomas Telford* (Stroud, Sutton, 2007)

Rykwert, Joseph, Neil Leach, and Robert Tavernor, *Leon Battista Alberti: On the Art of Building in Ten Books* (Massachusetts, MIT, 1988)

Saint, Andrew, *Architect and Engineer: a Study in Sibling Rivalry* (New Haven and London, Yale University Press, 2007)

Scott, Quint, *The Eads Bridge* (Columbia, University of Missouri Press, 1979)

Sells, Michael A., *The Bridge Betrayed: Religion and Genocide in Bosnia* (Berkeley and London, University of California Press, 1996)

Shirley-Smith, H., *The World's Great Bridges* (London, Phoenix House, 1964)

Talese, Gay, *The Bridge: Verrazano-Narrows Bridge* (New York, Walker and Company, 2003)

Telford, Thomas, *The Life of Thomas Telford*, ed. J. Rickman (London, J. and L.G. Hansard and Sons, 1838)

Tyrrell, Henry Grattan, *Artistic Bridge Design: A Systematic Treatise on the Design of Modern Bridges According to Aesthetic Principles* (Chicago, M. C. Clark Publishing Co, 1912)

Vitruvius Pollio, Marcus, *The Ten Books of Architecture*, ed. Morris Hickey Morgan, (New York, Dover Publications, 1960)

Watson, Bruce, *London Bridge: 2,000 Years of a River Crossing* (London, MoLAS, 2001)

Weigold, Marilyn E., *Silent Builder: Emily Warren Roebling and the Brooklyn Bridge* (Washington, Associated Faculty Press, 1984)

Westhofen, W., *The Forth Bridge, Reprinted from Engineering*, February 28, 1890

Woodward, Calvin M., *A History of the St. Louis Bridge: Containing a Full Account of Every Calvin Milton Step in its Construction and Erection, and Including the Theory of the Ribbed Arch and the Tests of Materials* (St Louis, G. I. Jones & Company, 1881)

Wright, Lewis, *The Clifton and Other Remarkable Suspension Bridges of the World* (London, John Weale; Bristol, J. Wright & Co, 1865)

ACKNOWLEDGEMENTS

Alan Baxter for wise advice and insights about the nature of bridge building; Robert Thorne for reading portions of the manuscript and for the benefit of his vast knowledge of the history and practice of engineered architecture; John Mullen for information on Devil's Bridges and discussions about Philip Larkin; Tim Knox and John Harris for information about Palladian Bridges; Andrew Saint for his thoughts on the creative relationship between engineers and architects; Helen Brocklehurst for sowing the seeds of the idea and helping shape the text, Helena Nicholls at HarperCollins for editing the text and - with incredible speed and skill - putting it into publishable form; Helen Hawksfield and Elen Jones for their crucial editorial assistance; Myfanwy Vernon-Hunt and Vanessa Green for their spirited design; Amanda Russell for her indefatigable picture research; Matthew Cook for delightful illustrations, and - of course - Hannah MacDonald for encouragement, advice and for agreeing to publish the book. And - as always - my agents Charles Walker and Katy Jones for their energy and indispensable support.

PICTURE CREDITS